"Good cartooning is basically good design. A cartoon character who looks good to you is a cartoon character who has been designed properly. You have to place things within your four panels so that you can break up the areas into nice shapes. I have discovered that, because of the type of humor in Charlie Brown, the drawings must remain simple—very simple. And I rarely do any backgrounds. Keeping it all very simple is the key here."

—*Charles M. Schulz*

SMALL KIDDING IN A BIG WAY . . .

PEANUTS

— A DELIGHTFULLY - DIFFERENT
COMIC STRIP TO APPEAR

in the

[NAME OF PAPER]

STARTING (DATE) • DON'T MISS IT!

UNITED FEATURES • 220 East 4

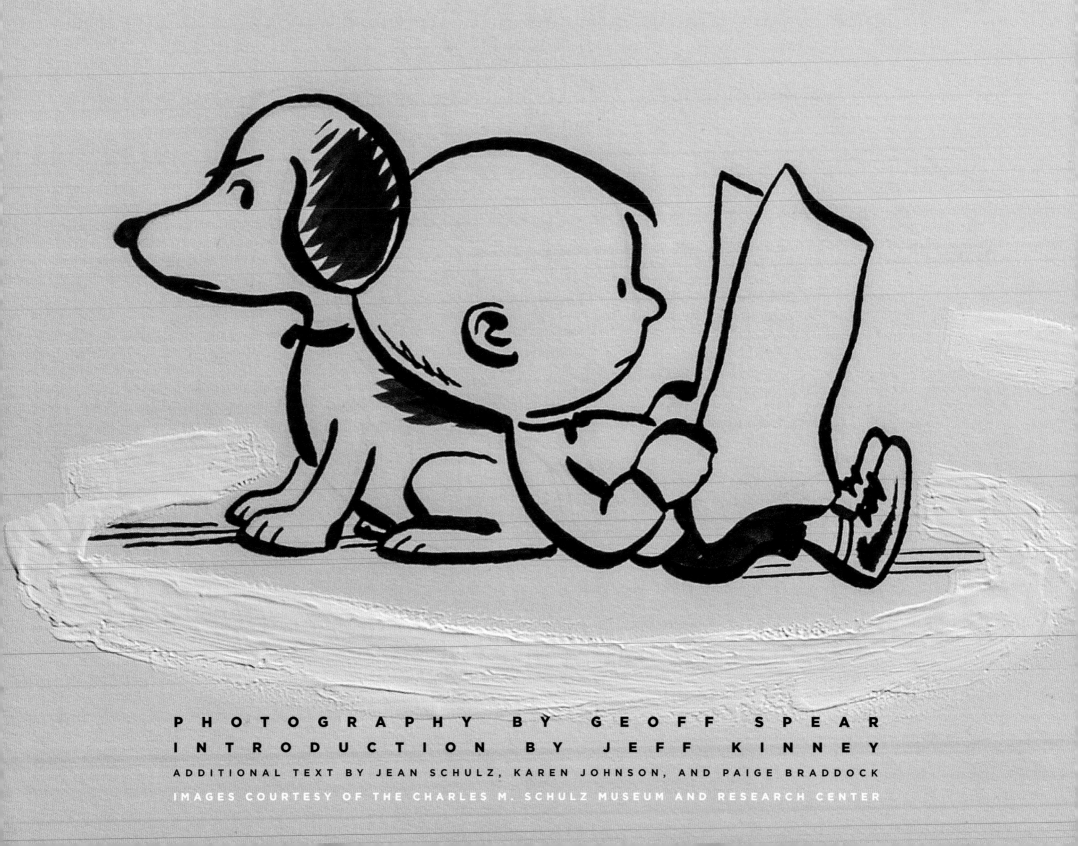

PHOTOGRAPHY BY GEOFF SPEAR
INTRODUCTION BY JEFF KINNEY
ADDITIONAL TEXT BY JEAN SCHULZ, KAREN JOHNSON, AND PAIGE BRADDOCK
IMAGES COURTESY OF THE CHARLES M. SCHULZ MUSEUM AND RESEARCH CENTER

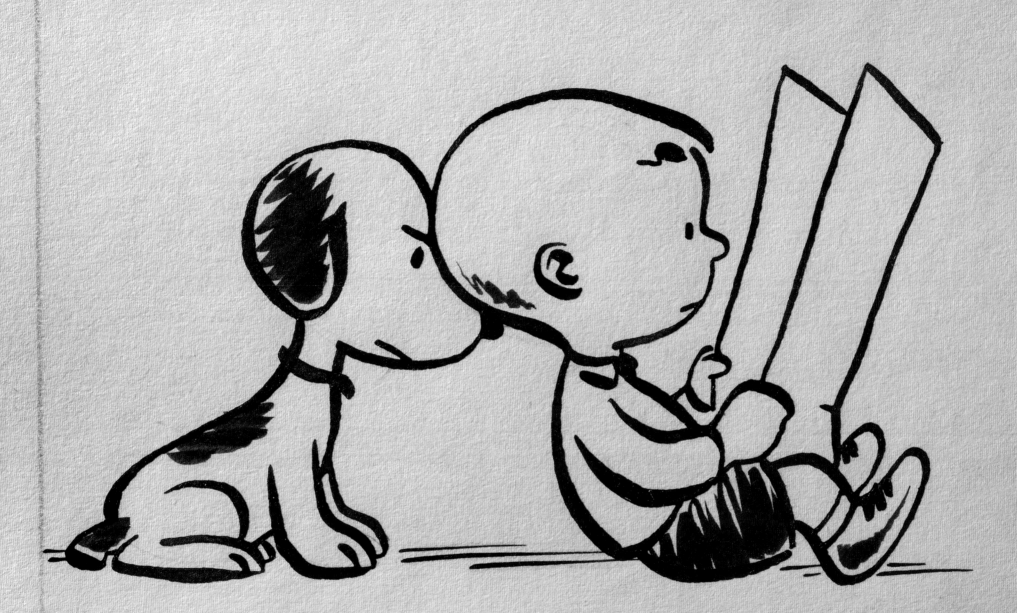

ONLY WHAT'S NECESSARY

CHARLES M. SCHULZ AND THE ART OF PEANUTS

TEXT, ART DIRECTION, AND DESIGN BY CHIP KIDD

ABRAMS COMICARTS • NEW YORK

COVER Detail, Charles M. Schulz stationery, 1960s.
ENDPAPERS Detail, Sunday comic strip, May 16, 1954.
ENDPAPER VERSO Detail, "Peanuts by Schulz" announcement flyer,
 distributed by United Features for subscriber promotion, fall 1950.
PAGE 1 Detail, Sunday comic strip, March 20, 1977.
PAGES 2-3 *Peanuts* paperback reprint collections published by
 Fawcett Crest, 1954–86.
PAGE 4 Detail, unfinished art for daily comic strip, undated.
PAGE 5 Detail, "Peanuts by Schulz" announcement flyer, distributed
 by United Features for subscriber promotion, fall 1950.
TITLE PAGES Unpublished *Li'l Folks* panels, spring 1950.

EDITOR Charles Kochman
ASSISTANT EDITOR Nicole Sclama
DESIGNER Chip Kidd
DESIGN MANAGER Shawn Dahl, dahlimama inc
MANAGING EDITOR Jen Graham
PRODUCTION MANAGER Alison Gervais

Library of Congress Cataloging-in-Publication Data
Kidd, Chip.
 Only what's necessary: Charles M. Schulz and the art of Peanuts / Text, art direction, and
design by Chip Kidd; Photography by Geoff Spear; Introduction by Jeff Kinney; Additional
text by Jean Schulz, Karen Johnson, and Paige Braddock; images courtesy of the Charles M.
Schulz Museum and Research Center.
 pages cm
 ISBN 978-1-4197-1639-3 (hardback) — ISBN 978-1-61312-863-3 (ebook)
 1. Schulz, Charles M. (Charles Monroe), 1922–2000—Criticism and interpretation. 2. Schulz,
Charles M. (Charles Monroe), 1922–2000. Peanuts. I. Schulz, Charles M. (Charles Monroe),
1922-2000. Peanuts. Selections. II. Charles M. Schulz Museum and Research Center. III. Title.
NC1764.5.U62S3835 2015
741.5'6973—dc23

 2015011111

ABRAMS
THE ART OF BOOKS SINCE 1949
115 West 18th Street
New York, NY 10011
www.abramsbooks.com

ABOVE Original art with tissue overlay. Advertisement for Aviva Enterprises Inc., 1981.
OPPOSITE Unpublished charcoal sketch on newsprint drawn for a cameraman who worked for
CBS Channel 5 in San Francisco, undated. The station featured Schulz in a live TV interview.

FOR JEANNIE AND PAIGE

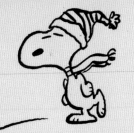

INTRODUCTION BY JEFF KINNEY

It was the clean lines.

Or maybe it was the white space. Whatever it was, something about *Peanuts* pulled me in every morning for all the mornings that I read the comics growing up.

Some things are self-evident, even to a kid. On the comics pages, there is *Peanuts*, and then there is everything else.

Charles Schulz couldn't have known that by agreeing to his syndicate's request to shrink the size of his comic strips down to a layout-friendly "space saver" format, he would reinvent the art form.

Less space meant making every line count. Every word of dialogue. Every gesture.

By using only what was necessary in his own strip, Schulz transformed people's understanding of what comics could *be*. In a time when the comics page was crowded with densely drawn, dialogue-heavy creations, Schulz's work was a beacon of simplicity and economy.

There's an oft-told story about a cartoonist who worked in the late 1800s who was once asked by his editor to produce more-detailed drawings like the work of his contemporaries. But the cartoonist's instincts were to *simplify* his drawings rather than embellish them. In fact, he said he should be paid more for using half the lines, given the skill it required. That man understood the essence of cartooning, which is efficiency. And

nobody got more out of fewer lines than Charles Schulz did with *Peanuts*.

Schulz economized in other ways, too. It was typical of the day to have multiple creators working on a single comic. A writer, a penciler, an inker, and a letterer. But by insisting on doing it all himself, Schulz created a singular work with a singular voice. A work that ran continuously for fifty years.

In creating Macbeth, William Shakespeare embodied a single character with a full and often contradictory range of human traits—ambition, weakness, gullibility, bravery, fearfulness, tyranny, kindness. A character as complex as Macbeth could only be created by someone with a complete

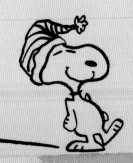

THIS PAGE **Original art for program, Redwood Empire Ice Arena (REIA) in Santa Rosa, California, c. 1960s.**

OPPOSITE **Ink on colored construction paper with die-cut hole, undated.**

understanding of what it means to be a human being, and suggests that Shakespeare himself shared many traits with his most famous literary character.

In the same way, the characters in *Peanuts* reflect the multiple dimensions of their creator. Interviewers asked Schulz if he was really Charlie Brown, expecting, perhaps, an uncomplicated confirmation. But Schulz was *all* the characters in *Peanuts*—Charlie Brown, Lucy, Linus, Schroeder, Pig-Pen, Franklin, Peppermint Patty, Marcie, even Snoopy. Each character represented a different aspect of Schulz, making *Peanuts* perhaps the most richly layered autobiography of all time.

As a work, *Peanuts* outgrew the confines of the comics page to permeate seemingly every imaginable facet of popular culture. From a touring musical to multiple bestselling books, a multitude of Macy's Thanksgiving Day Parade balloons, a truly unfathomable array of merchandise, and Emmy-winning animated television specials, the characters of *Peanuts* are perhaps the most recognizable and beloved in the world.

I recently had the chance to speak at a charity event with three other cartoonists who have had success in various literary formats. As the speeches unfolded, we discovered that each one of us had been inspired to become cartoonists by Charles Schulz. And each one of us, in turn, has made a pilgrimage to the Charles M. Schulz Museum and Research Center in Santa Rosa, California, to stand in awe of the artwork of a man we so admire.

There's *Peanuts*, and there's everything that came after it. Virtually every successful comic strip feature that has followed *Peanuts* owes a huge debt of gratitude to Schulz for getting to the very essence of what makes comics a powerful medium.

Schulz understood how to make every line count. Nothing extraneous, no waste.

Only what's necessary.

JEFF KINNEY IS THE AUTHOR OF THE DIARY OF A WIMPY KID SERIES.

CHARLIE BROWN
LOVES THE
WHOLE WIDE
WORLD!

10/4
SCHULZ

ABOVE Detail, daily comic strip, October 4, 1951.

OPPOSITE Ink on colored construction paper with
die-cut hole, undated.

FOREWORD BY JEAN SCHULZ

Chip Kidd, in his preface, speaks of the honor he feels in being allowed to work with the archives of the Charles M. Schulz Museum in the preparation of this book. Indeed, even before the museum opened its doors, our family cooperated with Chip and with photographer Geoff Spear to produce the 2001 book *Peanuts: The Art of Charles M. Schulz*. It was Chip's sincerity and dedication to letting the art speak for itself that impressed us, and we felt the resulting book rewarded our trust in his team.

Since its opening in 2002, the museum's collection has grown to include thousands of pieces of artwork and historically important items related to the life and work of my husband, Sparky, and his comic strip, *Peanuts*. I hope that the selections from the museum's collection showcased in this book will bring a taste of the museum into the homes of readers across the globe.

The title *Only What's Necessary* refers to Sparky's spare comics panels, which tell a story with a minimal number of pen lines. It wasn't necessary to draw every little detail because each reader's imagination automatically fills in what's needed. The result made *Peanuts* stand out on the comics page because, as Harry Gilbert of United Feature Syndicate once remarked, "it looks good between two busier strips."

One area where Sparky never spared the details, though, was in depicting rain. Paige Braddock, creative director of our Creative Associates Studio, remembers the day Sparky walked out of his studio and exclaimed, "Do you know how many pen lines it takes to make rain?" The question surprised Paige, and her retelling of the conversation made me curious. Well, I counted the rain in one of the strips, and there were over one hundred pen strokes in just one panel of that four-panel comic. I marvel at the concentration it must have taken to draw just that one panel, but I know for Sparky it was a thrilling exercise.

While cartooning has always been about the combination of words and pictures, for Sparky the drawing was central. He said each panel must be pleasant to look at, and I take that to mean in composition, balance, and structure. It's the architecture of each sequence and each panel that creates good design.

Here is Sparky's voice from a 1999 interview in Dr. Marshall B. Stearn's book *Portraits of Passion*:

> Even though I might be drawing something that may have some social comment or content, it is still the drawing itself—the creation of the actual cartoon, the pen lines that make up the cartoon, the quality of the pen lines, the craftsmanship that is involved, the composition of the cartoon—that is the real accomplishment. We have to forget about what the words are saying or things like that. Let's try to just talk about it as pictures, as drawings in the sand or drawings on the chalkboard. The quality of the drawing itself is so important to me. This is what I think real cartoonists admire. Not so much what the characters have said and things like that, but good cartoonists admire other cartoonists simply for the quality of the pen lines and the drawing itself. This doesn't mean literal draftsmanship always, but there is a certain warmth, there is the craftsmanship involved there beyond illustrative quality.

Sparky often spoke of admiring the work of J. R. Williams, who drew a daily syndicated panel, *Out Our Way,* which Sparky would have seen in his early years. Sparky recognized a dynamic quality in Williams's pen line. It conveyed an energy, even while the figures were still. With Sparky's drawing, too, nothing in the background is static; everything is squiggles and motion.

Paige Braddock, in a presentation to the animators at Blue Sky Studios, described the quality of Sparky's line as "organic." Interestingly, Sparky actually drew with his pen, rather than inking over a pencil sketch as many cartoonists and illustrators do. The ones you see in this book are the rare exceptions.

Drawing is magic.

It's like putting your negative into the developing solution and seeing the image—which you know is there—emerge. I imagine that is what Sparky felt as he saw what was in his head appear on the paper in front of him.

Paige also described the 3-D quality you can see in his originals. Sparky used three-ply hot press Strathmore Bristol board. This slick-surfaced paper allows the ink to sit on the surface rather than sink into the paper. Because the ink took a while to dry, Sparky worked on several strips at once. He would draw one panel and then set that strip aside to dry while he finished a panel on a different strip. The 3-D effect of the ink is lost when the art is printed in books or in

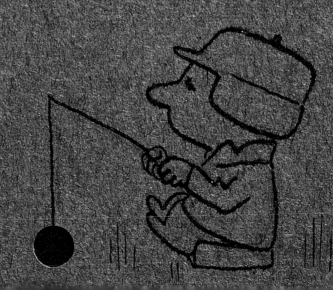

the newspaper. To truly see what Paige describes, you need to see the original strips on display at the museum. The photographs in this book come close, but no reproduction can evoke the feeling you get from looking at original art.

Another simple but interesting insight Sparky told Paige and that she related to the animators was about fingers, which should not all be the same. "No, no, no," Sparky said. "All the fingers have to be different—our fingers are unique." I love what the Australian cartoonist Jos Valdman wrote to me on this same subject:

> His drawing of hands, for example: They are so very refined and carry a truth of form that resonates in the same way his wonderful characters do, and to me, that is his essence. Sparky's work speaks from the heart and, of course, to it.

Sparky had a unique sense of humor. If you have read about him, you probably know that he followed the comics from an early age. He and his father looked forward to reading the comic pages of four different newspapers every Sunday. It is important to remember that comics were the television equivalent of the day and, as he and his father discussed what they found funny or exciting, Sparky would have observed a lot about comedic effects and timing.

Again, in Sparky's own words from Dr. Stearn's book:

> The trait of a cartoonist is to be able to see the humor in the tragedies man has to face. People say, how do you think of those funny ideas. I say, I'm very clever. I'm reasonably witty. I was astounded

about three or four months ago, I received a letter from a very close friend. We were in the same platoon and we spent a lot of time together and he said that he just thought it was about time that he wrote to me and just tell me how much he appreciated the friendship that he and I had during those years together. He said, you made me laugh. Well, it never occurred to me that I had made anybody laugh. I certainly was not the life of the party.… What he said made me feel good. It was something that never occurred to me.

So Sparky felt that he was clever and reasonably witty but, by his own admission, never the life of the party. That was not Sparky's humor. By "witty," I think Sparky is describing his ability to quickly see an incongruity in a situation or conversation and to make a humorous riposte. When Sparky uses a play on words, it comes directly from his experience and isn't a trite, recycled joke. A good example in this book is the strip with the punch line "emotional shocks," when Linus is talking about electrical shocks.

And by "clever," I don't think he meant clever-smart, but that he was attuned to the everyday absurdity in many ordinary situations.

I've often described Sparky's humor as a combination of the laughter and irreverence of Tom and Ray Magliozzi (the *Car Talk* guys) and the self-deprecating humor of Garrison Keillor (*A Prairie Home Companion*). But in addition to the wit, Sparky adds a visual punch line: a smug, chagrined, or sometimes deflated expression.

But other times the humor of the comic strip comes from things that Sparky thought were just

fun to draw, and he used them early and often, as they used to say about voting. The animated feeling of the jump-rope strips obviously tickled Sparky, and one example in this book resulted in Charlie Brown's very cartoony eyes. The theme of kids jumping rope is used again and again, always with a different take on it, and always with funny, sequential drawings that give the feeling of motion.

Sparky also found snowmen fun to draw, and coming from Minnesota, with its cold, snowy winters, he naturally brought them into the comic strip every winter. In a 1953 Sunday strip, Charlie Brown, when he is still in his "top of the world" phase, creates a snowman menagerie, and he continues proudly building snowmen until, in 1955, Linus creates a full-size Daniel Boone snowman, which takes the wind from Charlie Brown's sails. From then on, we think of Linus as the snowman builder. In reality, all the characters get into the act. In this case, and in the entire *Peanuts* oeuvre, the art drives the characters, and the characters, in turn, drive the art; and so the circle goes on, round and round.

Sparky's cast of distinct characters provided him with comic ideas. They could be counted on year after year (fortunately). Sometimes the characters are straight men, feeding the lines; sometimes they are gag men. But always they fit together, hand in glove, weaving a pattern that draws in readers day after day, year after year. But always, Sparky insisted, it was the art that made it work.

JEAN SCHULZ IS THE WIDOW OF CHARLES M. SCHULZ AND THE FOUNDER AND PRESIDENT OF THE BOARD OF DIRECTORS OF THE CHARLES M. SCHULZ MUSEUM AND RESEARCH CENTER IN SANTA ROSA, CALIFORNIA. READ HER BLOG AT SCHULZMUSEUM.ORG/JEANSCHULZ.

OPPOSITE **Detail, unfinished sketch for daily comic strip, undated.**

BEHIND THE DOOR
BY KAREN JOHNSON

To me, a childhood visit to any museum became more enchanting and mysterious when I found myself standing in front of a locked door with a sign saying STAFF ONLY. This sign left me pondering, "What's behind that door? Is this where all the art is, or the rest of the dinosaurs? Are there rooms full of statues, bugs, rocks, and books?" My mind just wondered about all the possibilities beyond that door.

Well, this book is the equivalent to having the highest staff clearance, or the master key, allowing you, the reader, access to the most protected artifacts and art pieces in the vaults of the Charles M. Schulz Museum and Research Center. As you turn each page, it is as if you have found the combination to the safe and are opening the drawers and culling through the archival files. Charles Schulz—the boy, the soldier, the husband, the father, the friend, the athlete, and the cartoonist—will come to life for you. Sparky, as his friends and family called him, will emerge. Collectively, this book gives you the most comprehensive overview of our collection to date.

In the 1990s, when the subject of a museum was first broached to Schulz, he showed little enthusiasm. After all, he was working on his daily comic strip and did not think of himself as a museum piece. Fortunately, this did not dampen the enthusiasm of the cartoonist's wife Jean, cartoon historian Mark Cohen, and Schulz's longtime friend and attorney Edwin Anderson. They had a collective dream of establishing a place where people could view Schulz's work and be immersed in his unique vision of the world. As Jean Schulz

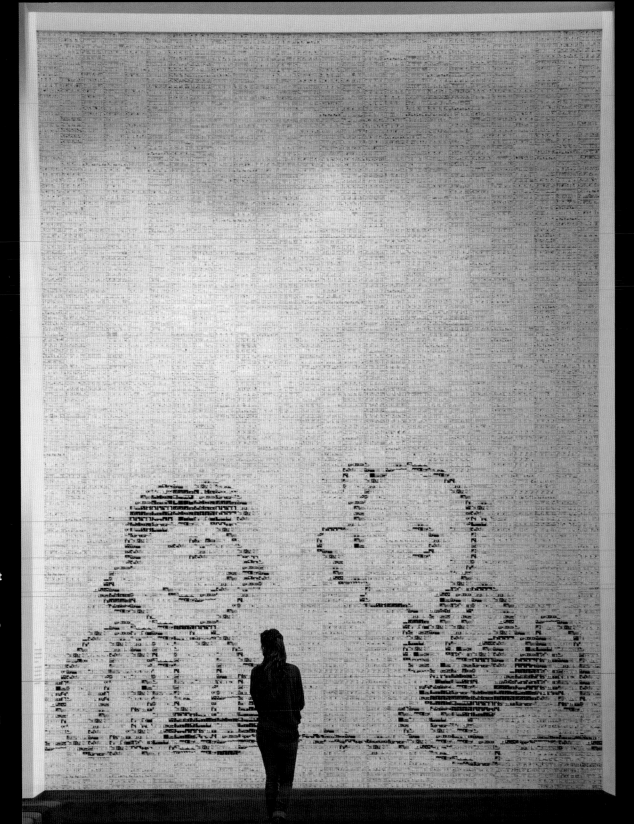

RIGHT **Mural by artist Yoshiteru Otani composed of 3,588** *Peanuts* **comic strip images printed on 8 × 2-inch ceramic tiles. Installation in the Great Hall of the Charles M. Schulz Museum and Research Center. Photograph by DJ Ashton.**

OPPOSITE **Detail of Otani's mural.**

has said, "I just wanted people to see his comic strips at their original size and not reduced to fit a newspaper's limited space. It is in the originals where you can really see his emotion through the strokes of his pen line and his master craftsmanship." As time progressed, Charles Schulz warmed to the idea of a museum whose main focus was to display his work.

In June 2000, just four months after Schulz's passing, friends, family, and local officials gathered for the groundbreaking of the museum in Santa Rosa, California. For the last thirty years of his life, Schulz's world centered on this property between his art studio and his beloved ice arena, where he started each day at the Warm Puppy Café with a simple breakfast of an English muffin, coffee, and the newspaper.

The Charles M. Schulz Museum and Research Center opened on August 15, 2002, with the mission to preserve, display, and interpret the art of Charles M. Schulz. In the past thirteen years, hundreds of thousands of visitors have walked through our galleries, reconnecting with their own life experiences of Snoopy, Charlie Brown, and the rest of the *Peanuts* gang. As I watch our guests roam through the galleries, their reflective and smiling faces tell me that they are lost in a world of their own personal delight and wonder. I have often thought, "How did one man, through one medium, universally connect with the world?" The truth about Schulz and his art—which is more complex than it seems—is that he found inspiration in life's daily occurrences that so many of us often take for granted. He was forever collecting bits of information that intrigued him, eventually finding a way to not only present them in his strip, but to make them relevant to his audience as well. Jean Schulz has remarked that Schulz's genius came from his simple and direct creative process; his ideas came from his head through his heart and were transferred by pen and ink onto paper.

Charles Schulz said, "If you read the strip, you would know me. Everything I am goes into the strip." As you turn the last page of this book, our wish for you, the reader, is that you have developed a deeper appreciation and understanding of the breadth of Schulz's artistic talent and have begun to see how his life experiences became the driving force for *Peanuts*.

It is appropriate that this book comes out on the sixty-fifth anniversary of *Peanuts*, a year filled with celebration, reflection, scholarship, and, ultimately, confirmation that *Peanuts* is truly art. A prominent museum director once told me he felt museums were in the "forever" business. I have never forgotten that, as it completely summarizes the essence of our day-to-day work. May the Charles M. Schulz Museum and Research Center forever be in the business of sharing Charles Schulz's life and the art of *Peanuts*—a universal gift for all humanity.

See you in the galleries.

KAREN JOHNSON IS THE MUSEUM DIRECTOR AT THE CHARLES M. SCHULZ MUSEUM AND RESEARCH CENTER IN SANTA ROSA, CALIFORNIA. VISIT THE MUSEUM ONLINE AT SCHULZMUSEUM.ORG.

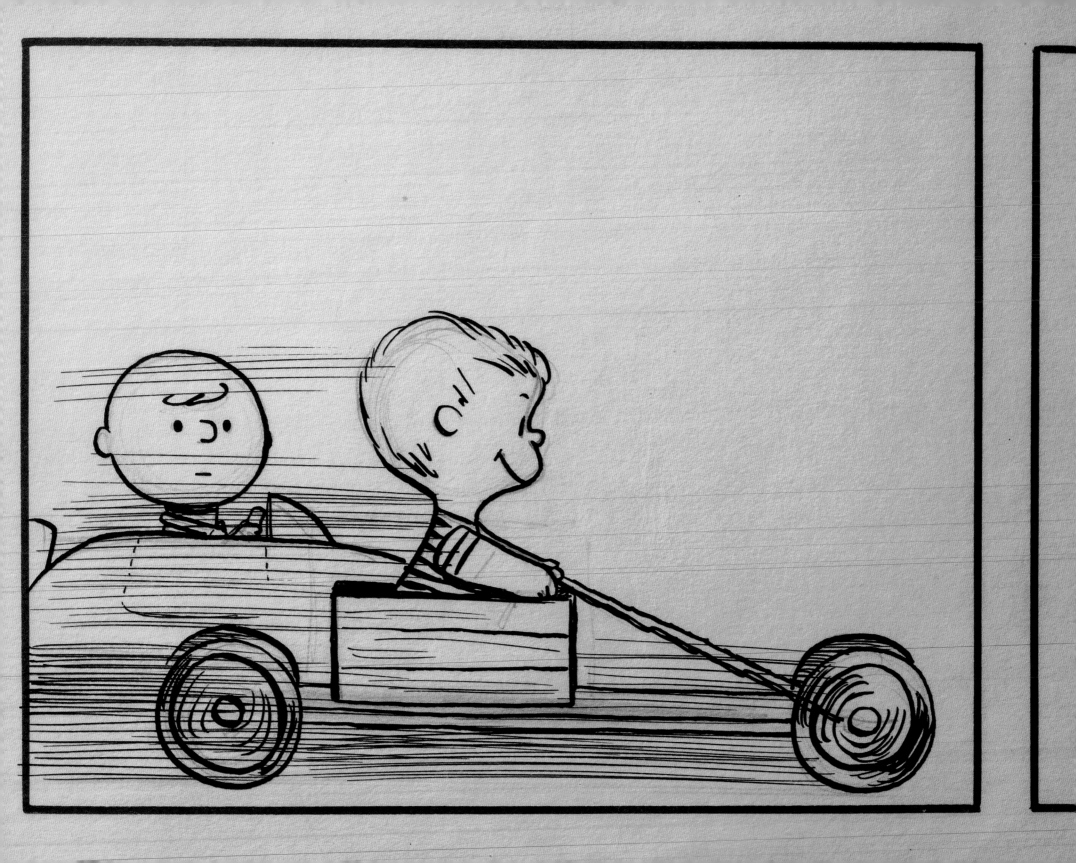

ONLY WHAT'S NECESSARY

If bringing joy to other people is proof of a meaningful existence, then Charles M. Schulz led one of the most meaningful lives of the twentieth century. I have few regrets in my own life, but not making an effort to meet Mr. Schulz, and thank him for his achievement while I might have had the chance, is definitely one of them. So I am trying to acknowledge his singular achievements here in this book.

To say I am a *Peanuts* nerd is putting it mildly, and I declare it with pride. But what separates me from the millions of other *Peanuts* nerds in the world is that I somehow became one who was granted *access*. On numerous occasions now, starting with my research for *Peanuts: The Art of Charles M. Schulz* in 2000, I have pored over his sketches, his original finished art, and the hidden treasures of his archive. And not only have I had access, but I was given the means to reproduce it. This is thanks to Jeannie Schulz, Paige Braddock, and the staff of the Charles M. Schulz Museum in Santa Rosa, California. I still can't quite believe that they gave me the opportunity to do it, but with this book I have tried my best to reward their trust.

Yes, there is much work here that Mr. Schulz never intended for the public to see, or to remember. And if he is somewhere in the great beyond shaking his fist at me, then I guess you could call me the Red Baron who worships him. Or maybe that's the wrong analogy. Maybe I am the little red-haired girl who always wanted to meet him and couldn't muster up the courage. Regardless, I don't have much in the way of analytic theories about what his career "meant," or how his creative process worked, or where he got his ideas. And I don't pretend to know. All I have is a deep appreciation for his work and the desire to share it.

Many books devoted to Mr. Schulz's oeuvre have come before this, and many more will follow, as well they should. But what we are attempting to do here is acknowledge Schulz the artist by examining his original art and ephemera as uniquely and eloquently as we can, for a life so well lived. A life of pathos, wit, humor, and passion; the joy and sorrow of love. A brilliant talent and the incredibly hard work he produced for more than fifty years.

How could we *not* thank him for that?

After all, it is only what's necessary.

—Chip Kidd
New York City
January 2015

OPPOSITE **Detail, unfinished sketch for daily comic strip, undated.**

RIGHT **Detail, daily comic strip, March 24, 1966.**

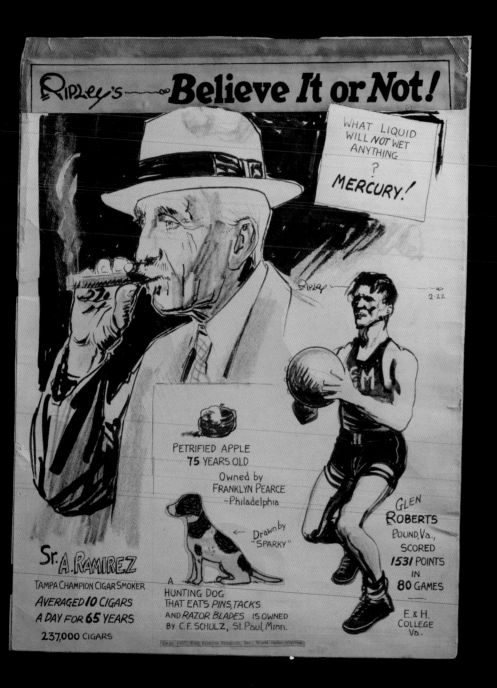

In an act that has long since become comics legend, fourteen-year-old Charles Monroe "Sparky" Schulz—the only son of Minneapolis barber Carl F. Schulz and his wife, Dena (pictured)—submitted a cartoon drawing of the family dog to the *Ripley's Believe It or Not!* feature. It was the winter of 1936. To the young Schulz's delight, the cartoon ran on February 22, 1937. The pooch, Spike, went unnamed, but it was a start for the young man who had only ever wanted to be a cartoonist.

The Ripley comic strip feature first appeared in 1918, compiling strange and unusual news events and facts that seemed too bizarre to be true. At the peak of its popularity in the 1930s, *Believe It or Not!* had a daily readership of eighty million. In comparison, *Peanuts*, at its peak, ran in over 2,600 newspapers, with a readership of 355 million in seventy-five countries, translated into twenty-one languages—believe it or not!

LEFT **Original art for *Ripley's Believe It or Not!*, February 22, 1937.**

BELOW **A teenage Charles Schulz poses for a family portrait with his parents, Carl and Dena, and their dog, Spike, c. 1937.**

OPPOSITE **Detail, *Ripley's Believe It or Not!***

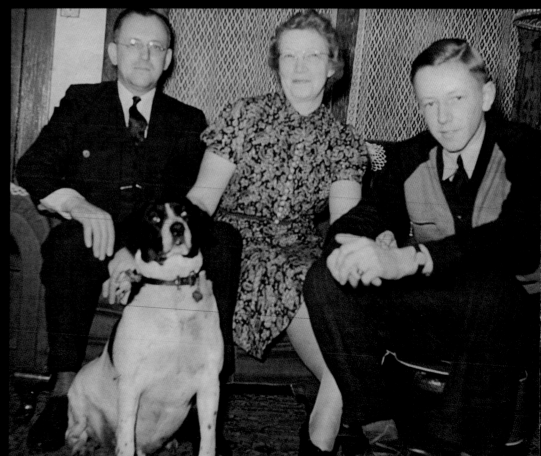

75 YEARS OLD

Owned by
FRANKLYN PEARCE
— Philadelphia

← Drawn by
"SPARKY"

REZ

AR SMOKER

GARS

EARS

S

A
HUNTING DOG
THAT EATS PINS, TACKS
AND RAZOR BLADES IS OWNED
BY C.F. SCHULZ, St. Paul, Minn.

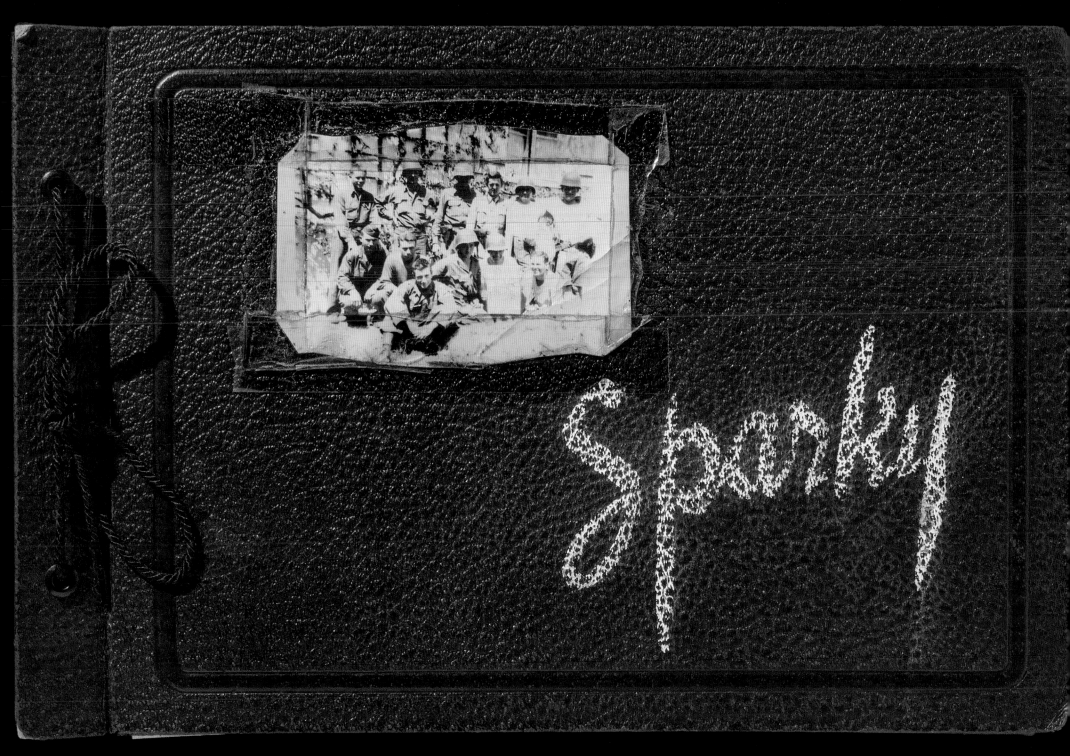

ABOVE **Cover of Schulz's personal World War II photo album, mid-1940s. Schulz was known to friends and family as Sparky, after Spark Plug the horse in the *Barney Google* comic strip by Billy DeBeck. Schulz was given the nickname by his uncle shortly after he was born on November 26, 1922.**

OPPOSITE **Sketch, mid-1940s.**

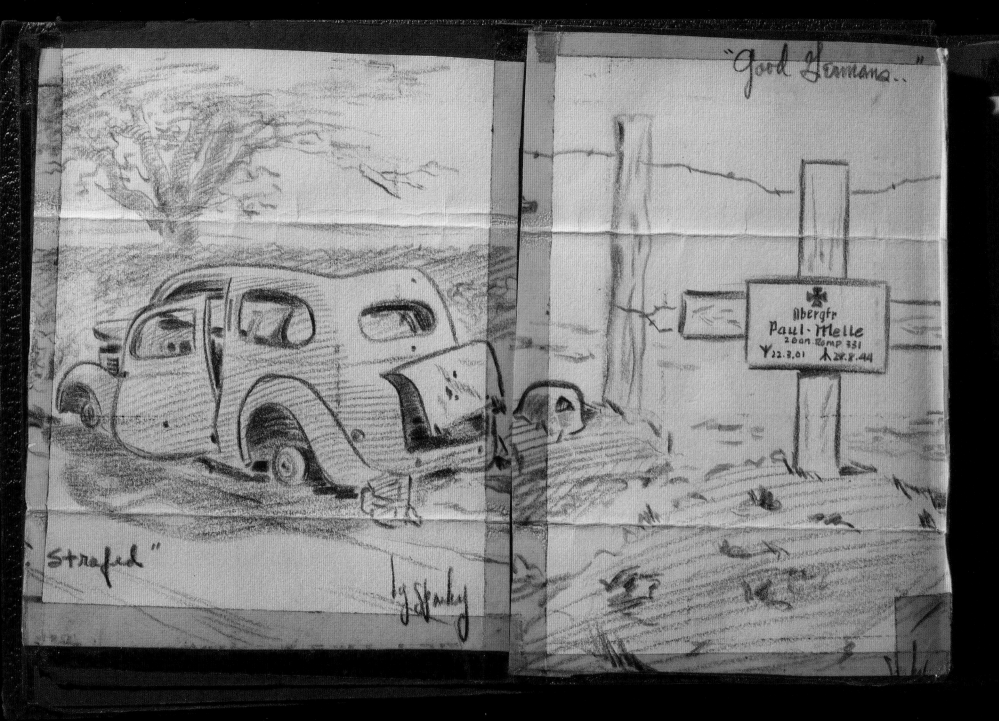

"Good Germans..."

"Strafed"

by Sparky

Ubergfr
Paul·Melle
26an Romp 331
22.3.01 27.8.44

Shortly after turning twenty in November 1942, Schulz—who had already enrolled in a local Minneapolis correspondence course in cartooning (Federal School of Applied Cartooning, which later became Art Instruction, Inc.)—was drafted into the army and sent to Fort Snelling in Minnesota for boot camp. While there, Schulz kept a sketchbook he titled "As We Were."

In February 1945, his outfit (the Bravo Company of the 20th Armored Division) was sent to Normandy for combat. Schulz kept a second scrapbook with photos and drawings of his experience, which would eventually provide plenty of material for future *Peanuts* strips about dreaded summer camp and Snoopy's imagined war scenarios chasing the Red Baron.

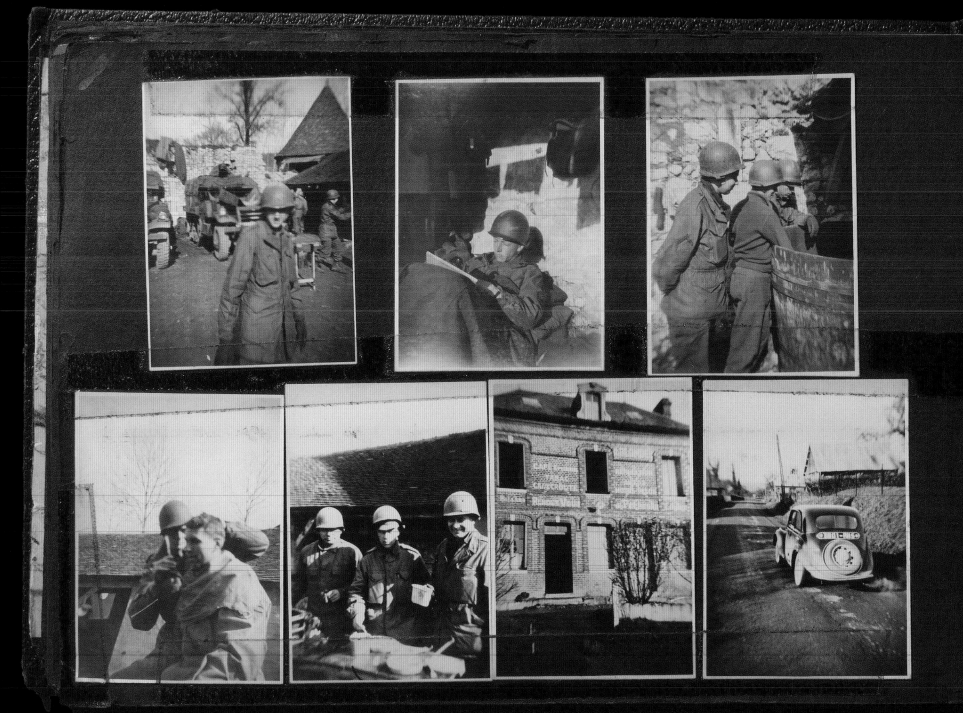

ABOVE **Photographs from Schulz's personal World War II photo album, mid-1940s.**

OPPOSITE LEFT **Newspaper article from the *St. Paul Pioneer Press* featuring Schulz's army sketchbook, January 9, 1944. A few years later, this same newspaper would publish Schulz's first comic strip, *Li'l Folks*.**

OPPOSITE RIGHT **Newspaper article, c. April–September 1944.**

'As We Were'

Army memories will be kept vivid in a rather unusual manner for Corp. Charles M. Schulz, son of C. F. Schulz, 170 N. Snelling. In a medium-size book with red covers are fifteen cartoons of Army life which the Central high school graduate has sketched in "off-duty" hours.

Formerly an employe of Northwest Printing and Binding Co. in St. Paul and later of the Associated Letter Service, the corporal always has liked to draw. He has an especial fondness for the comic strip style, working with pencil, pen and ink.

Since entering the Army ten months ago, he has been stationed at Camp Campbell, Ky. Typical of his work are the drawings in this series. He plans to continue making sketches of Army life as he sees it.

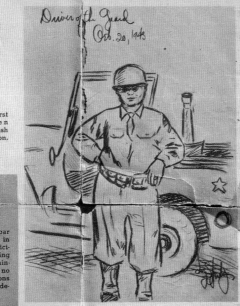

"Locker Cleanup"
Aug. 12, 1943

Driver of the Guard
Oct. 20, 1943

Lockers

usually are the first place the men straighten in the rush preceding inspection, the corporal says.

Humorous Ribbing

of the sighting bar range is depicted in this cartoon. Proficiency with the sighting bar, a wooden training aid, nets no medals or decorations but the term often deceives civilians.

"000...MACHINE GUN, RIFLE, SIGHTING BAR...."

Driver of the guard makes his rounds of the post in a "peep," as "jeeps" are called by the armored divisions.

August 27, 1943

"...by order of Colonel Colson, Commander 480 A.I.B., all patches must be sewed on securely."

Mending and patching clothes is a job not exactly a favorite with the soldiers.

"No reveille on Sunday morning."

Forty Winks extra are obtained each Sunday morning, the one day reveille is not sounded. "We miss breakfast—but it's worth it," the corporal believes.

"Flophouse" (simulated)

Day Is Done and the soldiers flop on their bunks for well-earned rest.

SOLDIER HOME ON VISIT—
Has Comic Strip Plans

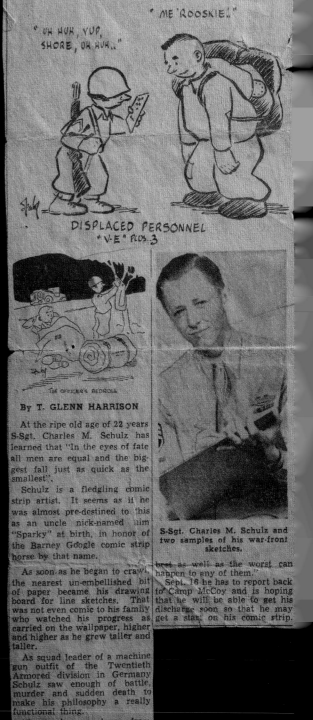

"UH HUH, YUP, SHORE, UH HUH.."

"ME 'ROOSKIE!.."

DISPLACED PERSONNEL
"V-E" PLUS 3

THE OFFICER'S BEDROLL

S-Sgt. Charles M. Schulz and two samples of his war-front sketches.

By T. GLENN HARRISON

At the ripe old age of 22 years S-Sgt. Charles M. Schulz has learned that "In the eyes of fate all men are equal and the biggest fall just as quick as the smallest".

Schulz is a fledgling comic strip artist. It seems as if he was almost pre-destined to this as an uncle nick-named him "Sparky" at birth, in honor of the Barney Google comic strip horse by that name.

As soon as he began to crawl the nearest un-embellished bit of paper became his drawing board for line sketches. That was not even comic to his family who watched his progress as carried on the wallpaper, higher and higher as he grew taller and taller.

As squad leader of a machine gun outfit of the Twentieth Armored division in Germany Schulz saw enough of battle, murder and sudden death to make his philosophy a really functional thing.

"I saw 'em go down, from raw private to high ranking officer," he said thoughtfully. "I just had to begin to believe that all men are equal and that the best as well as the worst can happen to any of them."

Sept. 16 he has to report back to Camp McCoy and is hoping that he will be able to get his discharge soon so that he may get a start on his comic strip.

Corporal Elmer Roy Hagemeyer, thirty-one, took the twenty-one-year-old (lonely, homesick) Private Charles Schulz under his wing during training at Fort Snelling in Minnesota, and a lifelong friendship was born. Hagemeyer's guidance, leadership and compassion helped turn his young charge into a confident soldier. Schulz returned the favor by illustrating the envelopes to the letters Elmer wrote home to his wife, Margaret, depicting whimsical details of their life in the barracks.

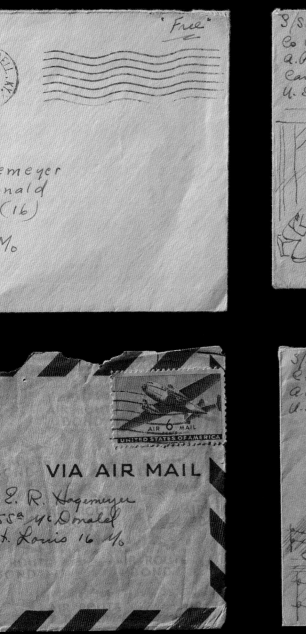

Schulz.

ember 31, 1943. Bottom, left to right: January 3, 1944; February 11, 1944.

, 1944. Bottom, left to right: June 4, 1944; August 17, 1944.

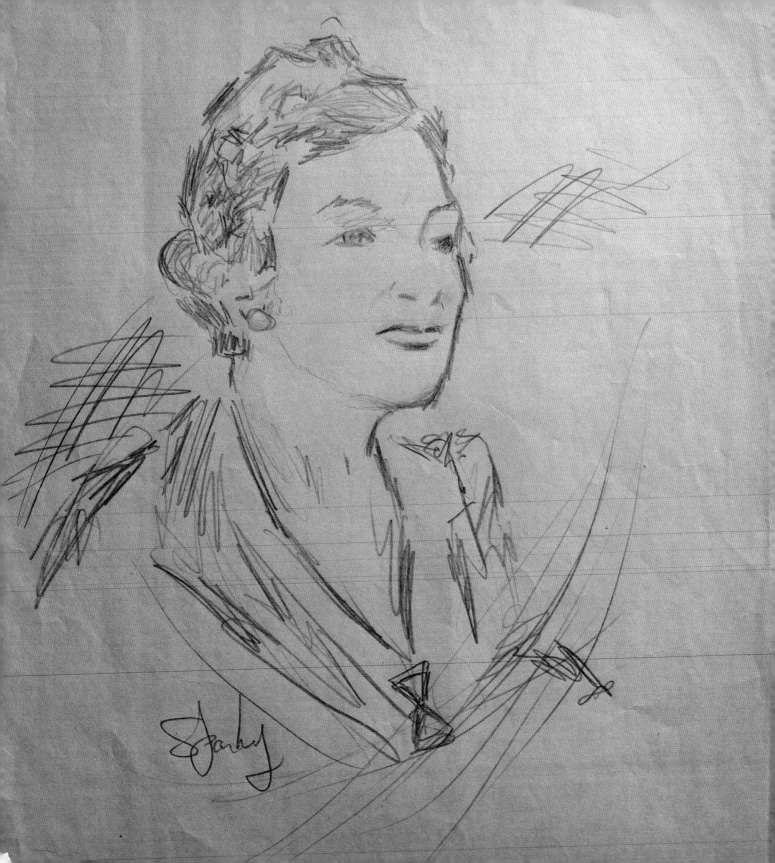

"THE WORLD'S TALLEST SNOWMAN!"

"OF COURSE, YOU MAY BE RIGHT, BUT I'LL BET THEY MEANT TO HAVE THE STRIPE RUN AROUND THE ROOM HORIZONTALLY

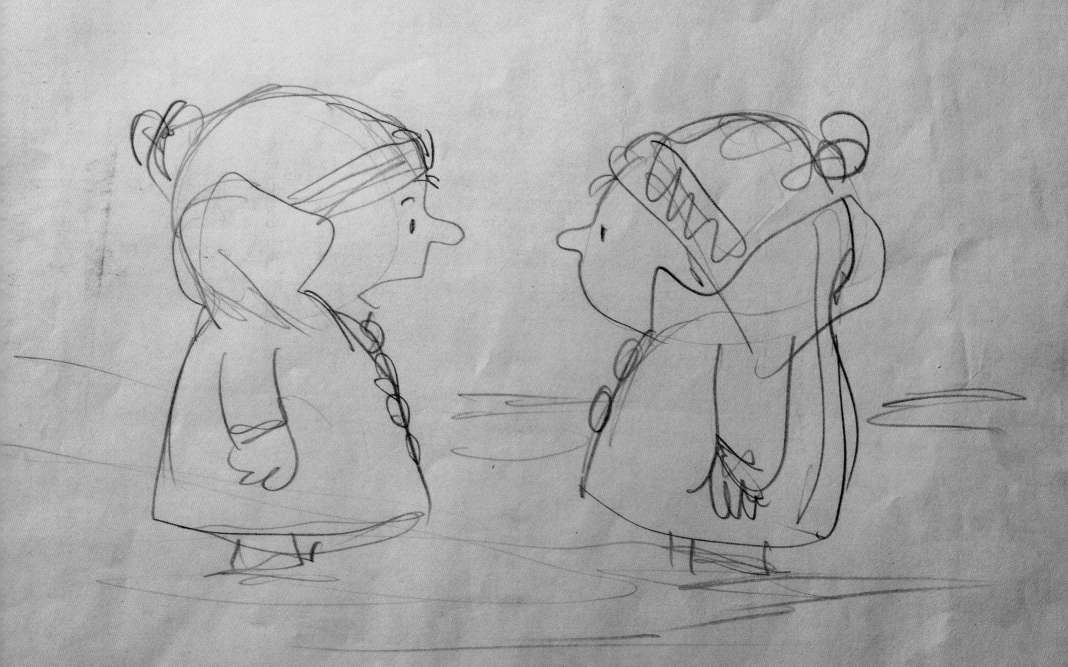

"BOY OR GIRL?"

" We're going to go out of business pretty soon if those hotcakes don't
start selling like hotcakes ! "

LEFT **Pencil sketch for the strip** *It's Only a Game*, **published October 5, 1958. Schulz's good friend and associate Jim Sasseville would ink the final cartoon.**

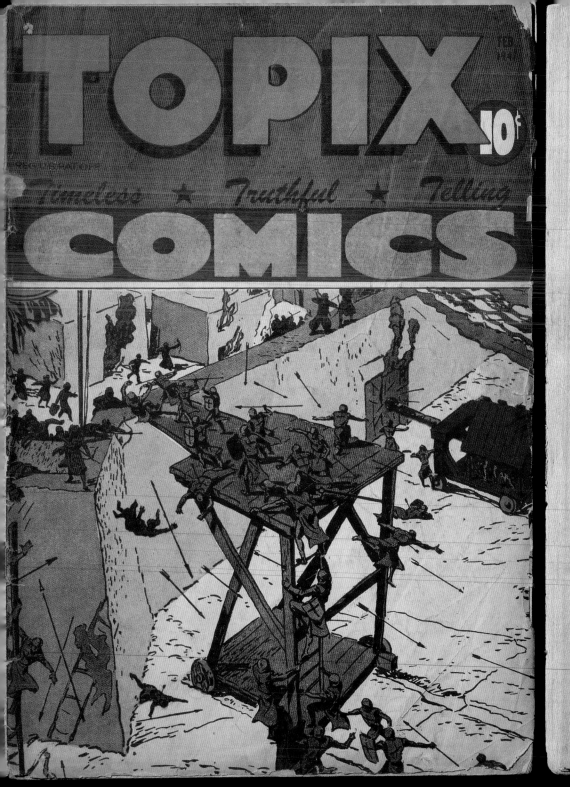

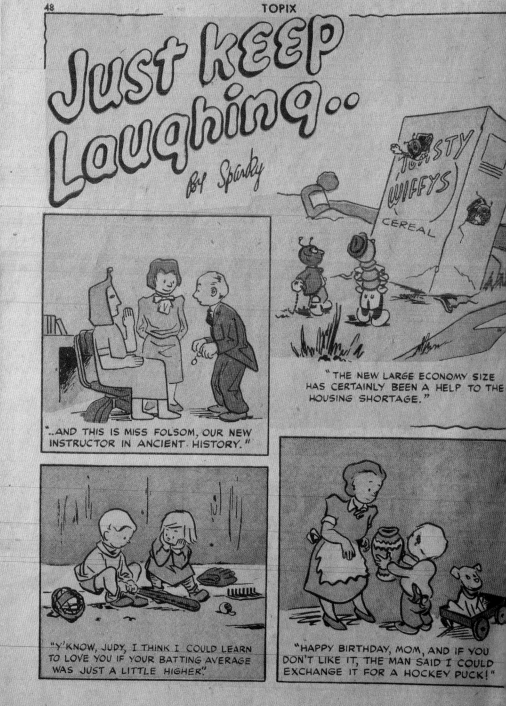

Schulz's first two printed comic strips: "Just Keep Laughing," *Topix Comics* no. 5, Catechetical Guild Educational Society, February 1947 (above), and no. 7, April 1947 (opposite).

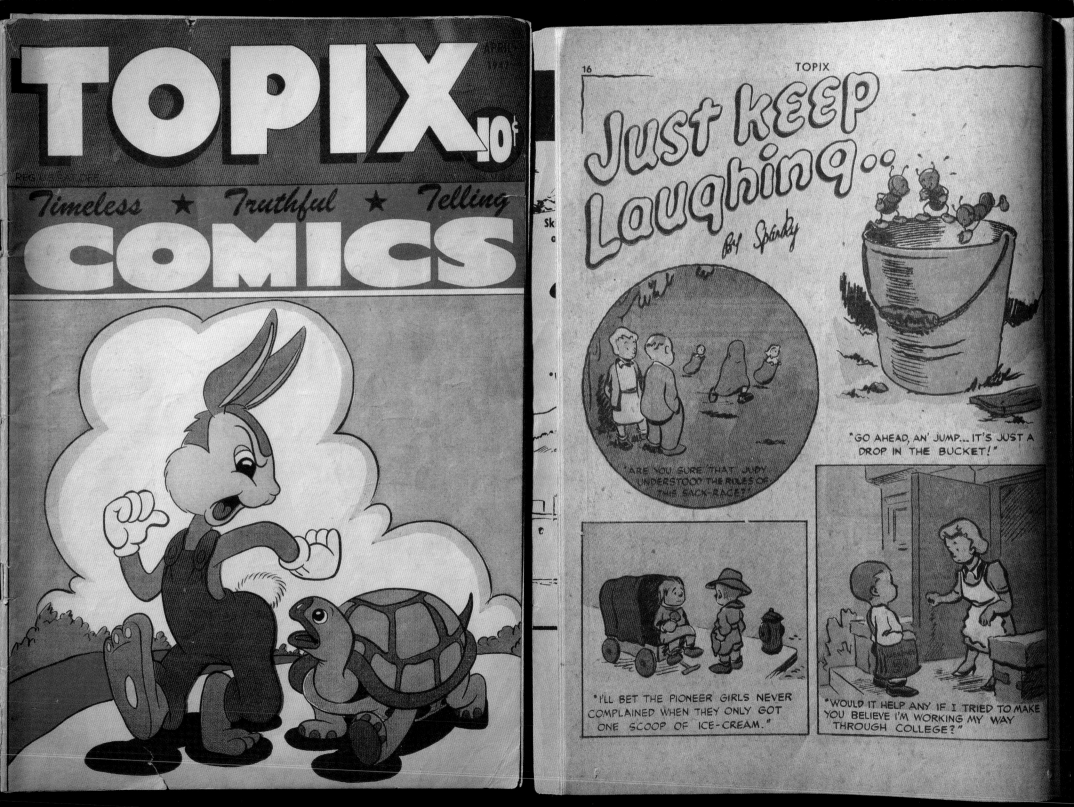

"YOU MURDERER!!"

THE FIRST STEP

After small but encouraging success publishing two strips in *Topix Comics* in 1947, Schulz channeled his cartooning efforts into *Li'l Folks*, a vertical feature containing three or four single-panel gags with kids and their often beyond-their-years dialogue and mannerisms. Schulz got these published weekly in the *Minneapolis Tribune* on June 8 and 15, 1947, then in the *St. Paul Pioneer Press* starting on June 22, 1947. To his increasing dissatisfaction, they appeared in the "women's section" in the back of the paper as opposed to the actual comics page. After selling a handful of cartoons in 1948 and 1949 to the *Saturday Evening Post*, a national magazine, Schulz was emboldened to ask his editor at the *Press* for better placement in the newspaper, perhaps even making it a daily feature. When that didn't work, he asked for a raise. Instead he was told that he was free to go elsewhere. So . . .

"In the spring of 1950, I took all the best [*Li'l Folks*] cartoons I'd done for the *Pioneer Press* and redrew them and submitted them to United Feature Syndicate. They liked them enough to ask if I'd care to come to New York and talk about it."

A selection of these redrawn strips are shown here and on the following eight pages. Most of the gags previously appeared in *Li'l Folks*, but now with notable differences: The heads of the characters are proportionally larger to their bodies and their facial features further minimized. At this point Schulz also experimented with plugging them into a more conventional multi-paneled horizontal strip. The examples here could be seen as something of a missing link between *Li'l Folks* and what would eventually become *Peanuts*. Larry Rutman, president of United Feature Syndicate, liked what he saw . . .

HERE AND FOLLOWING PAGES **Original art for a handful of unpublished *Li'l Folks* comic strips, spring 1950.**

OPPOSITE **An earlier version of this panel ran on July 11, 1948.**

RIGHT **Earlier versions of these panels ran on July 24, 1949 (top left), June 6, 1948 (top right), and August 21, 1949 (bottom).**

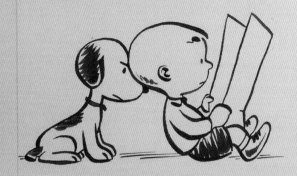

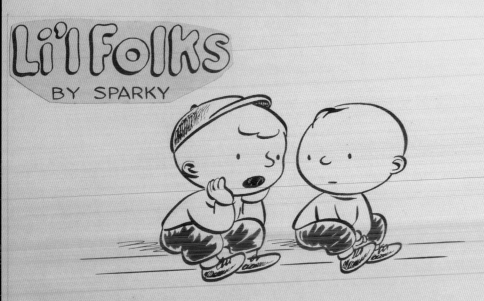

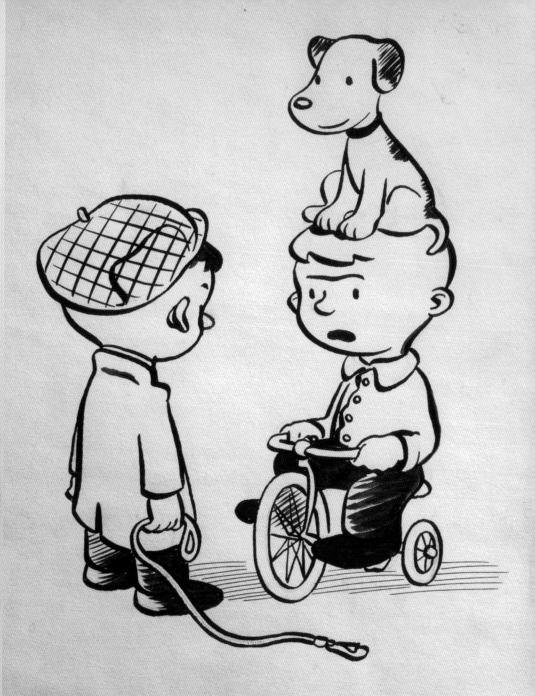

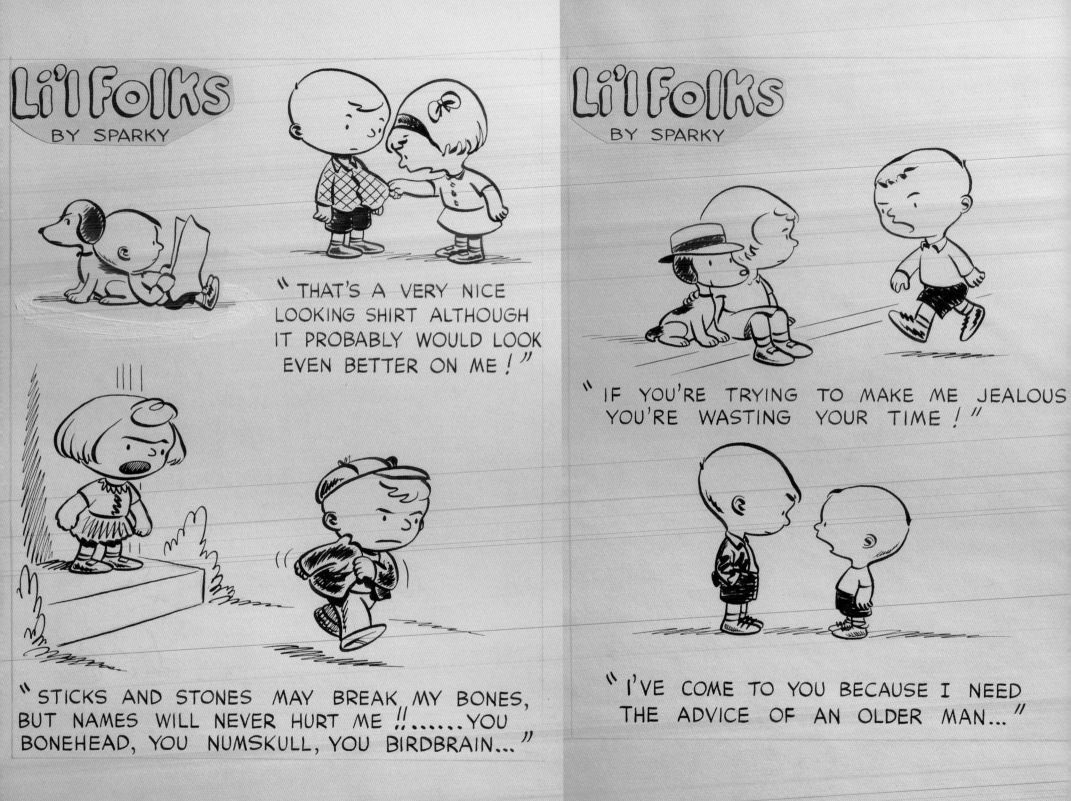

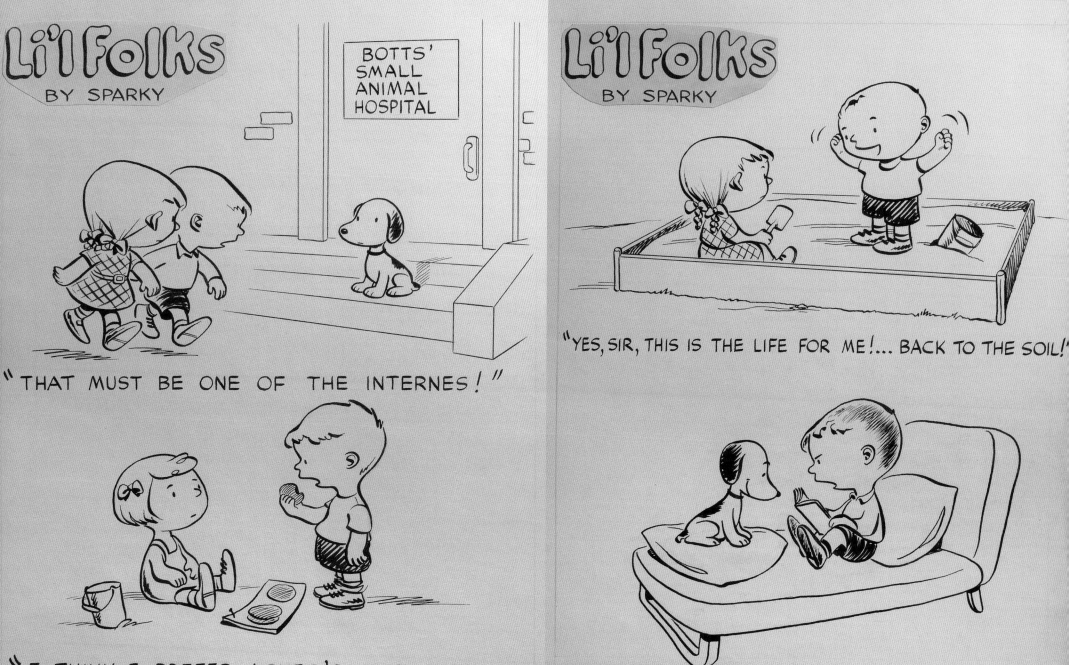

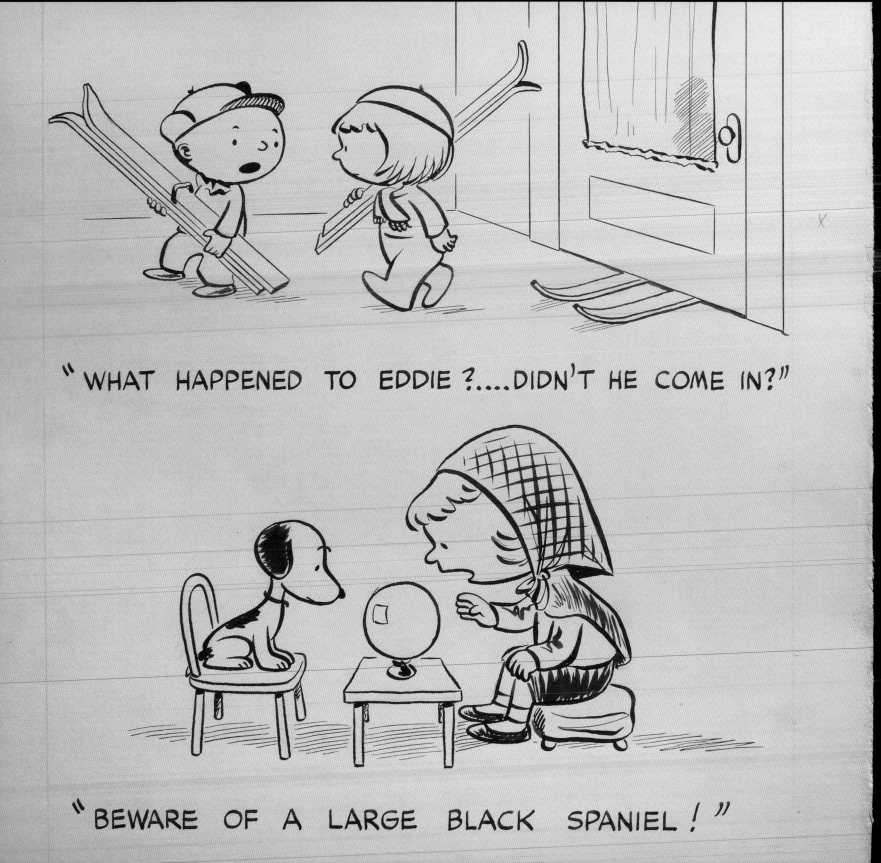

"WHAT HAPPENED TO EDDIE ?....DIDN'T HE COME IN?"

"BEWARE OF A LARGE BLACK SPANIEL ! "

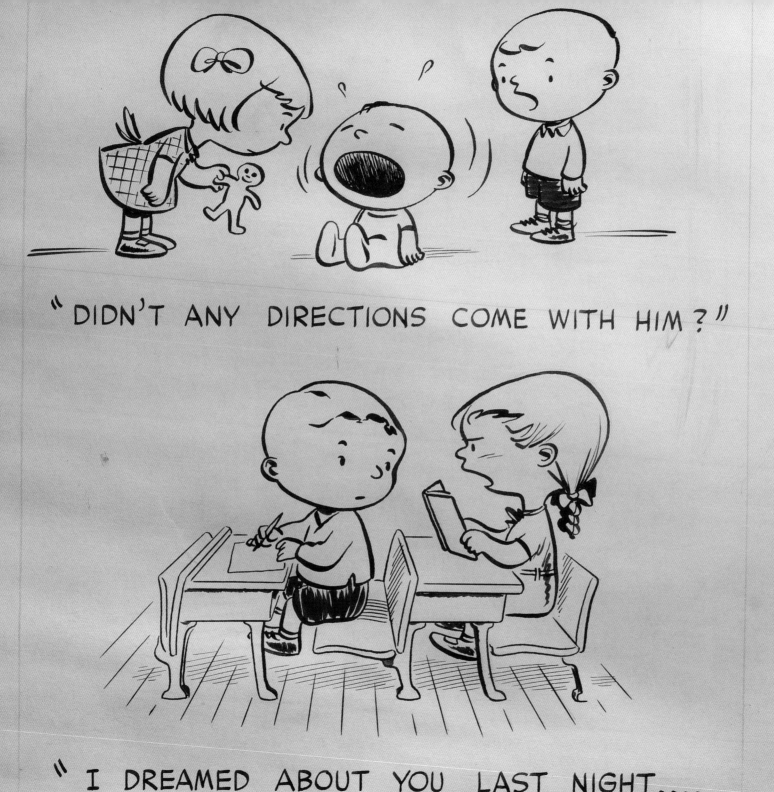

"HOW DO YOU EXPECT ME TO SLEEP WITH THE REST OF THE WORLD TOSSED IN TURMOIL ?! "

"THIS IS WHAT I DON'T LIKE ABOUT PLAYING HOUSE.... SOMETIMES YOU GET DANGEROUSLY CLOSE TO REALISM"

"THE WHOLE TROUBLE WITH YOU IS THAT YOUR EYES ARE BIGGER THAN YOUR STOMACH ! "

"THERE HE GOES....OUT OF MY LIFE FOREVER... I'LL PROBABLY MISS HIM A LOT AT FIRST, BUT BY THREE O'CLOCK I SHOULD BE OVER IT.... "

"ALL RIGHT, LET'S BREAK IT UP, AND GO TO BED!"

OPPOSITE LEFT Earlier versions ran on April 10, 1949 (top), and August 14, 1949 (bottom).

OPPOSITE RIGHT Earlier versions ran on September 4, 1949 (top), and May 22, 1949 (bottom).

ABOVE Original art for published Li'l Folks, April 24, 1949, a variation of a gag from February 8, 1948.

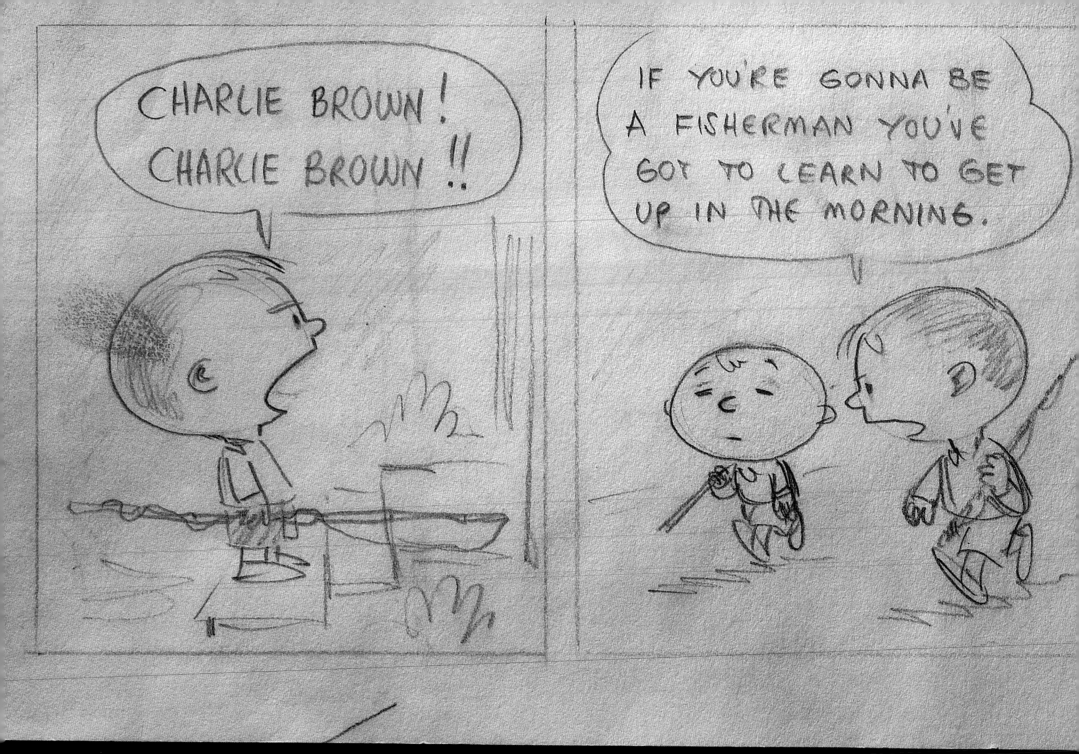

Charlie Brown's namesake, Charles Francis Brown, was an affable young man who worked in the education department of Art Instruction, Inc. (whose staff Schulz joined in 1946) and wanted to be liked by all. "He was a very bright young man," recalled Schulz, "with a lot of enthusiasm for life. I began to tease him about his love for parties, and I used to say, 'Here comes Good Ol' Charlie Brown. Now we can have a good time.'"

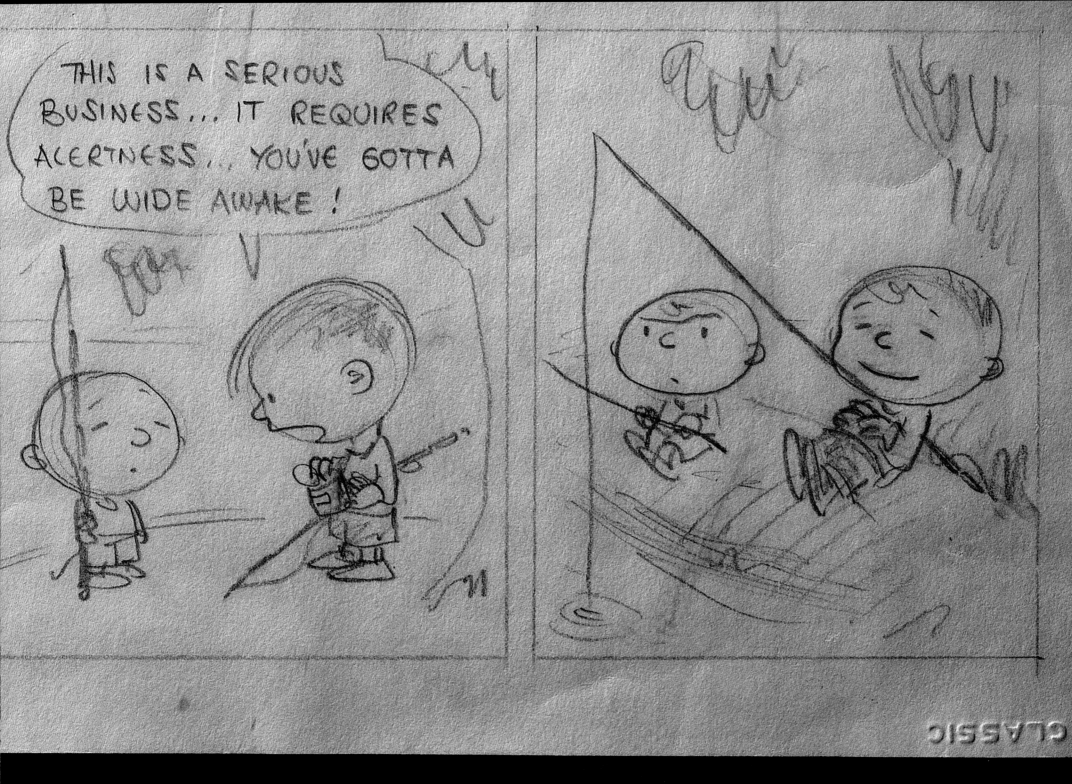

Pencil sketch for unpublished pre-*Peanuts* comic strip, spring 1950.

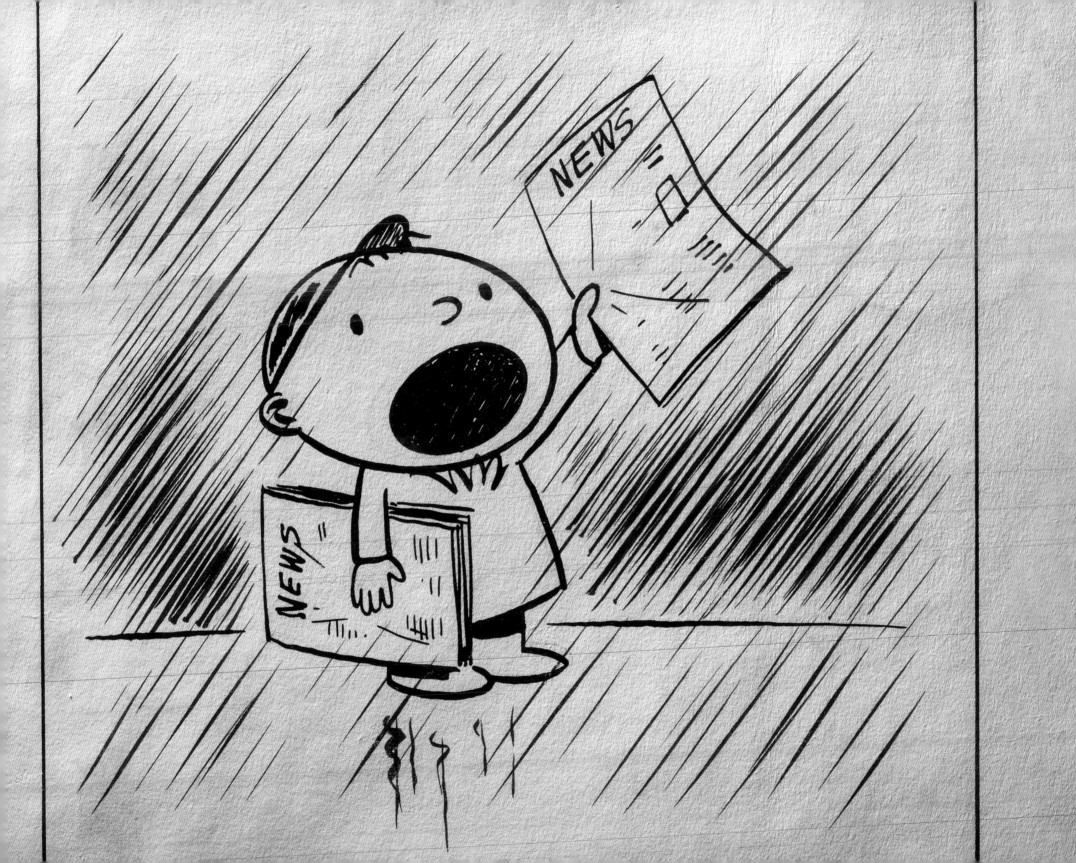

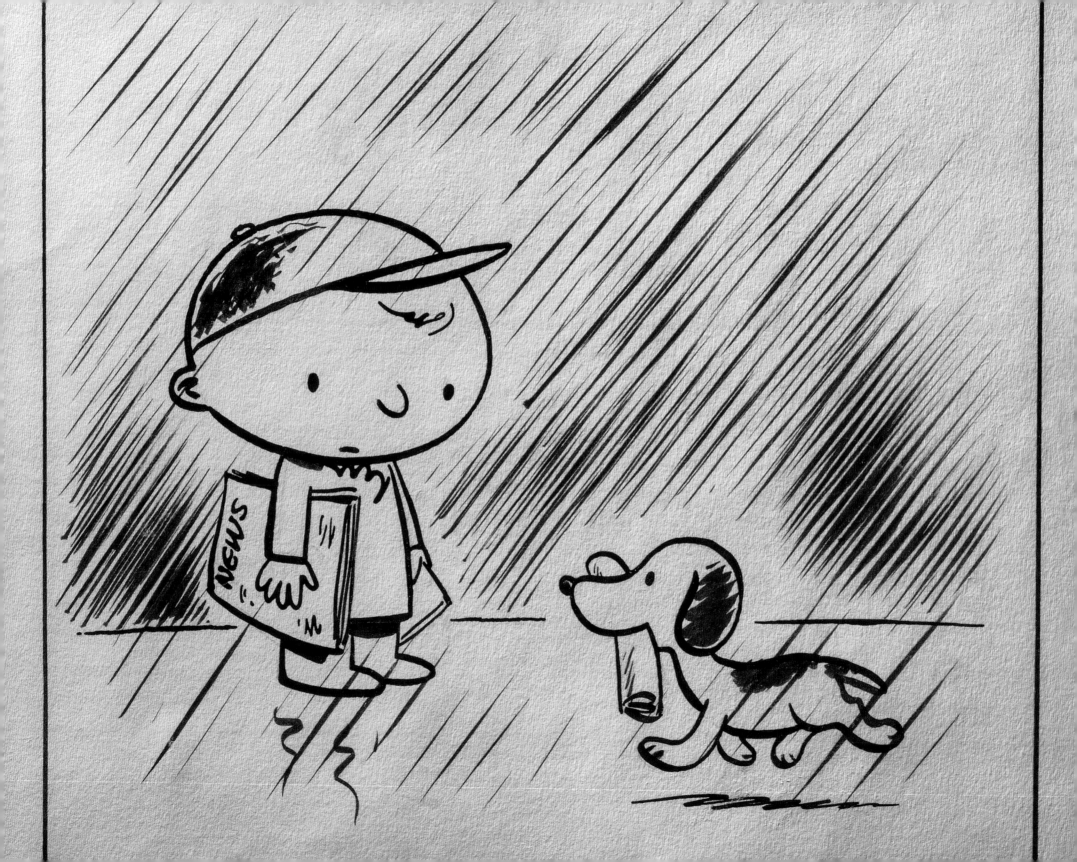

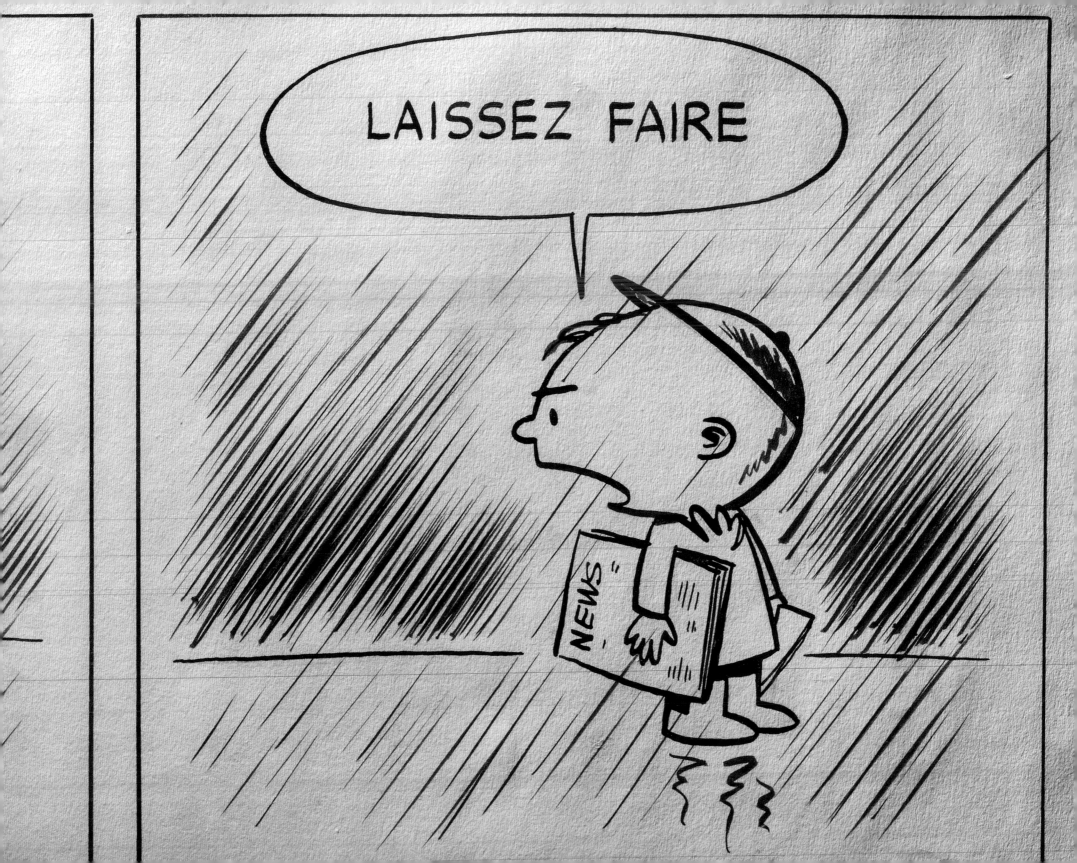

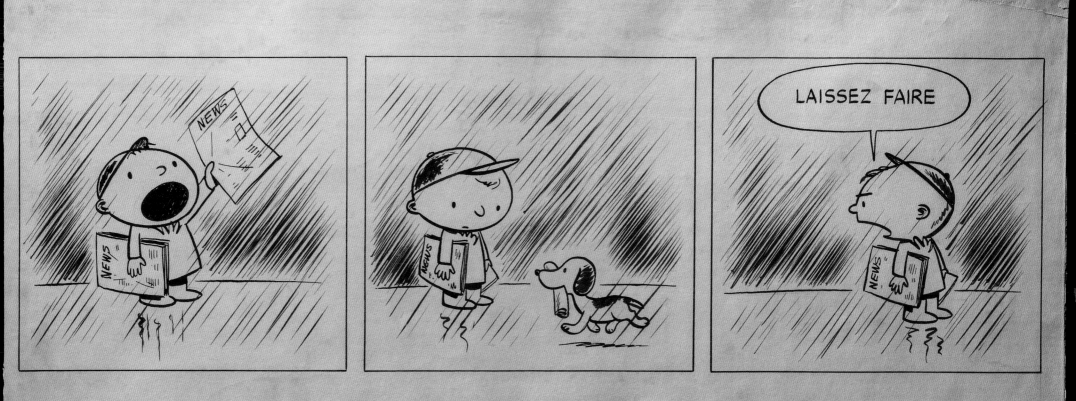

In what may be the first depiction of Charlie Brown and Snoopy in a sequential strip, Schulz also introduces the idea of word balloons in this transitional exercise between *Li'l Folks* and *Peanuts*.

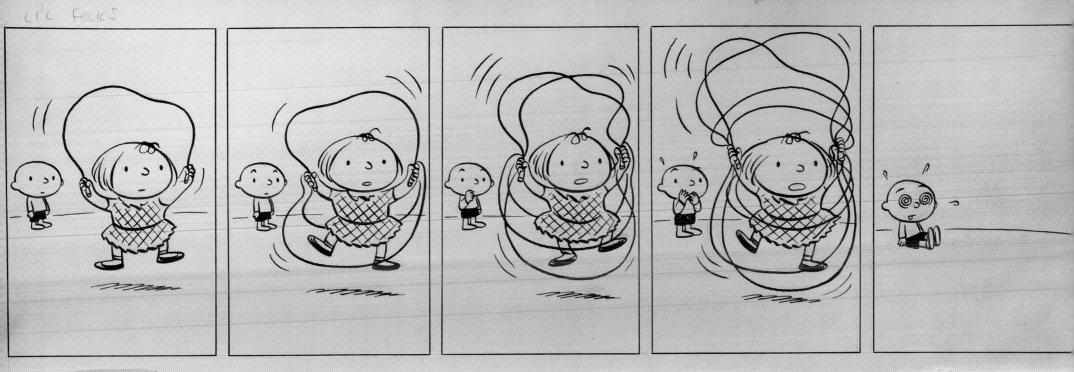

S

WEAK

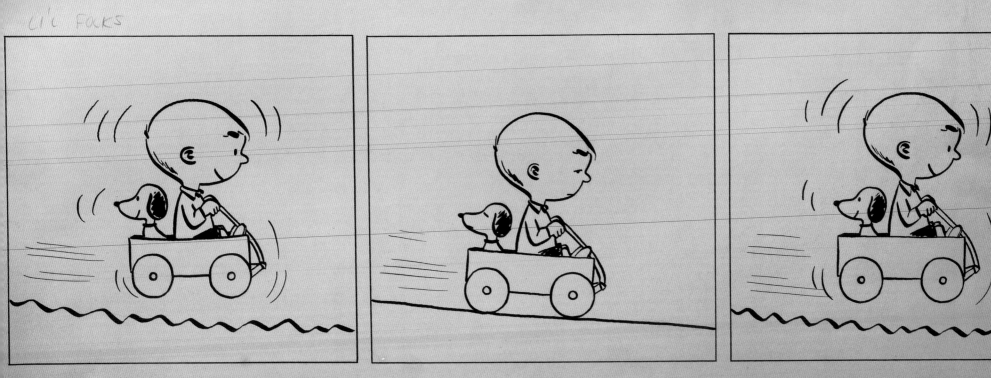

LIL FOLKS

ONLY FAIR

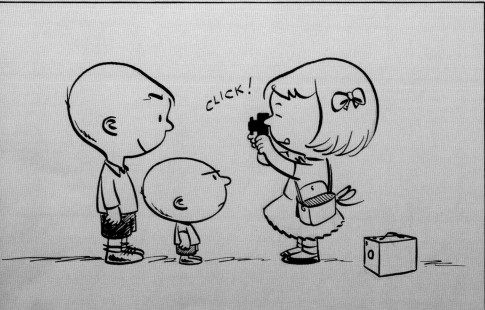

CLICK!

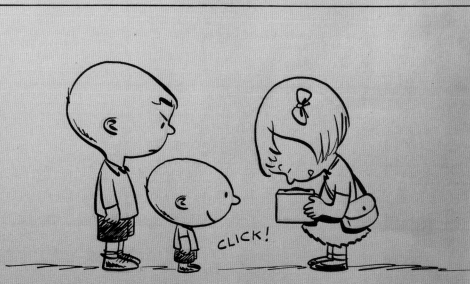

CLICK!

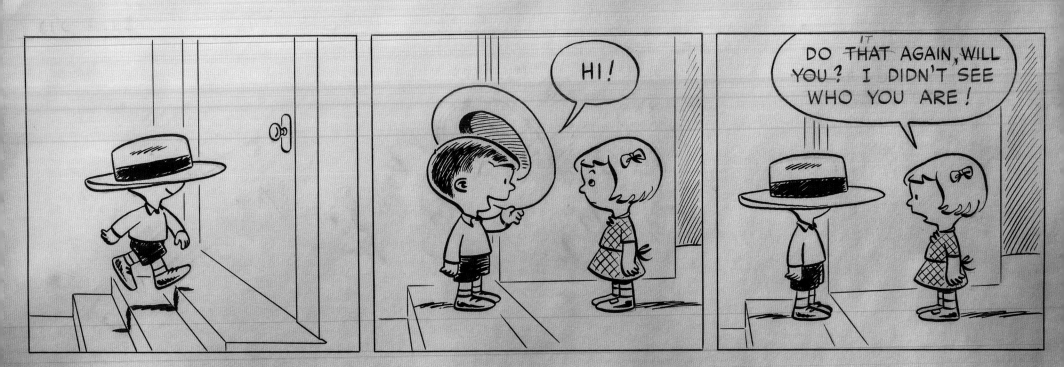

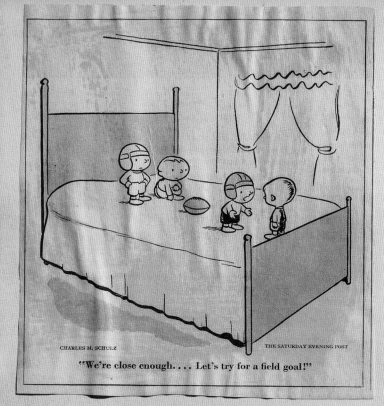

"We're close enough.... Let's try for a field goal!"

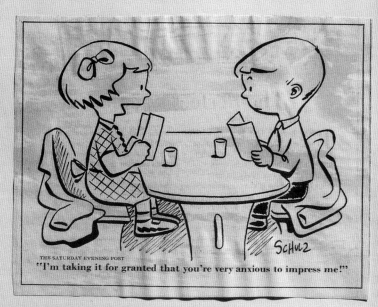

"I'm taking it for granted that you're very anxious to impress me!"

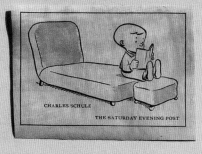

"Sure . . . you've seen me be-
fore. . . . That night on the
screen porch . . . remember?"

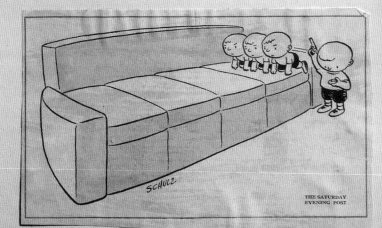

RIGHT A page from Schulz's personal
scrapbook of *Saturday Evening Post* gag
cartoons. The first was published on
May 29, 1948 (middle left), and features a
boy on a lounge chair reading a book. In
all, Schulz sold the *Post* seventeen single-
panel cartoons through July 8, 1950.

Charles Schulz...

Born in Minneapolis 27 years ago. Art Instruction correspondence course and night sketching classes at Minneapolis School of Art. Saw action as light-machine-gun squad leader in France and Germany during World War II. After war, became successful Saturday Evening Post contributor, instructor at Art Instruction, Inc., and cartoonist for St. Paul Pioneer Press, where Peanuts was created. His Post cartoons have been reprinted in the U. S. and many foreign countries.

UNITED FEATURES

PEANUTS
by SCHULZ

WATCH OUT FOR CHILDREN

The GREATEST little Sensation Since TOM THUMB!

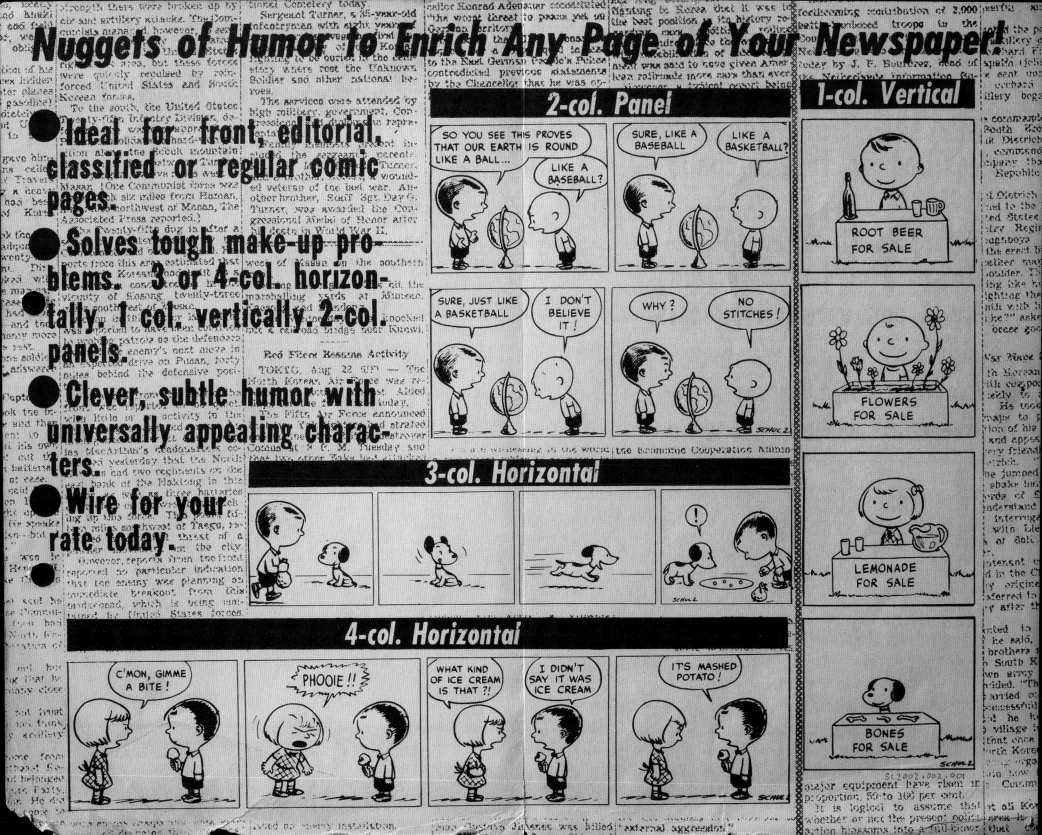

Subscriber Promotion: PEANUTS by Schulz

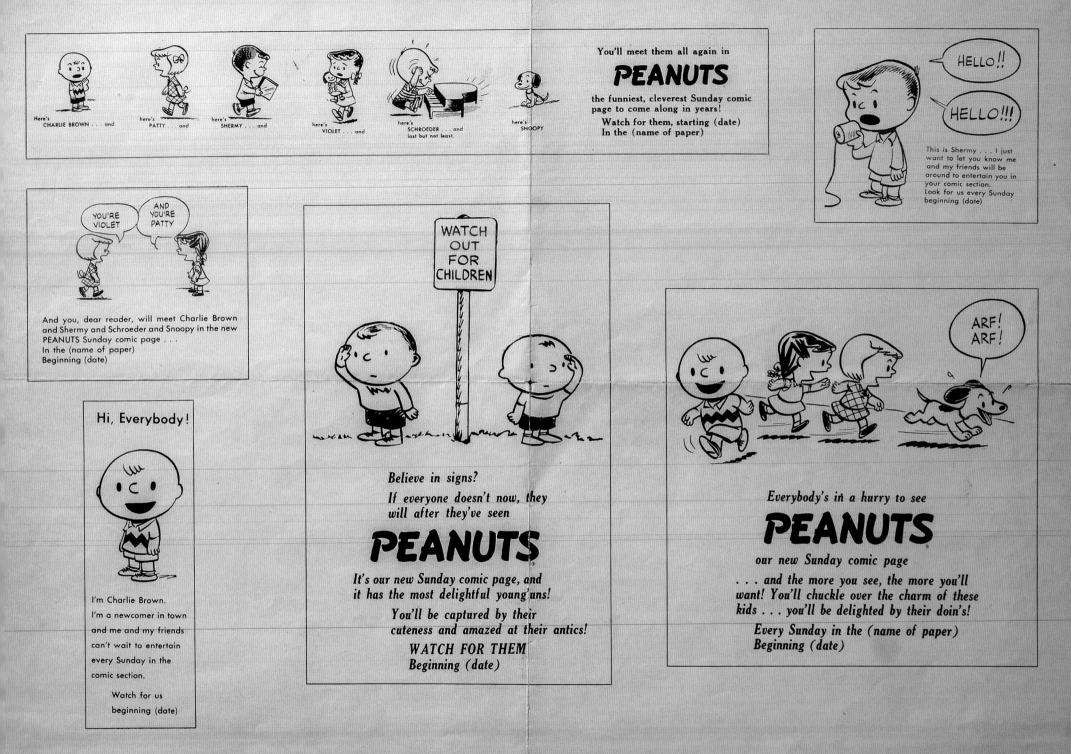

"PEANUTS"

THE NEXT STEP

Schulz signed a five-year syndication contract with United Feature Syndicate on June 14, 1950. *Peanuts* was originally to be called *Li'l Folk* (no *s*), but it soon came to light that a previous strip by Tack Knight from the 1930s was called *Little Folks* (by then long since ended but nonetheless under copyright), so another name was needed, and quickly. Schulz wanted "Charlie Brown," or "Good Ol' Charlie Brown," to reflect the main character he intended the feature to revolve around (just as with other eponymous strips such as *Popeye* and *Dick Tracy*), but corporate heads demurred. In a decision that may or may not have been influenced by the hit *Howdy Doody Show* on TV, whose stage audience of children was known as the Peanut Gallery, the new moniker was declared by United Feature. The cartoonist was not happy with the name *Peanuts* but didn't feel he had any leverage to challenge it. Besides, what he *did* have was a commitment from a top-tier comics syndicate and a daily strip to write and draw as he saw fit. He would start it off with an emotional bang . . .

PREVIOUS PAGES Announcement flyer created by United Feature Syndicate, sent to newspaper editors in the fall of 1950 to promote their newest acquisition, *Peanuts*.

OPPOSITE Subscriber promotional ads for launch of *Peanuts* Sunday comics, which made their debut on January 6, 1952.

ABOVE Detail, unfinished sketch for daily comic strip, undated.

PEANUTS

For Release

Oct. 2-7

10/31 —NO 1
3 " 2 1950
 " 3
" 4

+ 166

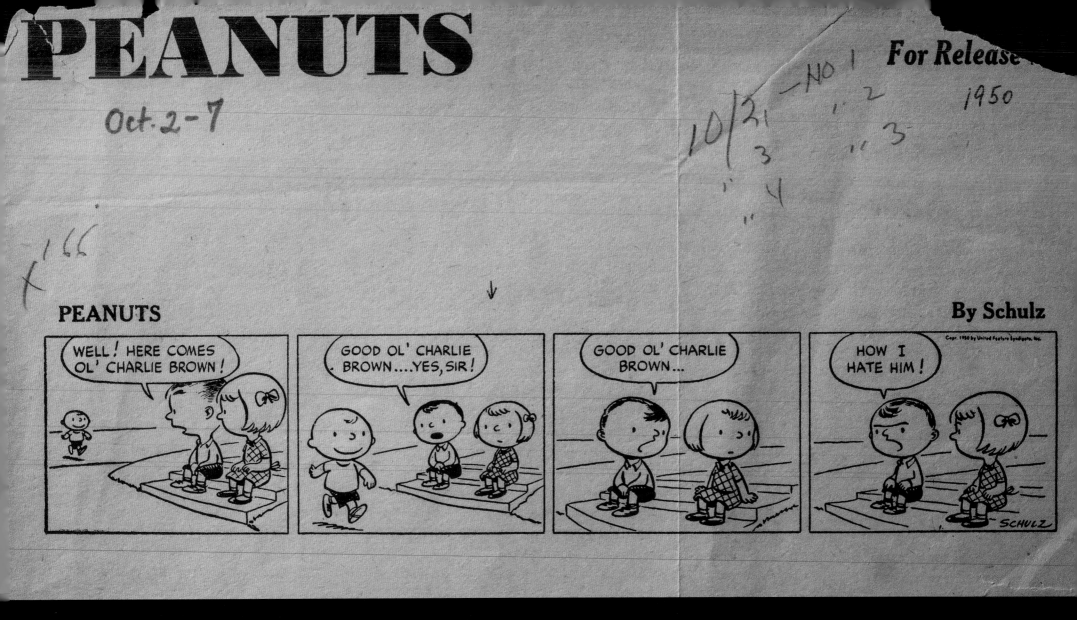

Proof sheets were provided by the syndicate to subscribing newspapers, collecting an entire week's worth of strips. They were also used for reproduction

ABOVE AND OPPOSITE **Proof sheet for the first three *Peanuts* daily newspaper strips, October 2-4, 1950**

PEANUTS

By Schulz

PEANUTS

By Schulz

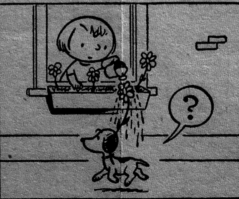

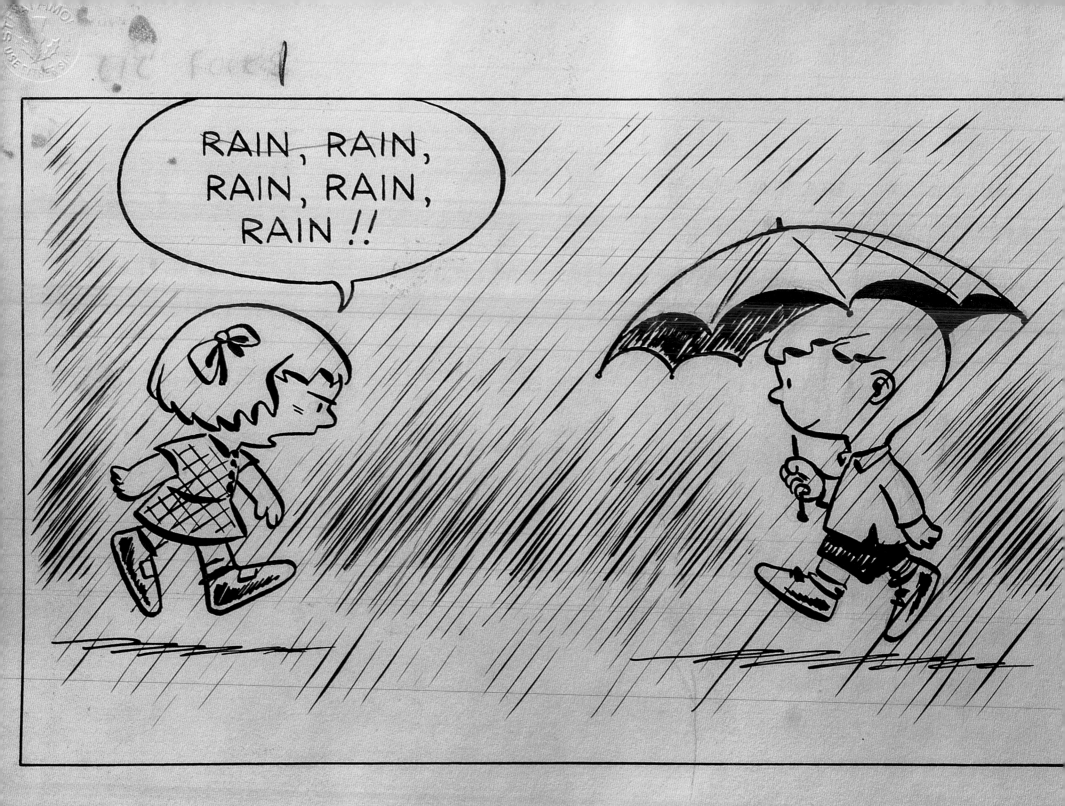

Original art for unpublished comic strip, spring 1950, repurposed a few months later as the fourth *Peanuts* daily, on October 5, 1950 (following page, top).

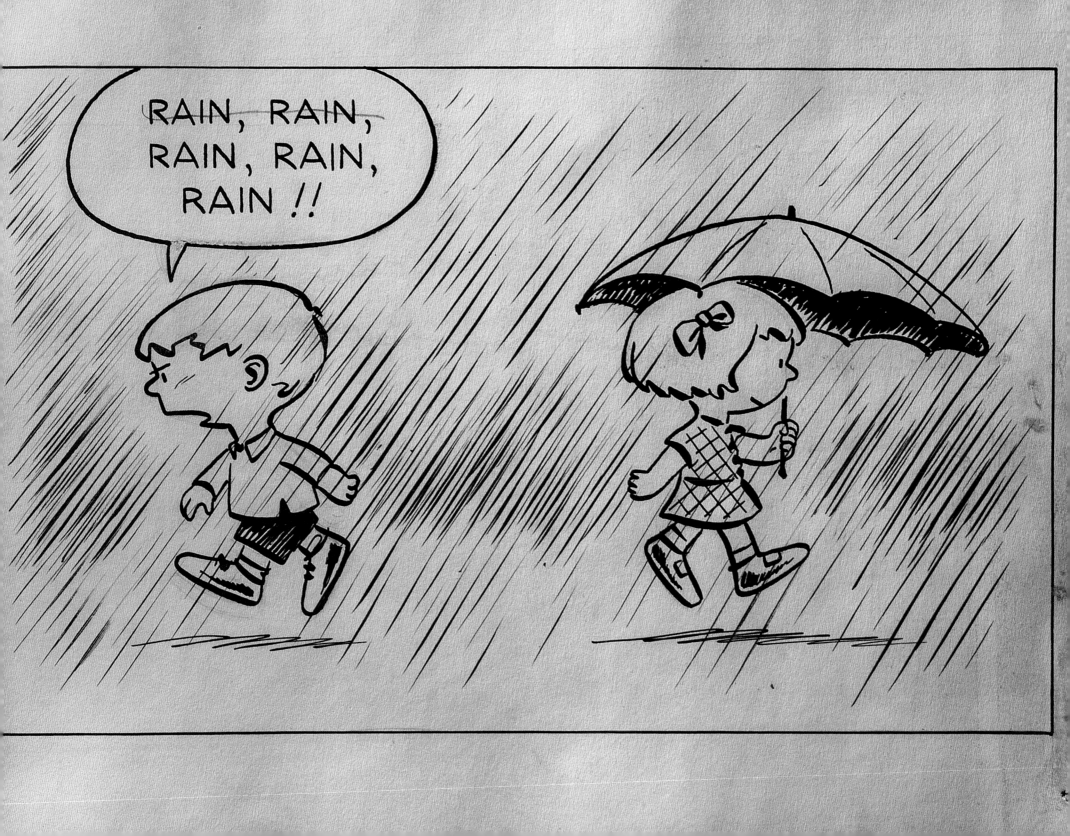

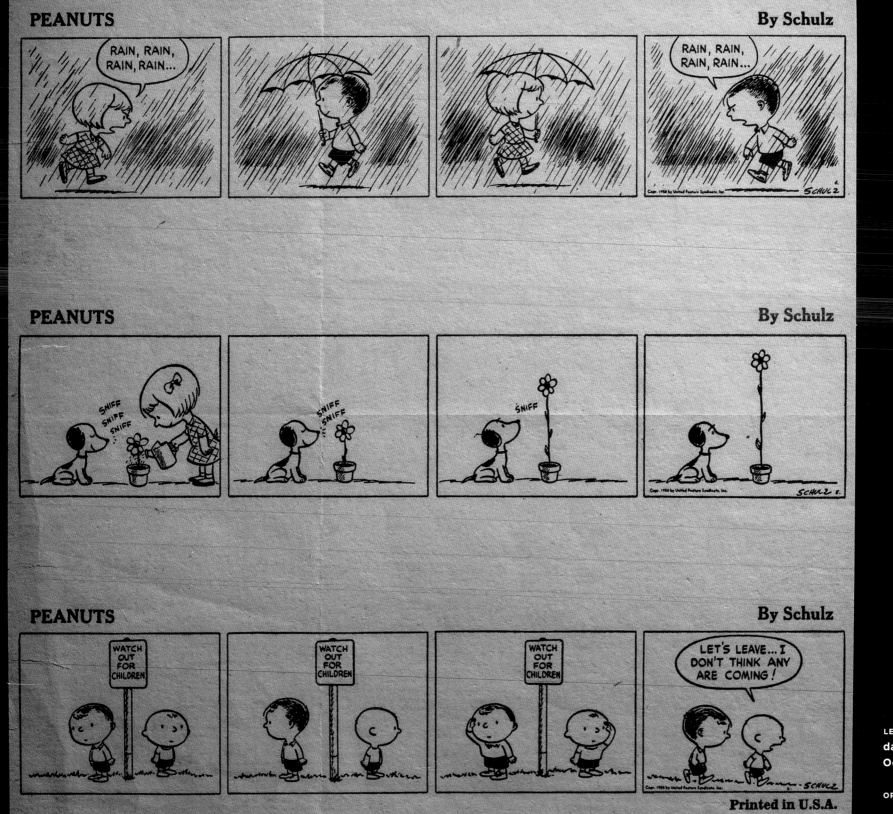

LEFT **Proof sheet for *Peanuts*
daily newspaper strips,
October 5–7, 1950.**

OPPOSITE **October 9–11, 1950.**

PEANUTS

By Schulz

PEANUTS

By Schulz

PEANUTS

By Schulz

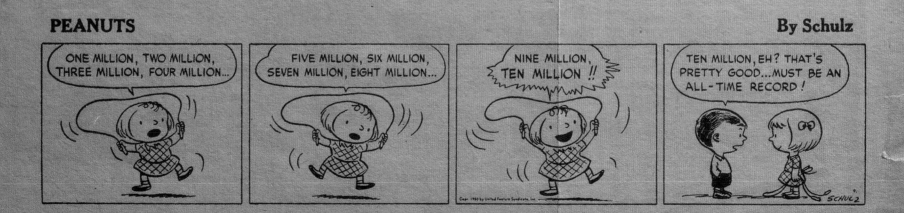

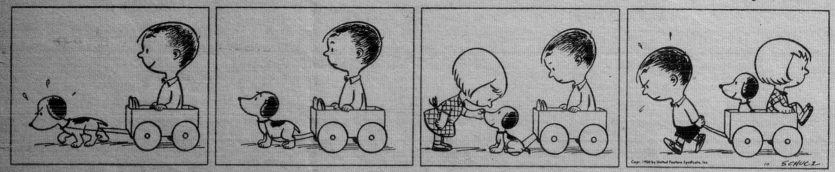

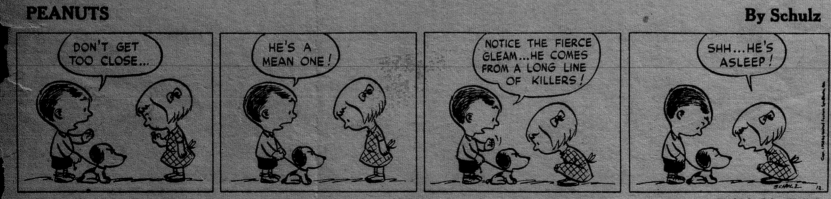

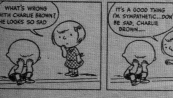

NITED FEATURE SYNDICATE ♦ 22.. E. 42nd Street, New York 17, N. Y.

Printed in U.S.A.

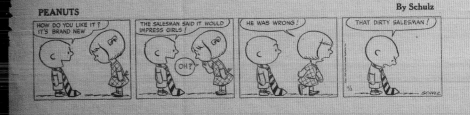

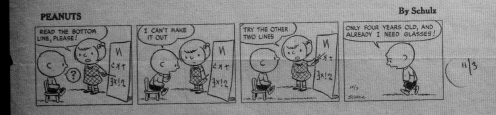

PEANUTS By Schulz

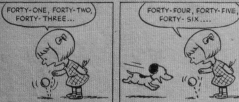
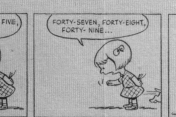

PEANUTS By Schulz

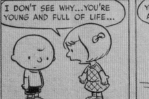
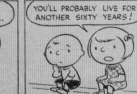
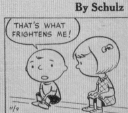

PEANUTS By Schulz

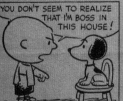
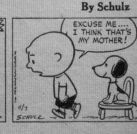
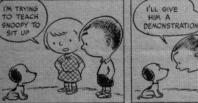
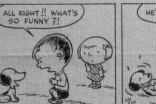

PEANUTS By Schulz

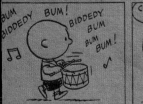

PEANUTS By Schulz

Printed in U.S.A.

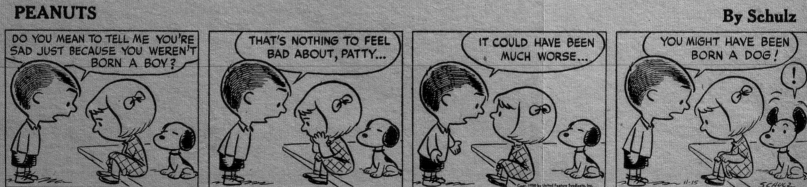

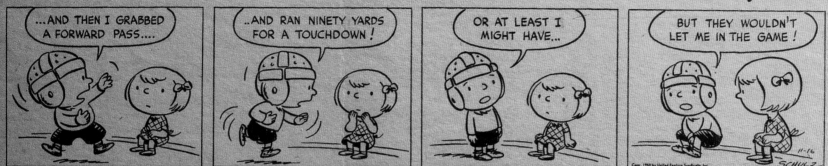

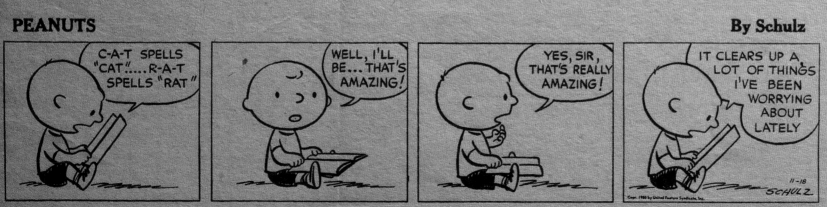

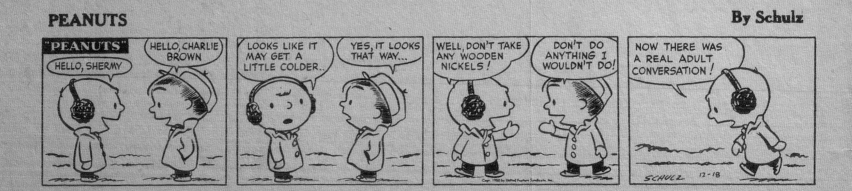

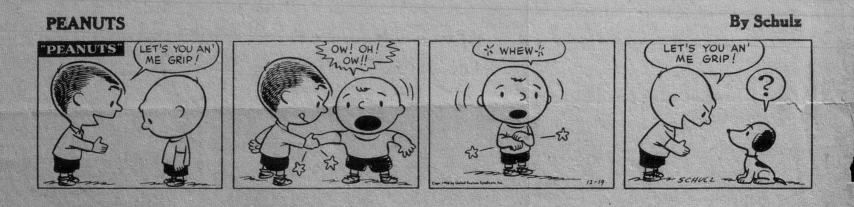

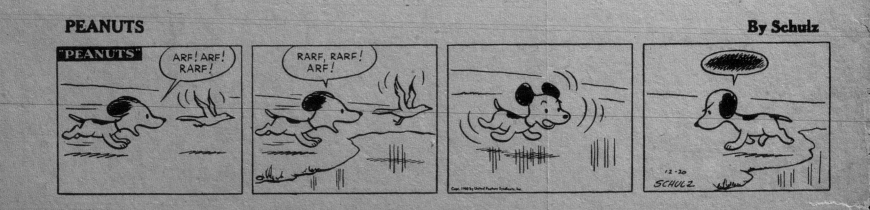

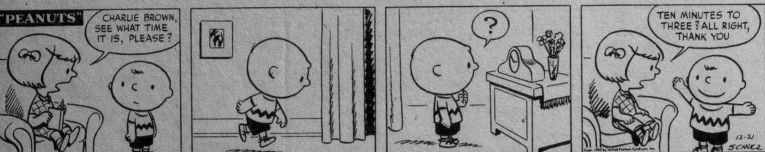

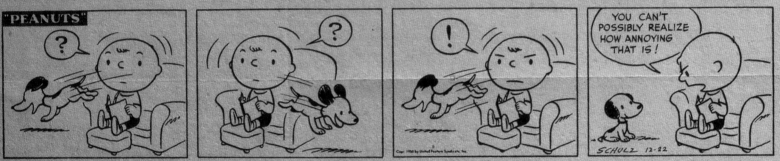

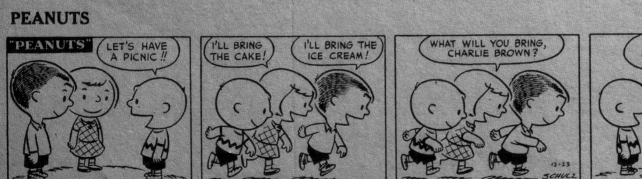

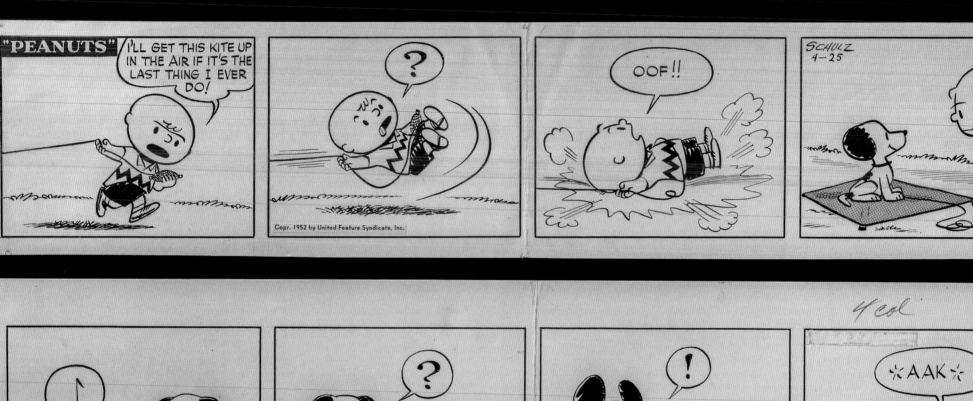

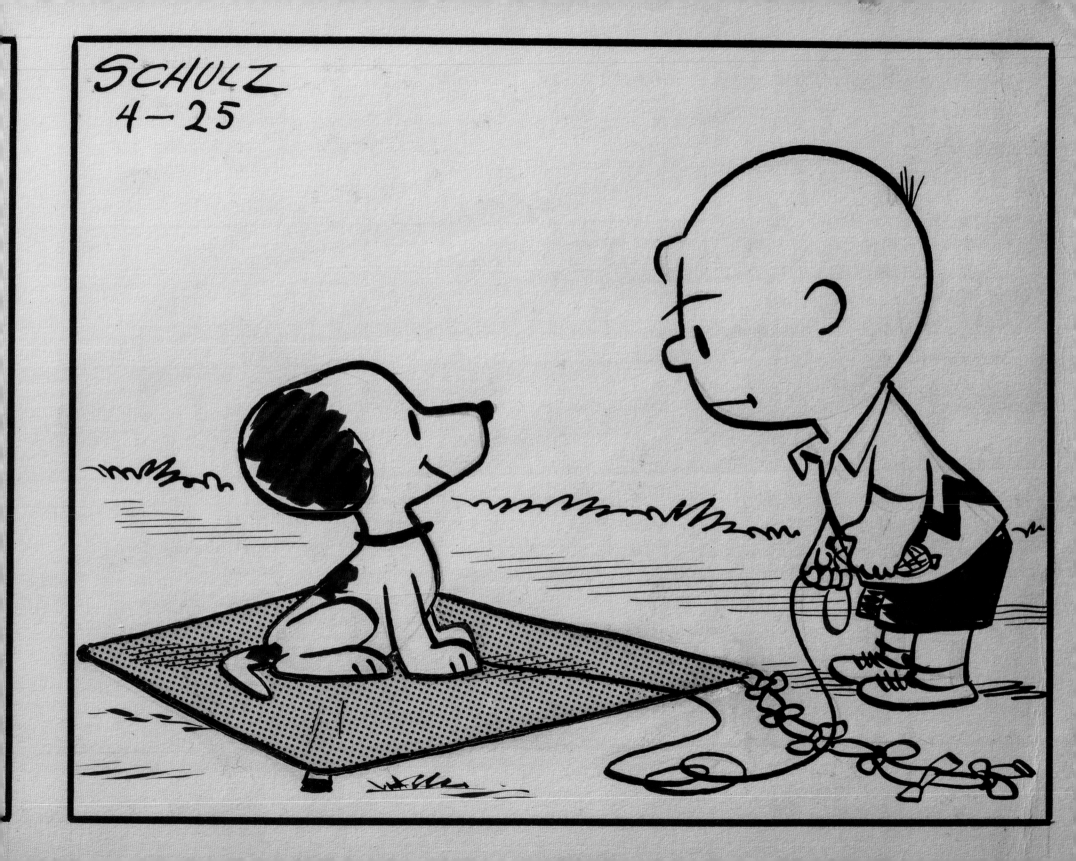

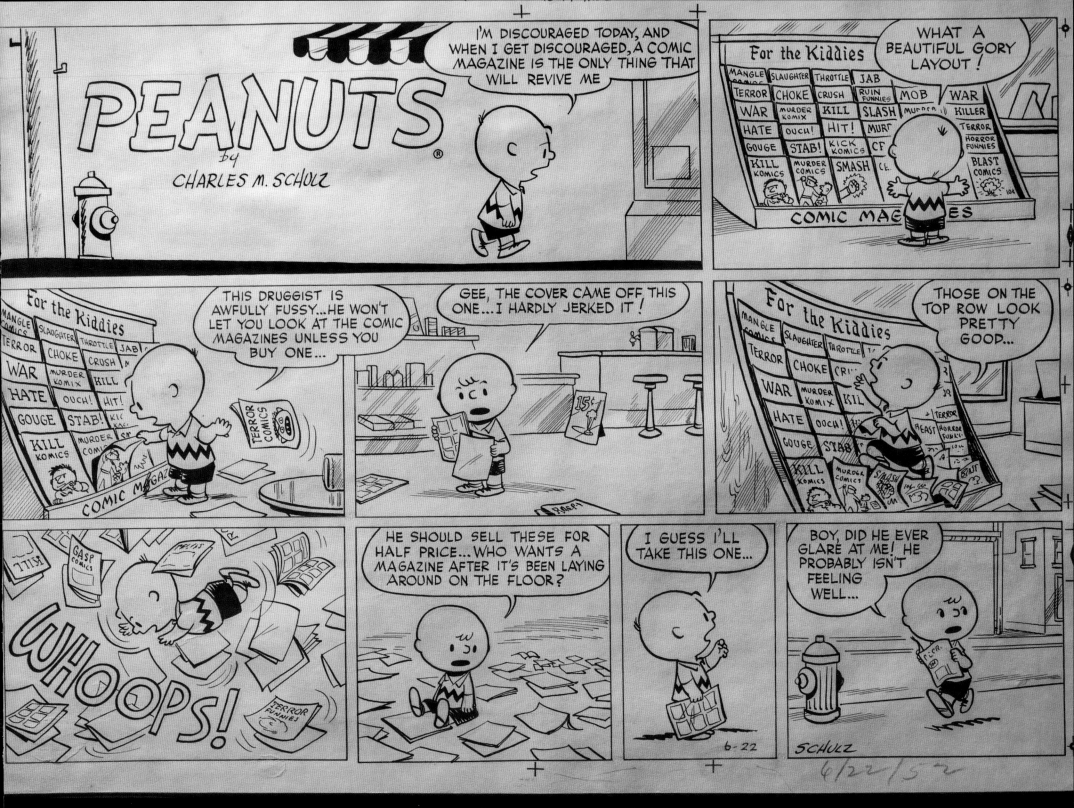

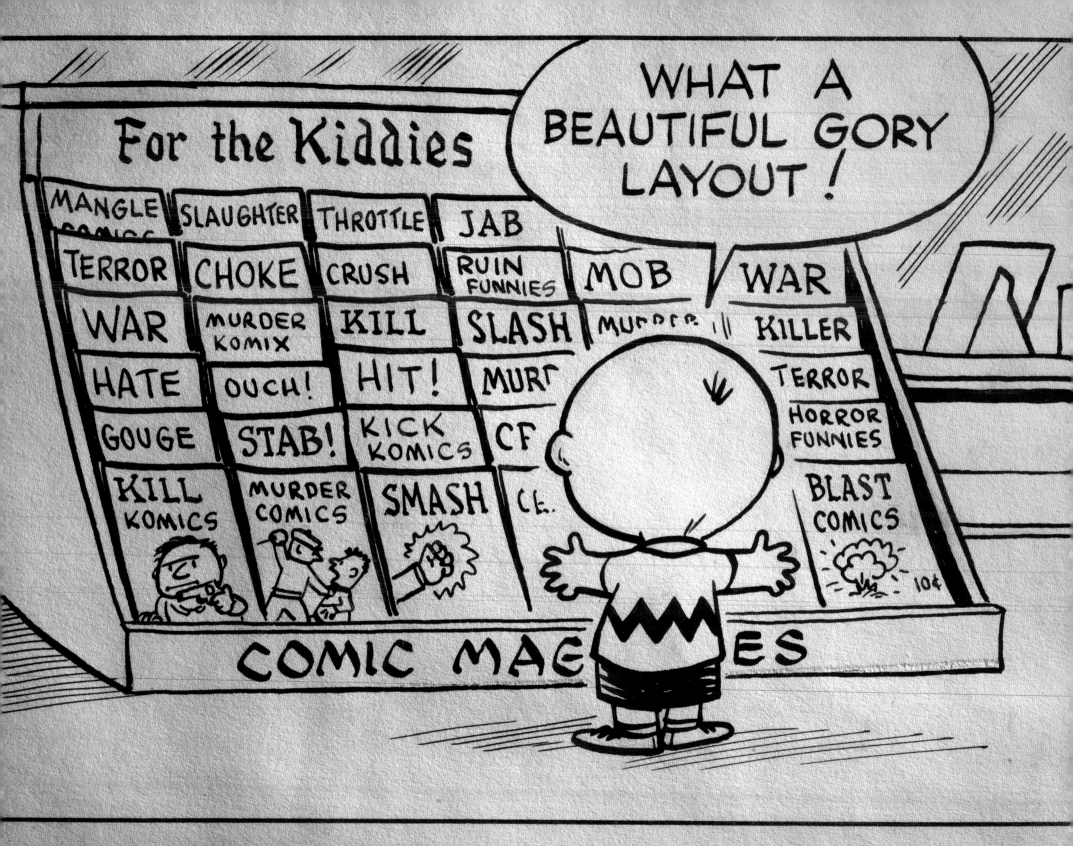

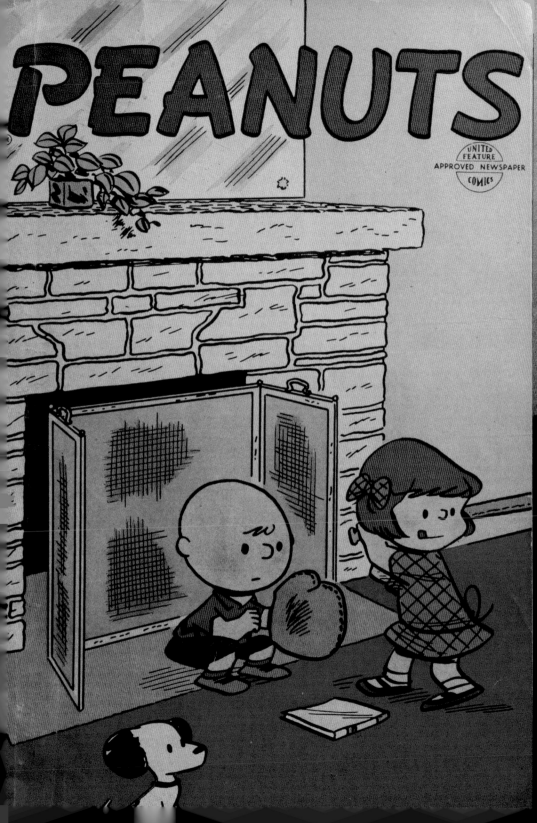

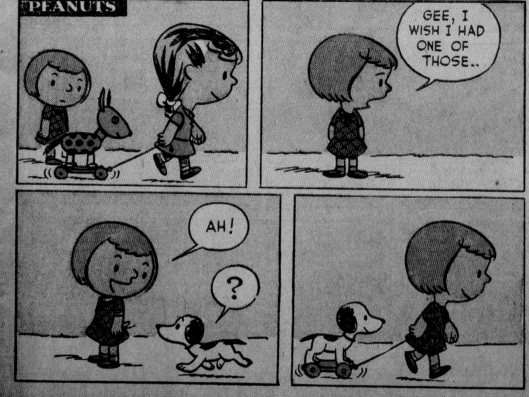

Comic strips and comic books are two entirely different formats of the medium (think of a short story as compared to a novel, or a music single in contrast to a full-length album), but in the 1950s United Feature routinely combined the two. In titles that included *Tip Top Comics*, *Tip Topper Comics*, and *Fritzi Ritz*, the multiple properties of the syndicate were collected in comic books that recycled their daily exploits into monthly magazines—and on occasion Charlie Brown and the gang were included. Starting off with the extremely rare one-shot shown above, these appearances marked the only time that *Peanuts* dailies ever appeared in color.

One gag that Schulz returned to several times early on in the strip was the wildly graphic nature of "horror" comics during the McCarthy era and their inappropriateness for kids the age of Charlie Brown. Which apparently is why he (and so many others) liked them (opposite).

LEFT **Comic book cover,** *Peanuts: Comics on Parade* **no. 1, United Feature Syndicate, 1953.**

ABOVE **Comic book page,** *Peanuts: Comics on Parade* **no. 1. This daily**
strip was first published in black and white on March 22, 1951

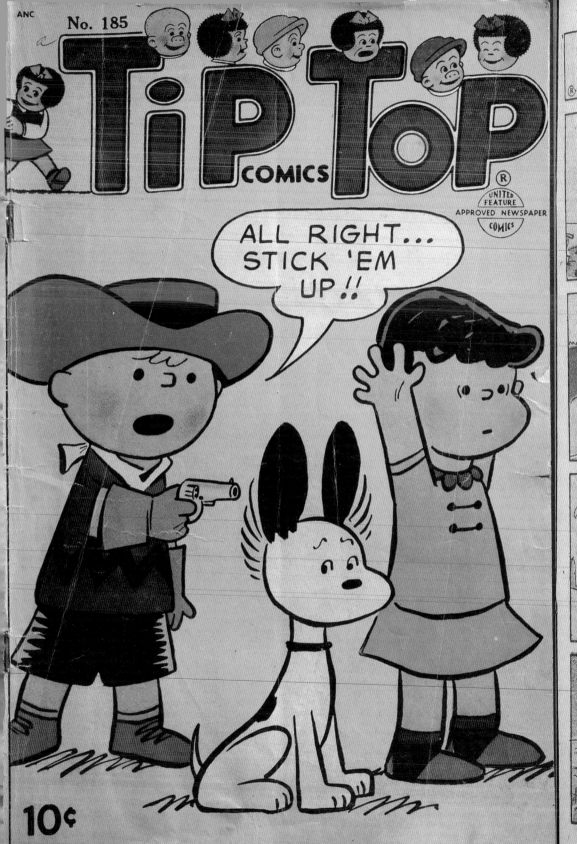

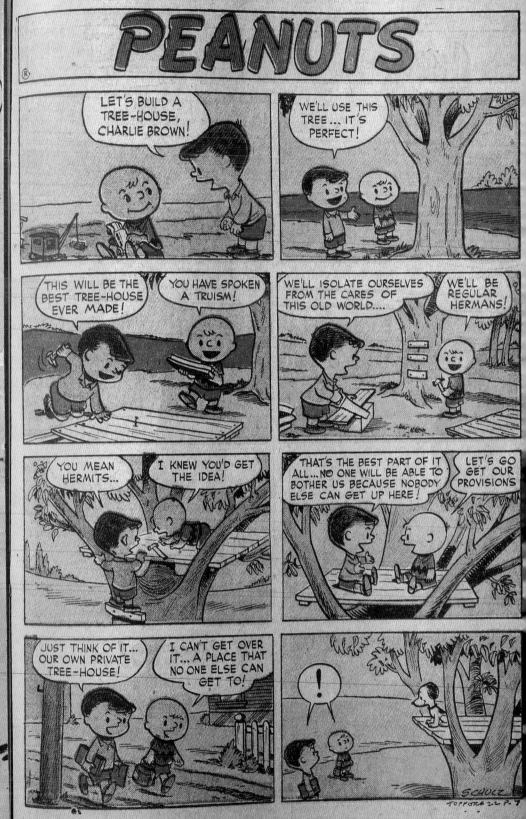

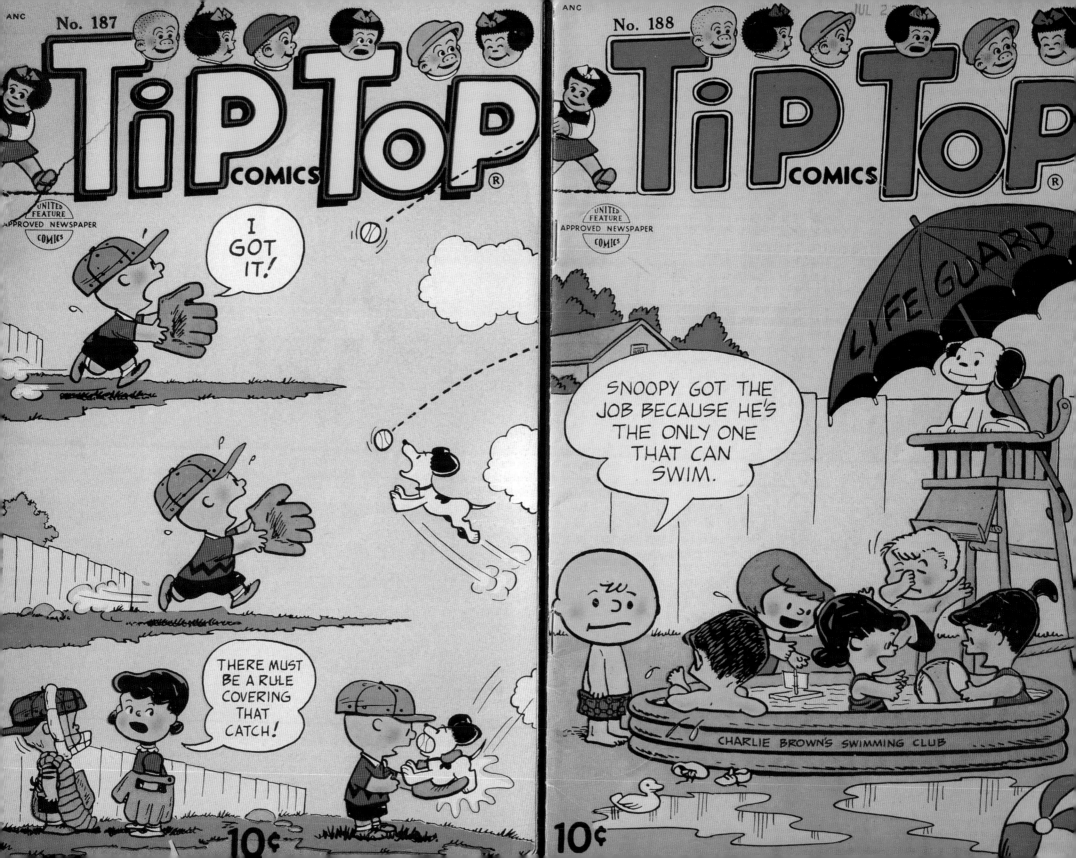

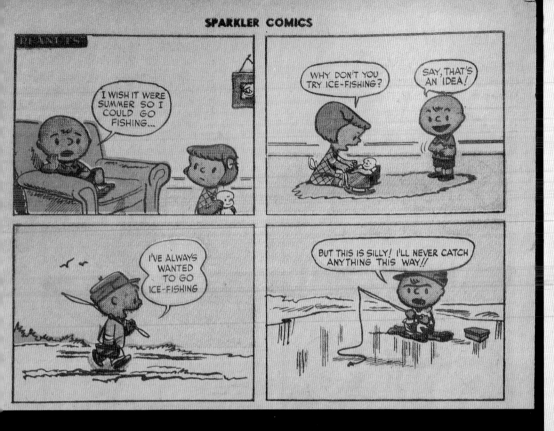

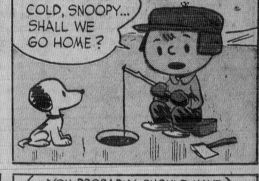

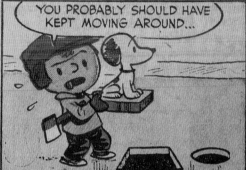

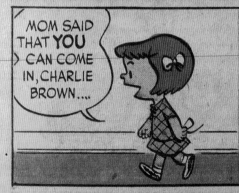

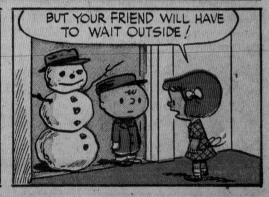

PREVIOUS PAGES, LEFT TO RIGHT Comic book cover, *Tip Top Comics* no. 185, United Feature Syndicate, March–April 1954.

Comic book page, *Fritzi Ritz* no. 39, United Feature Syndicate, March 1955. This Sunday page was first published on February 17, 1952.

Comic book covers, *Tip Top Comics* no. 187, United Feature Syndicate, July–August 1954, and no. 188, September–October 1954.

ABOVE Comic book page, *Sparkler Comics* no. 115, United Feature Syndicate, January–February 1954. This daily strip was first published in black and white on December 6, 1951.

RIGHT Comic book page, *Fritzi Ritz* no. 40, United Feature Syndicate, May 1955. These two daily strips were first published in black and white on December 13, 1951 (top), and December 5, 1951 (bottom).

OPPOSITE Detail, Sunday comic strip, May 24, 1953.

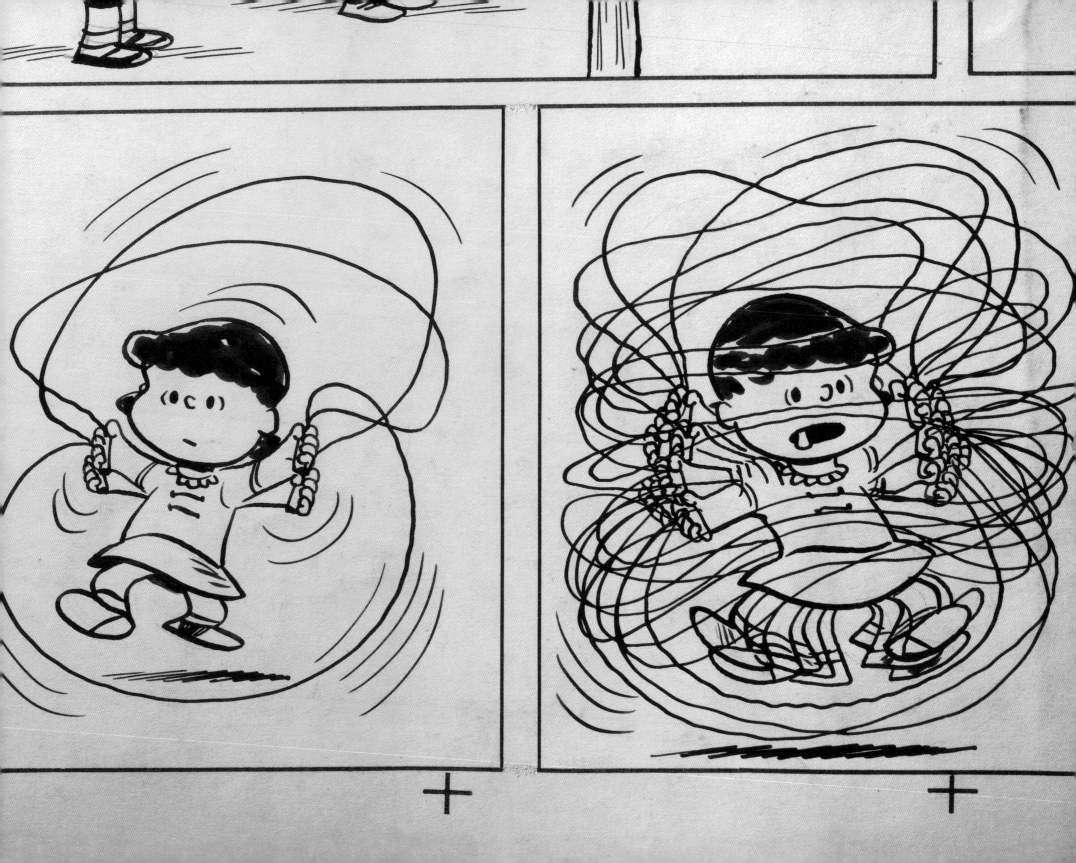

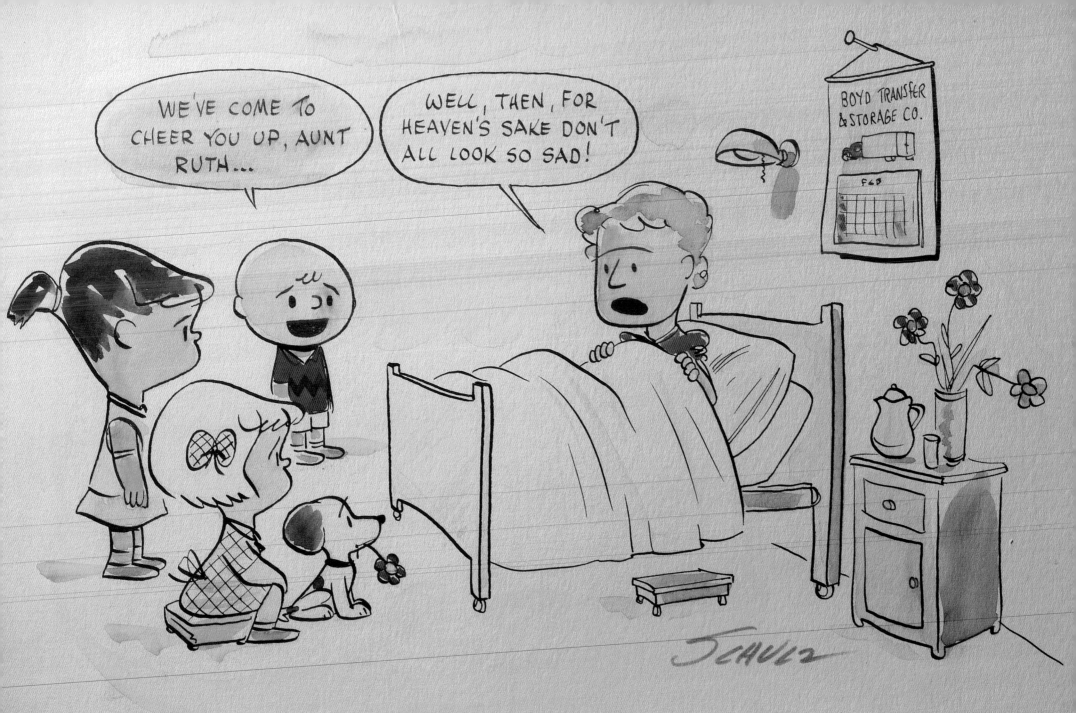

CHARLES M. SCHULZ
NUMBER ONE SNOOPY PLACE
SANTA ROSA, CALIF. 95401

January 7, 1980

Ms. D. J. Comport
1712 Parkcrest Terr.
Arlington, TX 76012

Dear D.J.:

Unfortunately, we never like the drawings we did
a long time ago, but I suppose this is a nice
souvenir. I remember the evening we dropped into
the hospital and gave it to your mother.

I really appreciated our being able to get together.
Talking with you again was a complete delight.

Love,

Sparky

CMS/pl

Copr. © 1958 United Feature Syndicate

OPPOSITE **Unpublished watercolor drawing, February 1952.**
Get-well card for Schulz's Aunt Ruth.

LEFT **Letter to Ruth's daughter, D. J. Comport, January 7,**
1980. Almost thirty years later, Schulz comments on the
drawing that she returned for his archives.

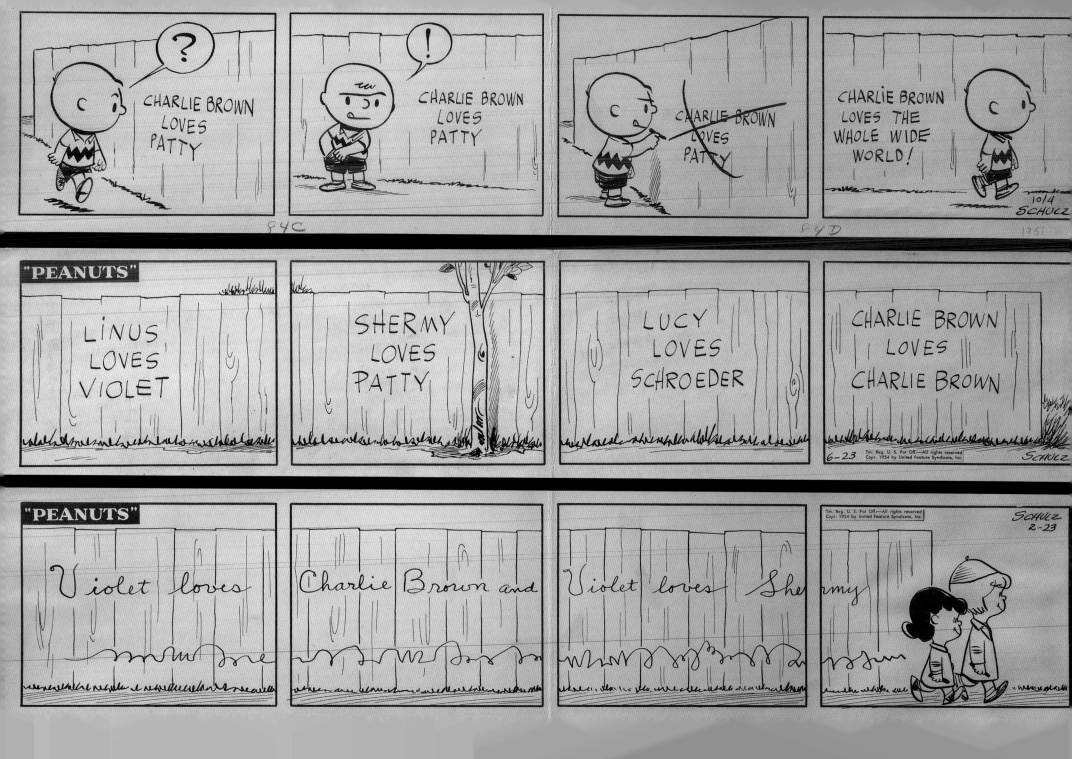

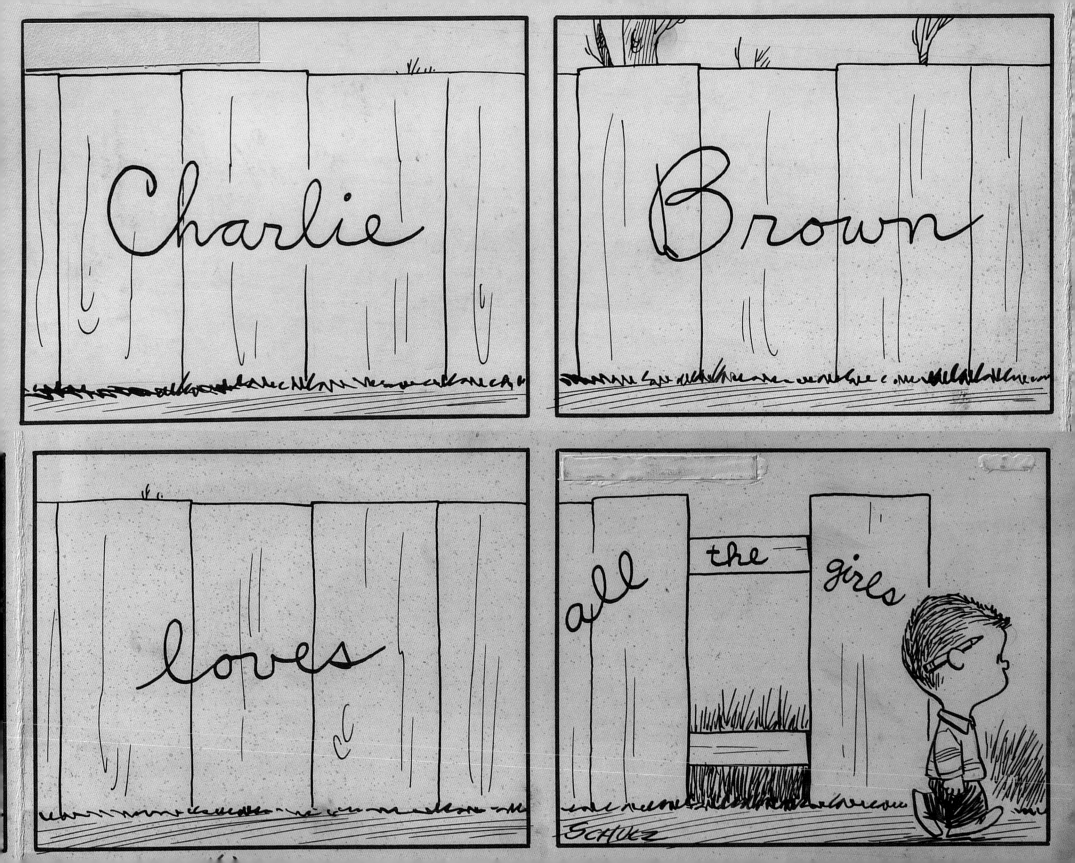

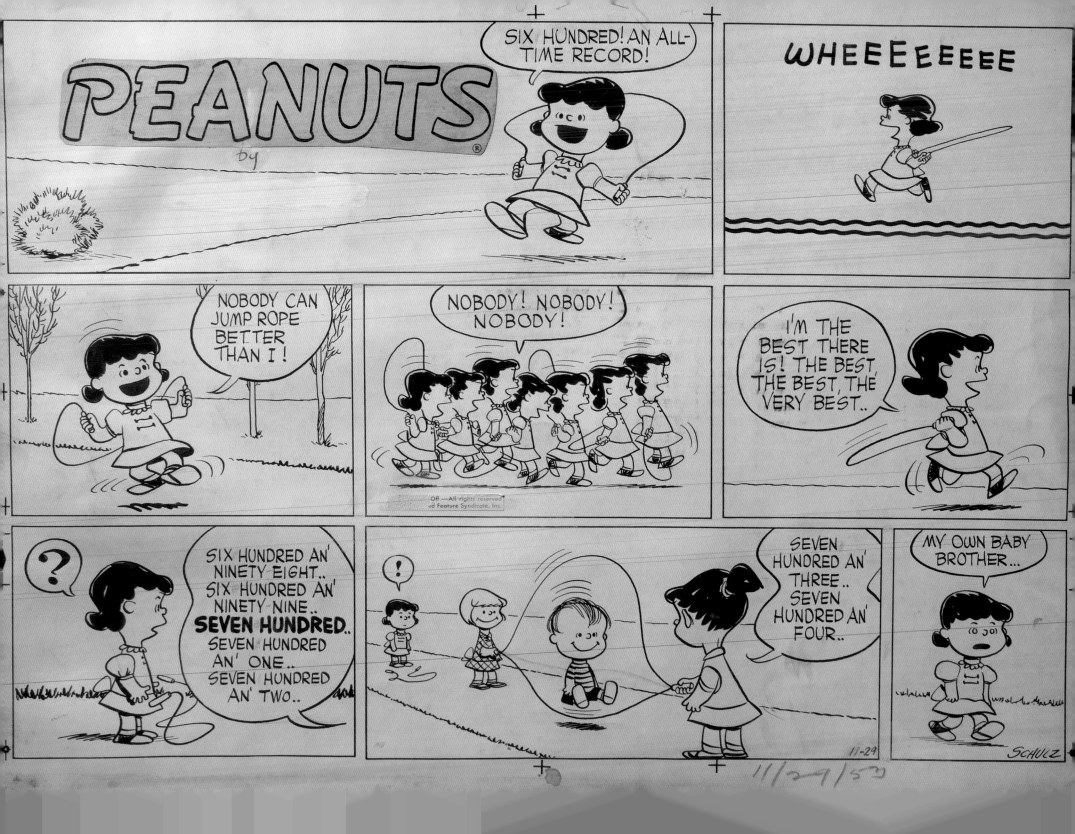

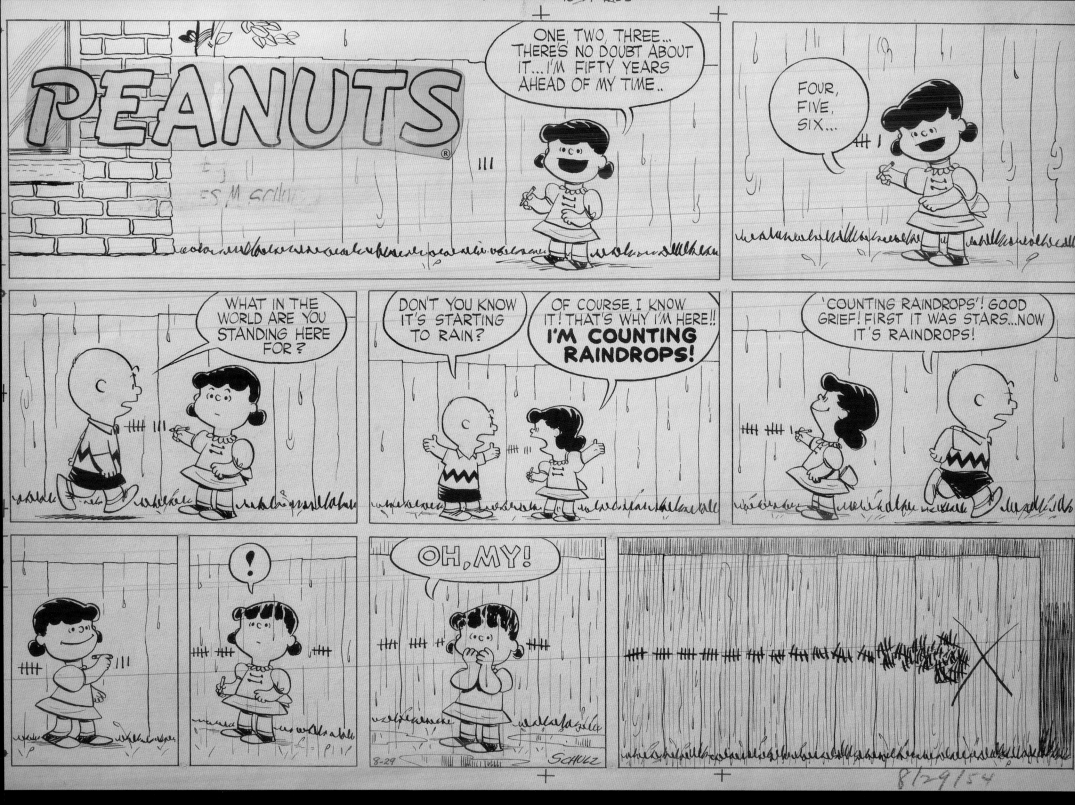

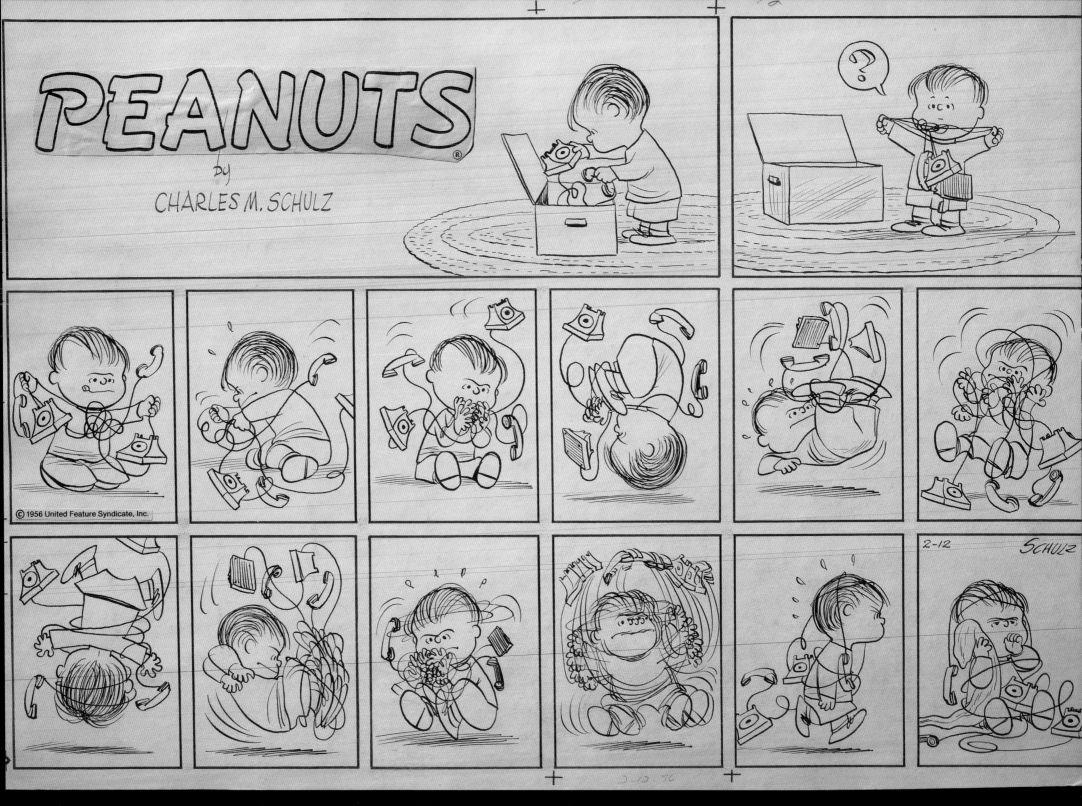

Original art for Sunday comic strips, February 12, 1956 (above), and November 8, 1953 (opposite).

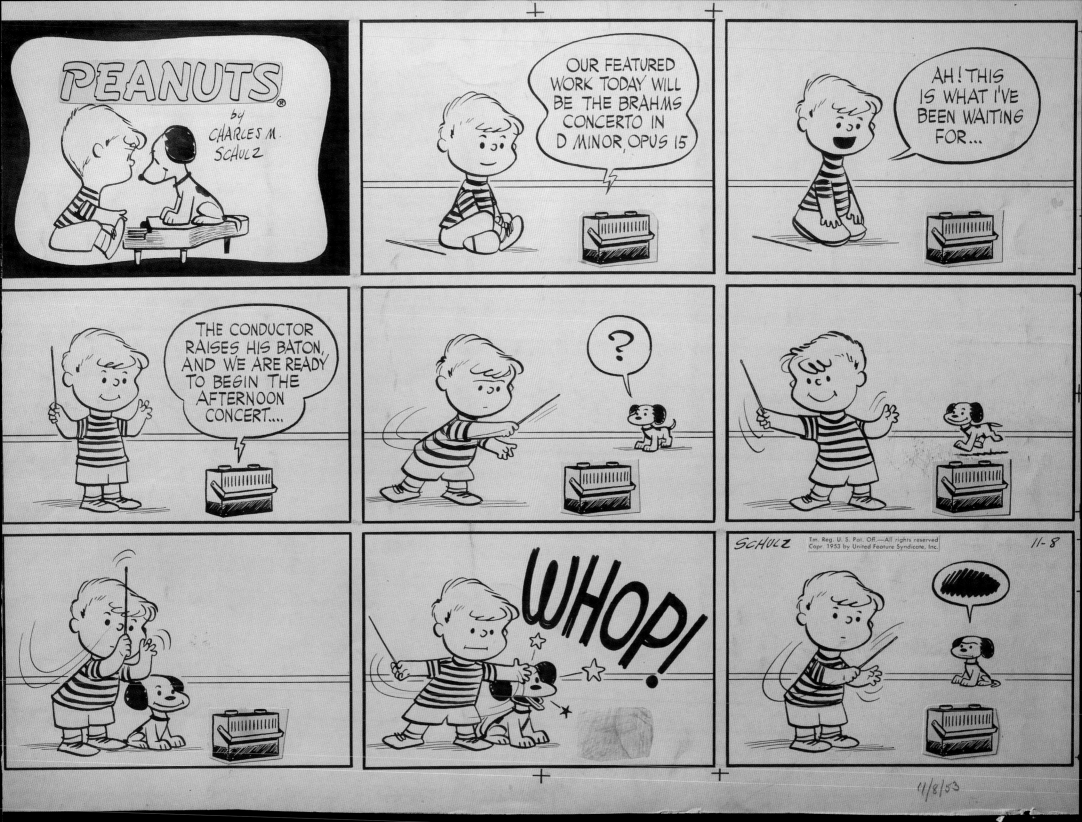

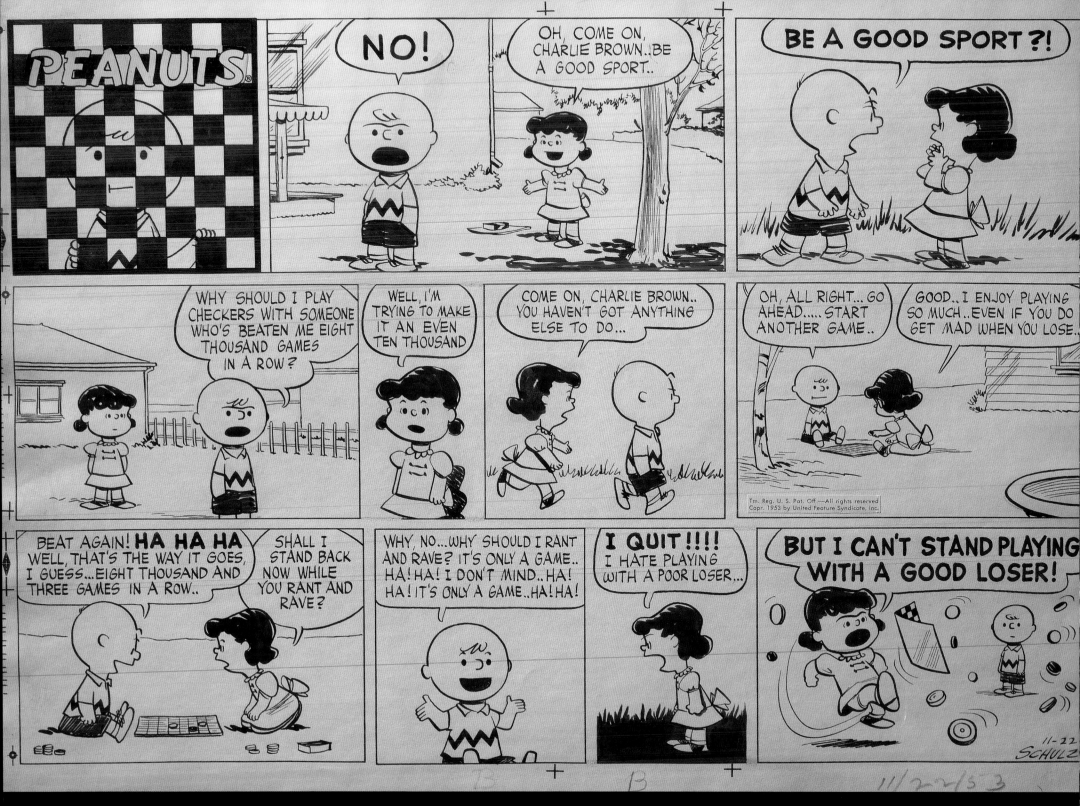

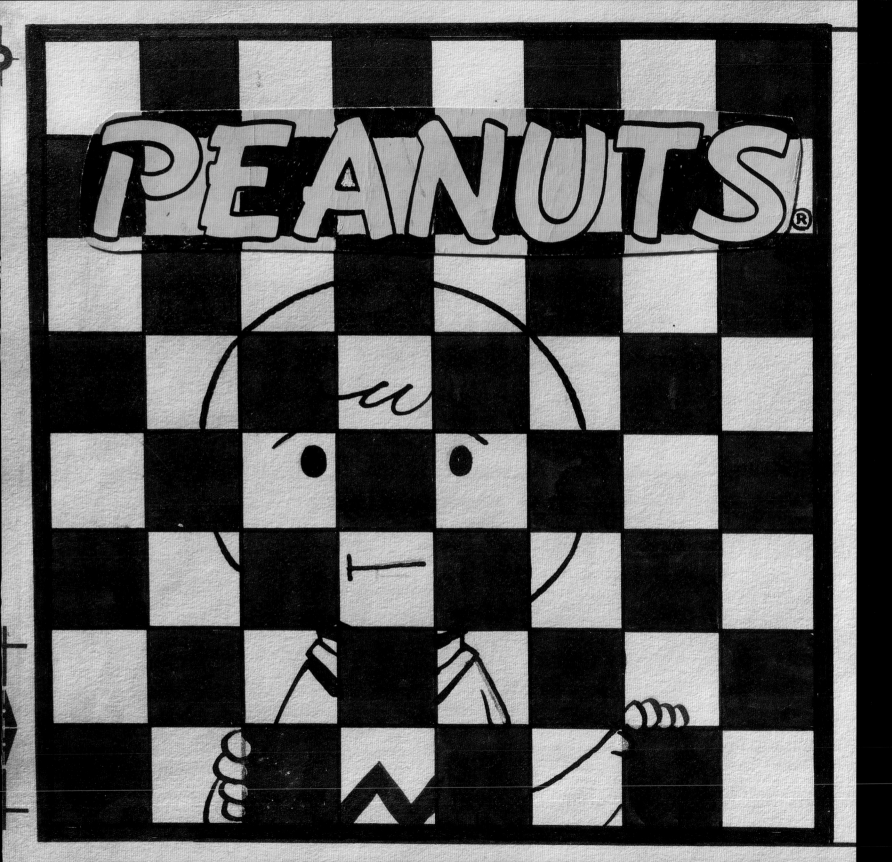

Sunday strips had to be designed so that the panels along the top could be eliminated by any newspaper that wanted to save space and fit as many cartoon features on a page as they could. Therefore these "headers," as they are known, were often decorative suggestions of the panels to follow. This checkerboard design is especially striking in its use of juxtaposed geometrics.

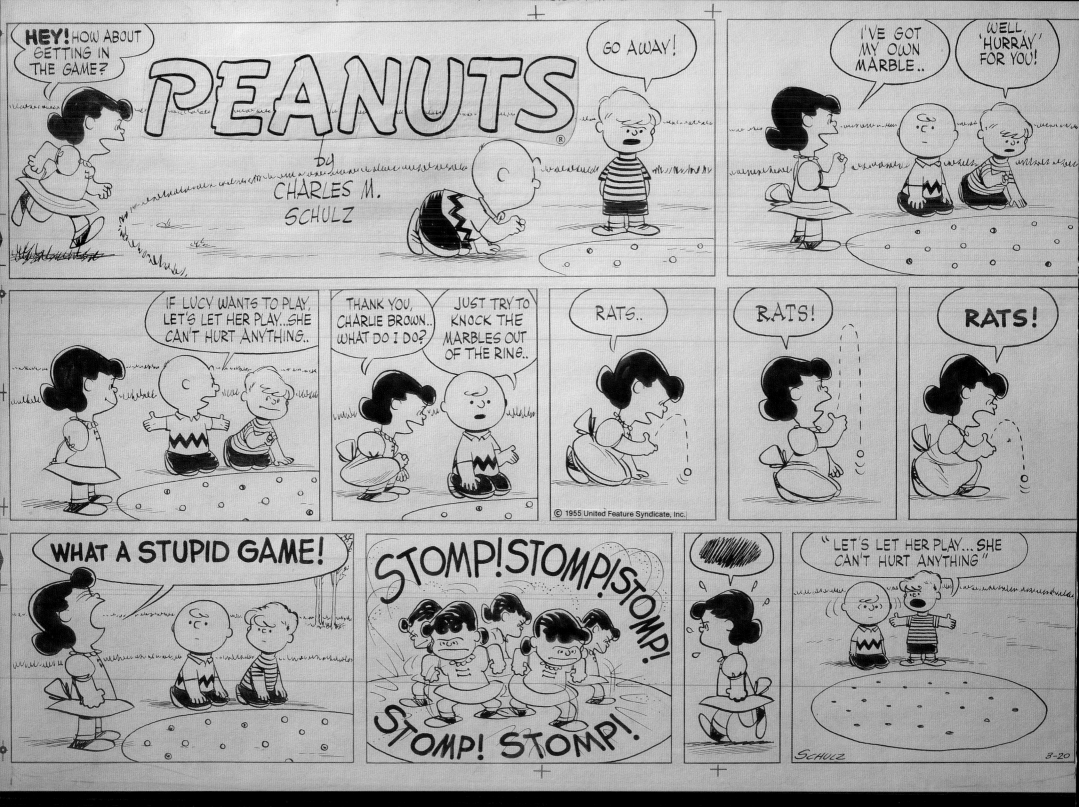

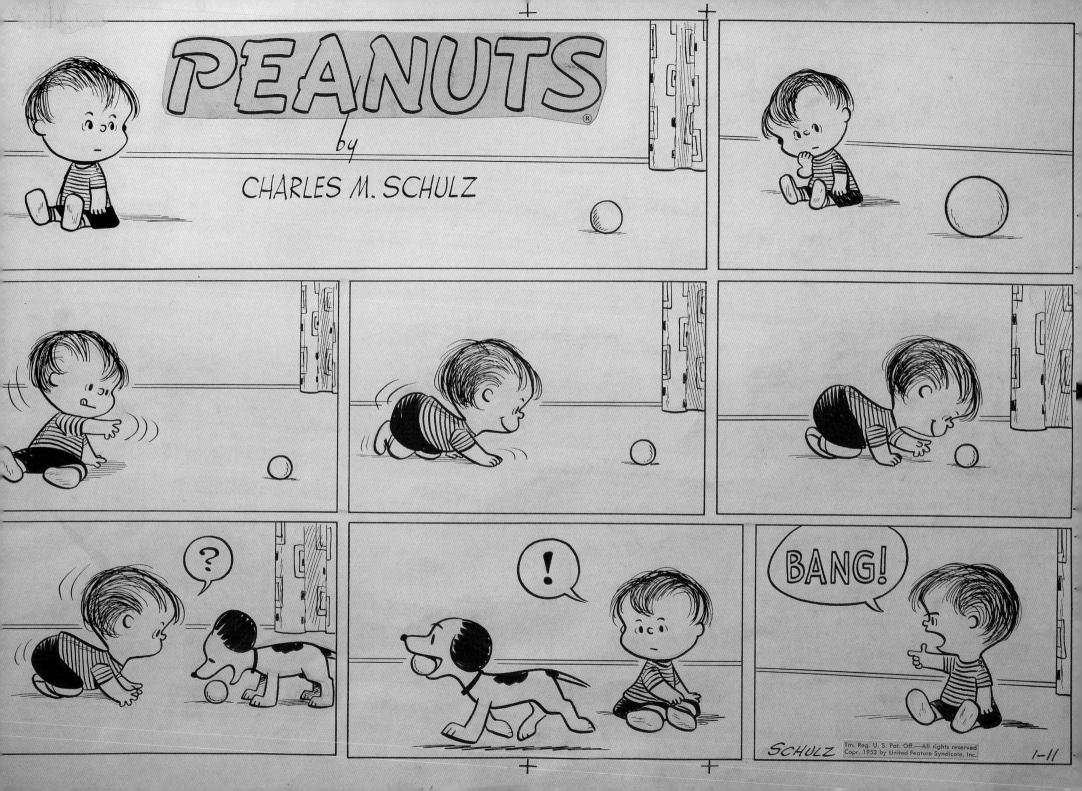

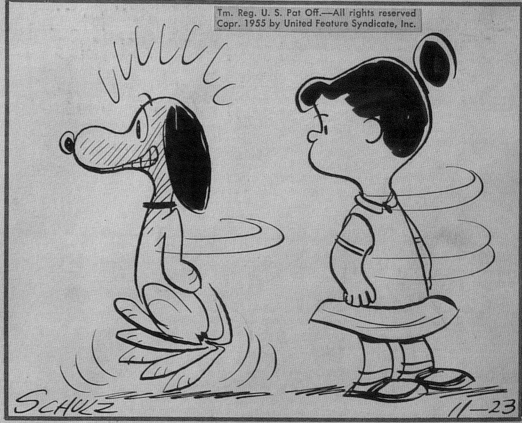

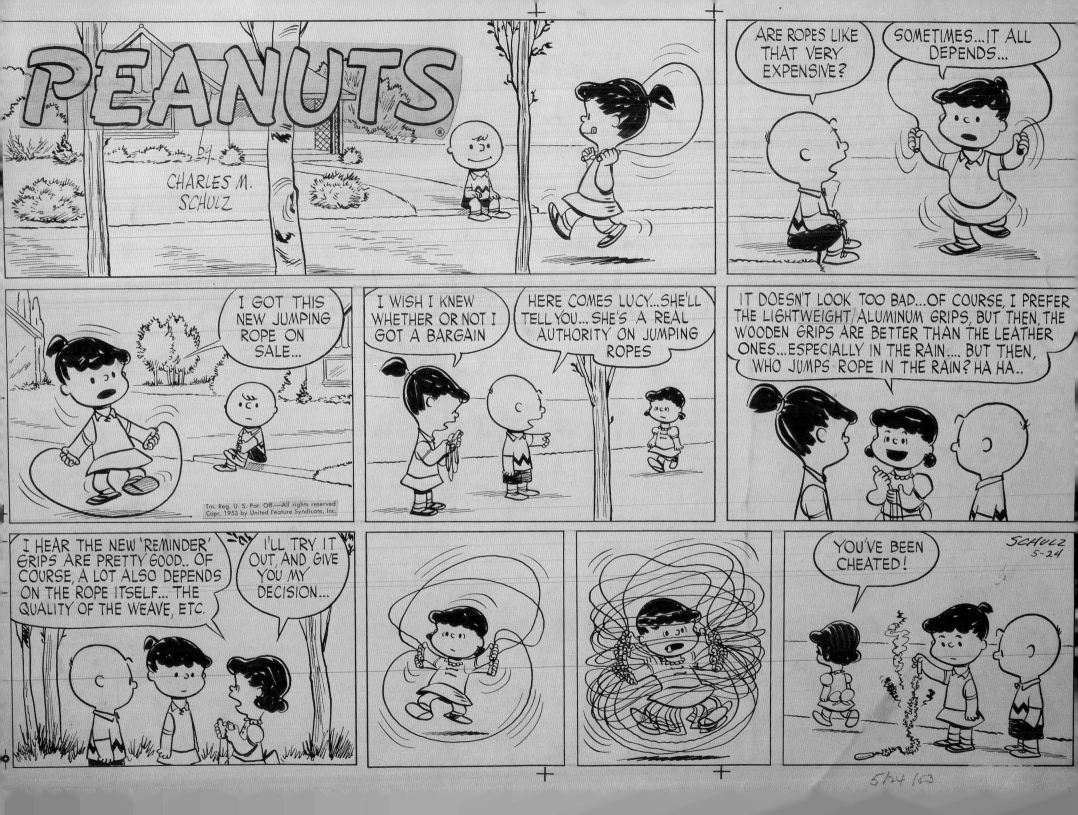

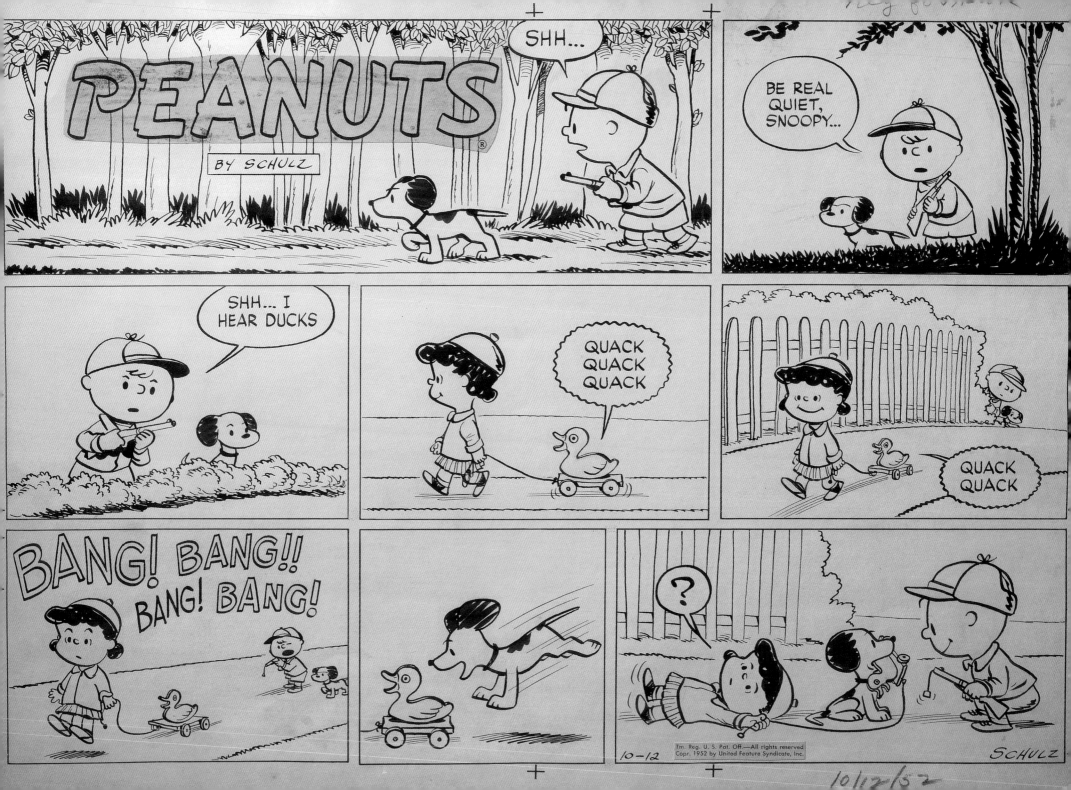

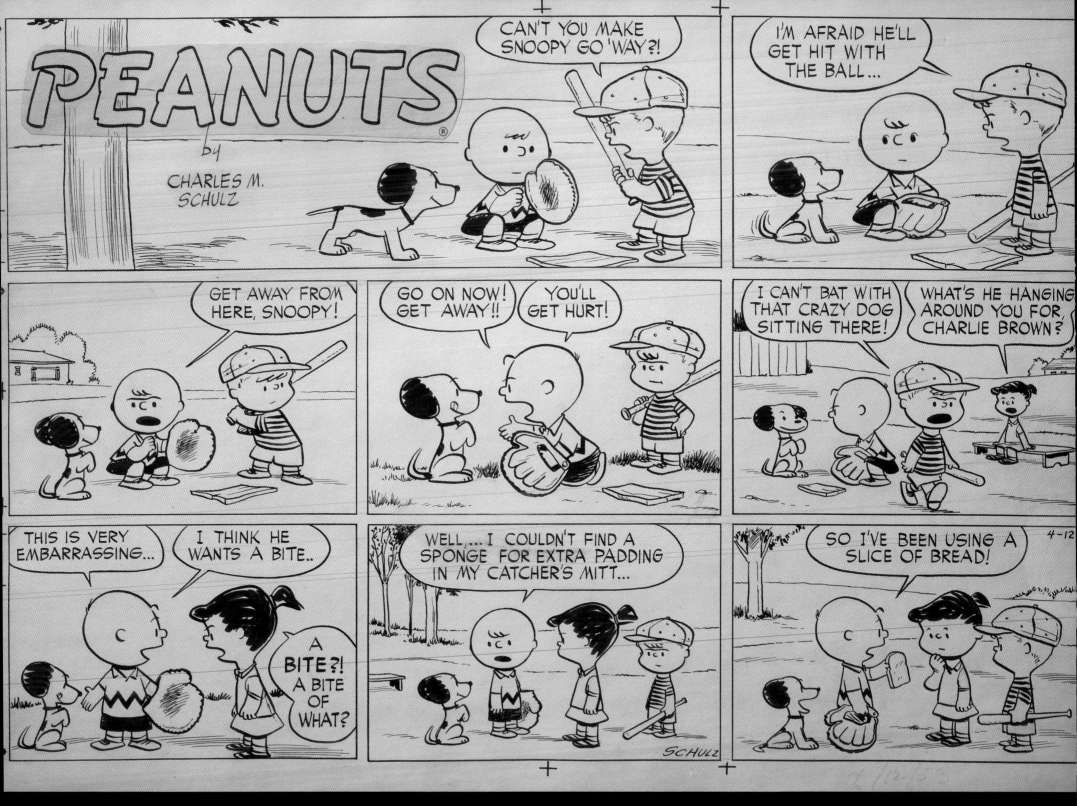

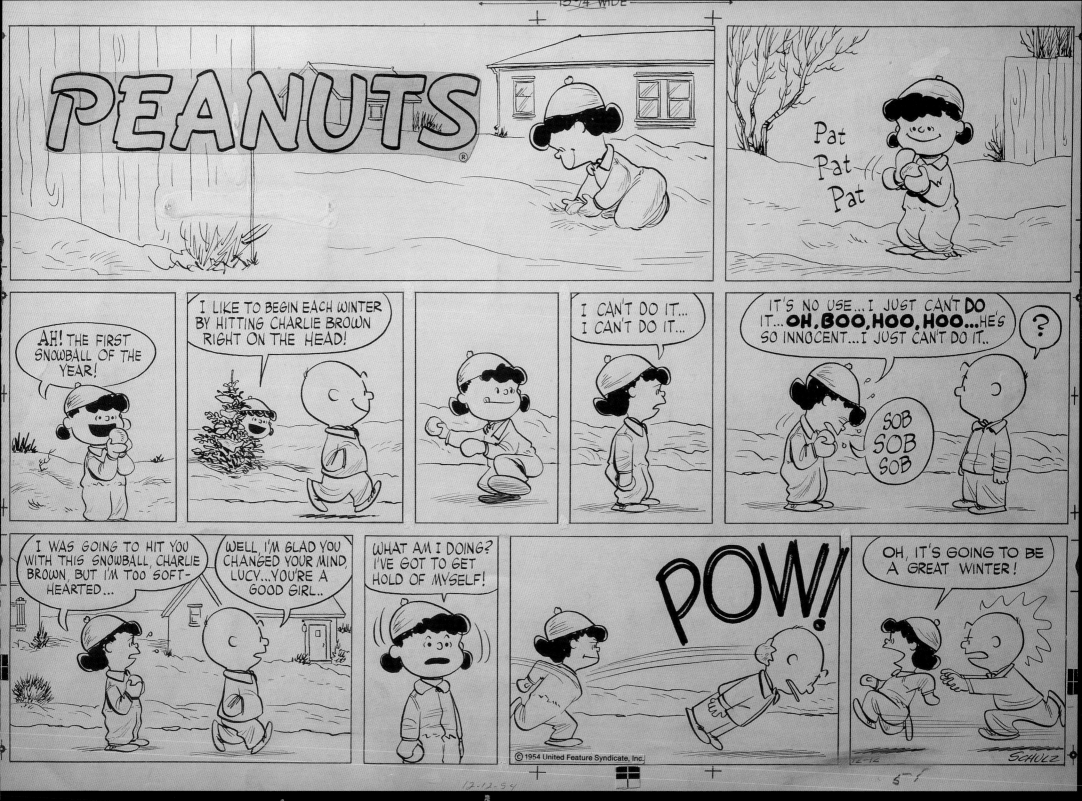

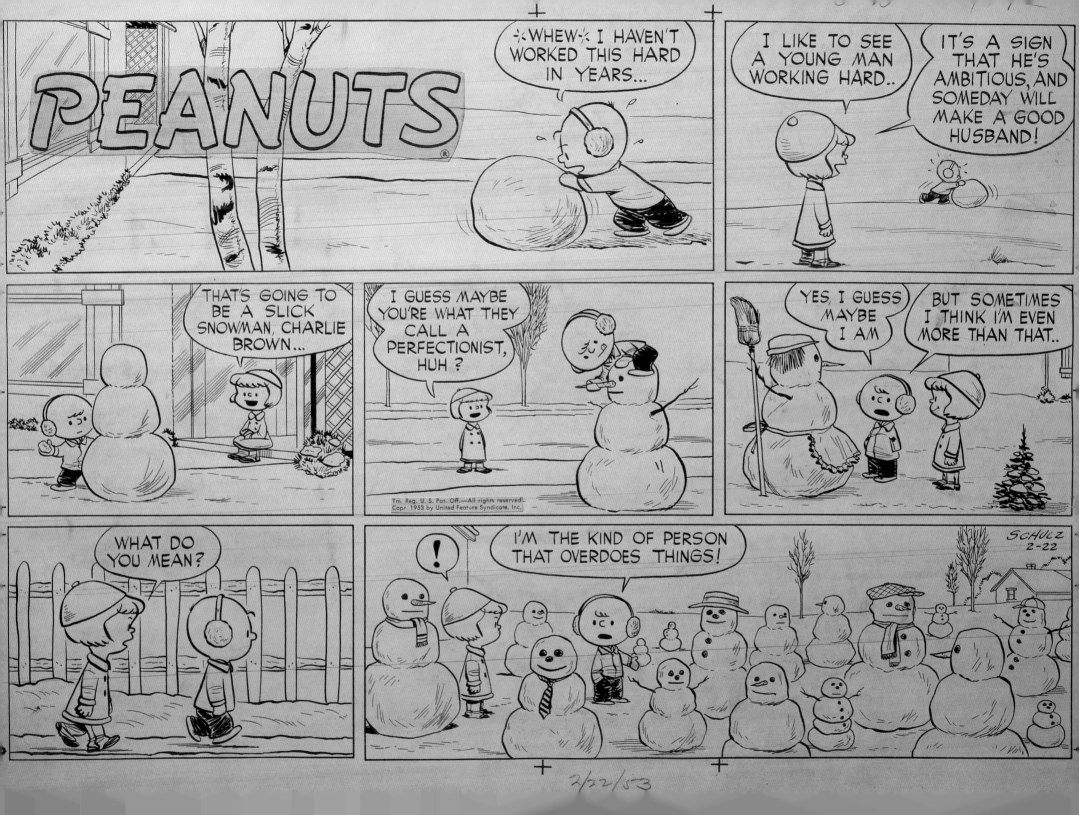

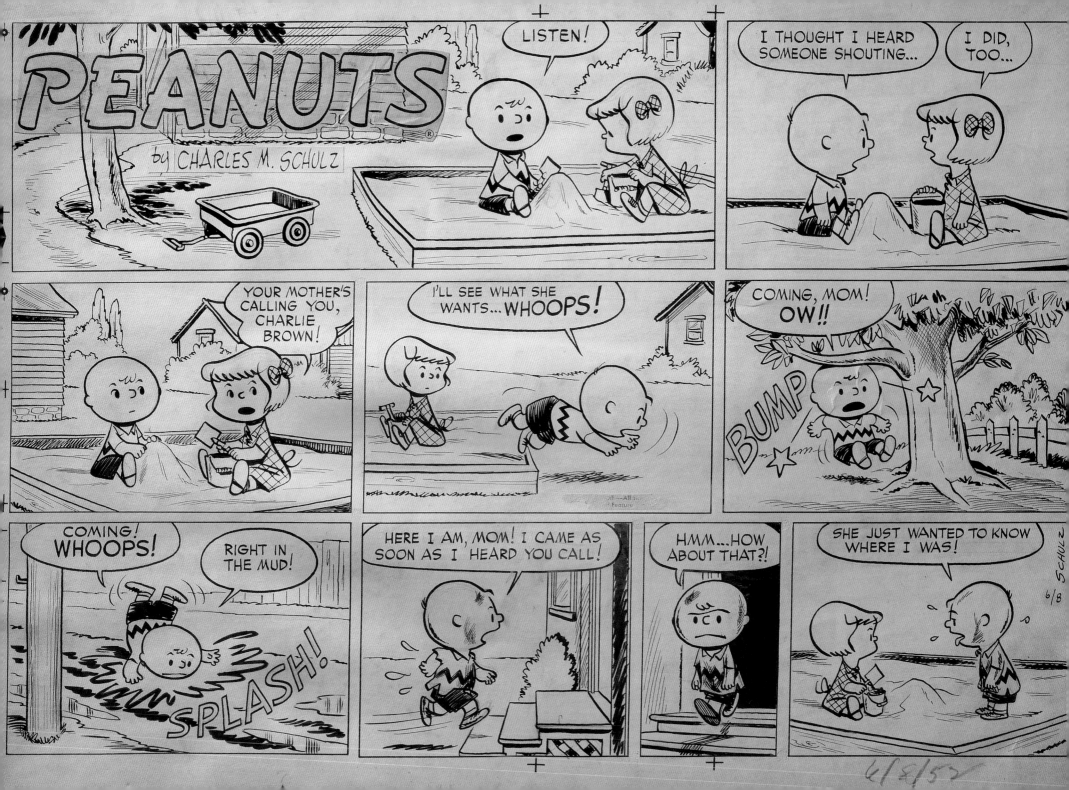

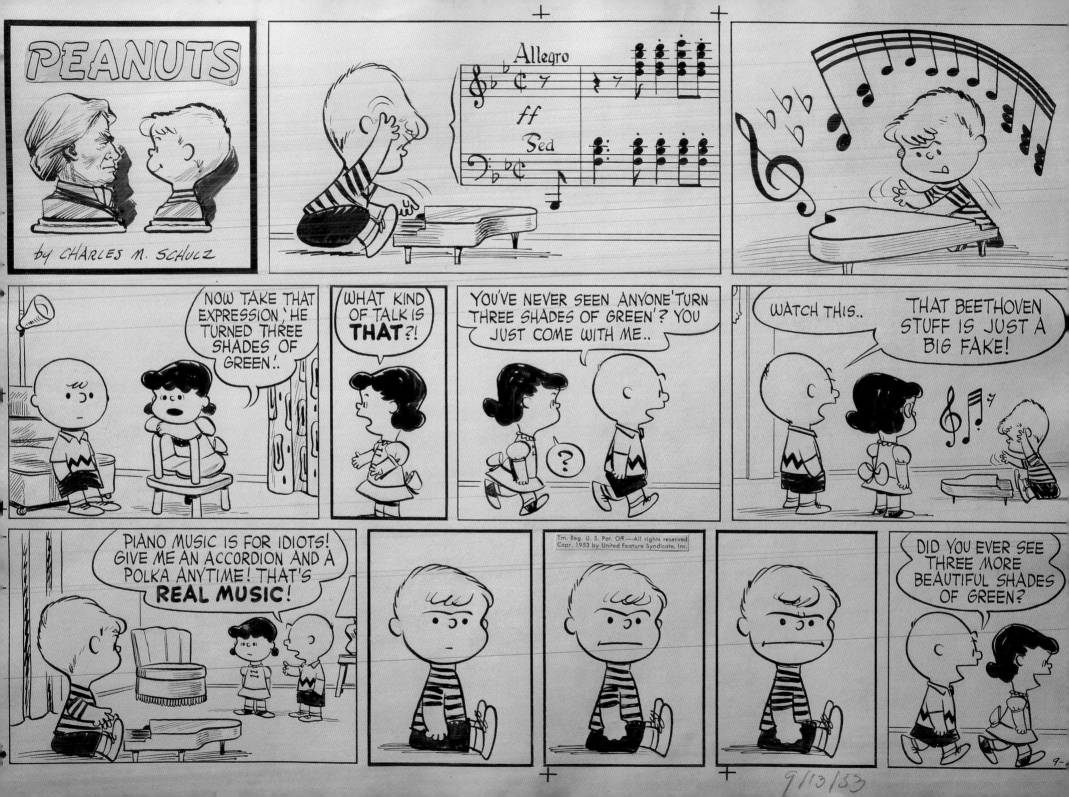

OPPOSITE **Original art for Sunday comic strip, September 13, 1953.**

RIGHT **Unpublished drawing on sweatshirt, created for a Beethoven birthday celebration hosted by the Schulzes, 1960s.**

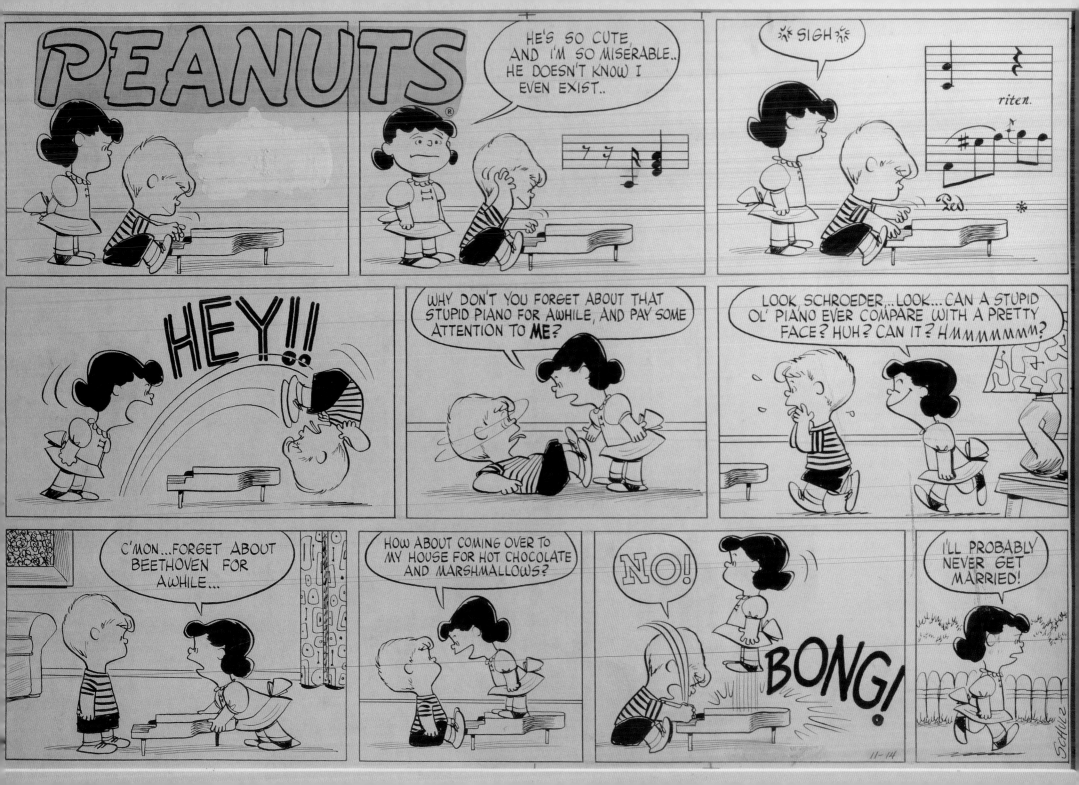

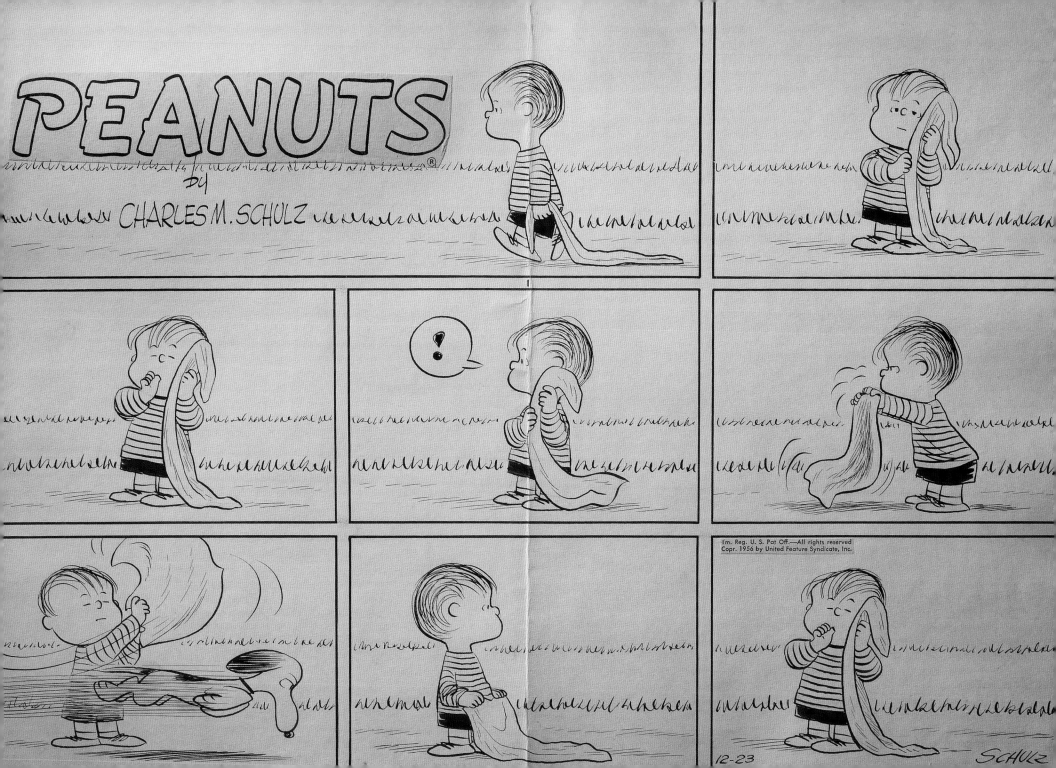

THE PROCESS

Thinking of a good idea was the most important—and often the hardest—part. If Schulz was stuck, he would often stare out his window and/or doodle with a pencil on a pad to jog his imagination. Once he thought of something he liked, he would start with the lettering, in pencil, which was constantly open to revision right up to the point of inking (and sometimes after). Once the lettering was down in graphite, Schulz would proceed with sketching the characters. Then came the ink, in the same order: First he would ink the lettering (with a C5 Speedball pen), then the figures (with an Esterbrook 914 Radio writing nib). Speech balloons around the words came last.

By the mid-1950s, Schulz had preprinted strips of blank panels made on lightweight uncoated drawing board so he wouldn't have to redraw the basic elements every day. But for his entire fifty-year career, Schulz never hired an assistant to work on backgrounds or to ink his lettering. "That would be like Arnold Palmer having someone else hit his chip shots!"

Over the years, as the strip and Schulz's facility with it evolved, so did the process. He relied less and less on penciling—especially the figures, eventually leaving their faces blank. At that point, he was so in control of his craft that he could let the spontaneity of his eye-to-hand coordination guide the pen to get the perfect expression.

The examples of abandoned 1950s strips shown here (below, opposite, and on the following pages) leave us to only ponder what about them wasn't working for him. Was the go-cart too busy? Did he think the camera gag wore thin? Regardless, no known published strips correspond to these.

BELOW, OPPOSITE, AND FOLLOWING PAGES Unfinished sketches for two daily comic strips, undated.

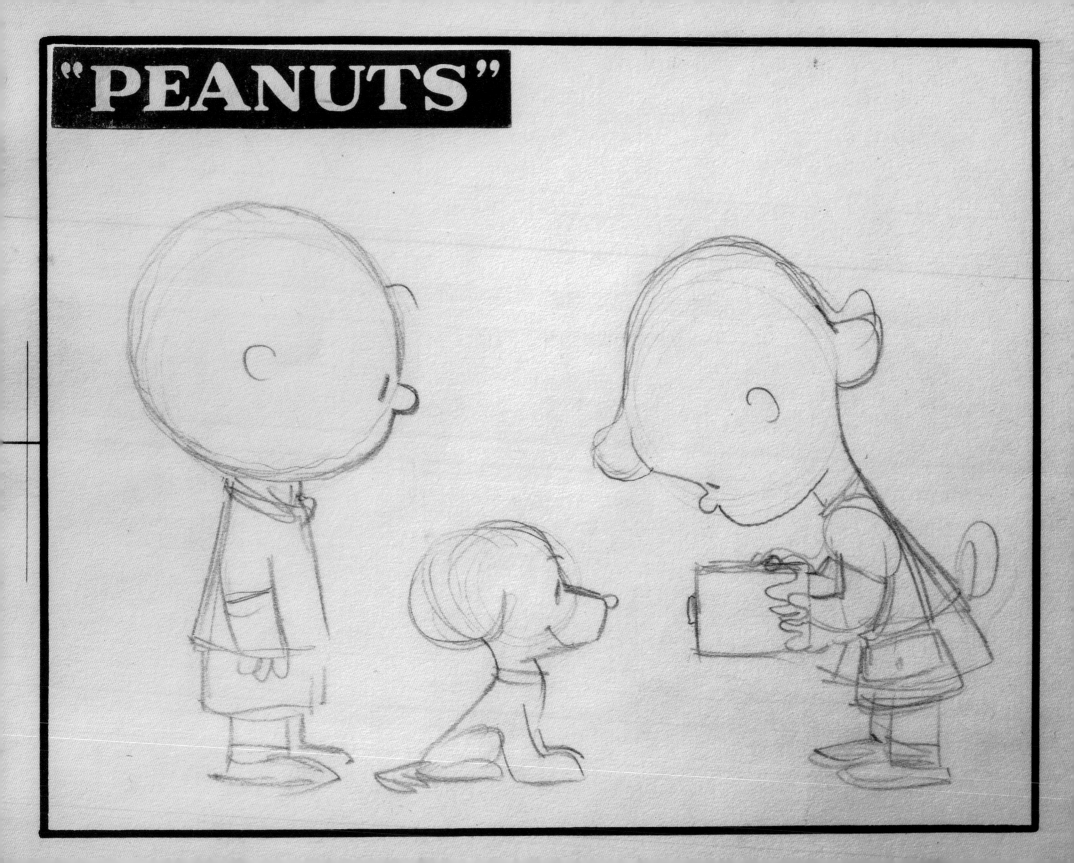

PEANUTS

WHY ARE YOU SITTING HERE IN THE DARK, MR. SACK?

I'M WAITING FOR THE SUN TO COME UP..

MAY I WAIT WITH YOU, MR. SACK? I PROMISE NOT TO BE LIKE THE DISCIPLES IN THE TWENTY-SIXTH CHAPTER OF MATTHEW WHO "COULD NOT WATCH ONE HOUR"

PEANUTS

MR. SACK, WHICH STAR IS THE NORTH STAR?

WELL, DO YOU SEE THOSE TWO STARS THAT MAKE THE END OF THE BIG DIPPER? JUST FOLLOW THEM STRAIGHT UP SIX SPACES, AND THERE'S THE NORTH STAR...

THAT'S AMAZING! BEING WITH YOU, MR. SACK, HAS BEEN THE GREATEST EXPERIENCE OF MY LIFE!

"A PROPHET IS NOT WITHOUT HONOR SAVE IN HIS OWN COUNTRY"

WHAT DID YOU SAY, MR. SACK?

TOP **Unfinished daily comic strip, c. 1973.**

BOTTOM **Original art for daily comic strip, June 30, 1973.**

One of the most endearing and popular series of strips in the history of *Peanuts* ran in June 1973 and involved Charlie Brown developing a rash in the pattern of baseball stitches on his head. This leads him to wear a paper bag with eyeholes right as he takes off for summer camp, where he is dubbed "Mr. Sack" by the other campers—quickly gaining the respect and admiration from his peers that he's sought all his life. The episode is based on Schulz's promotion to buck sergeant and squad leader in the army and discovering his powers as a sage leader to his young trainees.

Here we see an example of the lettering Schulz started for one of these strips (top), which he did not pursue. Below that is the finished strip, a variation on the direction he started with the top strip.

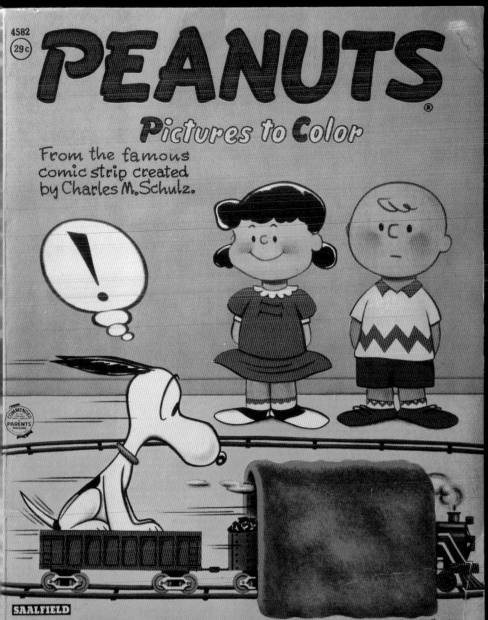

ABOVE Coloring book, *Peanuts Pictures to Color*, The Saalfield
Publishing Company, 1959.

RIGHT AND OPPOSITE Promotional flyer, United Feature Syndicate,
c. 1956. Reprint of Sunday comic strip from July 15, 1956.

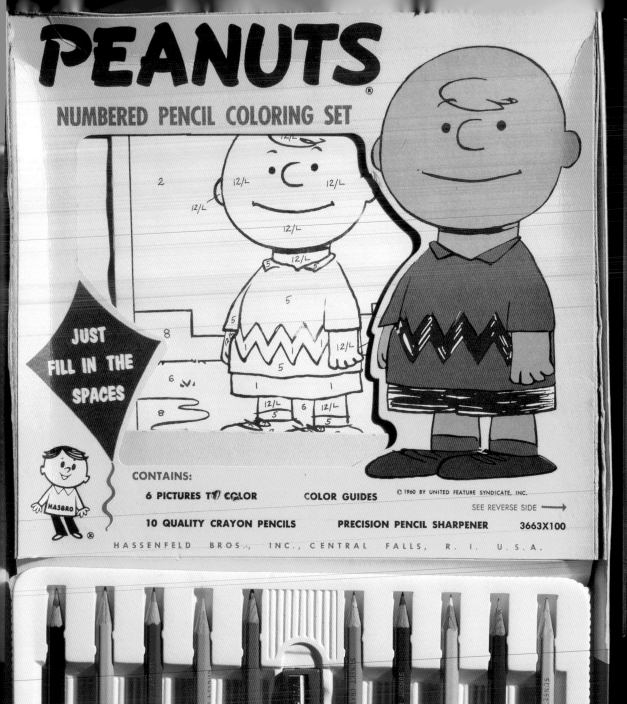

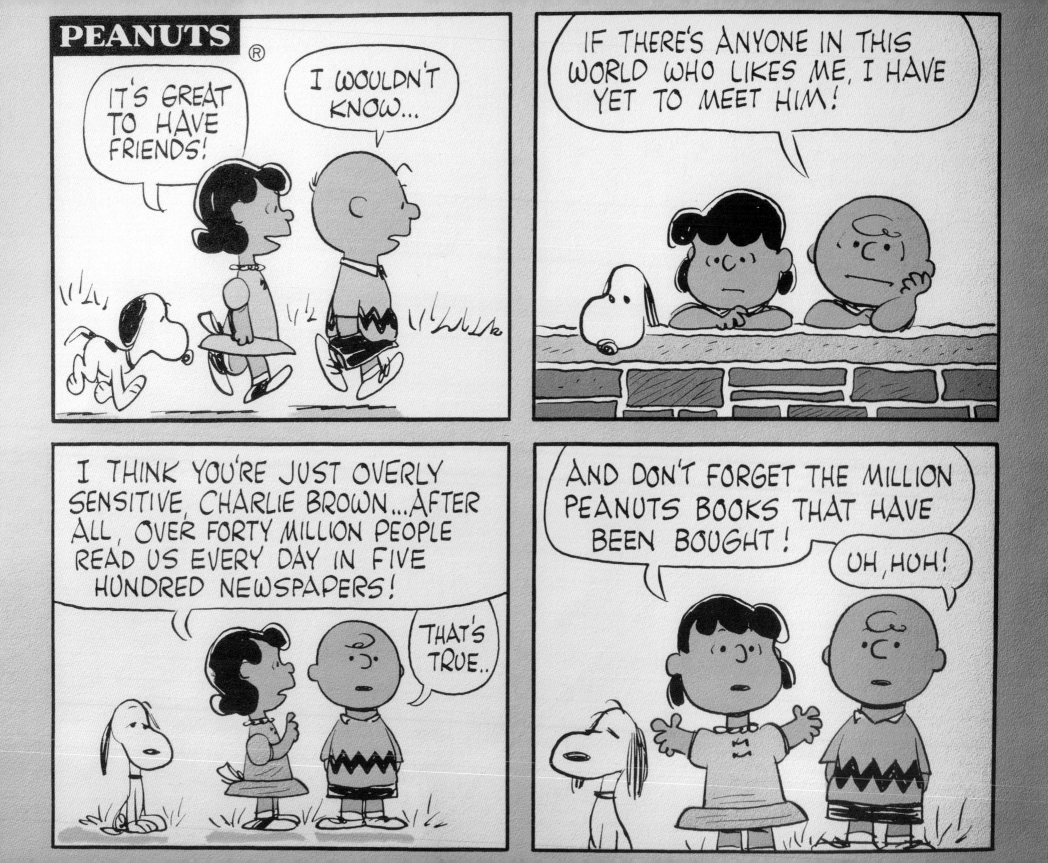

Charles M. Schulz, creator of "PEANUTS," is a resident of Minneapolis. Frequently he gets to his studio at 6:30 A.M. to work on his daily strip and Sunday page. That's to permit a little golf in the afternoon. Golf is one of his two hobbies—the other is bridge.

During World War II, he served as a machine gunner in Europe and, after his three year "hitch" in the Army, returned to Minneapolis and got down to the serious business of cartooning which eventually led to the creation of "PEANUTS." He is 31 years old.

There are three "Peanuts" in the Schulz home. The photo at the left shows (l. to r.) Craig, Mrs. Schulz, Meredith, Charles, Sr., and Charles, Jr.

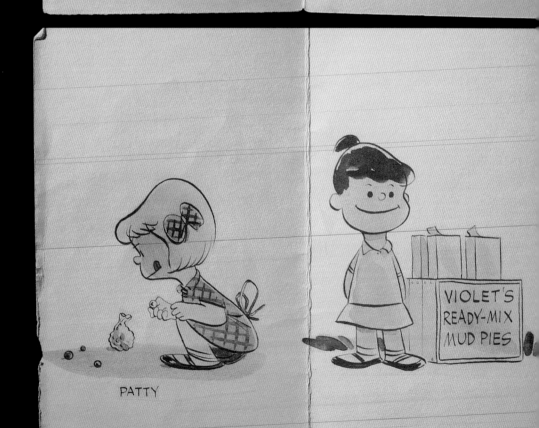

PATTY

VIOLET'S READY-MIX MUD PIES

"The Peanuts Album," c. 1953. This promotional foldout booklet features early versions of the characters and a photo of Schulz and his family. Fans who wrote in to the syndicate would receive this two-sided mini album, which was advertised in newspapers.

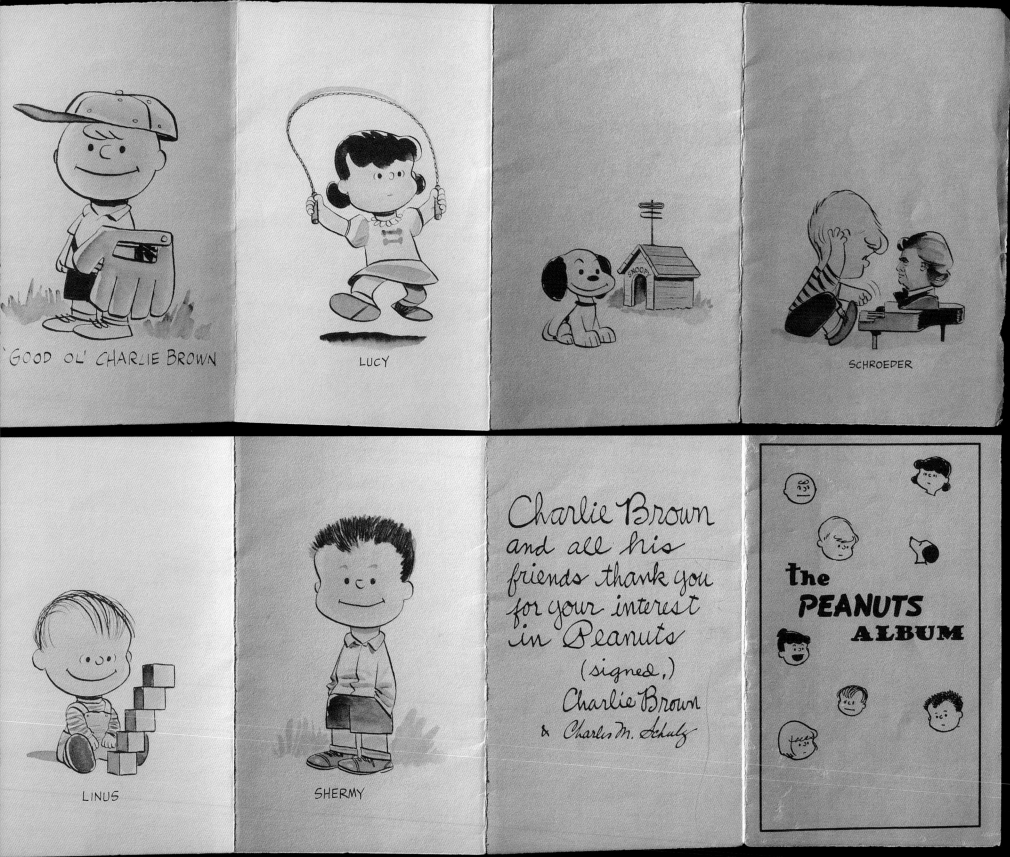

'GOOD OL' CHARLIE BROWN

LUCY

SCHROEDER

LINUS

SHERMY

Charlie Brown and all his friends thank you for your interest in Peanuts (signed,) Charlie Brown & Charles M. Schulz

the PEANUTS ALBUM

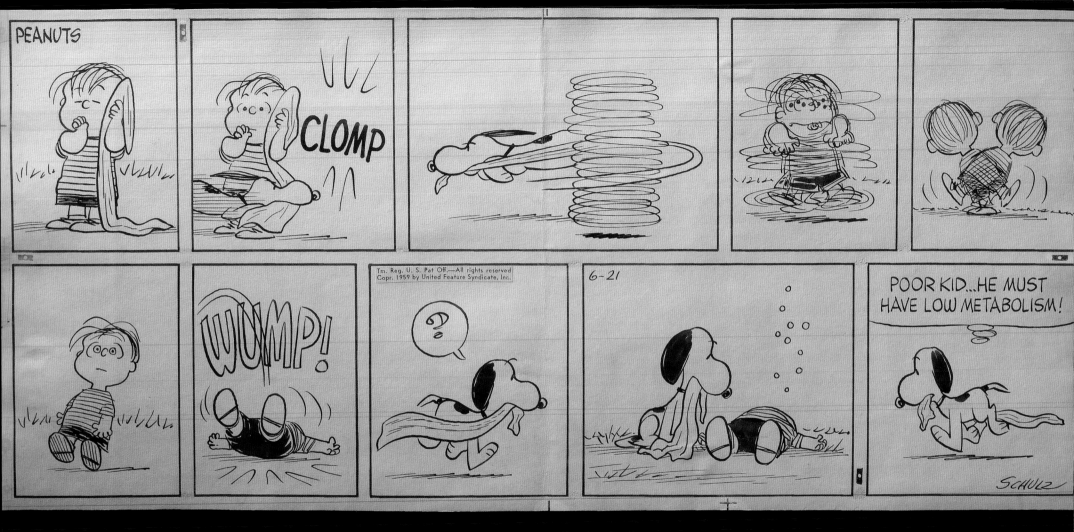

ABOVE **Original art for Sunday comic strip, June 21, 1959. Note, the original art was trimmed and is missing the top two panels.**

OPPOSITE **Original art for Sunday comic strip, May 16, 1954. This is one of a handful of rare instances where Schulz depicted adults. Considered by the artist to be a failed experiment, this cartoon was**

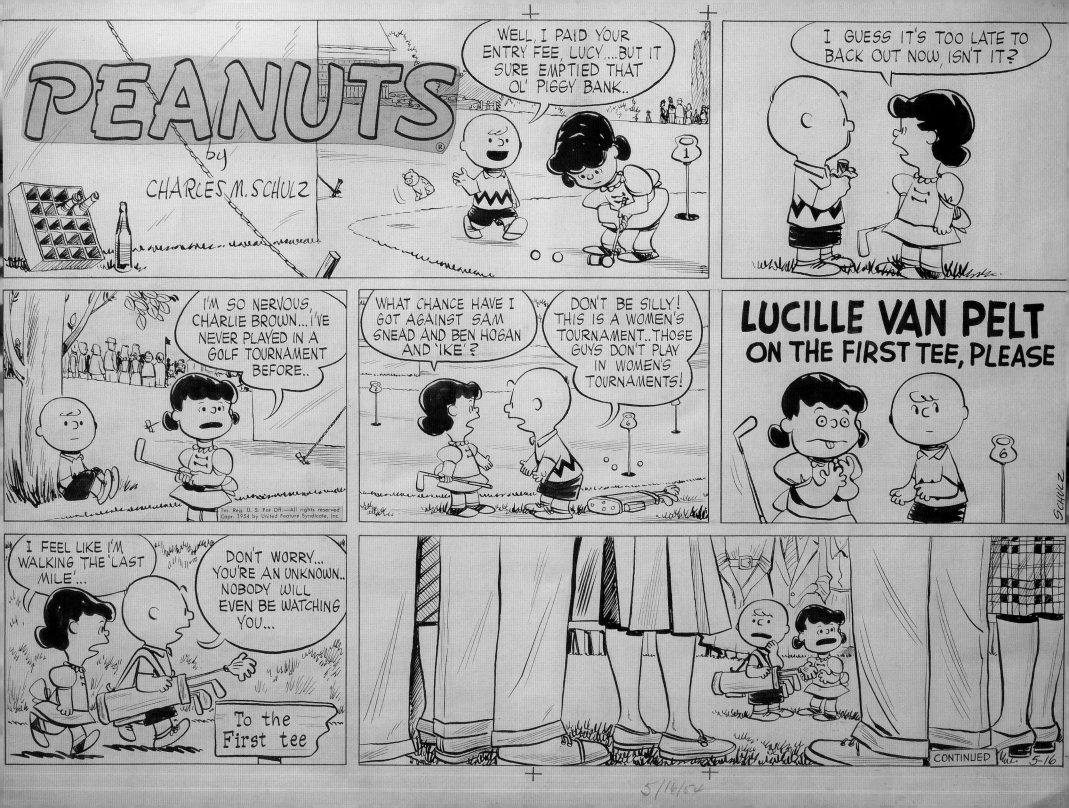

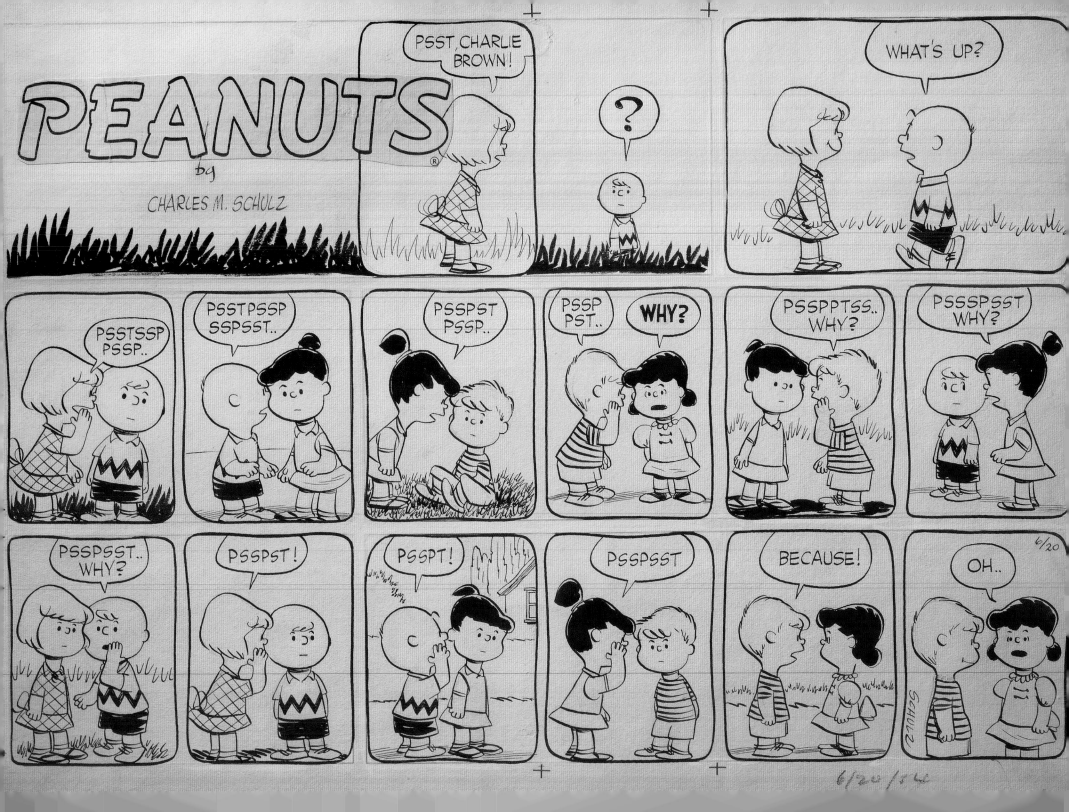

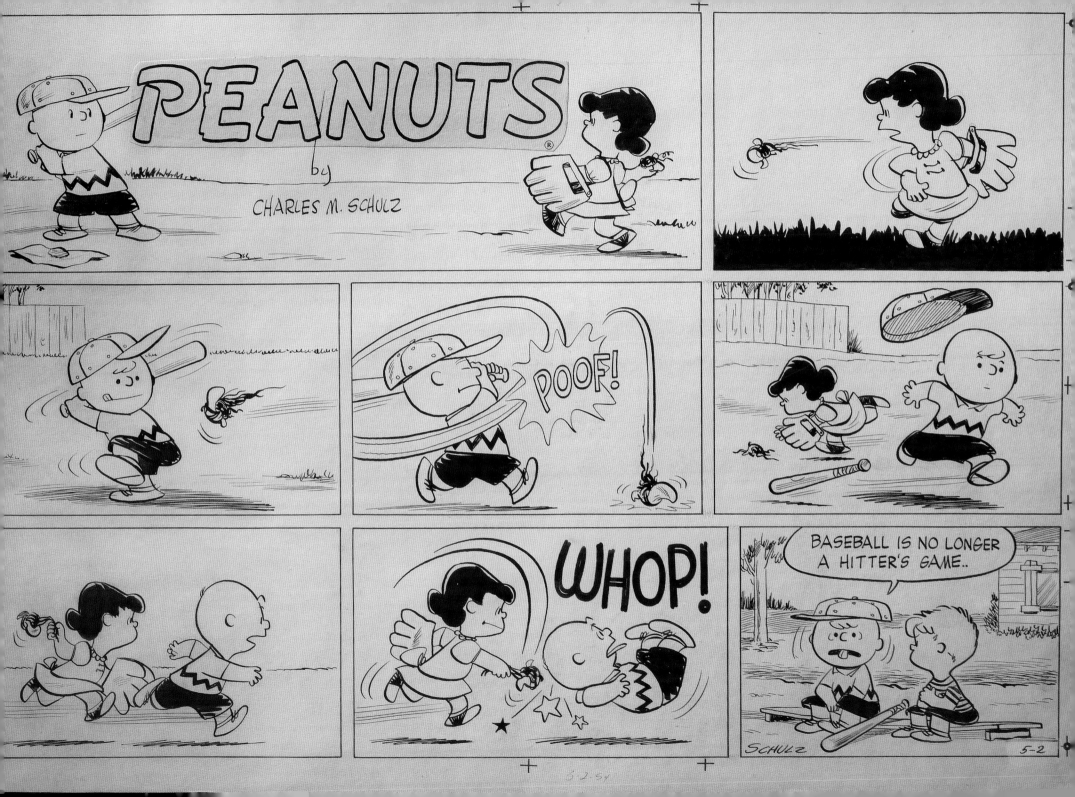

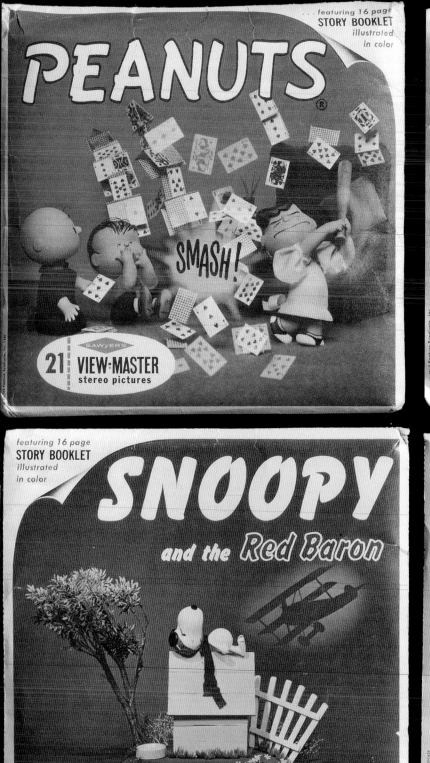

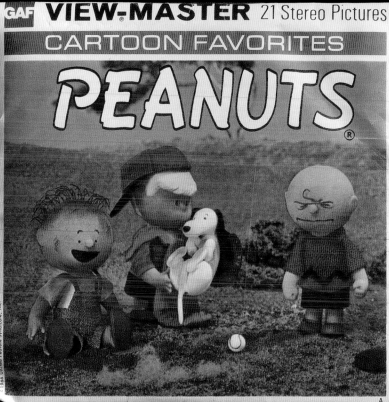

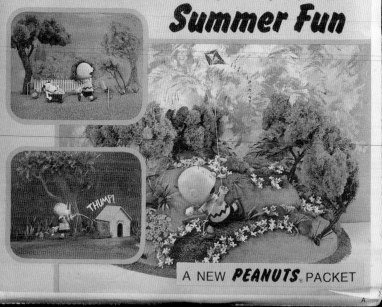

View-Master stereoscopes.

TOP, LEFT TO RIGHT *Peanuts*, first produced by Sawyer's Inc. in 1966, then repackaged and reissued later that same year by the GAF Corporation.

BOTTOM, LEFT TO RIGHT *Snoopy and the Red Baron*, 1969; *Charlie Brown's Summer Fun*, 1972.

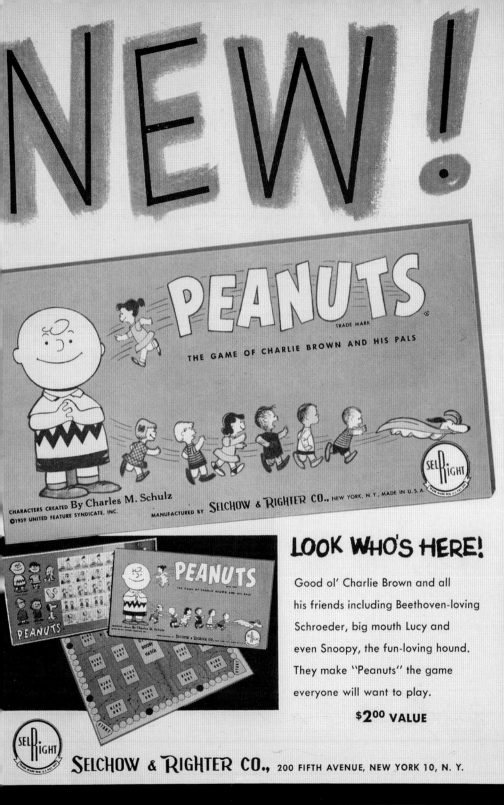

NEW!

LOOK WHO'S HERE!

Good ol' Charlie Brown and all his friends including Beethoven-loving Schroeder, big mouth Lucy and even Snoopy, the fun-loving hound. They make "Peanuts" the game everyone will want to play.

$2⁰⁰ VALUE

SELCHOW & RIGHTER CO., 200 FIFTH AVENUE, NEW YORK 10, N. Y.

PEANUTS
the game of the year!

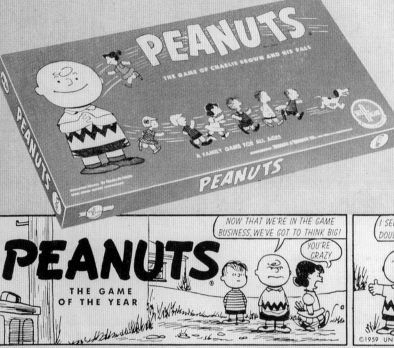

Selling faster and faster as the season progresses. This is big business, with 65 million Peanuts comic strip fans anxious to play the game featuring their favorite characters. Have you ordered yet?

$2⁰⁰ value

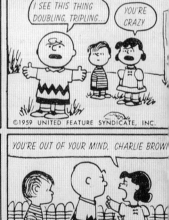

SELCHOW & RIGHTER CO., 200 FIFTH AVENUE, NEW YORK 10, N. Y.

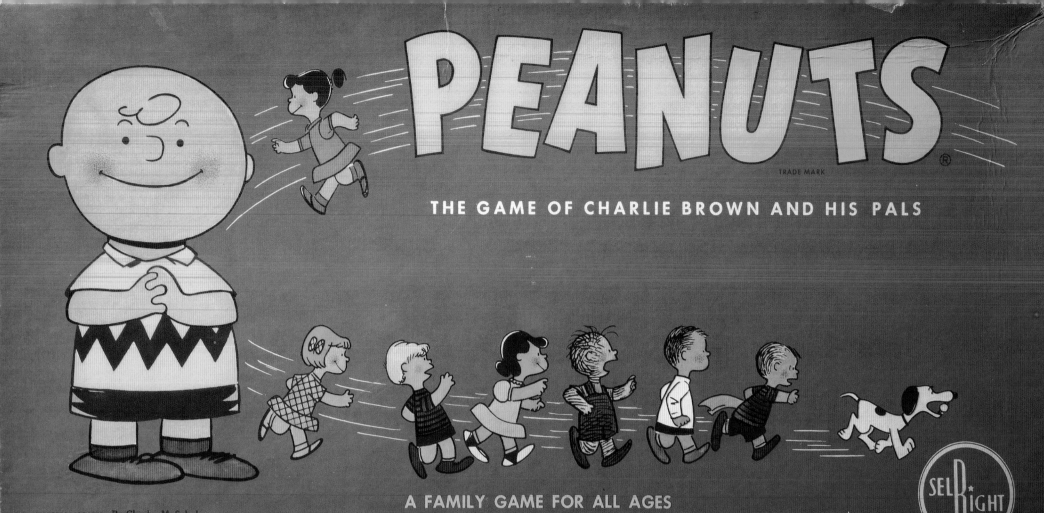

ABOVE AND OPPOSITE *Peanuts* board game,
S̶e̶l̶c̶h̶o̶w̶ ̶&̶ ̶R̶i̶g̶h̶t̶e̶r̶ ̶C̶o̶.̶,̶ ̶1̶9̶5̶9̶

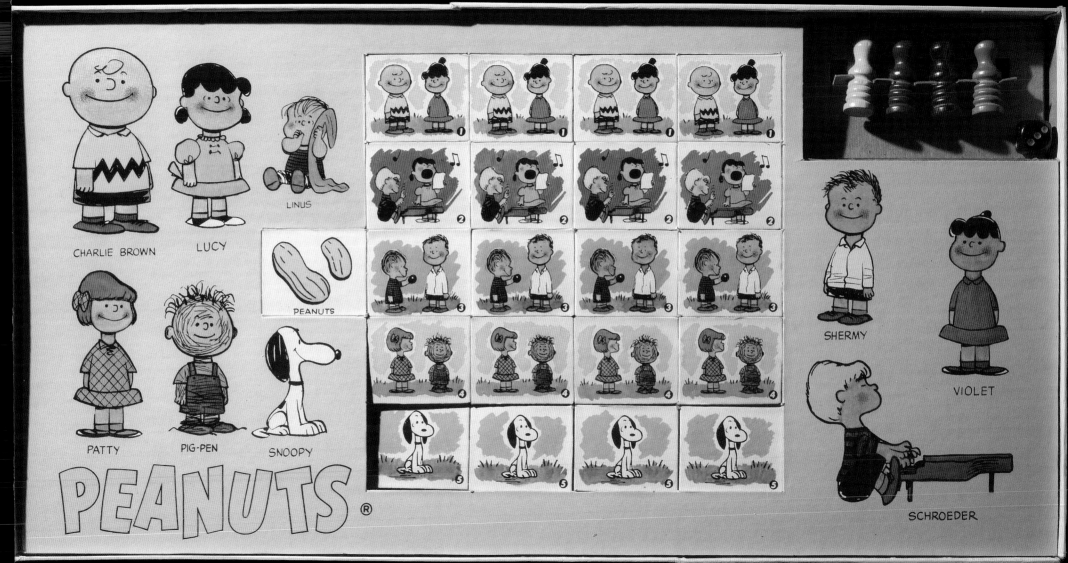

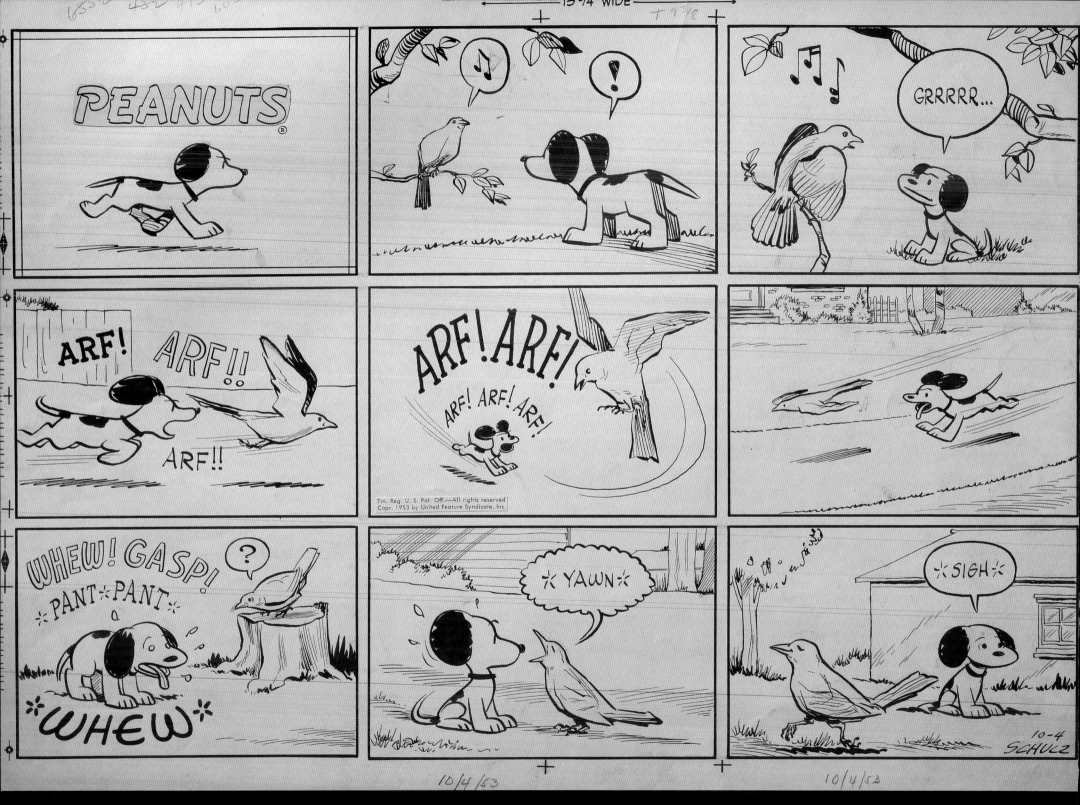

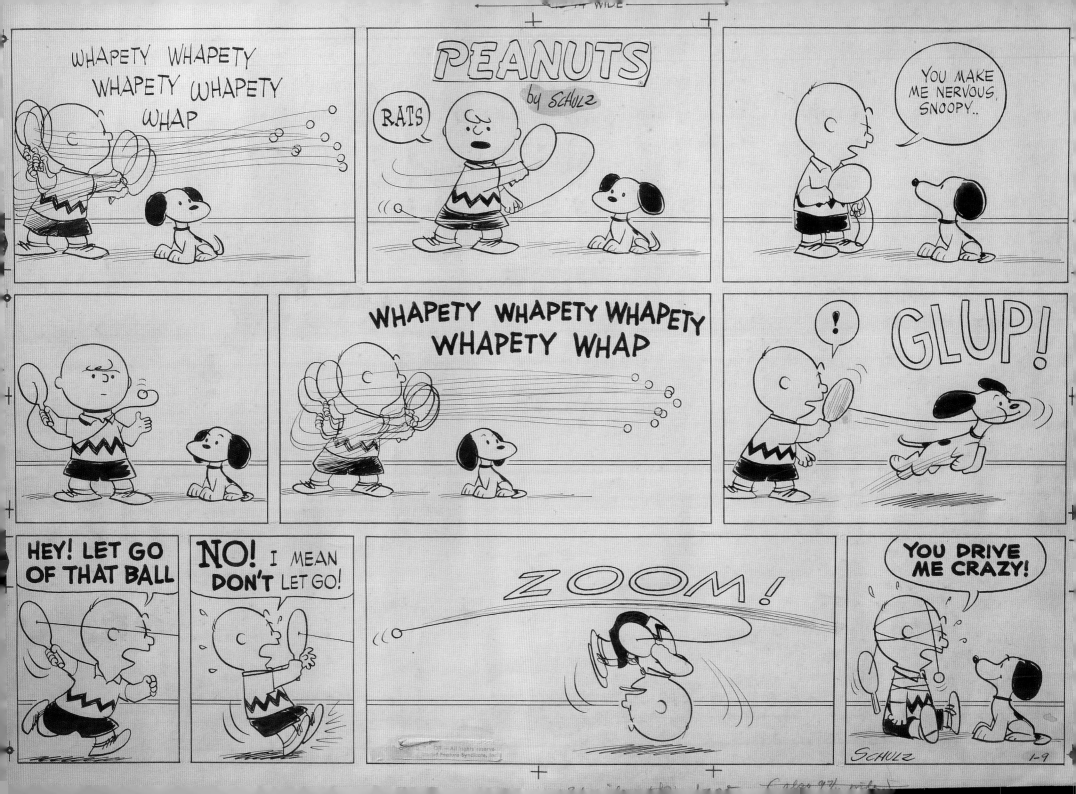

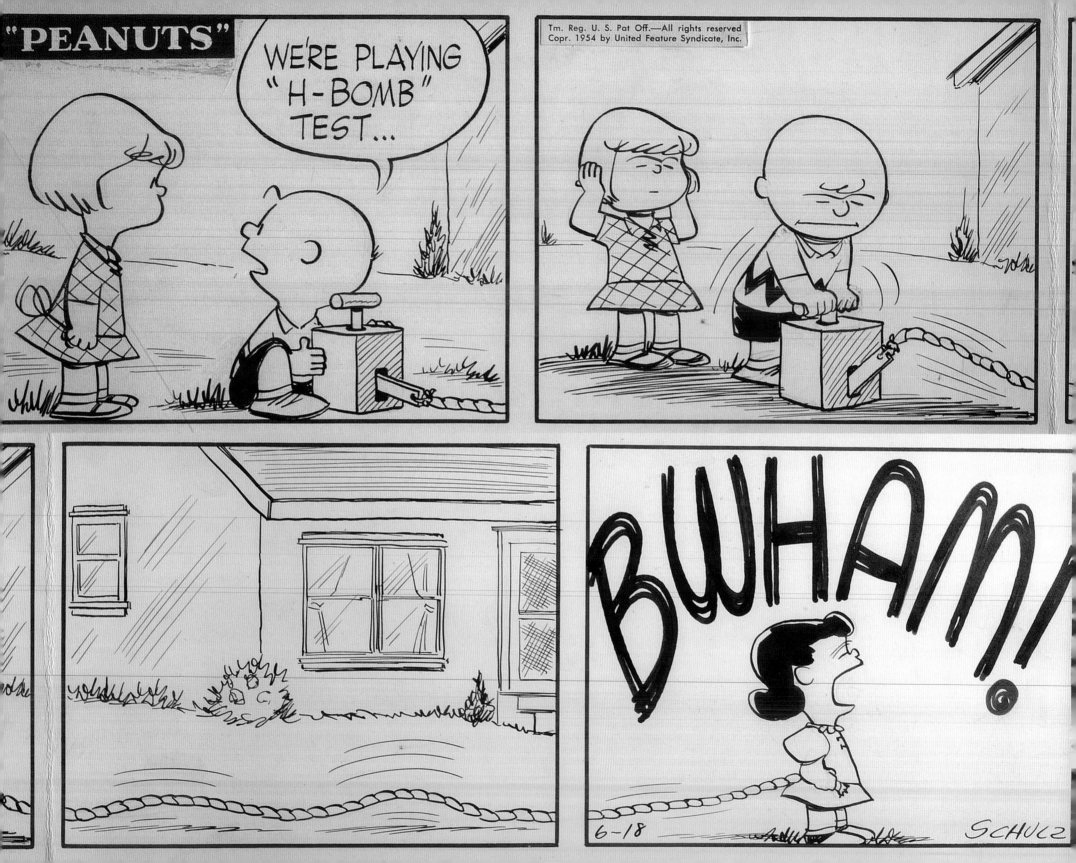

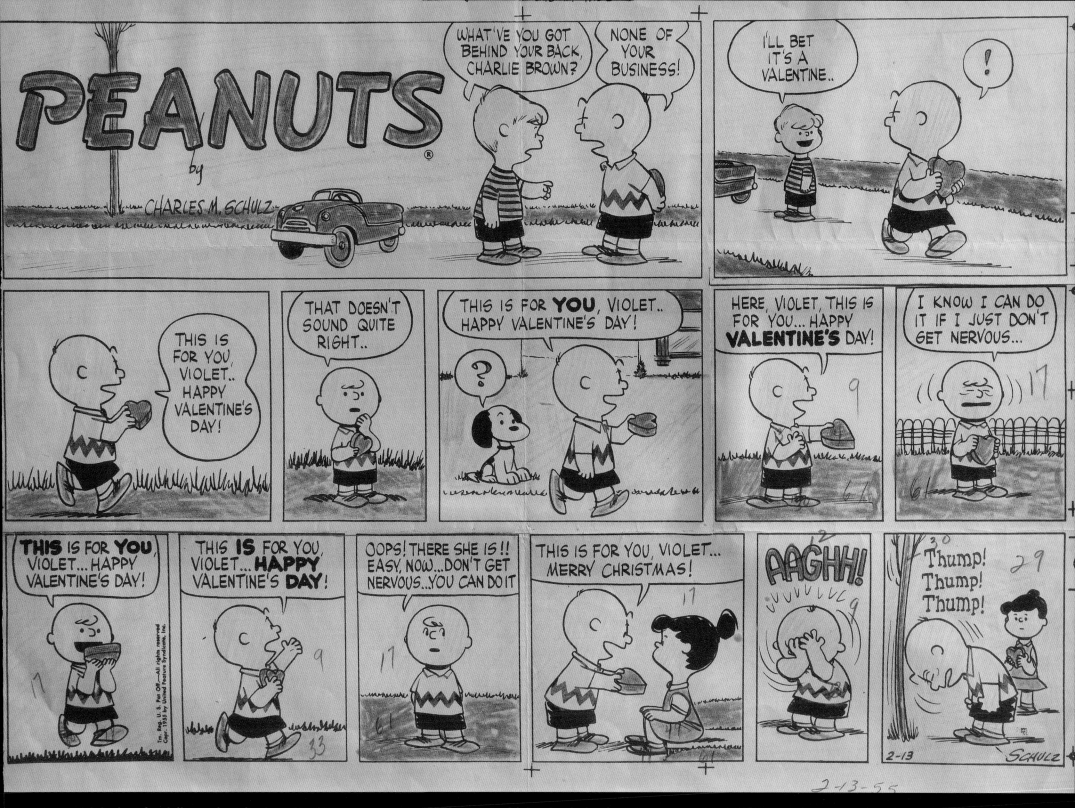

OPPOSITE Original art for daily comic strip, June 18, 1954. ABOVE Photostat with hand coloring by Schulz as a guide for the syndicate. Sunday comic strip, February 13, 1955.

Good Grief, HERE

THE N

PEAN

DO

Made of Safe, Sanitary

Made Exclusively by **HUNGERFORD** PLASTICS

30,000,000 POTENTIAL BUYERS
read the PEANUTS® COMIC STRIP

DIRECT FROM THE PEANUTS® COMIC STRIP

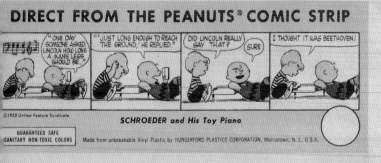

© 1955 United Feature Syndicate

SCHROEDER and His Toy Piano

GUARANTEED SAFE SANITARY NON-TOXIC COLORS | Made from unbreakable Vinyl Plastic by HUNGERFORD PLASTICS CORPORATION, Morristown, N. J., U.S.A.

SCHROEDER and His Toy Piano

The delight of music lovers everywhere! Schroeder, the musical virtuoso of Charles M. Schulz's famous PEANUTS® Comic Strip, is the only little boy who has had to forego a national concert as it required staying up past his bed time. Schroeder and his toy piano now join the rest of the lovable PEANUTS® Comic Strip family which, in their new three dimension vinyl plastic form, have delighted millions.

ITEM #W-4
RECOMMENDED RETAIL PRICE
$2.00 EACH

F.O.B. MORRISTOWN, N. J.
TERMS — 2-10 NET E.O.M.
PACKED ONE DOZEN PER CARTON
WT. PER CARTON — 10½ #

DESCRIPTION

PEANUTS COMIC STRIP CHARACTER SCHROEDER AND HIS TOY PIANO - WITH A BUST OF BEETHOVEN - 7" high - made of flexible vinyl plastic - decorative non-toxic colors - integrally molded whistle - sturdy two piece construction - packed in poly bag - colorful PEANUTS® Comic Strip Hanger Tag.

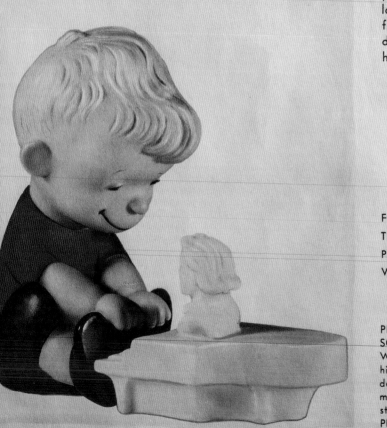

Made Exclusively by **HUNGERFORD PLASTICS CORPORATION,** MORRISTOWN, NEW JERSEY, U.S.A.

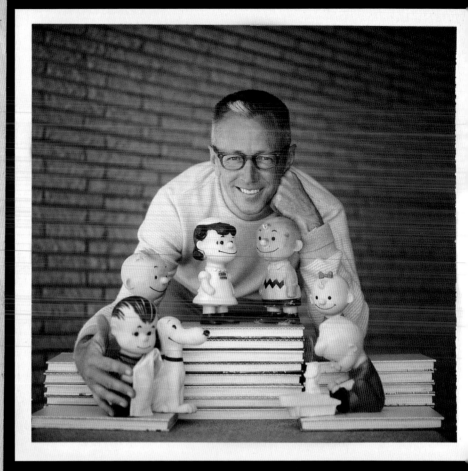

In 1958, the Hungerford Plastics Corporation of Morristown, New Jersey, introduced the first three-dimensional depictions of the *Peanuts* characters: six-inch-tall figures cast in polyvinyl, packaged in clear plastic bags with yellow header cards that featured the comic strip. In 1961, Hungerford issued a larger line of the dolls and included Charlie Brown's new baby sister, Sally.

PREVIOUS PAGES Display poster for the first *Peanuts* toys, Hungerford Plastics Corporation, 1958.

LEFT Sell sheet for the holy grail of vinyl toys, Schroeder and His Toy Piano Hungerford doll, 1958.

ABOVE Charles M. Schulz in Los Angeles with the Hungerford line of *Peanuts* dolls (clockwise from left): Snoopy, Linus van Pelt, Pig-Pen, Lucy van Pelt, Charlie Brown, Sally Brown, and Schroeder, January 1, 1962.

OPPOSITE Sell sheet for a new, larger line of Hungerford dolls, 1961.

THE FAMOUS "PEANUTS®" COMIC STRIP CHARACTERS

©1961 UNITED FEATURE SYNDICATE

"CHARLIE BROWN"	"FUSS BUDGET"	"PEANUTS® DOG"	"LINUS"
9½" HIGH • VINYL • 3 COLORS	9" HIGH • VINYL • 4 COLORS	7½" HIGH • VINYL • 2 COLORS	9" HIGH • VINYL • 3 COLORS
WHISTLE • POLY BAG • HEADER	WHISTLE • POLY BAG • HEADER	WHISTLE • POLY BAG • HEADER	WHISTLE • POLY BAG • HEADER
NO. W1 RETAIL $1.98	NO. W8 RETAIL $1.98	NO. W7 RETAIL $1.50	NO. W9 RETAIL $1.98

★ EDUCATIONAL

PEANUTS®
"CHARLIE BROWN"

NEW SENSATIONAL
3V
Color-Me KIT

NO. P1
RETAIL $1.00

© 1961 UNITED FEATURE SYNDICATE

★ BEAUTIFULLY BOXED

HUNGERFORD
for the Finest in
VINYL TOYS

1961 LINE INCLUDES

NEW

SOFT VINYL SQUEEZE TOYS
AND REPEAT BEST SELLERS

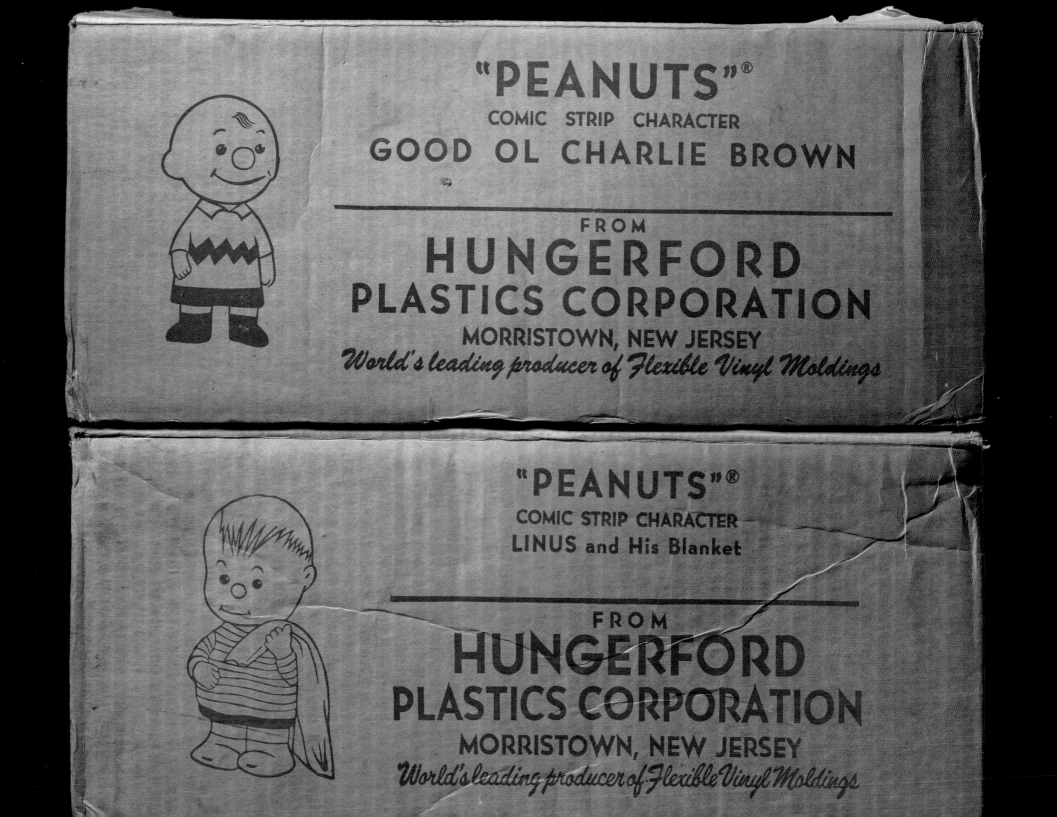

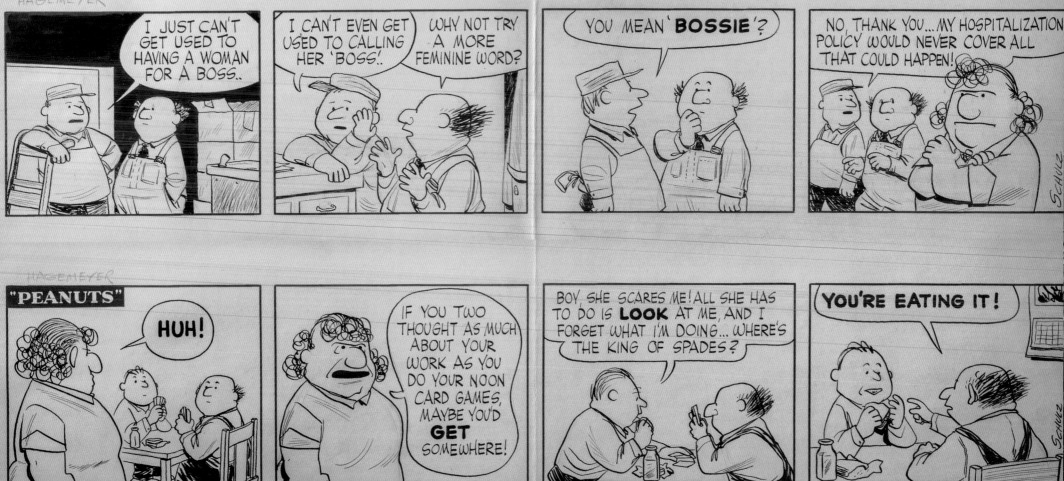

THE HAGEMEYER STRIPS

Schulz apparently found the name of his old army chum, Elmer Hagemeyer, amusing enough to use it in an experimental strip about actual adults. Although numbered one through five, these four examples from the mid-1950s (the only known to exist) depict similar themes to those found in *Peanuts*: a strong woman intimidating mild-mannered men.

ABOVE AND OPPOSITE TOP *Hagemeyer*, original art for four unpublished daily comic strips, c. 1954.

OPPOSITE BOTTOM **Original art for unpublished round-robin comic strip drawn by Schulz and animator/director Bill Melendez, 1966. The first two panels are by Schulz; the last two panels are by Melendez. This was created after *A Charlie Brown Christmas* aired in December 1965, as they were working on ideas for their next animated television special.**

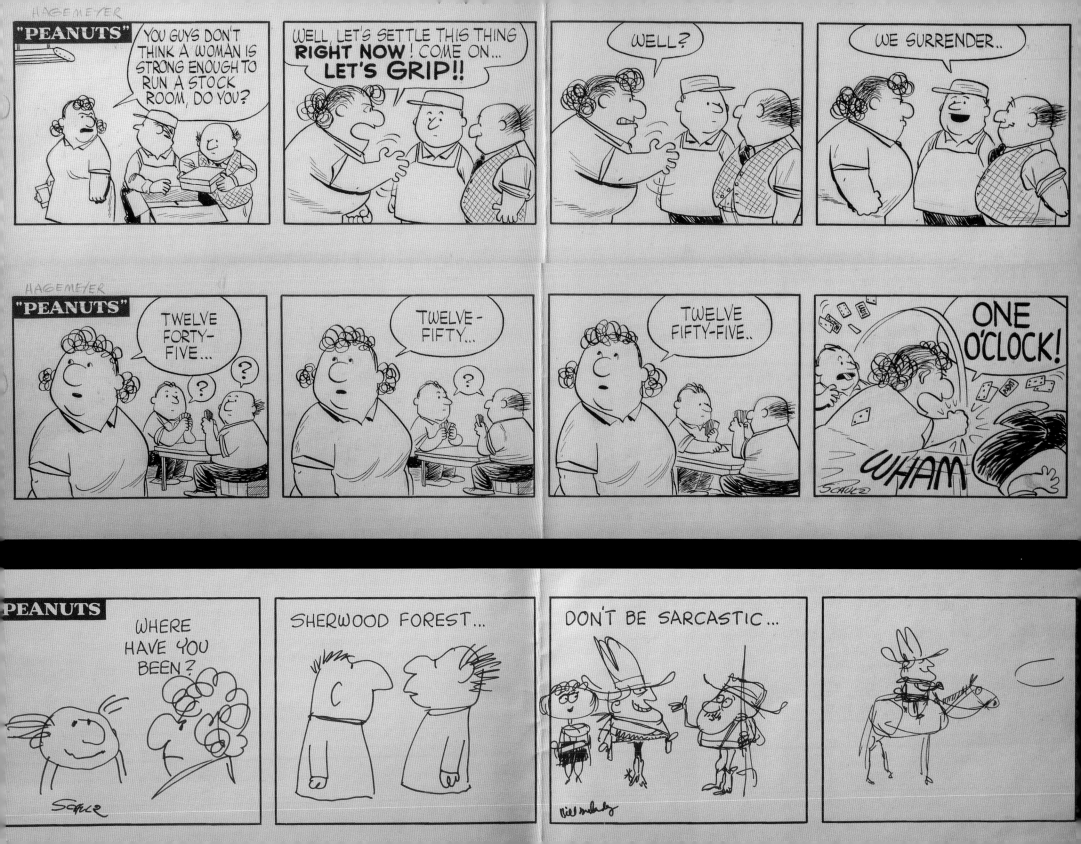

SUBSCRIBER PROMOTION — IT'S ONLY A GAME

DON'T MISS IT!

It's Only a Game

The new and delightfully different comic feature by Charles M. Schulz

Starting (. . . **Day and Date** . . .)

in the

(NAME OF PAPER)

Grown-Ups Are Funny, Too!

As you'll find out when you see the new, delightfully different cartoon feature

It's Only a Game

by Charles M. Schulz

Starting (. . . Day and Date . . .)

in the

(NAME OF PAPER)

Look For —

It's Only a Game

by Charles M. Schulz

A delightfully different comic feature . . .

STARTING **(Day and Date)**

in the

(NAME OF PAPER)

Laughter Ahead!

It's Only a Game

A Delightfully Different Carton Feature by Charles M. Schulz

STARTS (. . . **Day and Date** . . .)

in the

(NAME OF PAPER)

What's YOUR Game, Brother?

Whatever you play — bridge, ping-pong, golf, poker, checkers, shuffleboard, or just plain hammock-loafing — you'll find laughter a-plenty in

It's Only a Game

the new comic feature by Charles M. Schulz

STARTING (. . . **Day and Date** . . .) in the

(NAME OF PAPER)

The Funny Side of Fun . . .

That's what gifted comic artist Charles M. Schulz brings to you, in

It's Only a Game

. . . a new and delightfully different cartoon feature about adults at play . . .
See It In

(NAME OF PAPER)

STARTING **(Day and Date)**.

GROWN-UPS ARE FUNNY, TOO!

. . . as you'll find out in

It's Only a Game

A new, laughter-filled cartoon feature in which the gifted comic artist, Charles M. Schulz, turns his keen eye on the antics of adults at play.

STARTING **(Day and Date)**

in the

(NAME OF PAPER)

Are YOU a

BRIDGE FIEND —
BOWLING BUG —
GOLF ADDICT —
TENNIS TYRO —
POKER BLUFFER —
CHECKER CHUMP?

No matter what you like to play, you'll LOVE the laughs in

It's Only a Game

The delightful new comic feature by Charles M. Schulz.

SEE IT IN THE

(NAME OF PAPER)

Starting next (Day & Date)

United FEATURE SYNDICATE

20 EAST 42nd. STREET, NEW YORK 17, N.Y.

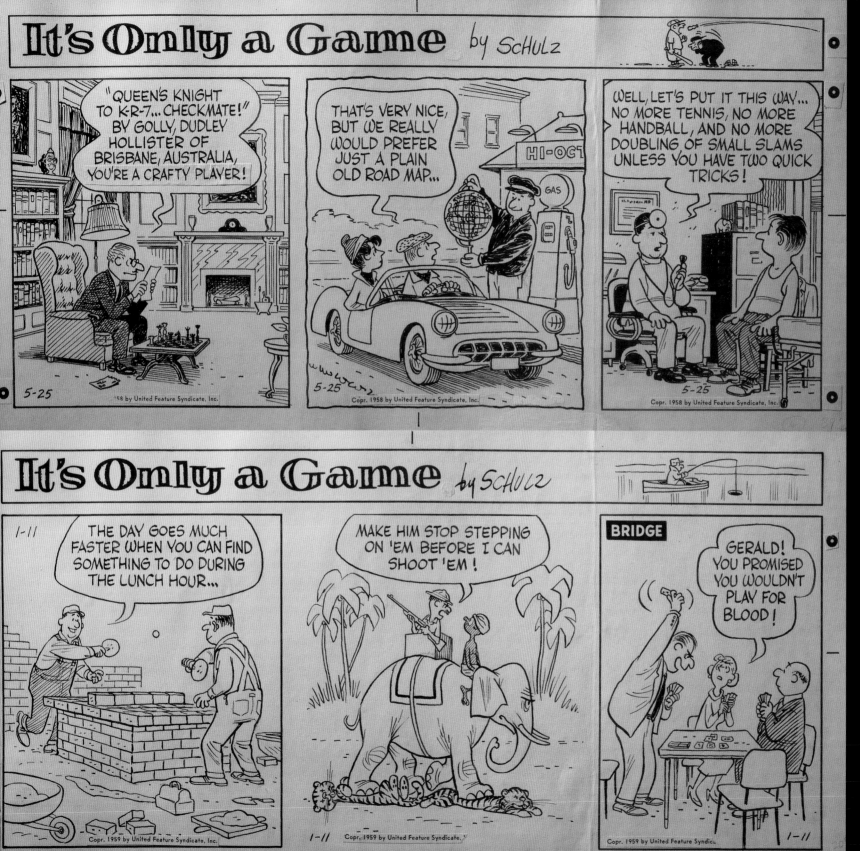

Whether or not the Hagemeyer experiment led directly to *It's Only a Game*, we can't know for sure, but in 1957 Schulz sent drawings for a one-panel feature on adults playing bridge to Harry Gilburt at United Feature Syndicate. The comic was accepted, with the caveat that the artist expand the idea to cover other domestic sports and leisure activities such as golf and checkers, and that it run as a horizontal paneled strip. *It's Only a Game* ran for a little more than a year (from November 3, 1957, through January 11, 1959), with Schulz doing the preliminary pencils and an unbilled ghost artist, Jim Sasseville—Schulz's good friend and colleague at Art Instruction, Inc.—handling the inking and lettering chores.

OPPOSITE **Promotional advertising flyer for** *It's Only a Game* **daily newspaper strip, United Feature Syndicate, 1957.**

THIS PAGE **Original art for** *It's Only a Game*, **May 25, 1958 (top), and January 11, 1959 (bottom).**

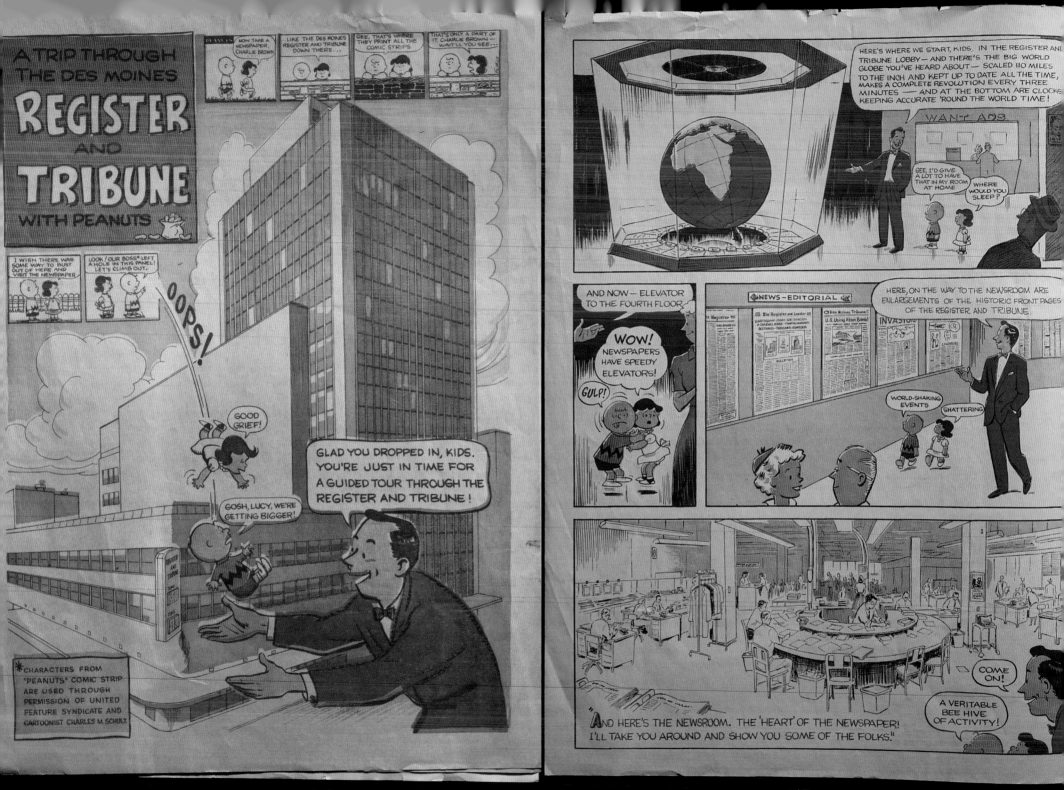

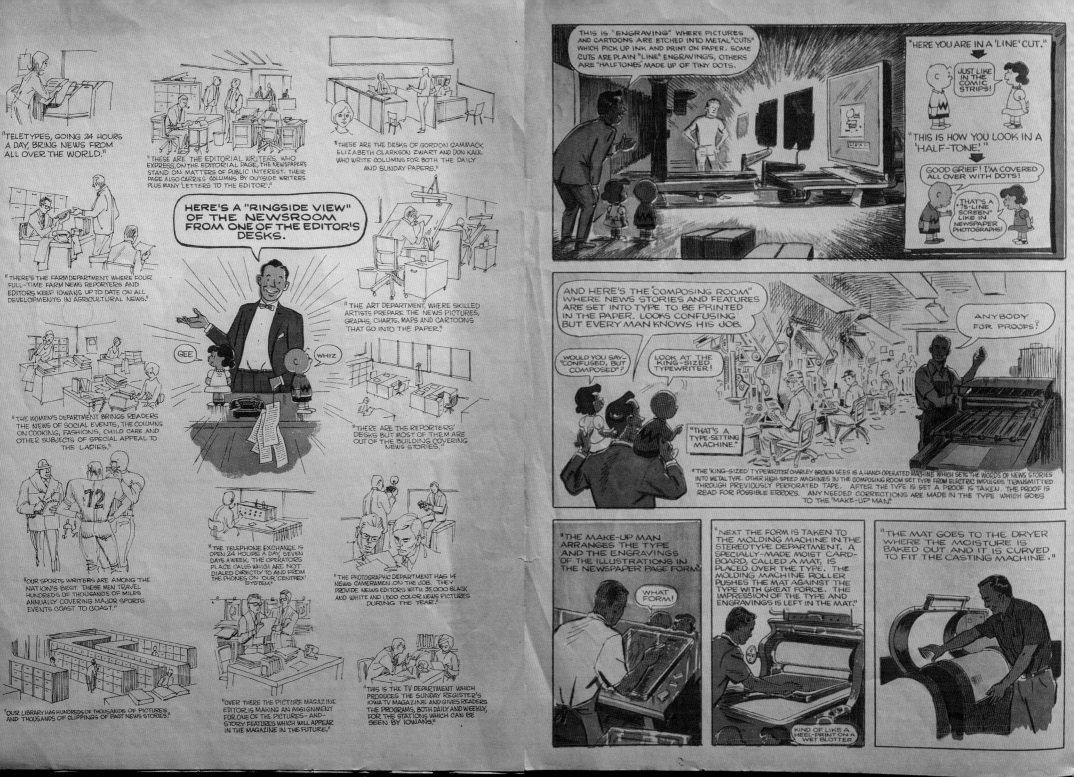

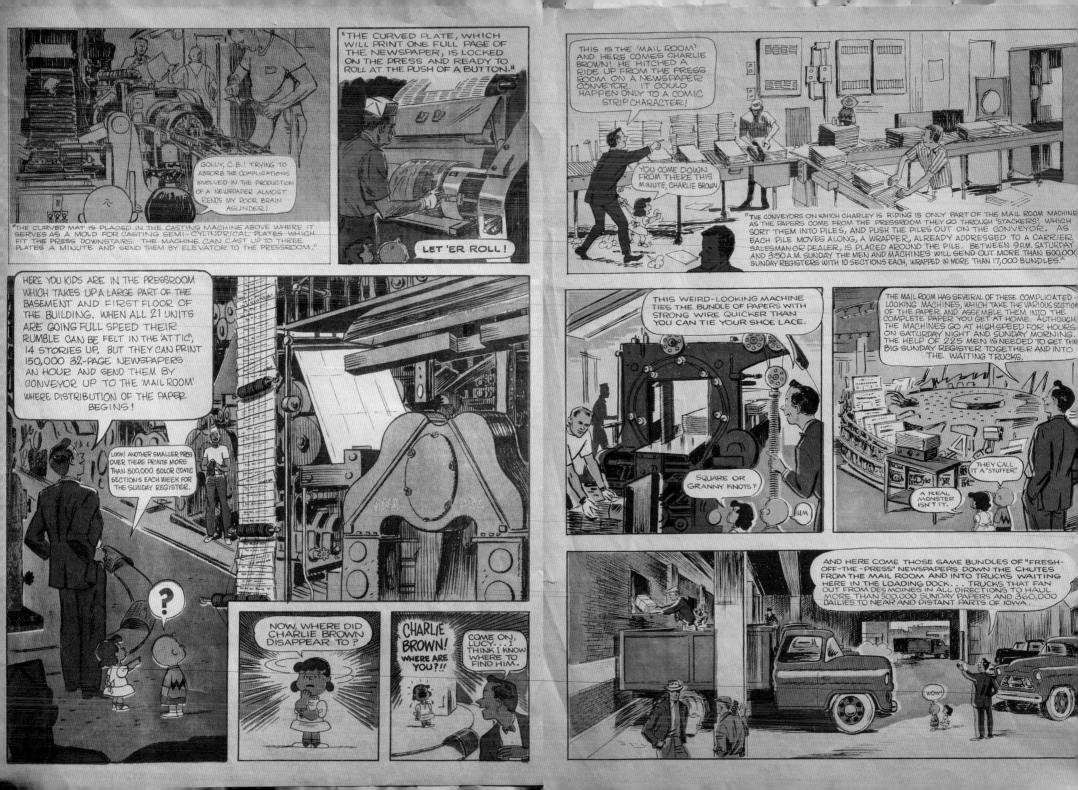

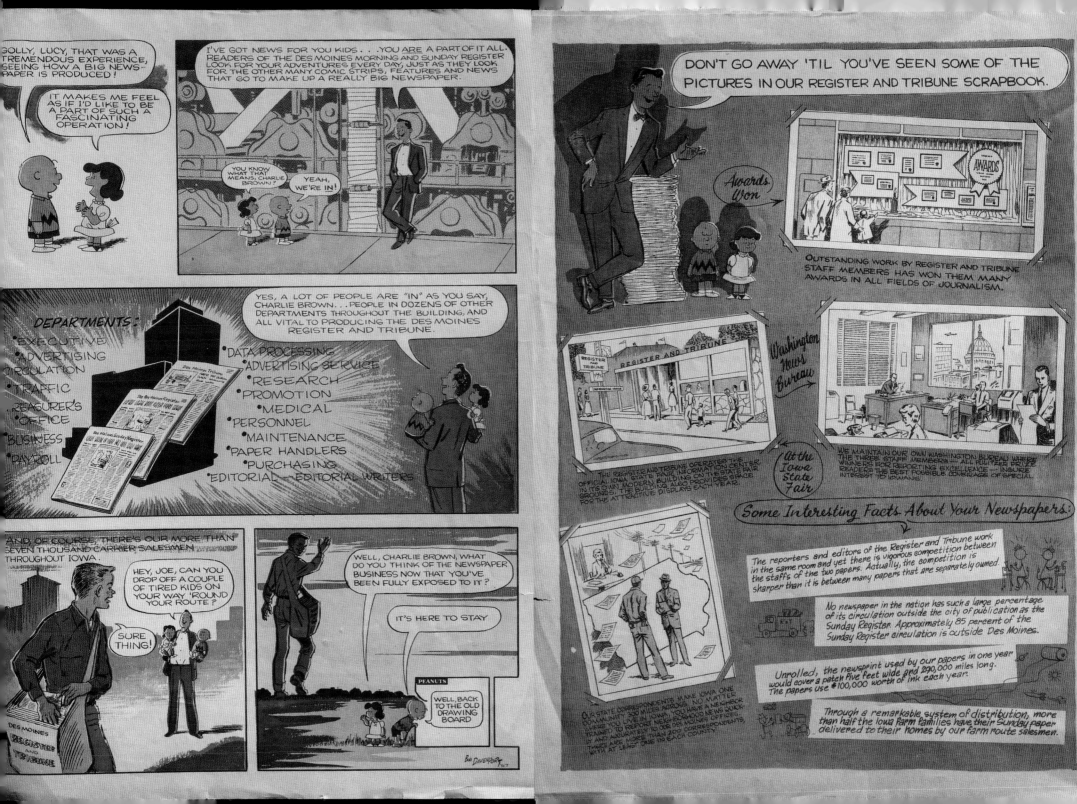

ART INSTRUCTION INC. MINNEAPOLIS 15, MINN.

CARTOON STRIPS

Developing a Comic Strip

By Charles Schulz

Charles Schulz

EDITOR'S NOTE — Charles Schulz, the internationally famous creator of the "Peanuts" cartoon strip, really does not need this introduction, but, for the few who may be unacquainted with his background, we are happy to fill in the details. Like the student who is reading this, Charlie studied cartooning by correspondence and, we are very proud to say, with our school. After his service in Europe in the second world war, we employed him as a cartooning instructor. It was while working as an instructor that he developed his cartoon children. When he tells you here what you should do to make good as a cartoonist, he knows what he is talking about and you will do well to follow his advice.

He is a member of our National Advisory Council of nationally renowned artists. Many honors have been bestowed upon him, including the award, in 1956, of *Best Cartoonist of the Year*. This is an annual award presented by the National Society of American Cartoonists and is equivalent to the motion picture industry's award of an *Oscar*. He also received the 1958 Yale Record Humor Award. His "Peanuts" cartoon books have been on the best seller list for years and his "Peanuts" cartoon strip appears in over 300 newspapers here and abroad, including England, Japan, Hong Kong, Singapore and Sweden. He also has a Sunday edition cartoon called, "It's Only a Game." His cartoons are syndicated by *United Feature Syndicate*, New York, through whose courtesy we are reproducing the "Peanuts" cartoons shown with this article. His has been a truly phenomenal success and it is a great pleasure to present the following article by this distinguished cartoonist of our day.

O NE of the hardest things for a beginner to do is merely to get started on his first set of comic strips. It is strange that most people who have ambitions in the cartoon field are not willing to put in the great amount of work that many other people do in comparable fields. Most people who have comic-strip ambition wish to be able to draw only two or three weeks' material and then have it marketed. They are not willing to go through many years of apprenticeship. Now, by this I do not mean that they are unwilling to serve the so-called minor-markets of cartooning, but they are unwilling to draw the many, many cartoons which are necessary even before one can approach these minor-markets.

It is strange that people in other areas of art are willing to paint and draw for the fun of it and for the experience involved, but that very few cartoonists are willing to draw set after set of comic-strips just for the experience involved. We seem to have a tendency to believe that all we have to do is perfect our lettering, our figure drawing, and our rendering, and then we are all set to go. Nothing could be further from the truth.

There is an area of thought training which has to be worked out. I think the beginner should reconcile himself to the fact that he is going to have to spend probably five to ten years developing his powers of observation and his sense of humor before he is able to venture into the professional side of the business.

Here, of course, I am speaking particularly of the humor-strips. However, the same can be said of the adventure-strips. The men who write adventure-strips are trained story tellers, and they did not arrive at this ability overnight. What, then, can we do to make our beginnings?

One of the main things to avoid is thinking too far ahead of yourself. Almost all of us have ideas which we think would be great for a comic-strip series, but when we attempt to break down these general ideas into daily episodes, we find it extremely difficult. This is where I think we should make our beginning. Try to think of your daily episodes without concentrating too heavily on the over-all theme of your comic feature. While you are concentrating on these daily episodes trying to get the most humorous idea you can out of each episode, you will also be developing the personalities of your characters. You will find that ideas will begin to come from these personalities.

As your ideas develop personalities and as your personalities develop more ideas, the overall theme of your feature then will begin to take form. This really is the only practical way to develop a good solid comic-strip feature.

If you go about it in the reverse manner, you are going to end up with weak ideas. You are going to be thinking so much about the general theme of your strip that your daily ideas will become diluted.

The system which I have recommended will also assure you of going in whichever direction your thoughts tend to take you. In these initial days of comic-strip work and practice, you must not confine yourself to any particular idea. You must be in constant search for the characters and ideas which will eventually lead you to your best areas of work.

The characters which you start out to draw today may not be the same characters which you will end up drawing a month or year from now. New personalities will come along which you never thought of creating at the beginning, and frequently these new personalities will take you to completely different places. In regard to the characters themselves, it is not advisable to worry too much about their development. Let them grow with your ideas.

Remember, the one thing, above all, to avoid is the idea that you can think about this whole business for a long time and then suddenly one day sit down and draw twelve or twenty-four strips, send them in and expect to make your fortune. Some of the things about which I have been talking can be illustrated in these four strips which have been reproduced here. The ideas in each one of these depend upon the developed personalities of the characters involved. Right from the very beginning, we had established that "Snoopy" was a dog who could understand all of the things which the children were saying to him. He also has a very highly developed sense of intelligence and frequently resents the things which the children say about him. He definitely has a mind of his own and expresses it in thoughts and action.

Charlie Brown's personality goes in several directions. Most of the time he is quite depressed because of the feelings of other people about him, but at the same time he has a certain amount of arrogance, and this is demonstrated in the strip concerning him and Snoopy. Generally, however, he is wholly struck down by the remarks of the other characters, especially Lucy. She represents all of the cold-blooded, self-sufficient people in this world who do not feel that it is at all necessary ever to say anything kind about anyone.

Schroeder is a rather innocent sort of fellow who is completely devoted to Beethoven and can sometimes serve as an outlet for the expressions of his friends, the way he is doing here for Charlie Brown.

I have always enjoyed working with Linus, who is Lucy's smaller brother, because I like to inject the naive things that he frequently comes up with. None of these characters could be doing or say-

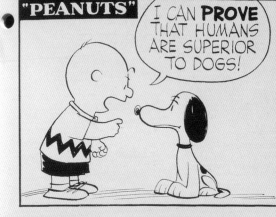

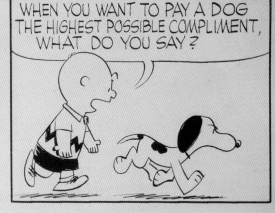

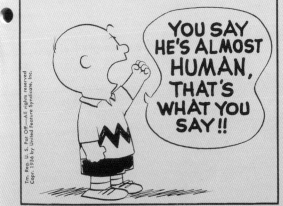

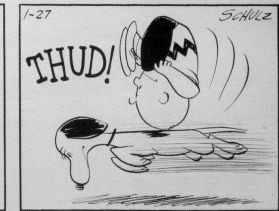

Charlie Brown and Snoopy

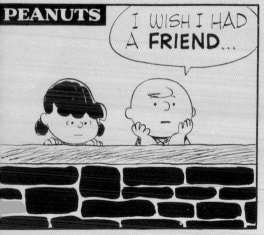
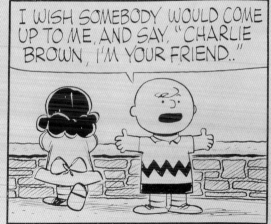
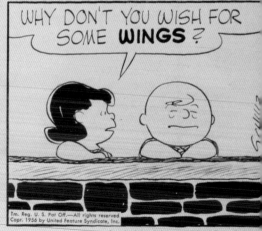

Charlie Brown and Lucy

ing any of the things which they have done and said in these four strips, when it first began, for it took many months and, in some cases, years, for them to develop these personalities. This is what I mean when I say you must be patient in developing your strip, and not try to look too far ahead. Be perfectly content to work on the single strip that is now in place on your drawing board.

Students always seem interested in some of the practical points of reproduction that are involved in various comic strips, so I feel that I might comment somewhat on these. "Peanuts" always is drawn with four equal panels so that a newspaper

editor can reproduce it in three different forms. He can run it horizontally, or he may drop one panel beneath another and run it vertically. Also, he may drop the last two panels beneath the first two and run the strip in the form of a square. Each one of the panels in these "Peanuts" strips is drawn 5½ inches high by 6½ inches wide in the original. This makes for quite a large panel, but I need the working space to be able to get the proper expressions and to make my lettering clear. "Peanuts" has a very great reduction and I have to work large in order that the pen lines can be made bold enough to stand this reduction.

I work exclusively with the pen and use the brush only to place the dark areas, such as we find here on the dog's ears, the brick wall and Lucy's hair.

I think that design plays a very important part in the drawing of comic strips. Design involves not only the composition of the characters and their place in each individual panel, but it involves the proper drawing of the other elements within the strip. I have tried to do this in the drawing of the brick wall by making the wall itself interesting and by varying the size and color of the bricks or stones in the wall. I have also tried to do this in

the little bit of drapery which shows in the strip where Charlie Brown and Schroeder are talking. There is also a rather modernistic painting placed on the wall in order to give the strip a little extra design.

In the strip on the next page, we have a corner of a house and the corner of a garage jutting into the panel to break up the square into pleasing areas. We also have the introduction of a little birch tree and a very small pine tree which are good items because of their interesting designs. This is the sort of thing which you search for all of your life trying to develop to the highest degree.

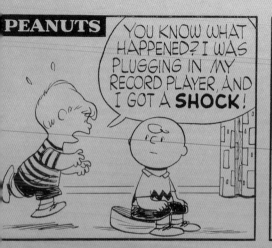
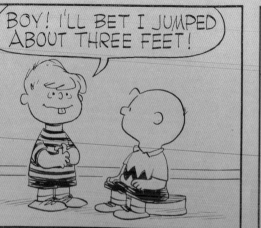
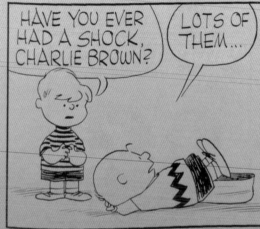
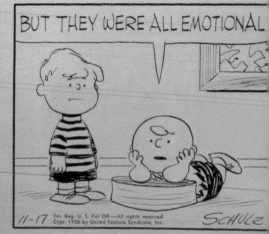

Charlie Brown and Schroeder

Cartoon Strips

Art Instruction, Inc.

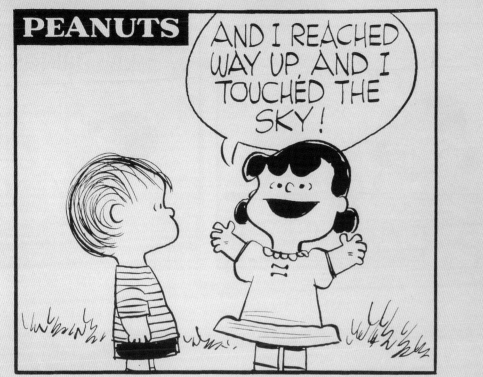

Reproduced in actual size of the original cartoon drawing.

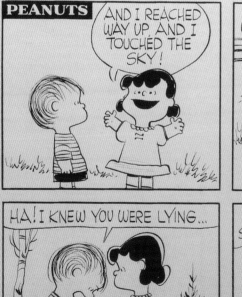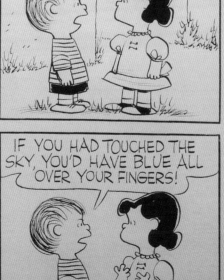

Linus and Lucy

Reproduced through the courtesy of United Feature Syndicate, Inc.

Cartoon Strips

Schulz officially graduated from the Federal School of Applied Cartooning, later known as Art Instruction, Inc., on December 1, 1941. "If that course did nothing else, it taught me to value good drawing in comics and good pen work." Schulz dove into submitting his drawings for publication, was met uniformly with rejections, and took several odd jobs with printing and direct-mail companies, none of which yielded art commissions. Almost a year later, he was drafted. Upon returning home from the war to Saint Paul in late 1945, Schulz again looked for work, and the following July his old teacher Frank Wing asked him to fill in for a vacationing instructor in the education department. To go from student to teacher at the same institution in a few years was a huge symbolic leap, and Schulz would maintain a connection to Art Instruction for the rest of his life.

By 1959, when this course brochure was published, Schulz had moved his family to Sebastopol, California. But he remained a loyal graduate and instructor emeritus, and offered this contribution, "Developing a Comic Strip."

Happy Birthday, Priscilla

Dear Priscilla —

Am going on my vacation tomorrow. Sorry we didn't get a chance to visit you — maybe we can get together soon after my return. Do get in touch with us when you get back.

Frieda (of course)

Hi Priscilla
Judy

Hi Priscilla
art

ABSINTHE MAKES
THE HEART
GROW FONDER
BILL

Best wishes from S.

Hank King

Happy Birthday
Larry Donohue

MADAM
BOVARY

Whatta tan you must have by now — Greetings on your birthday — from —

Happy Birthday Kiddo!
— Ginny

SPONSORED by THE
BIRTHDAY
PARTY

I NVU spending a summer at the lake. Been doing lots of swimming I bet! Stop up and say hi. Sure when you come back. Here's wishing you a Happy Birthday!
Vince

Hi Priscilla,
It must be wonderful enjoying the summer at the lake. Be sure to call us when you get in town, perhaps we can arrange a picnic.
Charlie Brown

"COME UP AND SEE ME SOMETIME!"

L. A. MAURIER
PRES. BUREAU ENGR

Boy, did we have a good time celebrating your birthday today!
Hedy

Hi Pris!
Beth

HOW!

Best wishes, Pris.
Hope you get fat and sassy at the lake — as I did — Ethel

Hi! Pris. good luck! on your 21st birthday (or is it the 20?)
Louise

HOPE YOUR OUT HUNTING EVERYDAY
Irene

Hi, watch for those natives! Happy birthday you

Hi, Priscilla!
Sparky

(they say I can't draw a figure over two heads high)

OVER →
Ruth

Once *Peanuts* reached its initial level of success in the 1950s, Schulz was inundated with unsolicited ideas for strips from friends and fans alike. Here we see his response to a suggestion from Sasseville.

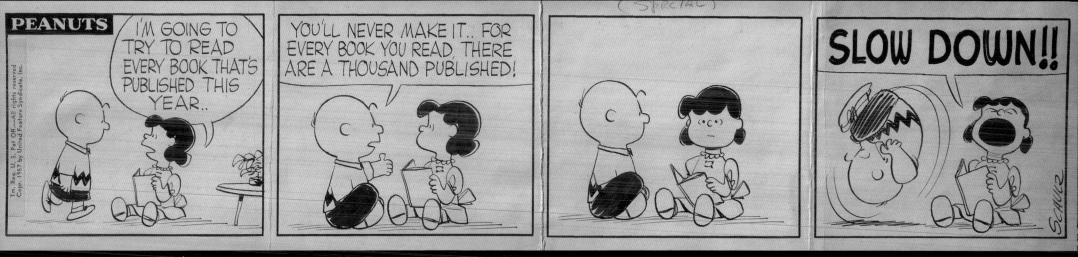

PEANUTS

I'M GOING TO TRY TO READ EVERY BOOK THAT'S PUBLISHED THIS YEAR..

YOU'LL NEVER MAKE IT.. FOR EVERY BOOK YOU READ, THERE ARE A THOUSAND PUBLISHED!

SLOW DOWN!!

THE FIRST STRIP COLLECTIONS

On February 7, 1952, John Selby, the editor in chief of publisher Rinehart & Company, inquired about collecting the *Peanuts* strips from 1950 and 1951 in a book. Schulz was amenable to the idea, with a caveat: "I am a bit ashamed of the earlier drawings, and hope that you do not intend to go back to the very beginning for reprints. My search for style both in drawing and humor had led me down various paths, with the result that the shape of poor Charlie Brown's head suffers a good deal. I am sure that you will notice this when you view the earlier gags." A good number of the earliest strips did not make it into the volume, with many appearing for the first time in 2004, when Fantagraphics started publishing the first of their twenty-five-volume series *The Complete Peanuts*. In fact, roughly 2,000 of the

17,897 *Peanuts* strips had never been reprinted in Schulz's lifetime. Regardless, the first paperback reprint collection, titled simply *Peanuts*, was an instant hit.

The second collection, *More Peanuts*, was released in 1954, and while the strip had of course evolved, Schulz still looked back on some of his previous efforts with frustration. Sending the book to fellow cartoonist Walt Kelly (*Pogo*), Schulz wrote, "After the first book came out, I wished that they would put out another so that my more recent work would show up. Now that the second one is out, I'm just as much ashamed." Fans, however, begged to differ. That book led to a veritable library's worth of *Peanuts* strip collections over the years, selling hundreds of millions of copies and counting.

ABOVE **Original art for unpublished daily comic strip, 1957.**

OPPOSITE **The first *Peanuts* paperback reprint collections, published by Rinehart & Company, Inc., 1952–60.**

PEANUTS

PRICE $1.00

By CHARLES M. SCHULZ

RINEHART & CO., INCORPORATED

$1.00

more PEANUTS

by Charles M. Schulz

RINEHART & CO., INC.

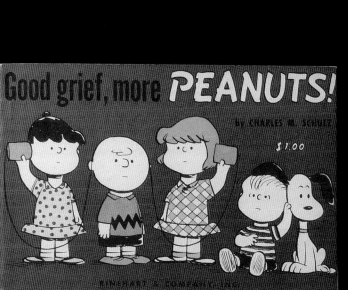

Good grief, more PEANUTS!

by CHARLES M. SCHULZ

$1.00

RINEHART & COMPANY, INC.

Good Ol' CHARLIE BROWN

A NEW PEANUTS BOOK

$1.00

by Charles M. Schulz

HOLT, RINEHART AND WINSTON, INC.

$1.00

A NEW PEANUTS BOOK
FEATURING

SNOOPY

by Charles M. Schulz

Rinehart & Co., Inc.

You're Out of Your Mind, Charlie Brown!

A New PEANUTS Book by CHARLES M. SCHULZ

$1.00

RINEHART & COMPANY, INC.

$1.00

BUT WE LOVE YOU, CHARLIE BROWN

A NEW PEANUTS BOOK

By CHARLES M. SCHULZ

HOLT, RINEHART AND WINSTON, INC.

$1.00

GO FLY A KITE, CHARLIE BROWN

A NEW PEANUTS BOOK

by Charles M. Schulz

HOLT, RINEHART AND WINSTON, INC.

Art Linkletter's 1957 book *Kids Say the Darndest Things!* is, at this point, most notable as the single time Charles Schulz and Walt Disney would be associated with the same creative project. It must have been some kind of vindication for the illustrator, who as a young man in his twenties had his work rejected more than once by Disney's animation studio. This is a rare instance of Schulz taking on a freelance job in which he had to draw stylized children who were not his *Peanuts* characters.

At the time, Linkletter was a popular radio and television personality known for his spirited interviews with kids. These collections of children's wisdom and witticisms were instant hits. It's hard to imagine a more popular combination for families across America during this era than Linkletter, Disney, and Schulz.

Be

"TEEN-AGER" IS NOT A DISEASE

by CHARLES M. SCHULZ
Creator of "Peanuts"

F3443 ★ 50¢ ★ A BANTAM FIFTY

THE "PEANUTS" GANG GROWS UP!
A GREAT NEW COLLECTION
OF RIOTOUS CARTOONS BY
CHARLES M. SCHULZ

TEEN-AGERS, UNITE!

"I NEVER CAN REMEMBER....ARE WE UNITING
FOR SOMETHING OR **AGAINST** SOMETHING?"

Dear President Johnson

selected by
BILL ADLER

illustrated by
Charles M. Schulz

What Was Bugging
Ol' Pharaoh ?

by
Charles M. Schulz
Creator of "Peanuts"

"The topic before the panel tonight is 'What do you think
it was that was bugging ol' Pharaoh?'"

"GERALD AND I HAVE BEEN
DOING A LITTLE PASTING"

two-by-fours

by
CHARLES M. SCHULZ
and KENNETH F. HALL

OPPOSITE *Young Pillars*, Warner Press, 1958 (left). *"Teen-Ager" Is Not a Disease*, Warner Press, 1961 (right).

THIS PAGE, CLOCKWISE FROM LEFT *Teen-Agers, Unite!*, Bantam Books, 1967. Originally published in hardcover by Warner Press in 1961.

Dear President Johnson, selected by Bill Adler, William Morrow, 1964.

What Was Bugging Ol' Pharaoh?, Warner Press, 1964.

with Kenneth F. Hall, Warner Press, 1965.

The "Sunshine Line"
YOUNG PILLARS
NOTES

by
Charles M. Schulz

"SOMEDAY WHEN I GET TO BE RICH AND FAMOUS, I WONDER IF I'LL STILL BE THE SWEET, LOVABLE, HUMBLE PERSON I AM NOW."

"Do you want to meet me after school but before Hi-Y, or after Hi-Y but before Student Council, or after Student Council but before Youth fellowship?"

"I'M A TEEN-AGER AND YOU'RE A TEEN-AGER . . .

ISN'T IT WONDERFUL TO HAVE SO MUCH IN COMMON?"

"I just remembered something... i don't KNOW HOW TO SING!"

"I HAVE BEEN TOLD THAT TO MAKE A BOY LIKE YOU, YOU HAVE TO LEARN TO TALK ABOUT THE SUBJECT HE IS MOST INTERESTED IN ...

DO YOU HAVE ANY BOOKS ON EATING?"

"I KNOCKED 'EM ALL OVER.....

HOW COME I CAN'T KEEP THEM?"

"I think we're quite lucky to have been born into the first society in all history that is dominated by teen-agers!"

"WHAT DO YOU MEAN, I DON'T LOOK FEMININE?

"I HAVE A RIBBON IN MY HAIR, HAVEN'T I ?"

TEEN AGERS, UNITE!

"i NEVER CaN REMEMBER . . .

ARe We uNiTiNG FOR something OR AGaiNST something?"

"I do TOO LIKE TO WALK IN THE RAIN . . .!

I JUST LiKe To see WHO I'M WALKING WiTH, THAT'S ALL!"

"Could you hold the line for just a moment?

I think I'm about to be hit on the head with my own shoe!"

"SOMEDAY WHEN I GET TO BE RICH AND FAMOUS, I WONDER IF I'LL STILL BE THE SWEET, LOVABLE, HUMBLE PERSON I AM NOW."

"He gave me his sweater!"

"IF YOU REALLY LIKED ME, YOU'D COME AND WATCH ME PLAY SOFTBALL, BUT I'M GLAD YOU'RE NOT BECAUSE I DON'T WANT YOU TO SEE WHAT A TERRIBLE PLAYER I AM!"

"I THINK I'M BEGINNING TO UNDERSTAND YOU BETTER . . .

I'VE BEEN READING A BOOK CALLED, 'HOW TO KNOW YOUR TEEN-AGER.'"

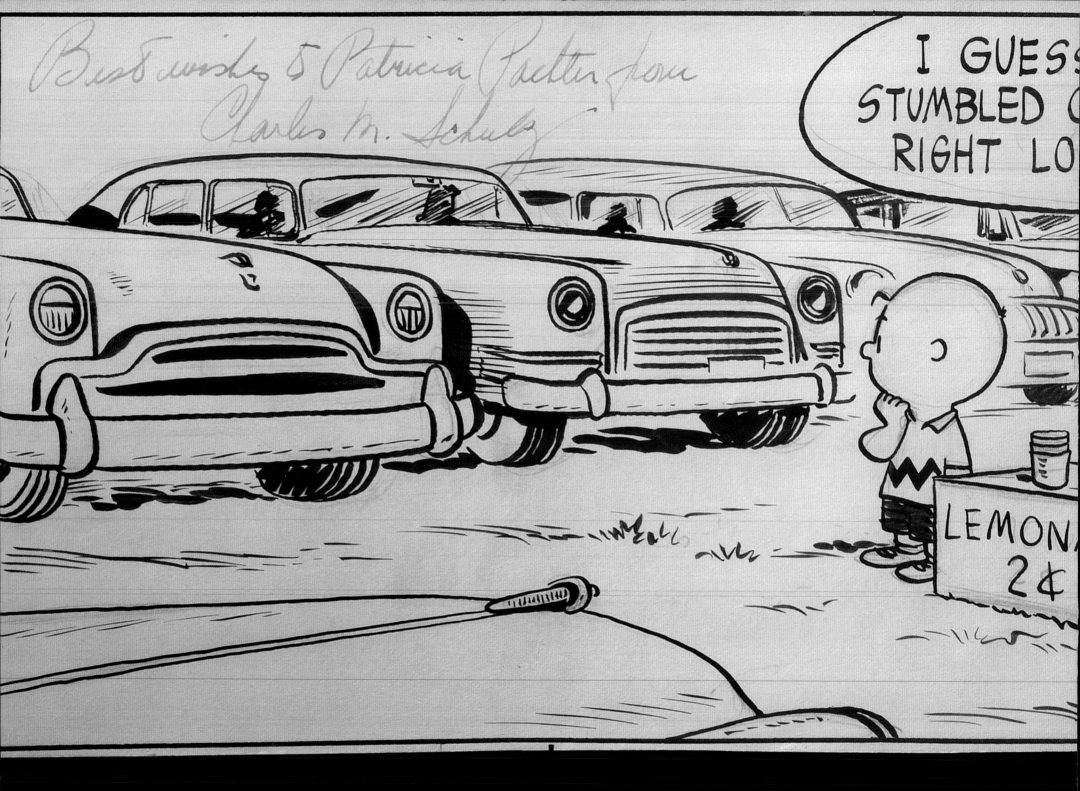

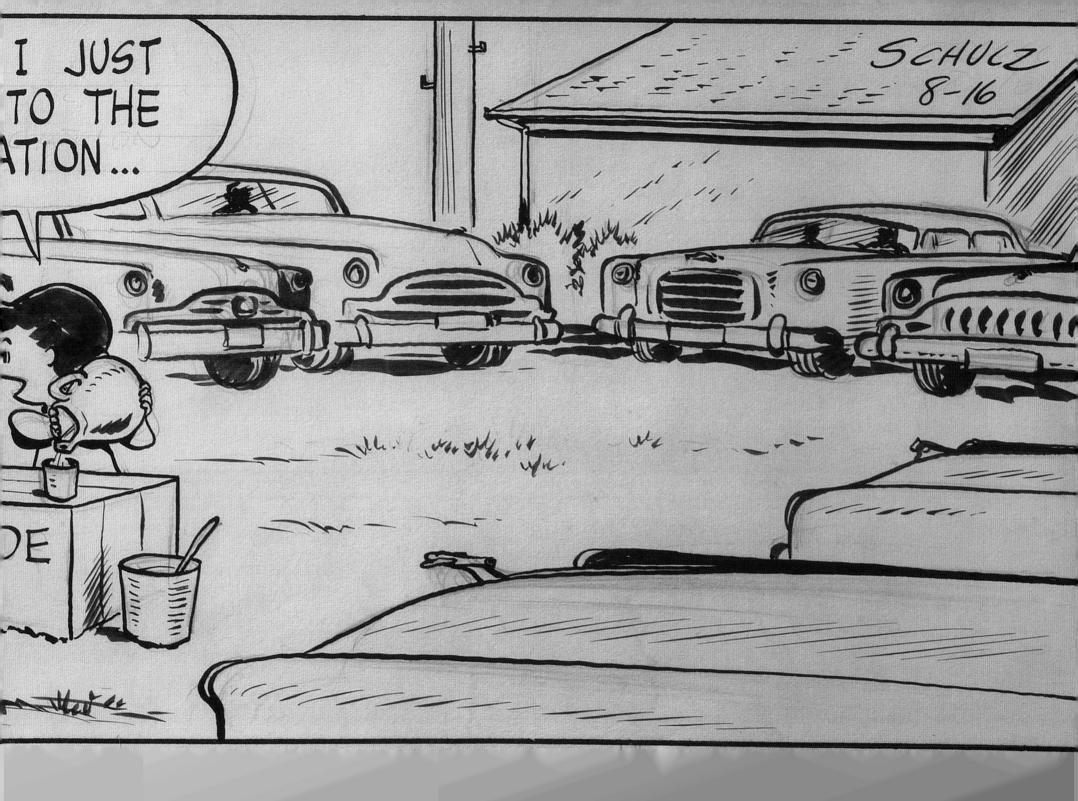

SEBASTOPOL LITTLE LEAGUE

1959

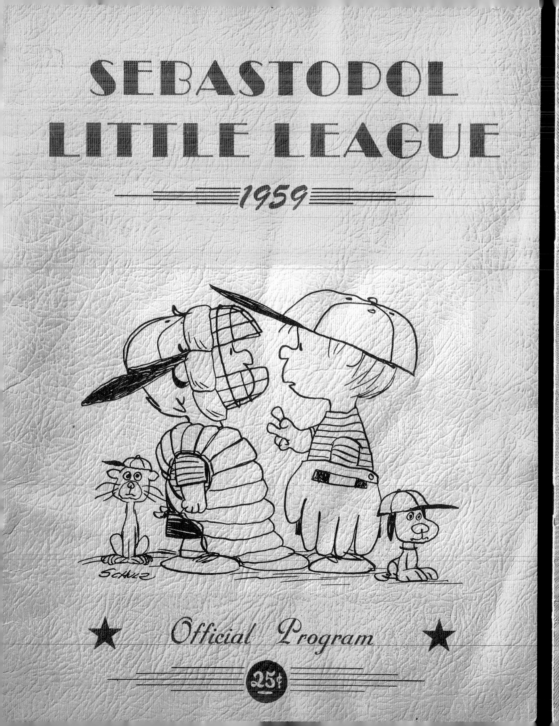

★ Official Program ★

SEBASTOPOL LITTLE LEAGUE

19 60

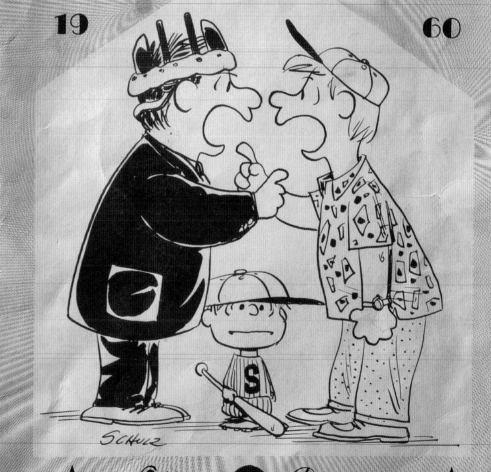

★ Official 25¢ Program ★

SEBASTOPOL LITTLE LEAGUE
◄ 1961 ►

Official 25 *Program* ★

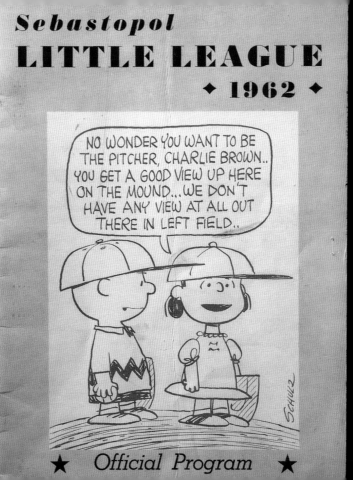

Sebastopol
LITTLE LEAGUE
♦ 1962 ♦

NO WONDER YOU WANT TO BE THE PITCHER, CHARLIE BROWN.. YOU GET A GOOD VIEW UP HERE ON THE MOUND... WE DON'T HAVE ANY VIEW AT ALL OUT THERE IN LEFT FIELD..

★ *Official Program* ★

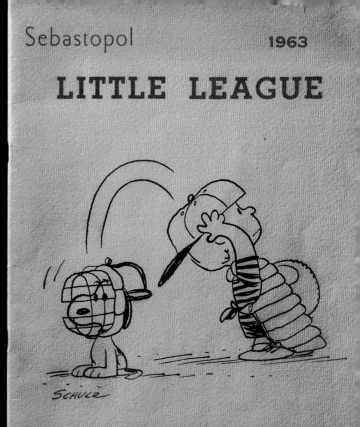

Sebastopol 1963

LITTLE LEAGUE

OFFICIAL PROGRAM

Licensing of the *Peanuts* characters had begun in earnest by the mid-1950s and reached a new milestone in 1959 when the Ford Motor Company (via the J. Walter Thompson advertising agency) offered to buy the exclusive rights to make Charlie Brown and the gang the official spokes-figures for Ford's new compact car, the Falcon. Schulz was consulted and given approval on every aspect of the ad campaign to ensure that all the characters were faithfully reproduced and the quality and spirit of the strip was not compromised. TV commercials for the Ford Falcon featured the first animated versions of the characters, directed by former Disney animator Bill Melendez, with whom Schulz would have a long and flourishing partnership on the many Charlie Brown animated prime-time TV specials.

CHARLIE BROWN and all his PEANUTS® PALS are FORD SALESMEN, NOW!

BEETHOVEN SCHROEDER SHERMY VIOLET PIGPEN PATTY LUCY LINUS CHARLIE BROWN SALLY SNOOPY

**CHAMPIONSHIP
GAS ECONOMY**

MOBILGAS ECONOMY RUN WINNER!

**BIG TRUNK
23.7 CU. FT.**

ROOM FOR EVERYTHING!

**FULLY ALUMINIZED
MUFFLER**

LASTS LONGER!

**12,000-MILE
LUBRICATION**

FRONT WHEEL BEARINGS!

**BOLT-ON
FRONT FENDERS**

REDUCED REPLACEMENT COST!

**DIAMOND LUSTRE
ENAMEL**

NO WAXING... JUST WASH & POLISH!

**6-PASSENGER
ROOM & COMFORT**

ROOM FOR EVERYBODY!

**PARALLEL ACTION
WINDSHIELD WIPERS**

BETTER VISIBILITY!

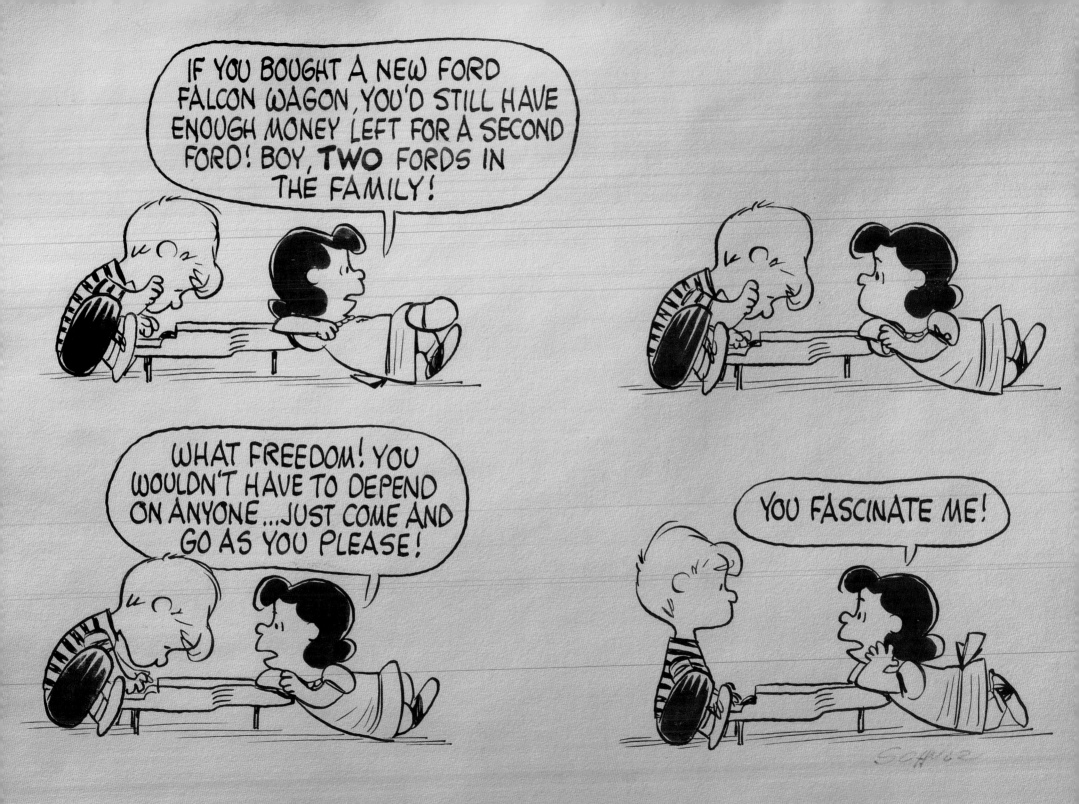

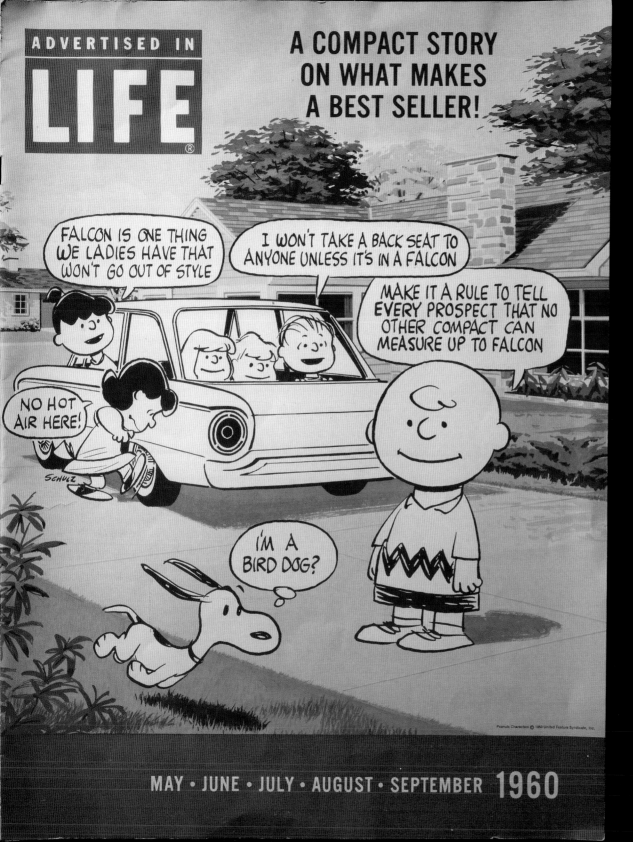

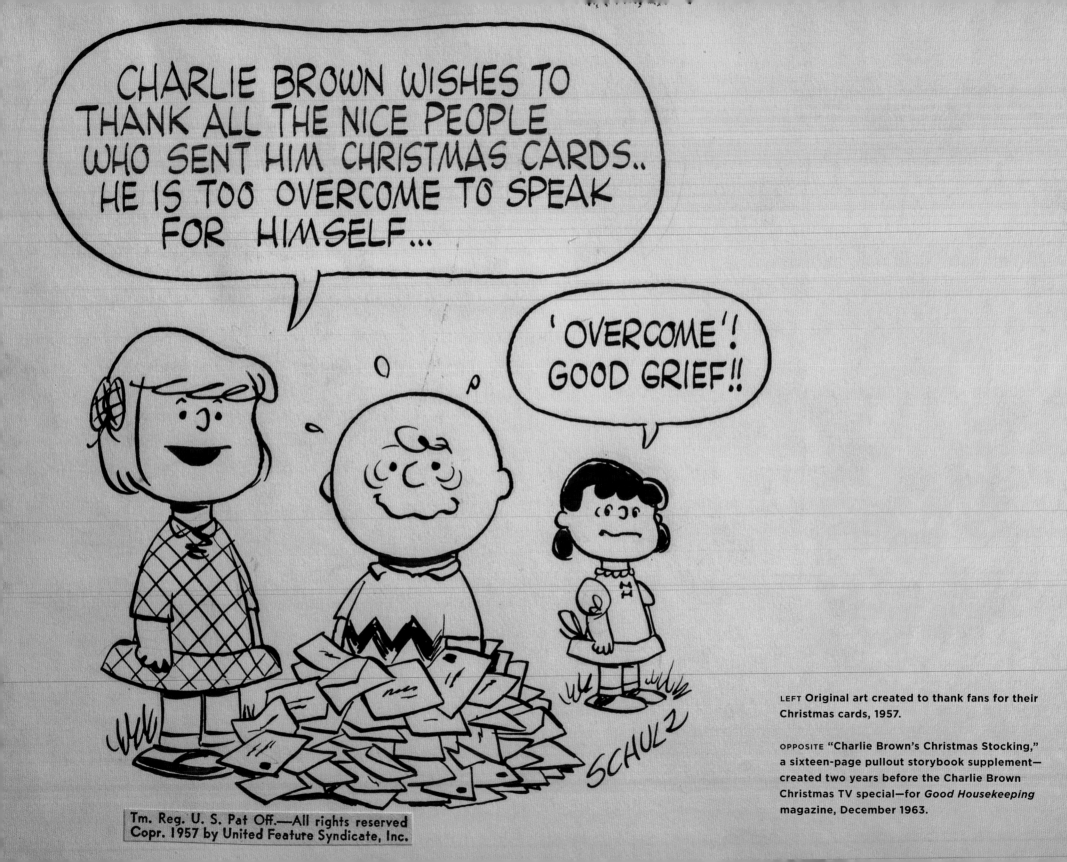

LEFT Original art created to thank fans for their Christmas cards, 1957.

OPPOSITE "Charlie Brown's Christmas Stocking," a sixteen-page pullout storybook supplement—created two years before the Charlie Brown Christmas TV special—for *Good Housekeeping* magazine, December 1963.

FRED LYON

Merry Christmas from CHARLIE BROWN SNOOPY
and Charles M. Schulz

Charlie Brown, the buffeted but unbowed hero of Charles M. Schulz's Peanuts, *shares honors with Snoopy on the cartoonist's Christmas cards. It is rumored that Charlie and Charles have interchangeable personalities.*

The little yellow book across the way —created expressly and exclusively for GH—is our Christmas gift to you. Frankly, we think it's the Practically Perfect Solution to the Practically Hopeless Problem of finding a gift that's right for 12 million women— let alone your husbands and children. The man who solved our problem is shown above with his jungle-gymnast daughter Jill, youngest of his five irrepressible children. He is Charles M. Schulz, one of the few Genuine Originals in the publishing world, creator of the great comic strip, *Peanuts*. Schulz is also the author of two quiet little books which have both become crashing best-sellers. They are, of course, last year's *Happiness Is a Warm Puppy* and its sequel, *Security Is a Thumb and a Blanket.*

CHARLIE BROWN'S CHRISTMAS STOCKING

by Charles M. Schulz

oming up

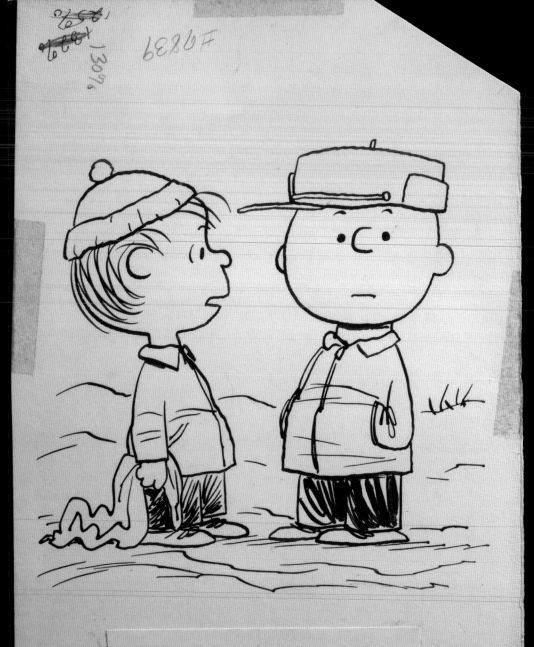

"I'm not going to hang up a Christmas stocking
this year . . . I've decided it's not scriptural!"

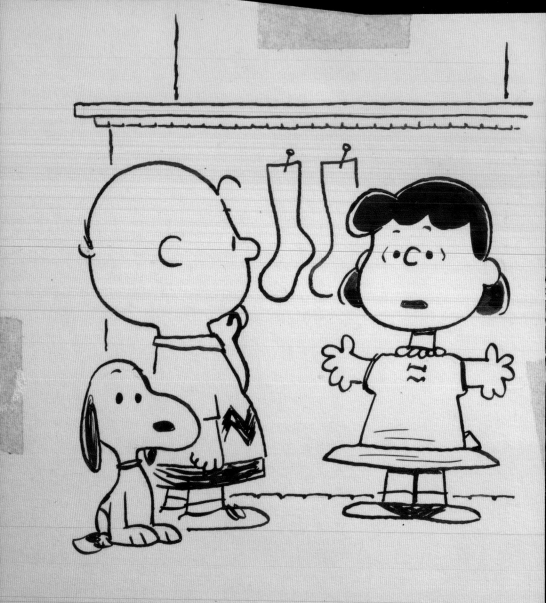

"Two stockings? Why not two stockings?
I have two feet, don't I?"

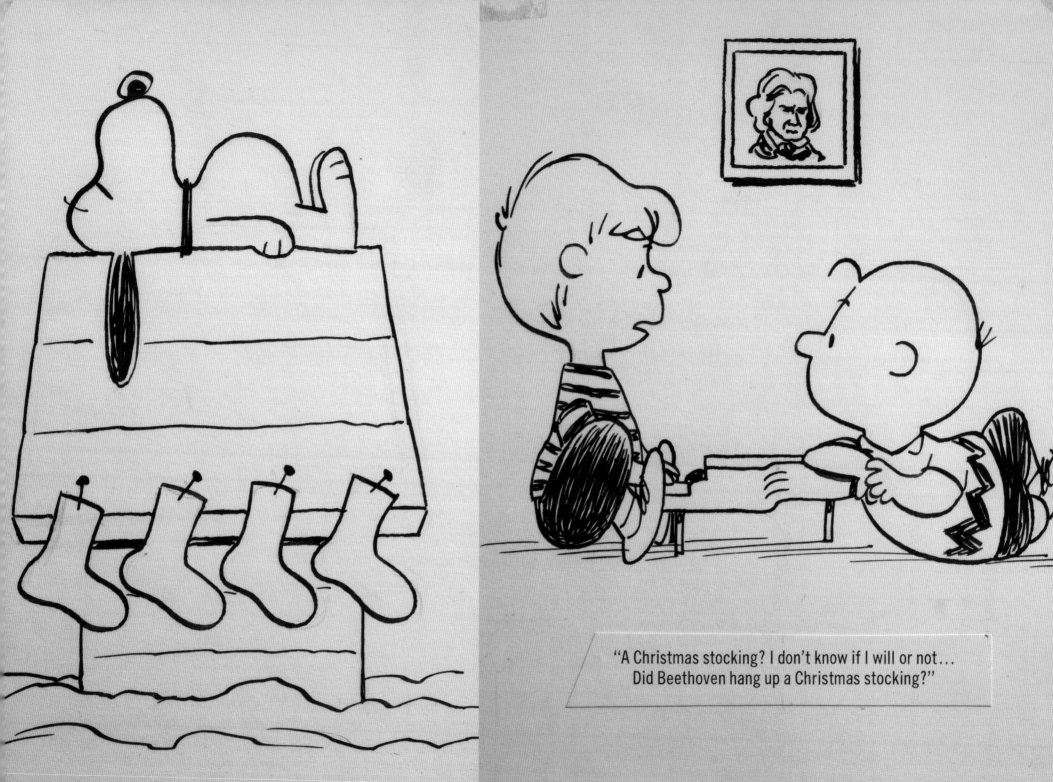

"A Christmas stocking? I don't know if I will or not...
Did Beethoven hang up a Christmas stocking?"

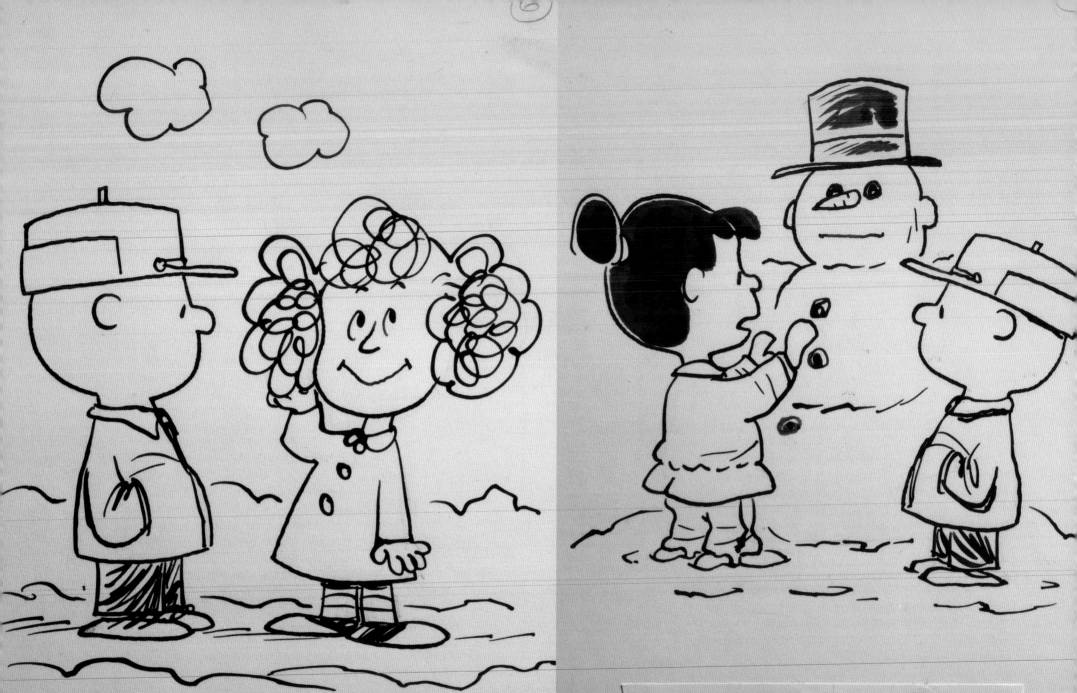

"I'm not a bit worried...The way I see it,
how can Santa help but bring a lot of presents to a
little girl who has naturally curly hair?"

"Grownups are the ones who puzzle me at Christmastime...
Who, but a grownup, would ruin a beautiful holiday
season for himself by suddenly attempting to correspond
with four hundred people he doesn't see all year?"

"What worries me the most is how Santa Claus is going to find where I live...On our block, all the houses look alike!"

"Do you realize there's no place in this house to hang a Christmas stocking? I say let's sue the architect!"

"She's right ... How can you hang a Christmas stocking on a thermostat?"

"A house with no fireplace! Oh, the trials of being part of the wrong generation!"

"Somehow this doesn't seem to be the solution..."

"It's almost midnight... Good grief! I feel like
the Chairman of the Board during an industrial crisis!"

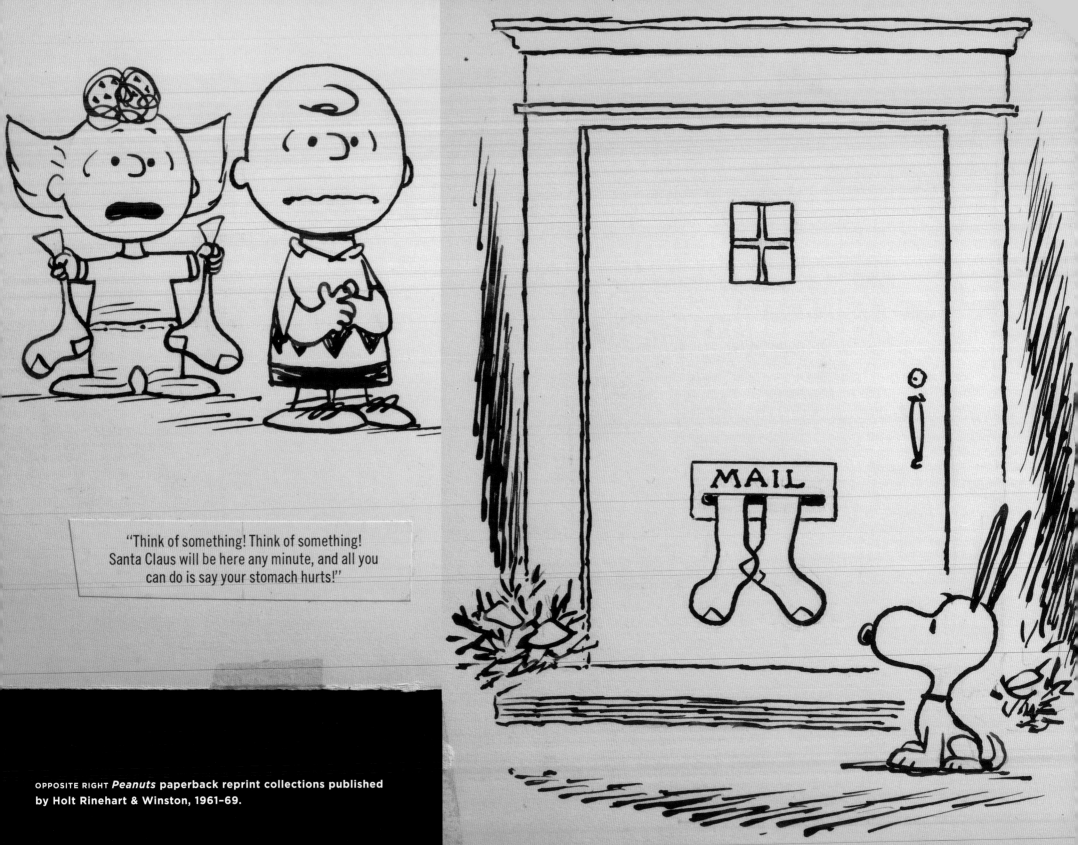

"Think of something! Think of something! Santa Claus will be here any minute, and all you can do is say your stomach hurts!"

PEANUTS EVERY SUNDAY

IT'S A DOG'S LIFE, CHARLIE BROWN

YOU CAN'T WIN, CHARLIE BROWN

SNOOPY, COME HOME

YOU CAN DO IT, CHARLIE BROWN

WE'RE RIGHT BEHIND YOU, CHARLIE BROWN

AS YOU LIKE IT, CHARLIE BROWN

SUNDAY'S FUN DAY, CHARLIE BROWN

YOU NEED HELP, CHARLIE BROWN

THE UNSINKABLE CHARLIE BROWN

YOU'LL FLIP, CHARLIE BROWN

YOU'RE SOMETHING ELSE, CHARLIE BROWN

YOU'RE YOU, CHARLIE BROWN

YOU'VE HAD IT, CHARLIE BROWN

"Big brothers know everything...
Merry Christmas, Charlie Brown!"

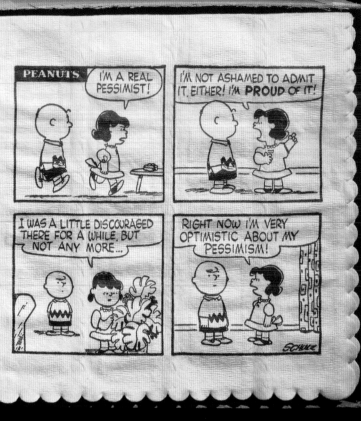

THIS PAGE *Peanuts* napkins, Monogram of California, 1958 (top) and Hallmark, early 1970s (left).

OPPOSITE Original art for daily comic strips, February 12, 1965 (top), March 24, 1966 (middle), and December 11, 1970 (bottom).

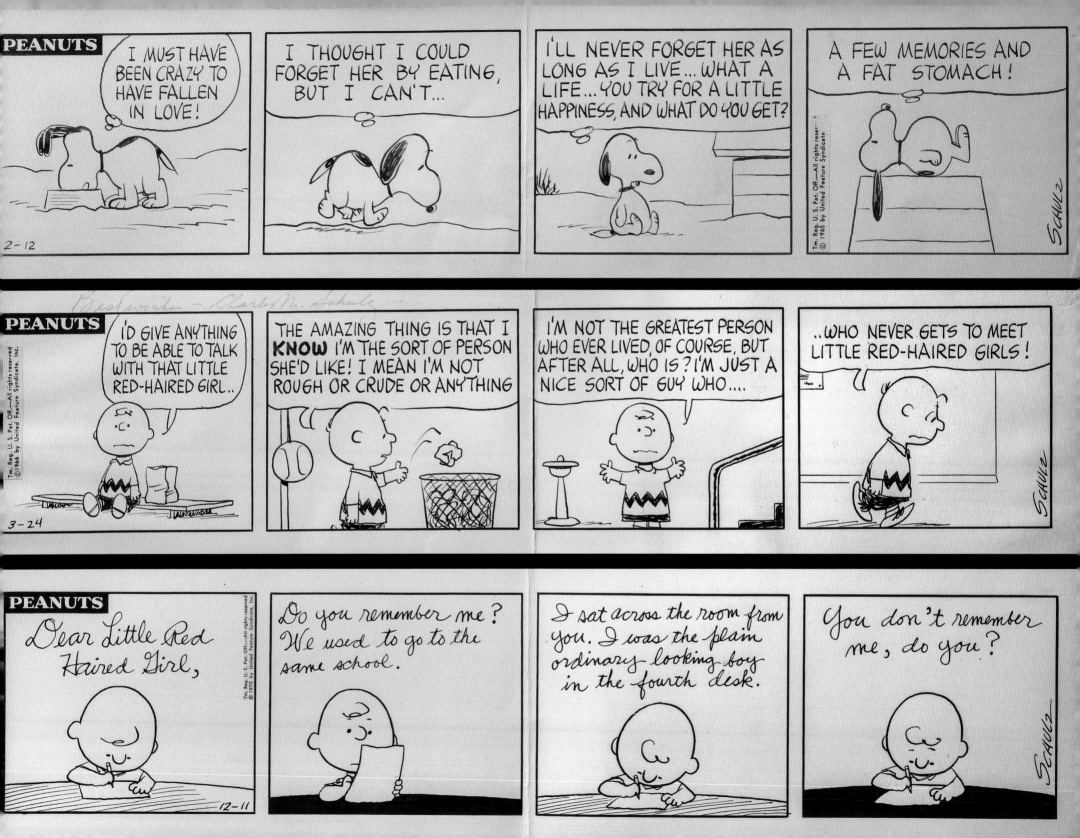

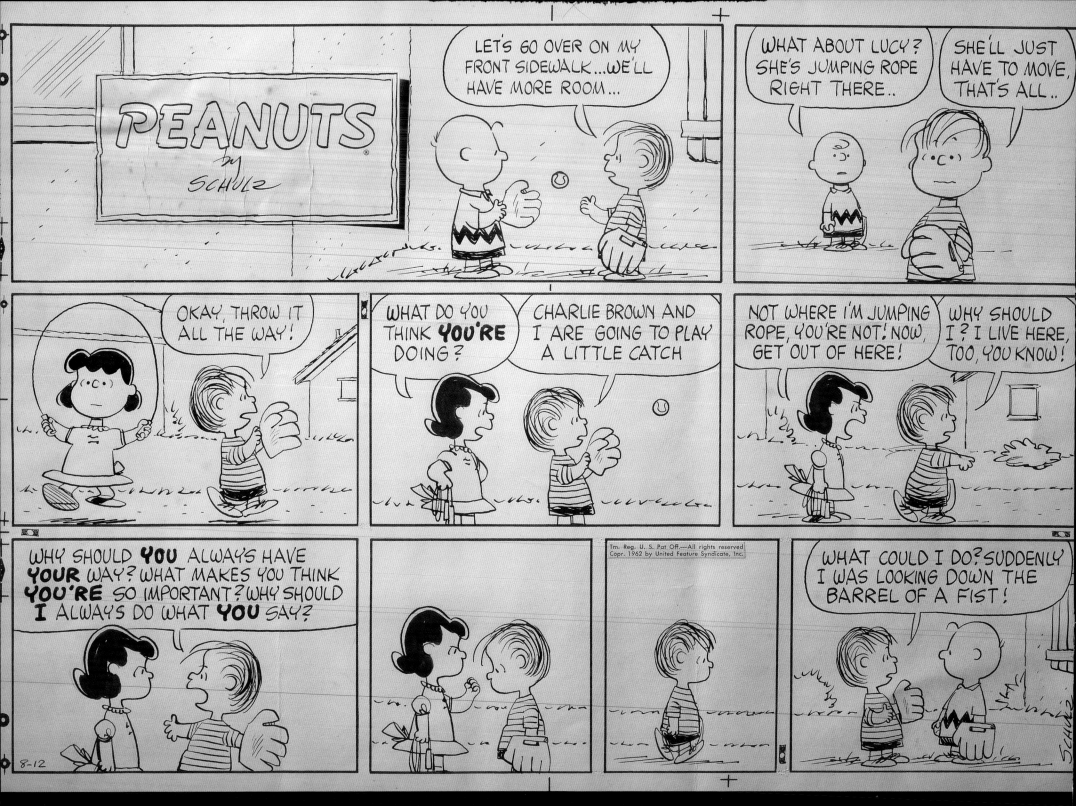

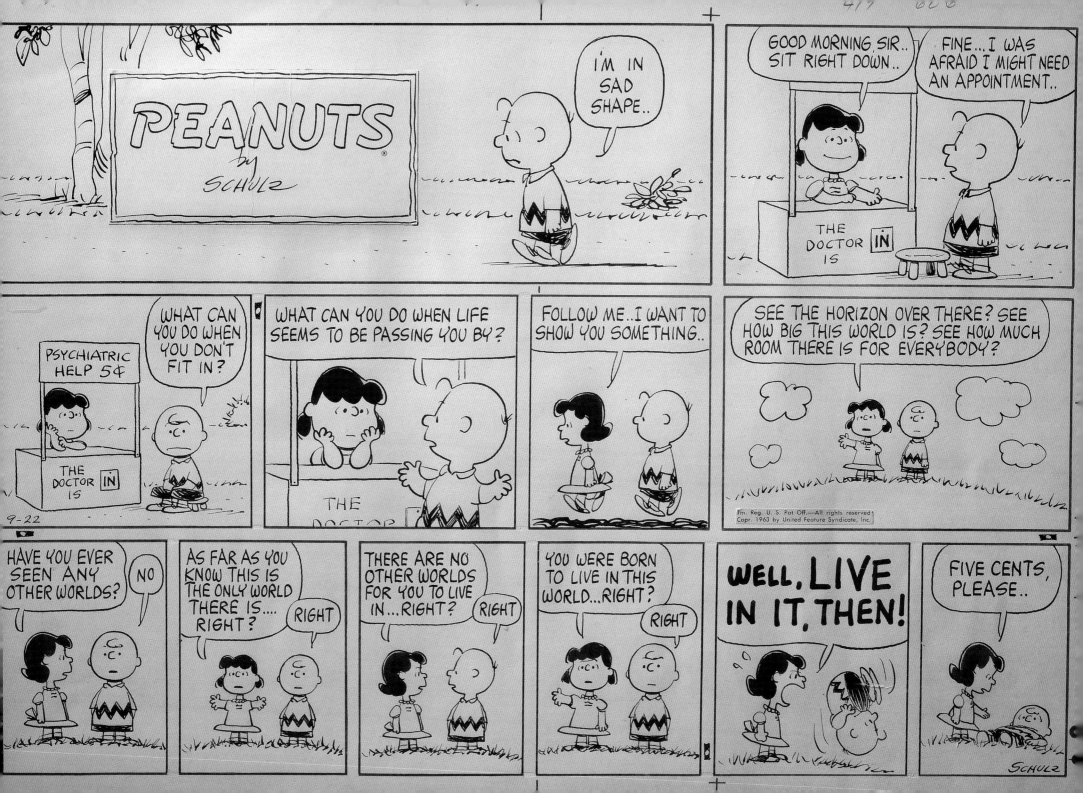

HAPPINESS

IS A

WARM PUPPY

BY

CHARLES M. SCHULZ

On April 25, 1960, via Lucy hugging Snoopy in the daily *Peanuts* newspaper strip, Schulz gave the phrase "Happiness Is a Warm Puppy" to his readers. A year and a half later, Connie Boucher, who created Determined Productions as a budding publishing concern from San Francisco, helped Schulz bring the phrase to the whole world. Boucher suggested using that strip and its message as a starting point to create an entire original book, and while Schulz was initially skeptical, the seed had been planted, and he wrote and mapped out the whole thing in an evening. The result was yet another publishing phenomenon that spawned more than a dozen titles, hefty seven-figure sales, and unprecedented stints on the bestseller lists. These were also the first *Peanuts* books to appear in braille. Jean Scott Neel of Twin Vision and the American Brotherhood for the Blind produced several of these titles, which included vacuform relief pages so that blind fans could perceive the drawings by touching them.

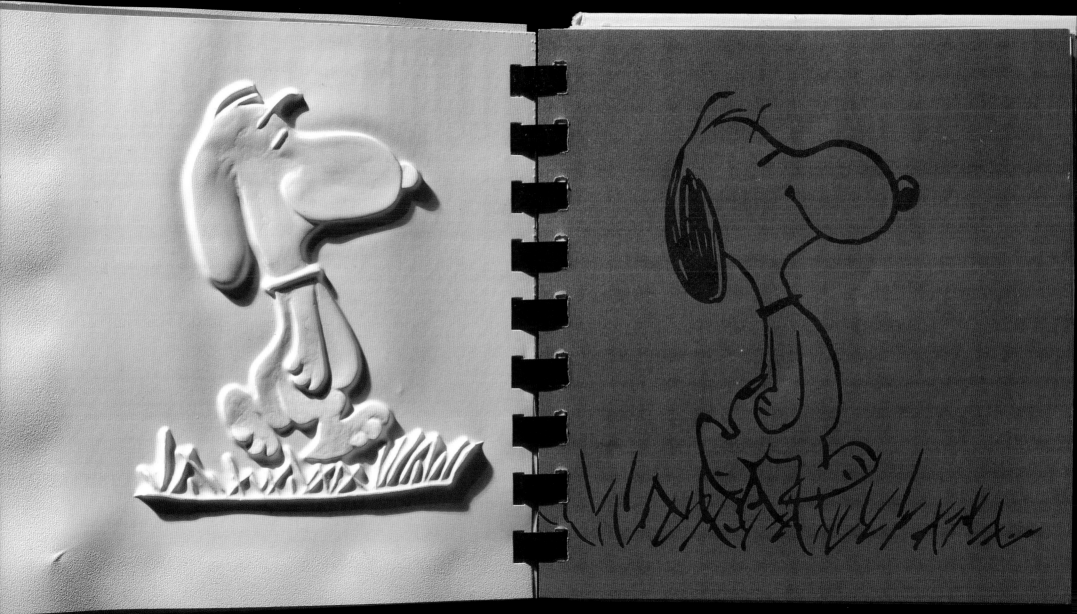

Security is having someone to lean on.

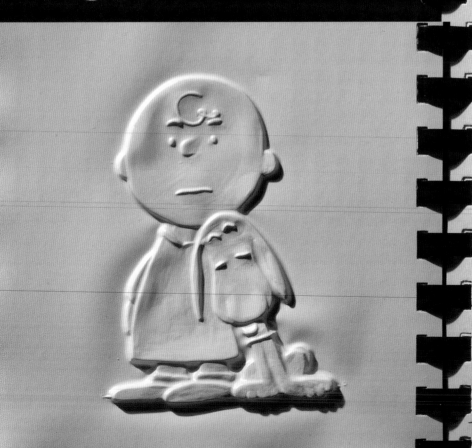

"I think cartooning has a certain quality and a certain charm unlike any other medium, whether it's somebody drawing for over 2,000 newspapers or if it's somebody drawing a little cartoon on the outside of an envelope in a letter to a friend. There's a communication there, a bringing of joy, a bringing of happiness without being too pompous about it. I simply like to draw something that is fun.**" —CMS**

OPPOSITE *Security Is a Thumb and a Blanket*, 1963.

RIGHT *Peanuts* gift books, Determined Productions, Inc., 1962–70. The first title, *Happiness Is a Warm Puppy*, was so successful that it spawned a number of sequels. Shown here are the first ten books in the series.

HAPPINESS IS A WARM PUPPY

SECURITY IS A THUMB AND A BLANKET

I NEED ALL THE FRIENDS I CAN GET

CHRISTMAS IS TOGETHER-TIME

LOVE IS WALKING HAND IN HAND

HOME IS ON TOP OF A DOG HOUSE

HAPPINESS IS A SAD SONG

SUPPERTIME!

PEANUTS COOK BOOK

PEANUTS LUNCH BAG COOK BOOK

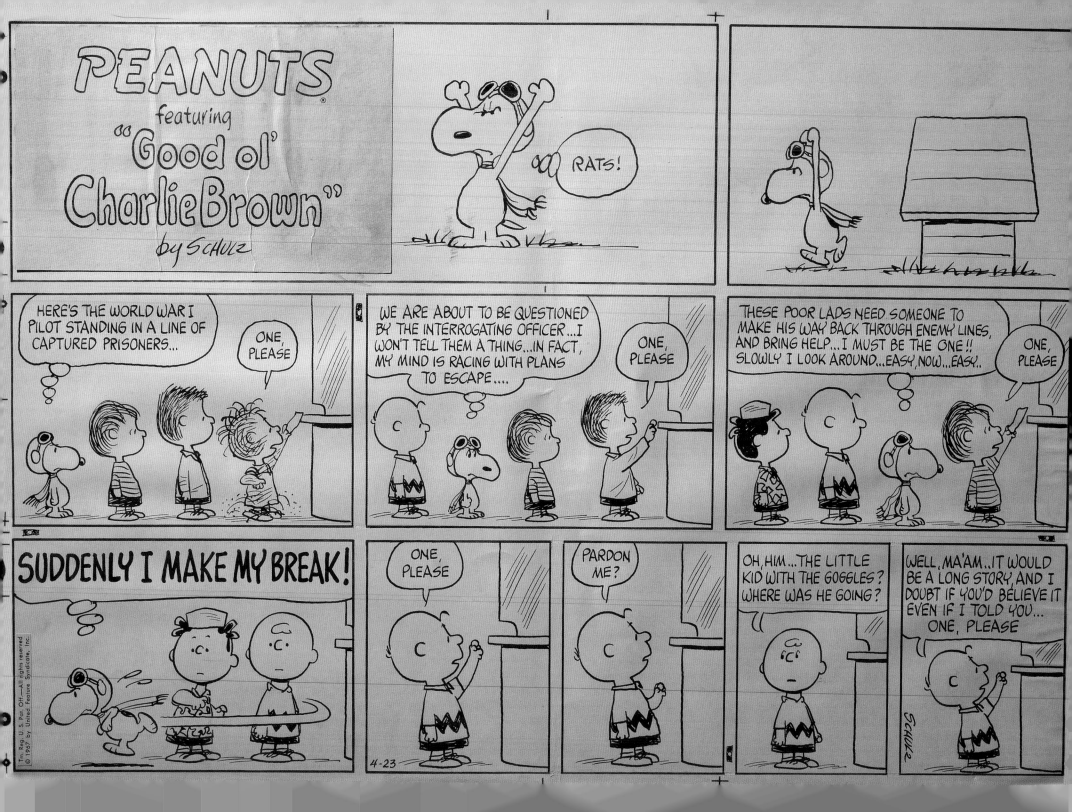

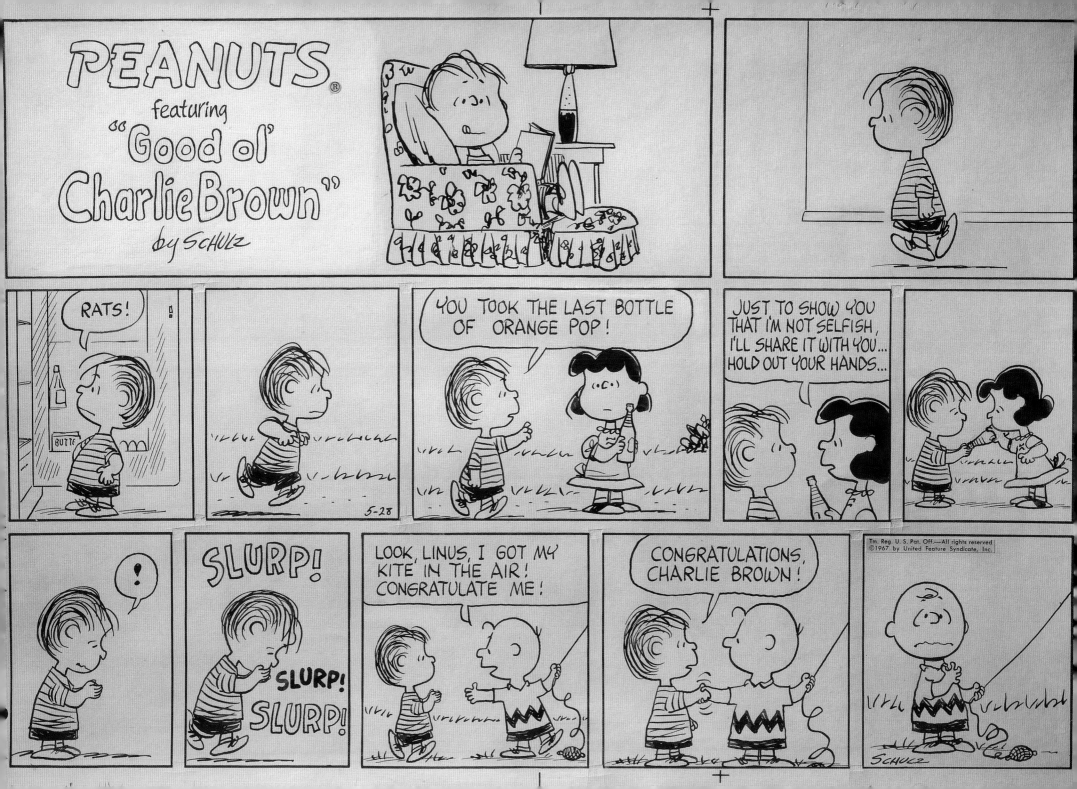

SNOOPY

TRADE MARK

A DOG-ON FUNNY GAME

AGES 6 TO 12

A COMPANION GAME TO THE "PEANUTS" GAME

CHARACTER CREATED By Charles M. Schulz
© UNITED FEATURE SYNDICATE, INC.

MANUFACTURED BY SELCHOW & RIGHTER CO., NEW YORK, N.Y. MADE IN U.S.A.

Snoopy board game, Selchow & Righter Co., 1967.

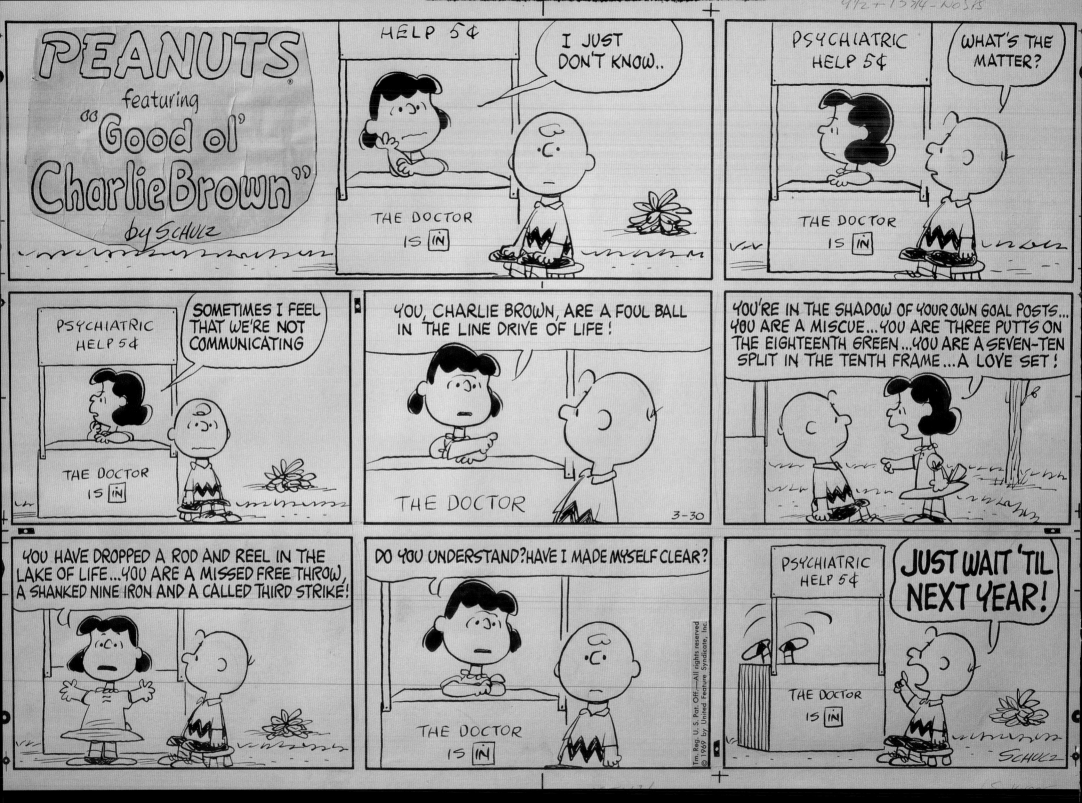

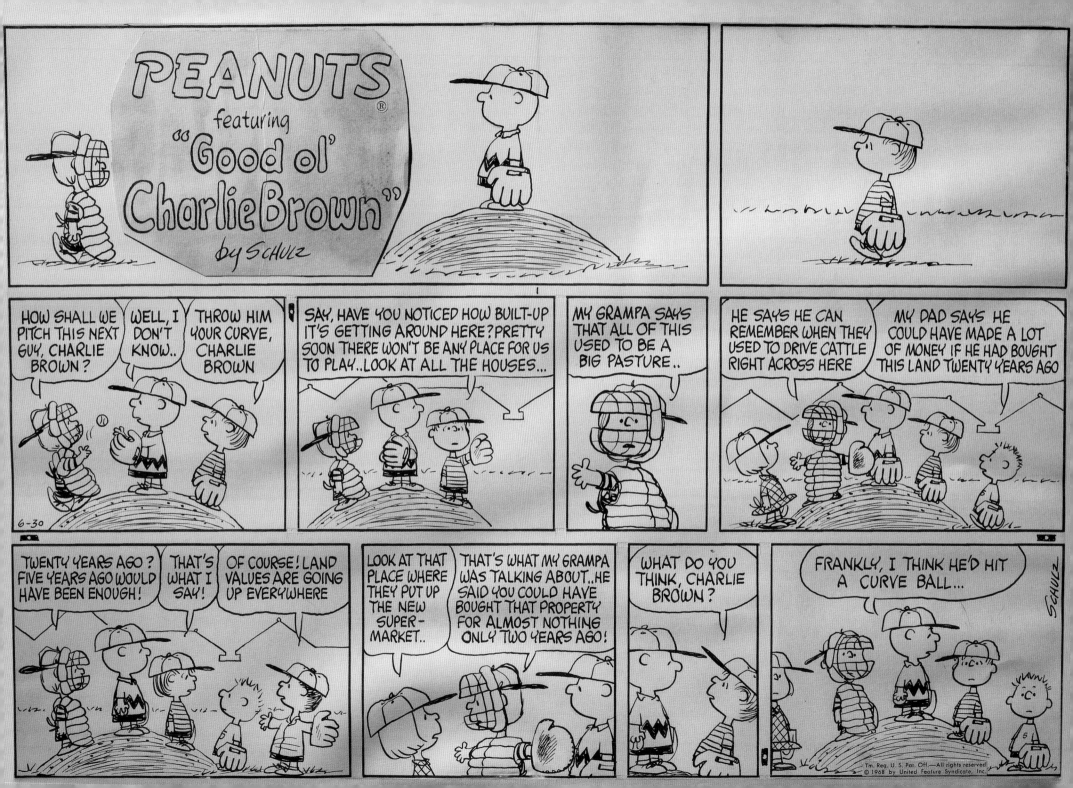

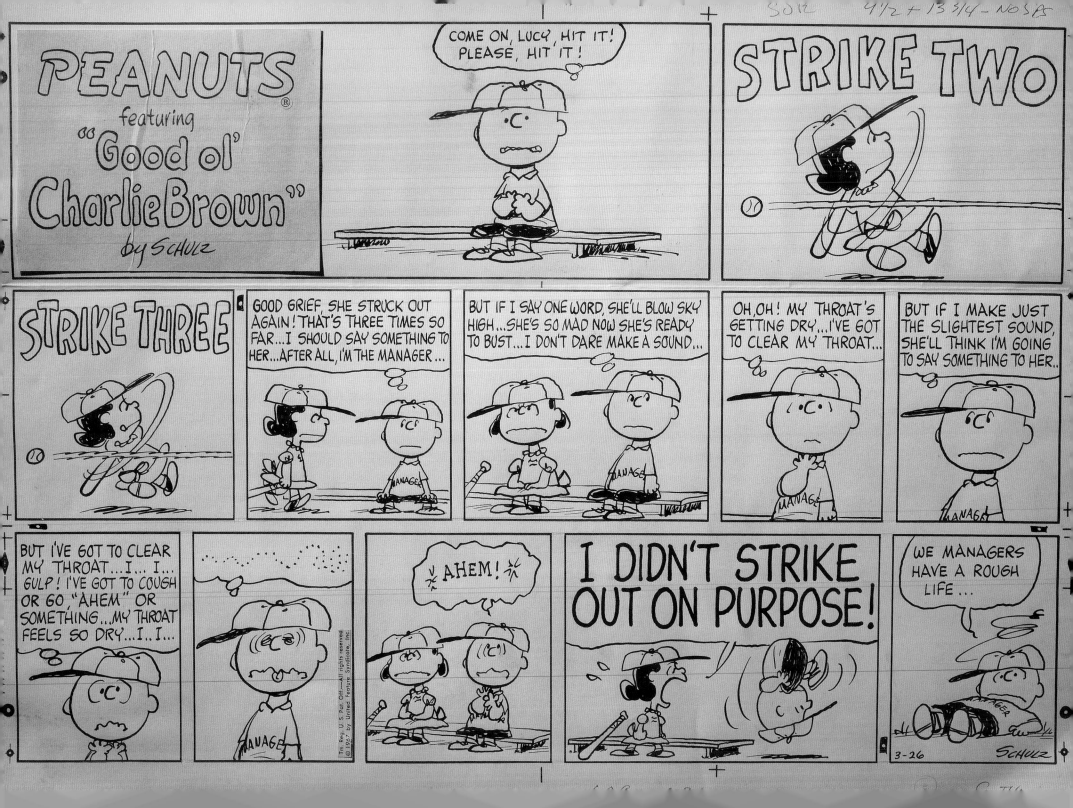

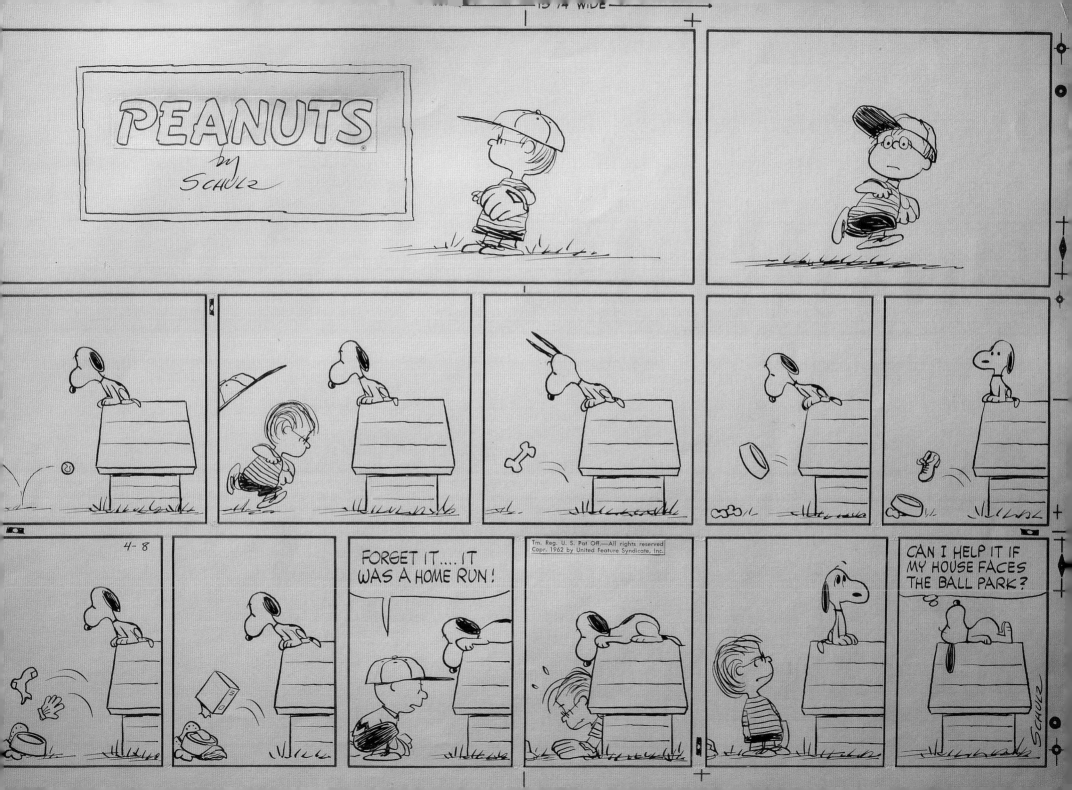

HARRIET GLICKMAN AND THE CREATION OF FRANKLIN

Just eleven days after the assassination of Martin Luther King Jr., Harriet Glickman, a self-proclaimed suburban housewife from Sherman Oaks, California, wrote to Schulz via United Feature Syndicate to ask him to consider creating African American *Peanuts* characters. Citing the strip as "one of the most adored, well-read and quoted parts of our literate society," she felt that integrating *Peanuts* could go far in helping the civil rights movement.

Schulz's response and the correspondence that follows is as timely now as it is fascinating, and ultimately led to the introduction of Franklin on July 31, 1968. Later, when asked in a 1988 interview with historian Michael Barrier about moments over the years when United Feature voiced concern about the strip, Schulz replied, "There was one strip where Charlie Brown and Franklin had been playing on the beach, and Franklin said, 'Well, it's been nice being with you, come on over to my house sometime.' [United Feature Syndicate] didn't like that. Another editor protested once when Franklin was sitting in the same row of school desks with Peppermint Patty, and said, 'We have enough trouble here in the South without you showing the kids together in school.' But I never paid any attention to those things, and I remember telling Larry [Rutman, president of United Feature] at the time about Franklin—he wanted me to change it, and we talked about it for a long while on the phone, and I finally sighed and said, 'Well, Larry, let's put it this way: Either you print it just the way I draw it or I quit. How's that?' So that's the way that ended. But I've never done much with Franklin, because I don't do race things. I'm not an expert on race. I don't know what it's like to grow up as a little black boy, and I don't think you should draw things unless you really understand them, unless you're just out to stir things up or to try to teach people different things. I'm not in this business to instruct; I'm just in it to be funny. Now and then I may instruct a few things, but I'm not out to grind a lot of axes. Let somebody else do it who's an expert on that, not me."

FOLLOWING PAGES **Letters between Harriet Glickman and Charles M. Schulz, April–July 1968.**

Mrs. Harriet Glickman 4933 Wortser Ave. Sherman Oaks, Calif/ 91403

Mr. Charles Schulz
United Features Syndicate
220 E. 42nd St.
New York, N.Y. 10017

April 15,1968

Dear Mr. Schulz,

Since the death of Martin Luther King, I've been asking myself what I can do to help change those conditions in our society which led to the assassination and which contribute to the vast sea of misunderstanding, fear, hate and violence.

As a suburban housewife; the mother of three children and a deeply concerned and active citizen, I am well aware of the very long and tortuous road ahead. I believe that it will be another generation before the kind of open friendship, trust and mobility will be an accepted part of our lives.

In thinking over the areas of the mass media which are of tremendous importance in shaping the unconscious attitudes of our kids, I felt that something could be done through our comic strips and even in that violent jungle of horrors known as Children's Television.

You need no reassurances from me that Peanuts is one of the most adored, well-read and quoted parts of our literate society. In our family, teen-age Kathy has posters and sweat shirts... pencil holders and autograph books. Paul, who's ten and our Charlie Brown Little Leaguer....has memorized every paper back book...has stationery, calendars, wall hangings and a Snoopy pillow. Three and a half year old Simon has his own Snoopy which lives, loves, eats, paints, digs, bathes and sleeps with him. My husband and I keep pertinent Peanuts cartoons on desks and bulletin boards as guards against pomposity. You see...we are a totally Peanuts-oriented family.

It occurred to me today that the introduction of Negro children into the group of Schulz characters could happen with a minimum of impact. The gentleness of the kids...even Lucy, is a perfect setting. The baseball games, kite-flying...yea, even the Psychiatric Service cum Lemonade Stand would accommodate the the idea smoothly.

Sitting alone in California suburbia makes it all seem so easy and logical. I'm sure one doesn't make radical changes in so important an institution without a lot of shock waves from syndicates, clients, etc. You have, however, a stature and reputation which can withstand a great deal.

Lastly; should you consider this suggestion, I hope that the result will be more than one black child....Let them be as adorable as the others...but please...allow them a Lucy!

Sincerely,

CHARLES M. SCHULZ
2162 COFFEE LANE
SEBASTOPOL, CALIFORNIA 95472

April 26, 1968

Harriet Glickman
4933 Wortser Ave.
Sherman Oaks, Calif. 91403

Dear Mrs. Glickman:

Thank you very much for your kind letter. I appreciate your suggestion about introducing a Negro child into the comic strip, but I am faced with the same problem that other cartoonists are who wish to comply with your suggestion. We all would like very much to be able to do this, but each of us is afraid that it would look like we were patronizing our Negro friends.

I don't know what the solution is.

Best regards.

Sincerely yours,

Charles Schulz

Charles M. Schulz

April 27, 1968

Dear Mr. Schulz,

I appreciate your taking the time to answer my letter about Negro children in "Peanuts."

You present an interesting dilemma. I would like your permission to use your letter to show some Negro friends. Their responses as parents may prove useful to you in your thinking on this subject.

Sincerely,

Harriet Glickman
4933 Wortser Ave.
Sherman Oaks,
Calif. 91403

CHARLES M. SCHULZ
2162 COFFEE LANE
SEBASTOPOL, CALIFORNIA 95472

May 9, 1968

June 6, 1968

Harriet Glickman
4933 Wortser Ave.
Sherman Oaks, Calif. 91403

Dear Mrs. Glickman:

I will be very anxious to hear what your
friends think of my reasons for not including
a Negro character in the strip. The more I
think of the problem, the more I am convinced
that it would be wrong for me to do so. I would
be very happy to try, but I am sure that I
would receive the sort of criticism that would
make it appear as if I were doing this in a
condescending manner.

Kindest regards.

Sincerely yours,

Charles Schulz
Charles M. Schulz

Mr. Charles M. Schulz
2162 Coffee Lane
Sebastopol, California 95472

Dear Mr. Schulz:

With regards to your correspondence with Mrs. Glickman on the subject
of including Negro kids in the fabric of Peanuts, I'd like to express an
opinion as a Negro father of two young boys. You mention a fear of being
patronizing. Though I doubt that any Negro would view your efforts that
way, I'd like to suggest that an accusation of being patronizing would be
a small price to pay for the positive results that would accrue!

We have a situation in America in which racial enmity is constantly
portrayed. The inclusion of a Negro supernumerary in some of the
group scenes in Peanuts would do two important things. Firstly, it would
ease my problem of having my kids seeing themselves pictured in the
overall American scene. Secondly, it would suggest racial amity in a
casual day-to-day sense.

I deliberately suggest a supernumerary role for a Negro character. The
inclusion of a Negro in your occasional group scenes would quietly and
unobtrusively set the stage for a principal character at a later date, should
the basis for such a principal develop.

We have too long used Negro supernumeraries in such unhappy situations
as a movie prison scene, while excluding Negro supernumeraries in quiet
and normal scenes of people just living, loving, worrying, entering a hotel,
the lobby of an office buidling, a downtown New York City street scene.
There are insidious negative effects in these practices of the movie industry,
TV industry, magazine publishing, and syndicated cartoons.

Sincerely,

KCK/bc

BOTTOM **Franklin makes his first appearance.**
Original art for daily comic strip, July 31, 1968.

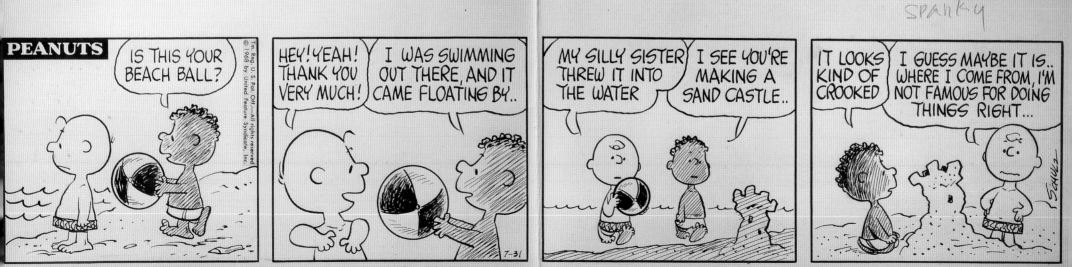

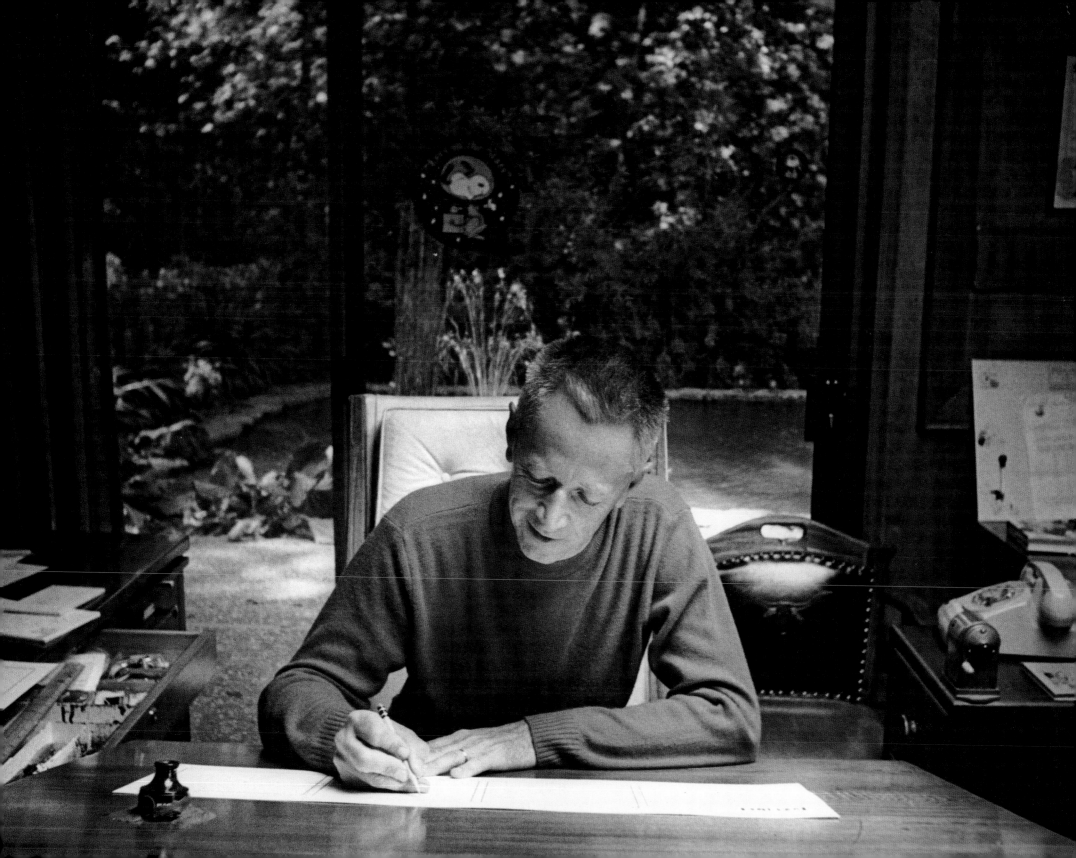

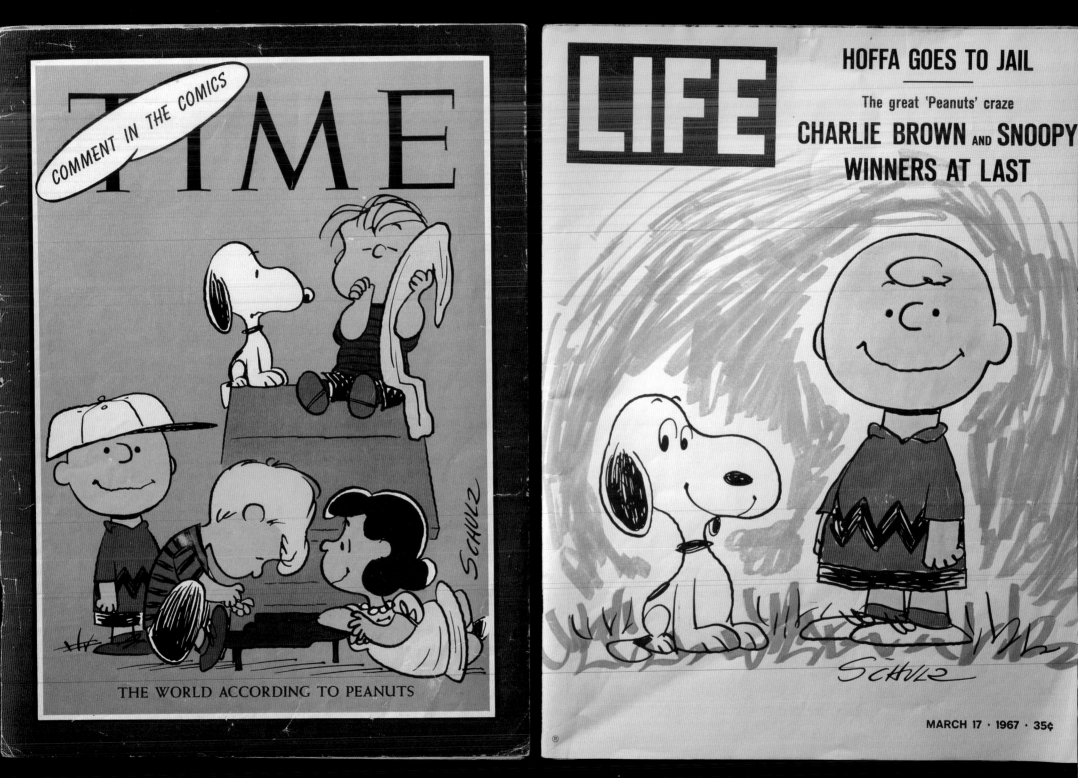

As the *Peanuts* characters became more and more iconic, they made the cover of all the major national magazines, cementing their place in popular culture. Schulz would create custom art for each cover, providing him with a rare opportunity to compose stand-alone images in full color.

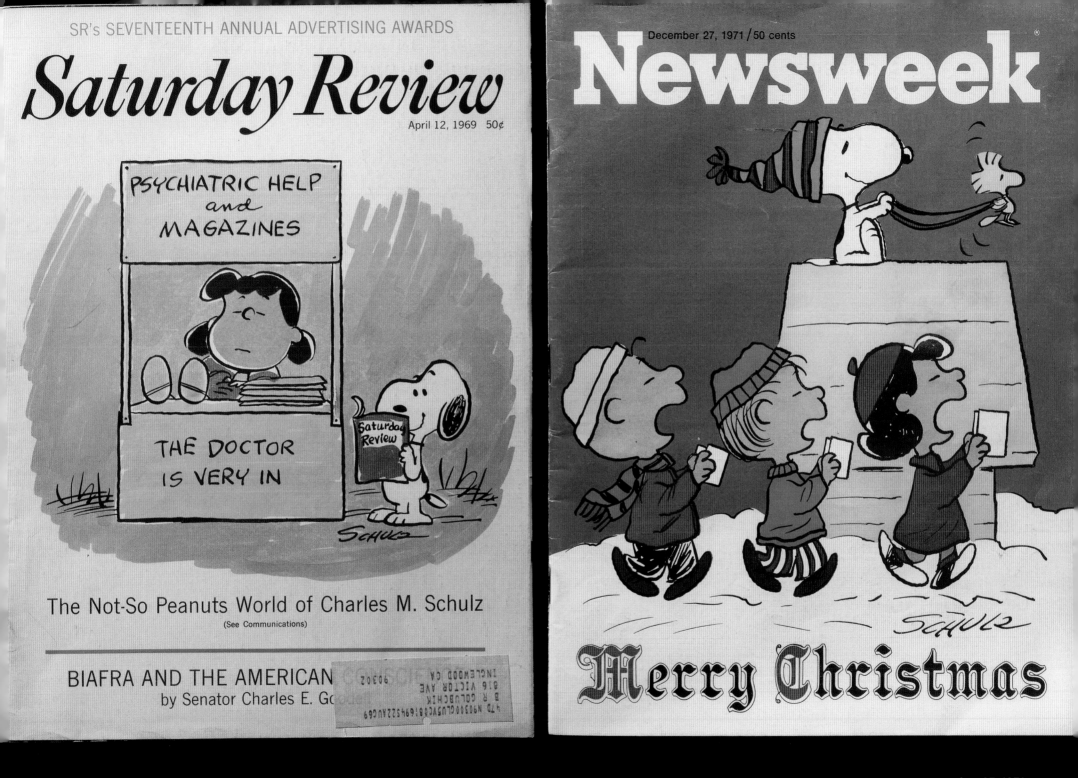

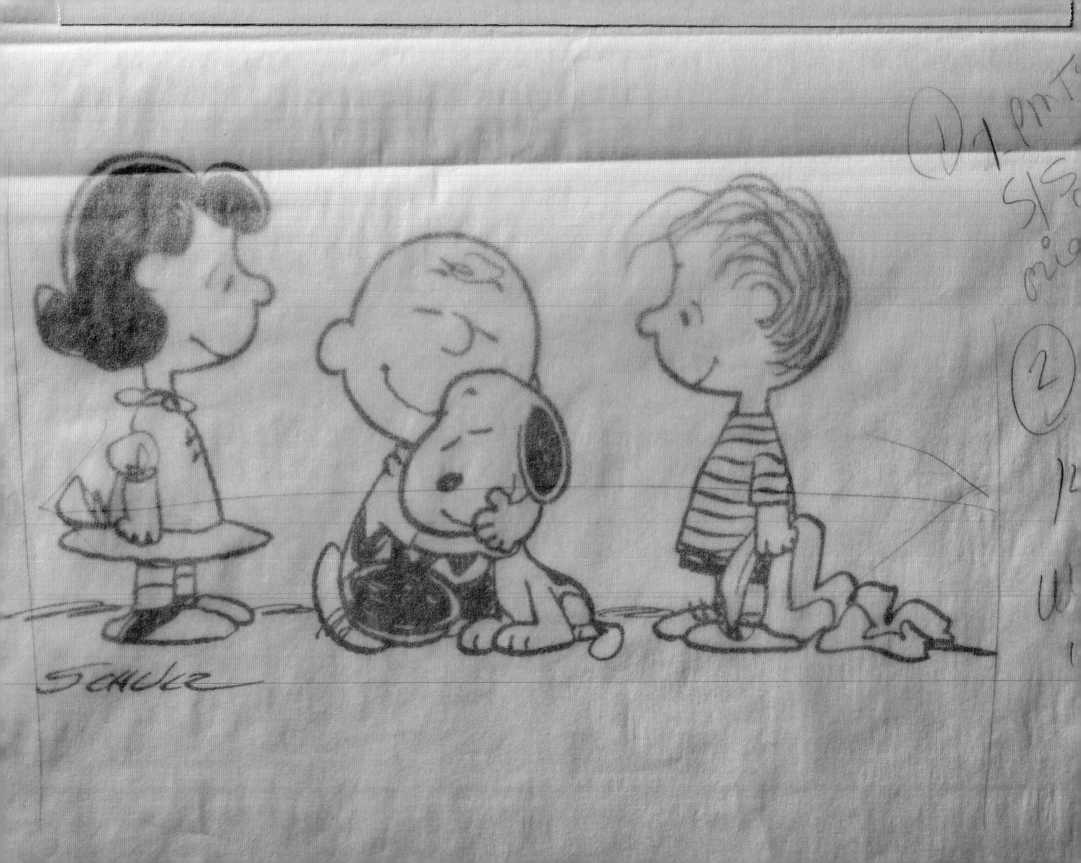

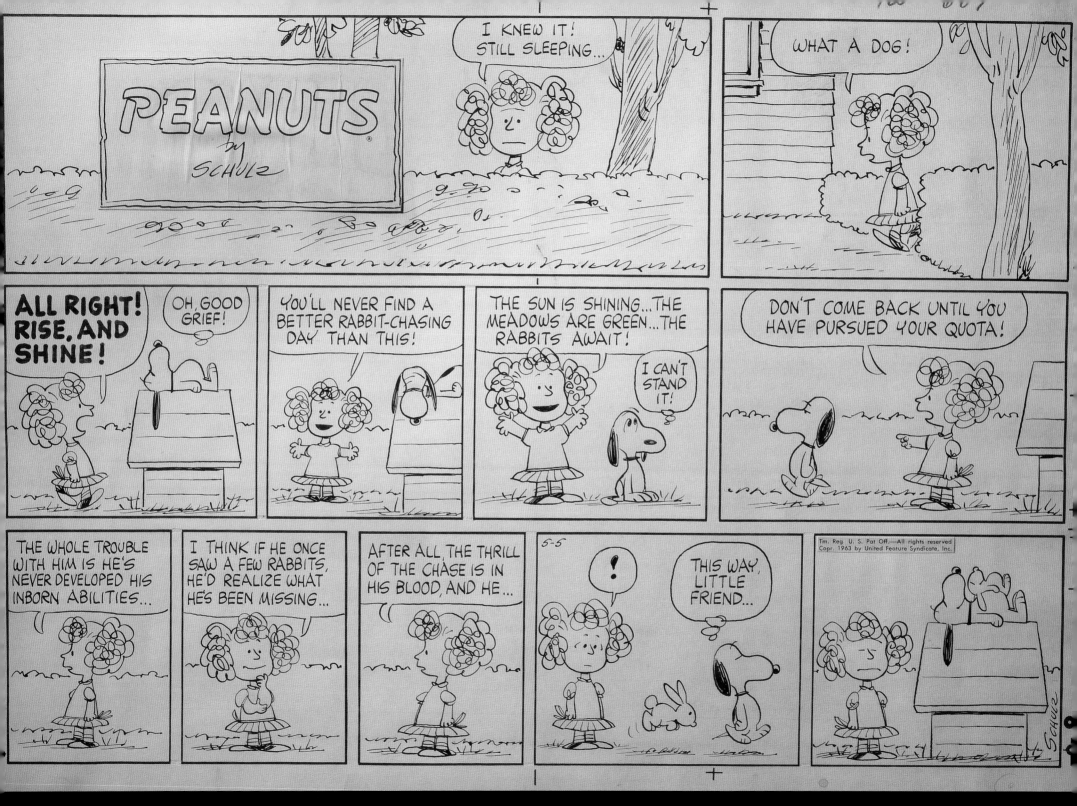

OPPOSITE **Unpublished original art created for the office of the Schulz family's pediatrician, c. 1960s.**

ABOVE **Comic book covers, *Peanuts* no. 2, Gold Key, August 1963 (left), and no. 3, November 1963 (right).**

sounds great in STEREO

THE ORIGINAL CAST ALBUM OF

"YOU'RE A GOOD MAN, CHARLIE BROWN"

MGM RECORDS

© Metro-Goldwyn-Mayer Inc./Printed in U.S.A.

© United Feature Syndicate, Inc. 1960. All Rights Reserved

ARTHUR WHITELAW AND GENE PERSSON PRESENT

"YOU'RE A GOOD MAN CHARLIE BROWN"

A NEW MUSICAL ENTERTAINMENT
BASED ON THE COMIC STRIP "PEANUTS"
BY CHARLES M. SCHULZ
MUSIC AND LYRICS BY CLARK GESNER

WITH

BILL HINNANT REVA ROSE KAREN JOHNSON
BOB BALABAN SKIP HINNANT GARY BURGHOFF

BOOK
JOHN GORDON

SETS & COSTUMES
ALAN KIMMEL

LIGHTING
JULES FISHER

MUSICAL SUPERVISION
ARRANGEMENTS
AND ADDITIONAL
MATERIAL
JOSEPH RAPOSO

ASSOC. PRODUCER
STANLEY MANN

ASS'T. TO THE DIRECTOR
PATRICIA BIRCH

DIRECTED BY JOSEPH HARDY

LEFT Original cast album, MGM Records, 1967.

OPPOSITE LEFT Playbill, *You're a Good Man, Charlie Brown.* Little Fox Theatre, San Francisco, June 1967.

OPPOSITE RIGHT Souvenir booklet, 1967.

YOU'RE A GOOD MAN
CHARLIE BROWN

PLAYBILL

"YOU'RE A GOOD MAN, CHARLIE BROWN"

"YOU'RE A GOOD MAN CHARLIE BROWN"

© 1966 United Feature Syndicates, Inc.

You're a Good Man, Charlie Brown first opened off-Broadway on March 7, 1967, at Theatre 80 St. Marks in New York's East Village. The play—starring Gary Burghoff as Charlie Brown, three years before his role as Radar O'Reilly in Robert Altman's *M*A*S*H*—won numerous awards, including the Outer Critics Circle Award for Outstanding Musical and a Grammy for Best Musical Show Album.

The show's memorable music and lyrics are by Clark Gesner, with the book by John Gordon, a "collective pseudonym," according to Gesner, that included himself, the cast, the production crew, and Schulz's source material.

At first Gesner tried unsuccessfully to obtain permission from United Feature Syndicate to use the characters of *Peanuts* in the songs he was writing, but after he sent

Schulz a demo tape directly, he was granted permission. "My only stipulation," Schulz wrote in the play's program, "was that they retain as much as possible the flavor of the comic strip and not try to introduce any new elements merely to make it more 'Broadway.'"

According to Gesner in his liner notes, "The time of the action is an average day in the life of Charlie Brown. It really is just that, a day made up of little moments picked from

all the days of Charlie Brown, from Valentine's Day to the baseball season, from wild optimism to utter despair, all mixed in with the lives of his friends (both human and non-human) and strung together on the string of a single day, from bright uncertain morning to hopeful starlit evening."

The play remains a staple of regional and community theater, as well as summer stock and high schools all over the country

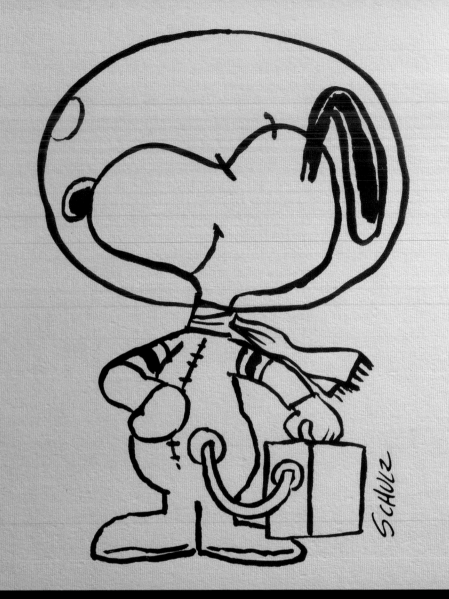

March 21, 1968

Mr. Samuel Cappelle
Space Division
North American Rockwell Corporation
12214 Lakewood Boulevard
Downey, California 90241

Dear Sam:

It is proposed that we do the Snoopy drawings for your proposed Apollo program Snoopy posters.

As of now, we have received 18, however, Mr. Schulz suggests that we do not do one of them. Therefore, tentatively speaking, it's around 17 Snoopy drawings.

The price will be $25.00 per drawing.

I thank you for the opportunity of working on something as rewarding as this Apollo project, even though our part in it is so minuscule.

Sincerely,

Bill Melendez

Bill Melendez
BM:jmd

p.s. Sorry we forgot a line.

In 1968, NASA commander Thomas Stafford, senior astronaut on the Apollo 10 crew, chose the names "Charlie Brown" for the command module and "Snoopy" for the LEM (lunar entry module) attached to it.

"It was a tremendous thrill for me," Schulz later recalled, "especially being an old Buck Rogers fan. To know your characters would be the first to really go to outer space is, I guess, the most exciting thing that happened to us!"

ABOVE **Original art for Snoopy poster created for NASA's Apollo program.**

RIGHT **Accompanying letter from animator Bill Melendez, dated March 21, 1968.**

**bill melendez
productions
incorporated**
429 North Larchmont Boulevard
Los Angeles, California 90004
O 213/463-4101 O

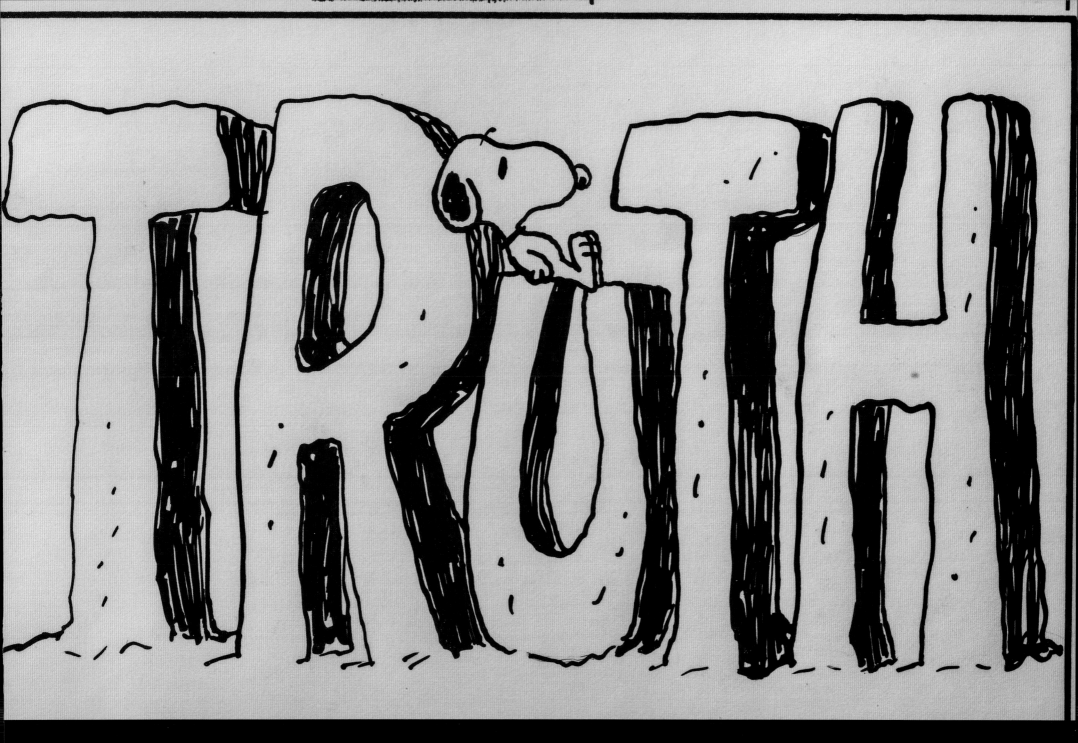

Detail, Sunday comic strip, February 9, 1975.

"If you're going to survive on a daily schedule, you survive only by being able to draw on every experience and thought that you've ever had. That is, if you're going to do anything with any meaning." —*CMS*

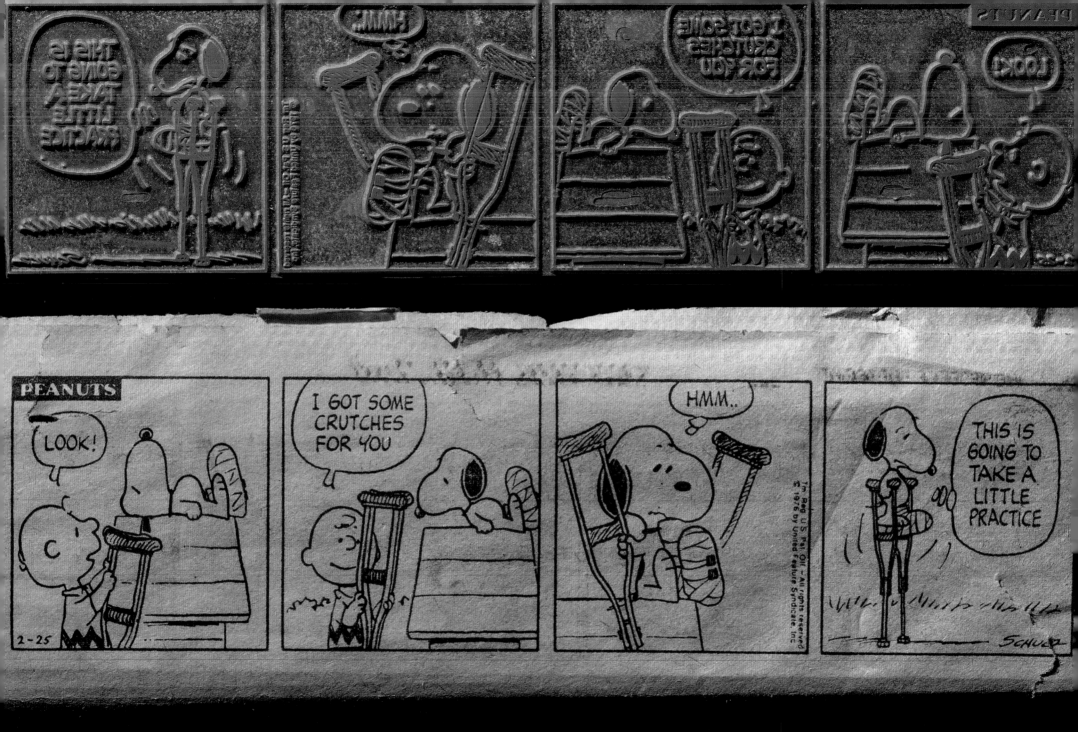

ABOVE **Printing plate and newspaper clipping for daily comic strip, February 25, 1976.**

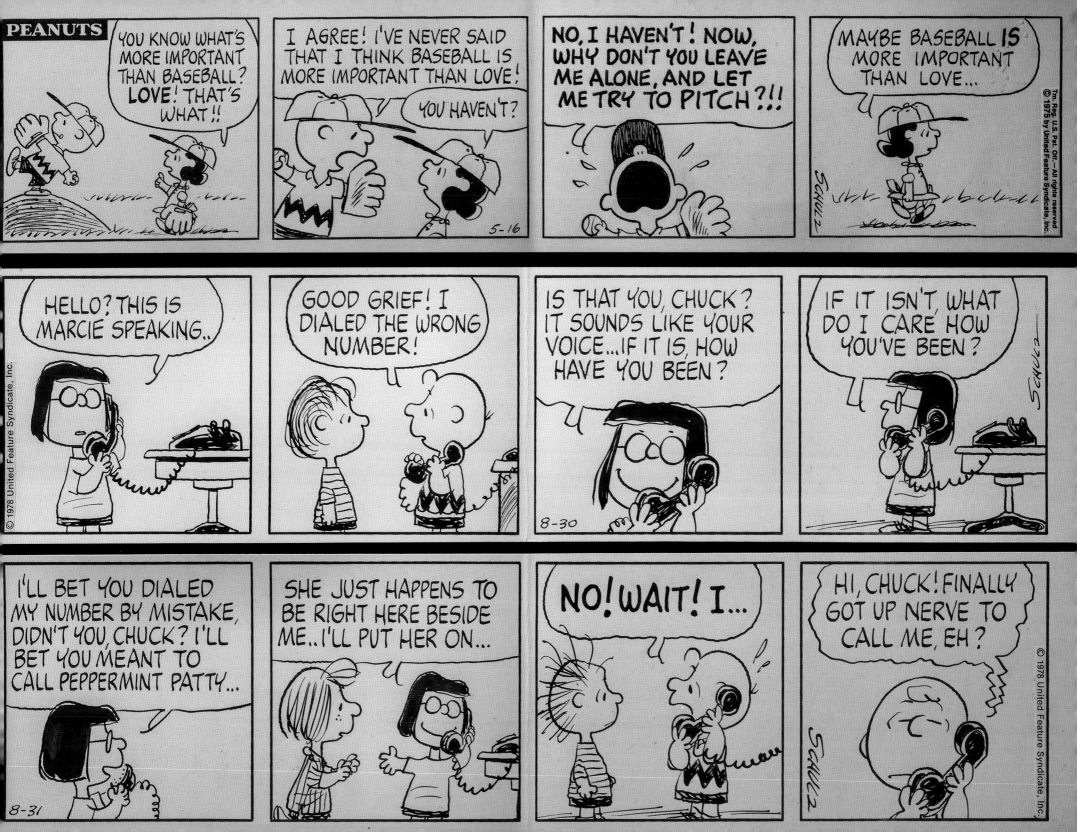

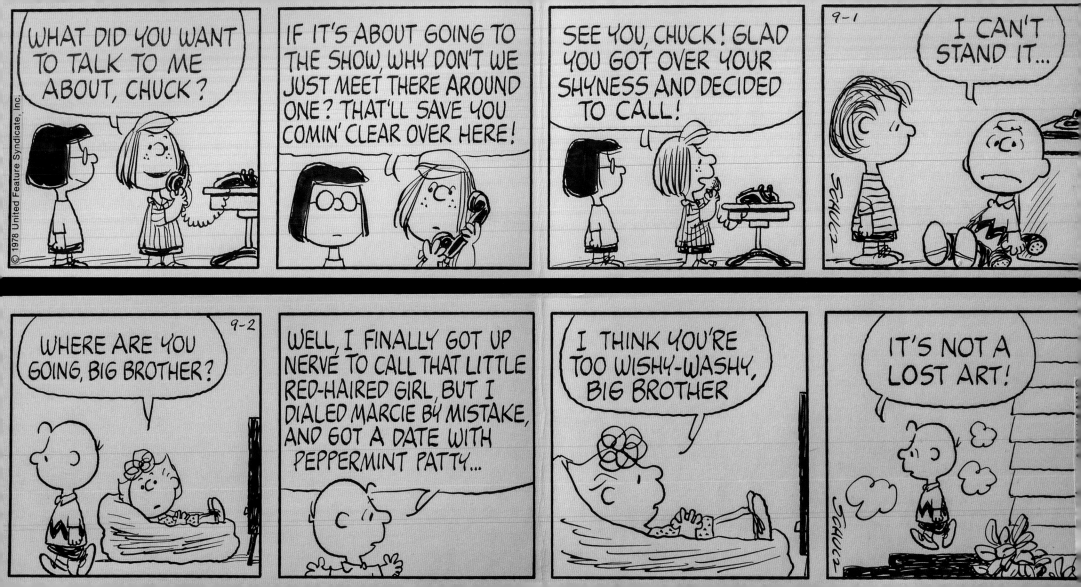

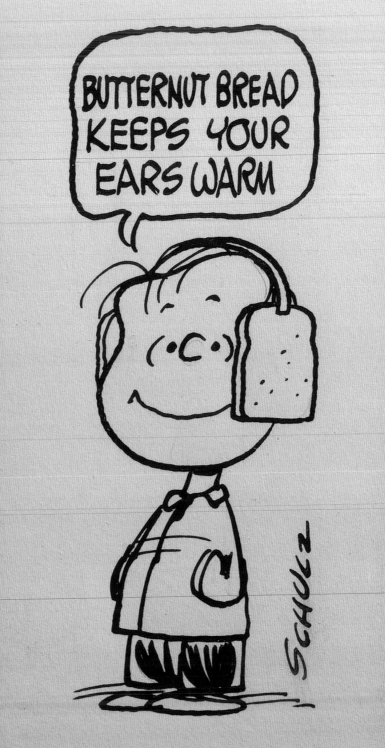

PLEASE CLOSE COVER BEFORE STRIKING

FLY WITH WEBER'S

PACIFIC OUTDOOR

Enriched Bread Enriches Health

PACIFIC OUTDOOR

SECURITY IS WEBER'S BREAD

UNIVERSAL MATCH, LOS ANGELES

UNIVERSAL MATCH, LOS ANGELES

WEBER'S KEEPS YOUR EARS WARM

PACIFIC OUTDOOR

Enriched Bread Enriches Health

PACIFIC OUTDOOR

"HANG TEN" WITH WEBER'S

OPPOSITE **Original advertisement art for Dolly Madison snack cakes, 1978 (top) and 1979 (bottom).**

ABOVE **Original art for daily comic strip, July 31, 1975, and related pencil sketch (left).**

CMS

SPIKE, SNOOPY'S BROTHER

In the daily strip on August 4, 1975, the first mention is made of Snoopy's brother, Spike, who writes to say that he will be visiting from his desert home in Needles, California. Nine days later Spike shows up, and the visual punch line is that he is relatively skinny, has whiskers that look like a mustache, and wears a fedora.

By the 1990s, Spike became a major *Peanuts* character, with Schulz drawing literally dry humor out of the beagle's meager surroundings. Many of Spike's desert-based jokes (his only friends are cacti and rocks) would seem to be a reference to Schulz's time in Needles, California, as a child, when his father moved

the family there in 1929 for two years before returning them to Minneapolis. Needles was, the artist recalled later, "a miserable place."

The curious thing, from a historical perspective, is that after twenty-five years Schulz finally used the actual name of his beloved childhood pet—"the wildest and smartest dog I ever encountered"—for a character in his strip. And yet that quote far from describes how he depicted Spike in *Peanuts*. Initially laconic, docile, and passive, he would come into his own as a gently hopeful personality, sharing his thoughts and feelings with "Joe Cactus," which he eventually . . . hugged. Ouch.

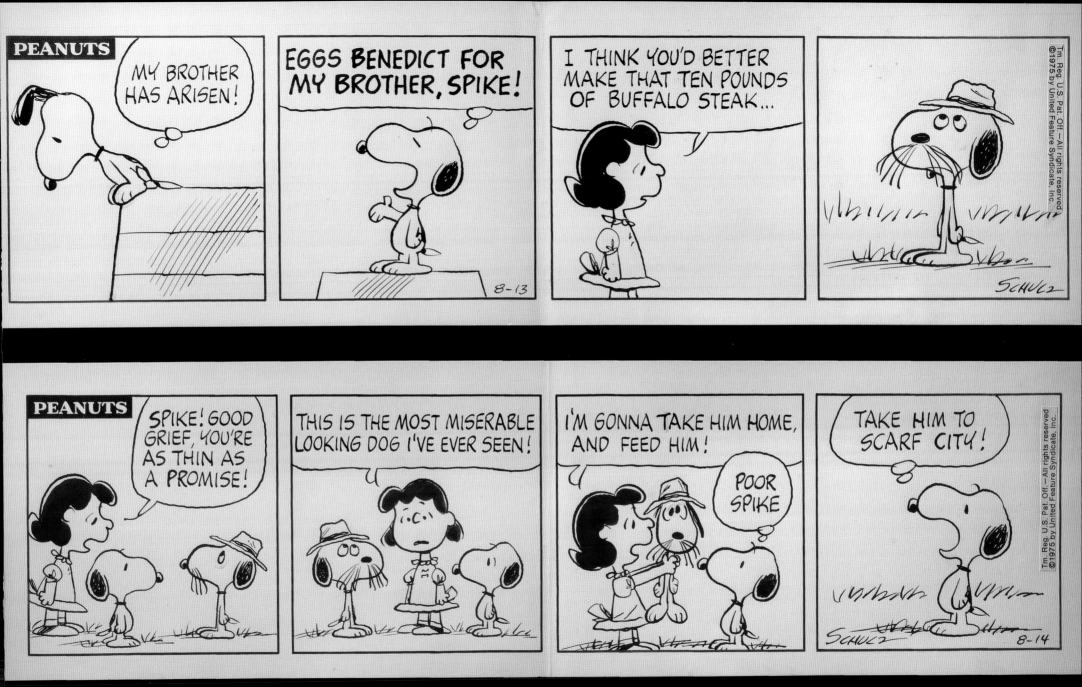

OPPOSITE LEFT **Preliminary pencil sketches for Spike, Snoopy's brother, 1975.**

I Forget I said it,
forget I said it.

It's not true! 4

There, there,
little friend — 3
Don't cry —
don't cry —
your Mom's not
in a birdcage
don't cry, don't cry —

We'll just sit here, ~~and for~~
until your Mom flies by &
then you can give her the
flower.... 2

Whoever invented these holidays anyway? 1

Maybe she moved up to
Anchorage — maybe she's 7
gone back East...
living in the Caribbean —
Maybe she's in a bird cage somewhere, and — 6
Oh, I didn't mean that! Cool it
my tongue! — 5

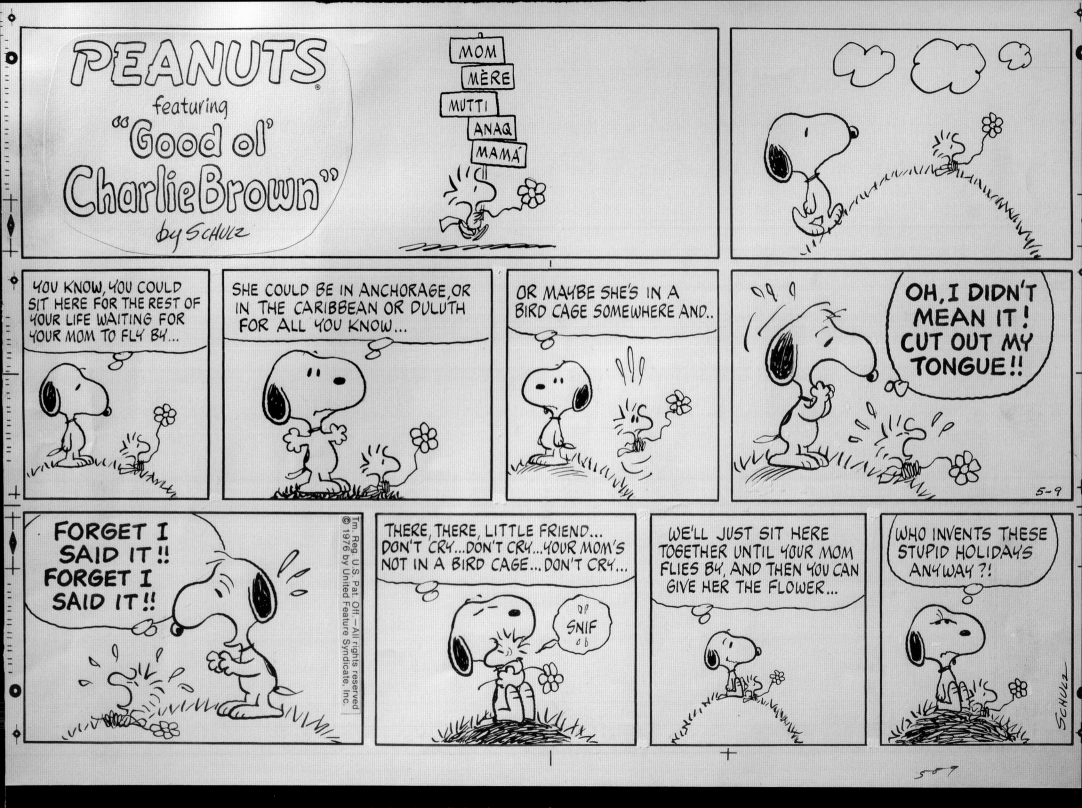

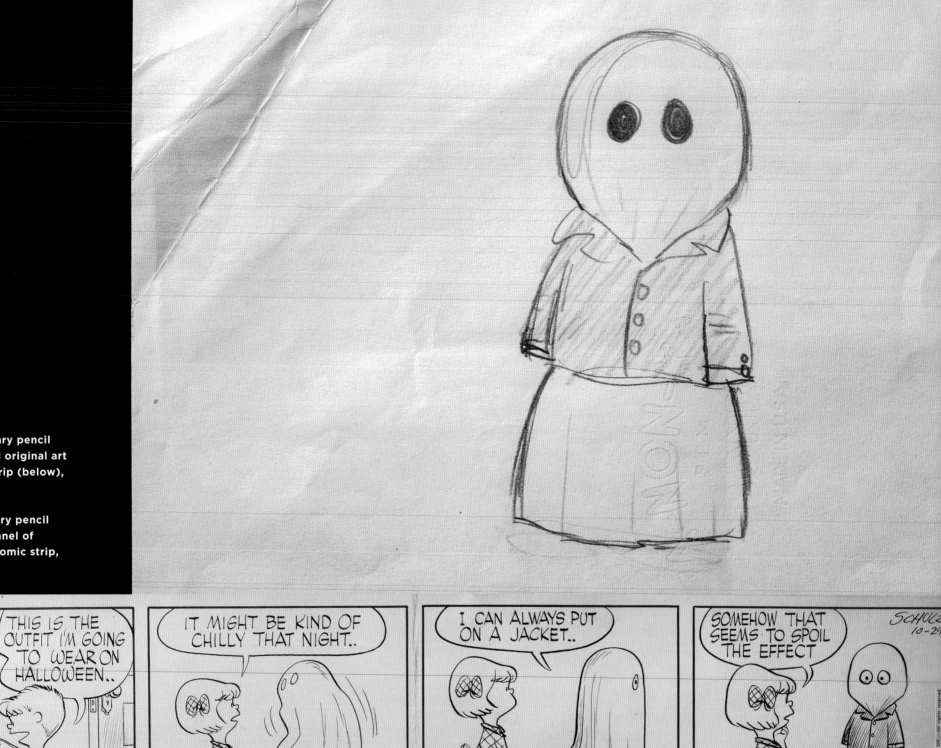

THIS PAGE **Preliminary pencil sketch (right) and original art for daily comic strip (below), October 29, 1954.**

OPPOSITE **Preliminary pencil sketch for final panel of unfinished daily comic strip, c. 1976.**

I WAS
Lectomnd
with they
where for

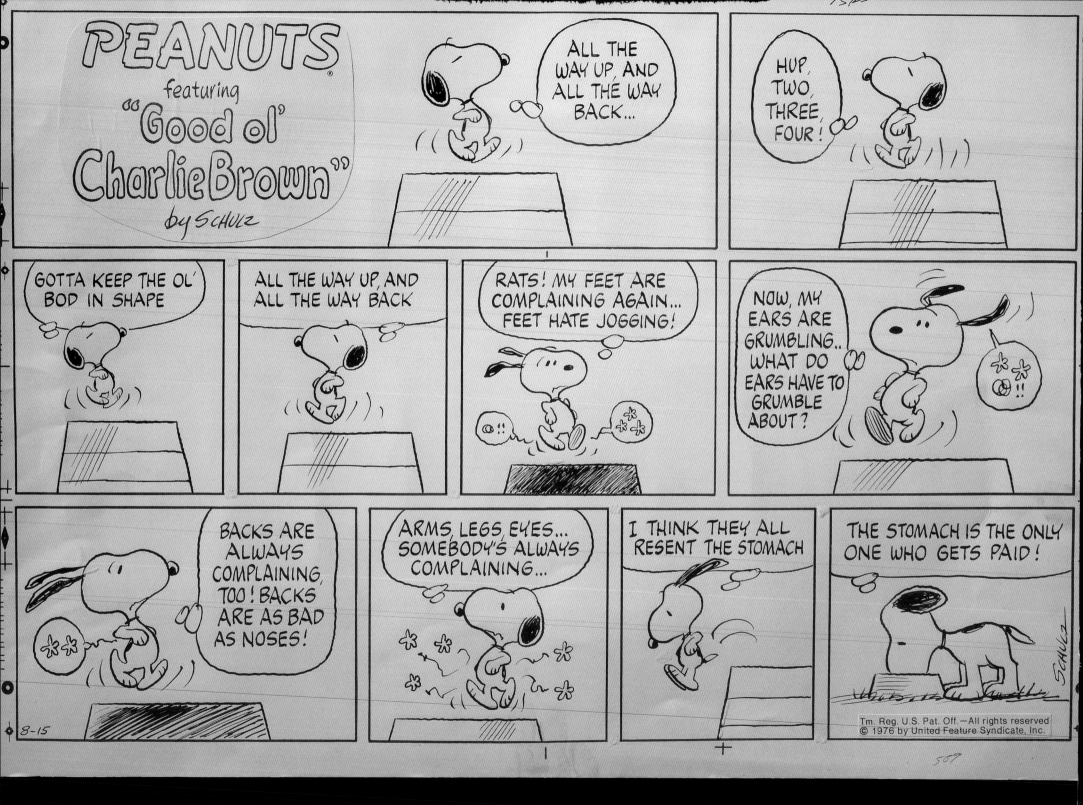

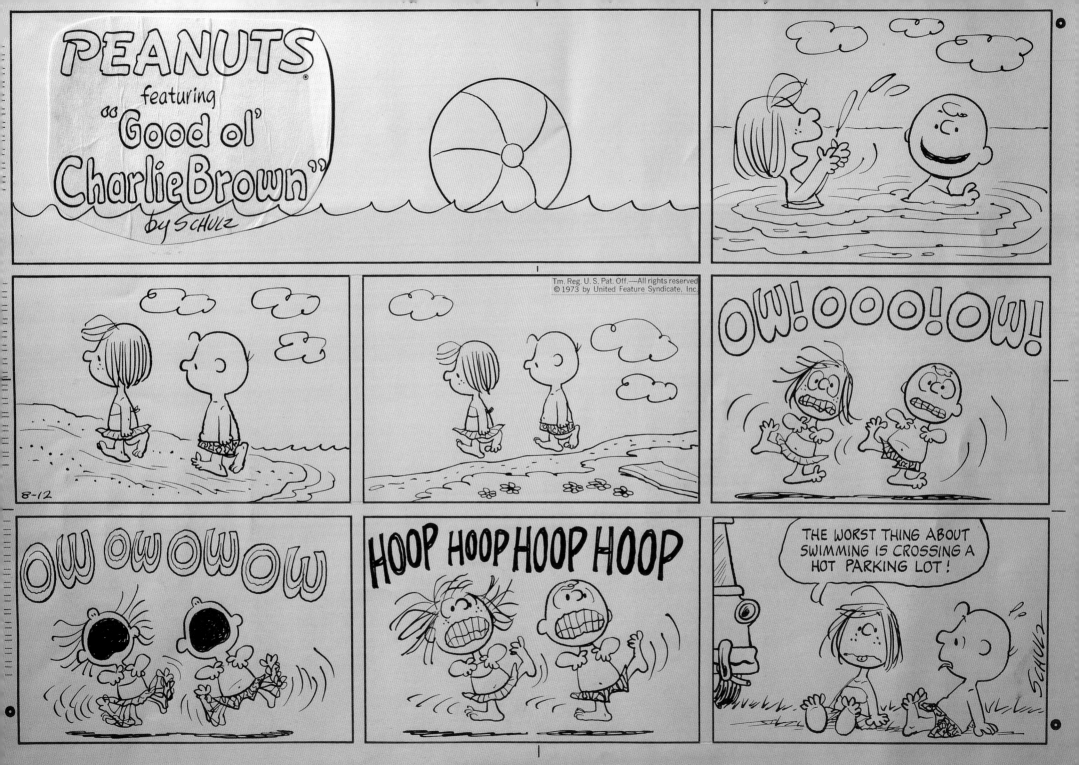

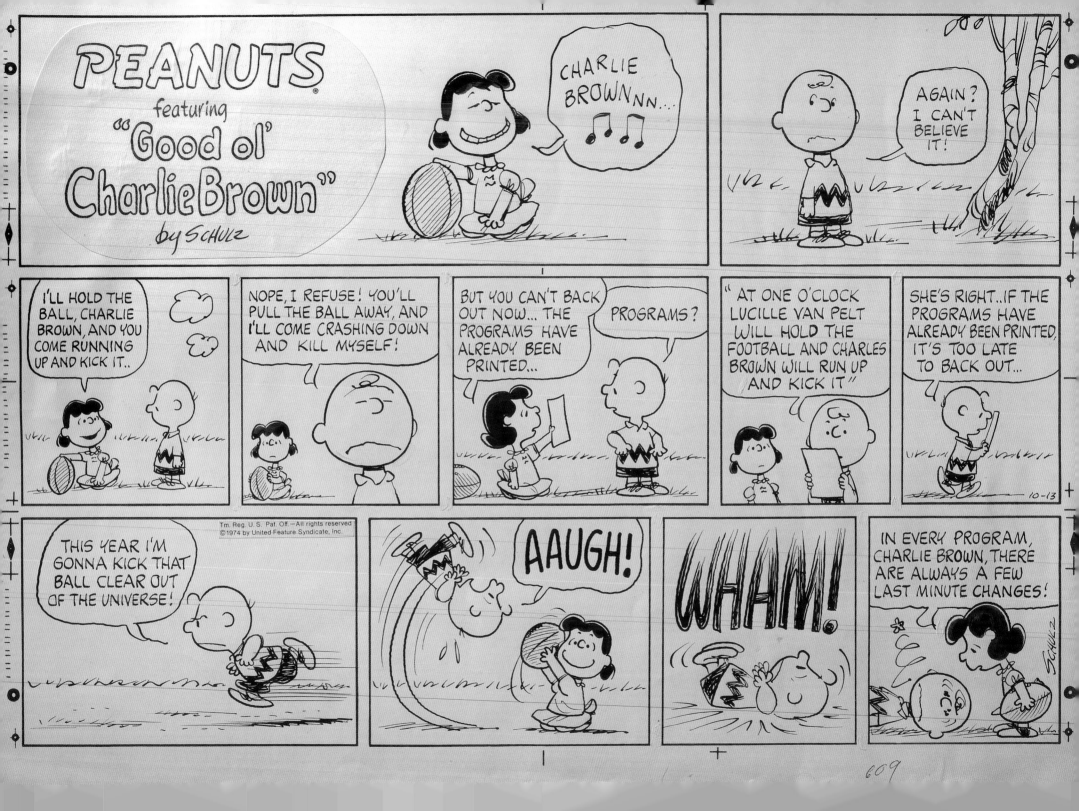

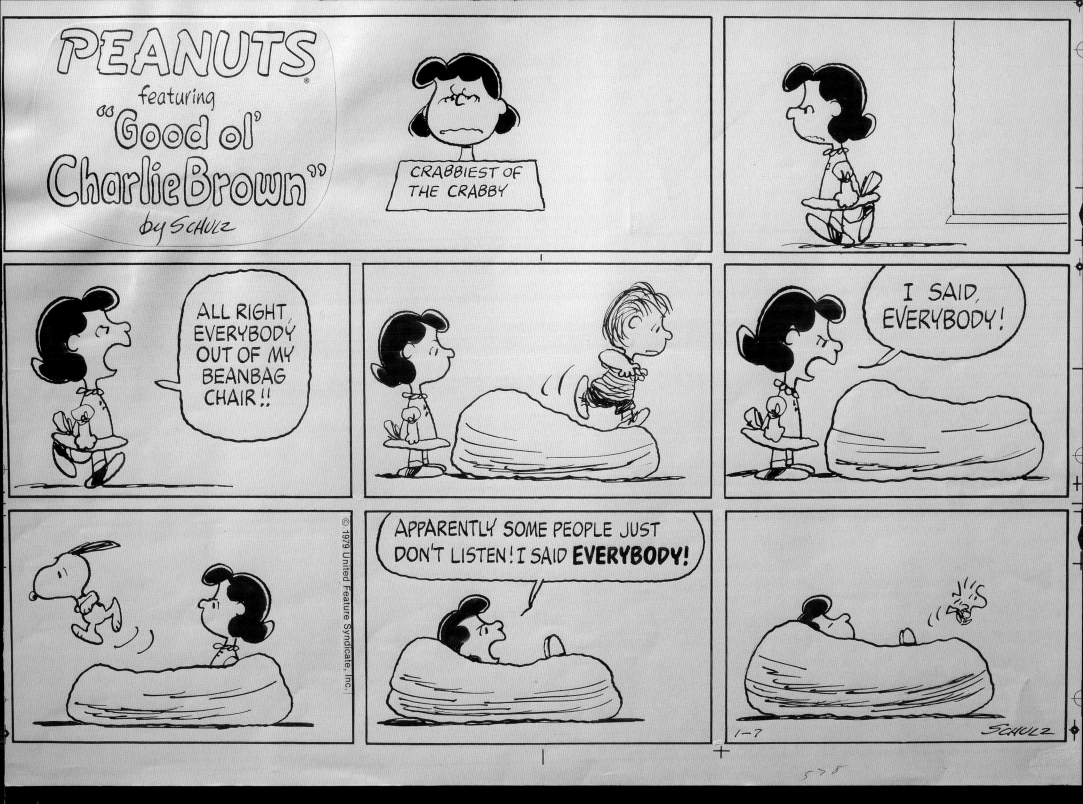

SCHULZ

SCHULZ

FAR LEFT Original art, Joe Cool Snoopy, c. 1970s.

ABOVE Original art, *Young Athlete* magazine cover, August 1977 (left).

OPPOSITE Painting on canvas, Snoopy on a "Wanted" sign, created for an ice-skating performance at the Redwood Empire Ice Arena (REIA) in Santa Rosa, California, c. 1980s.

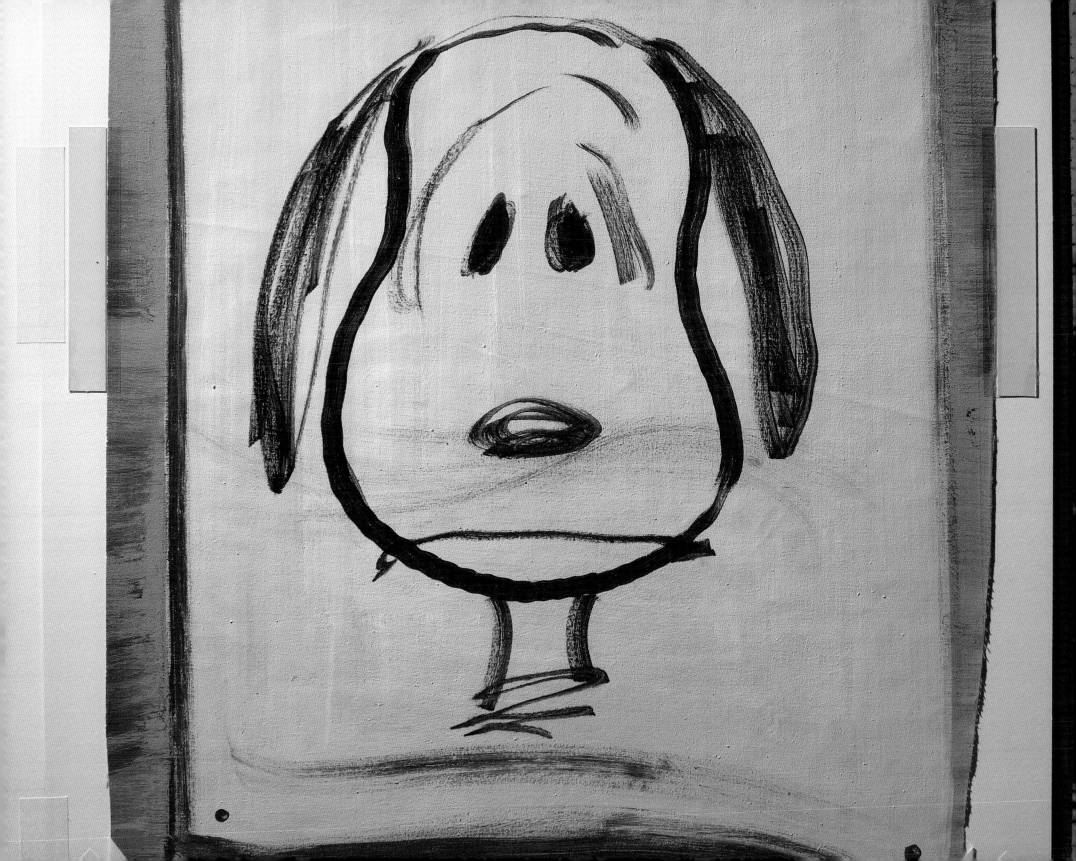

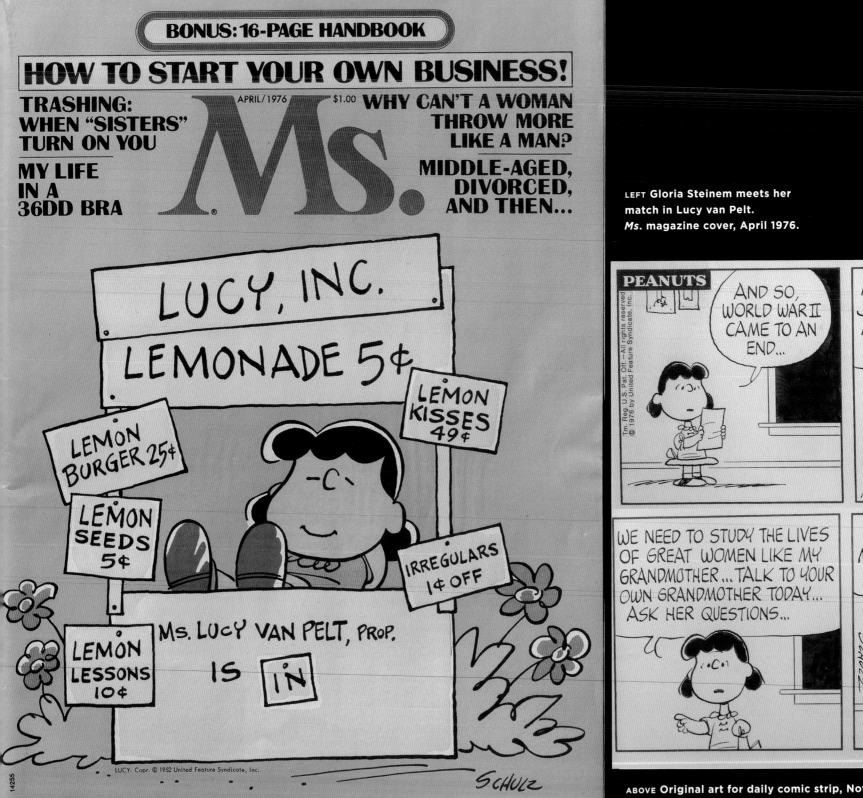

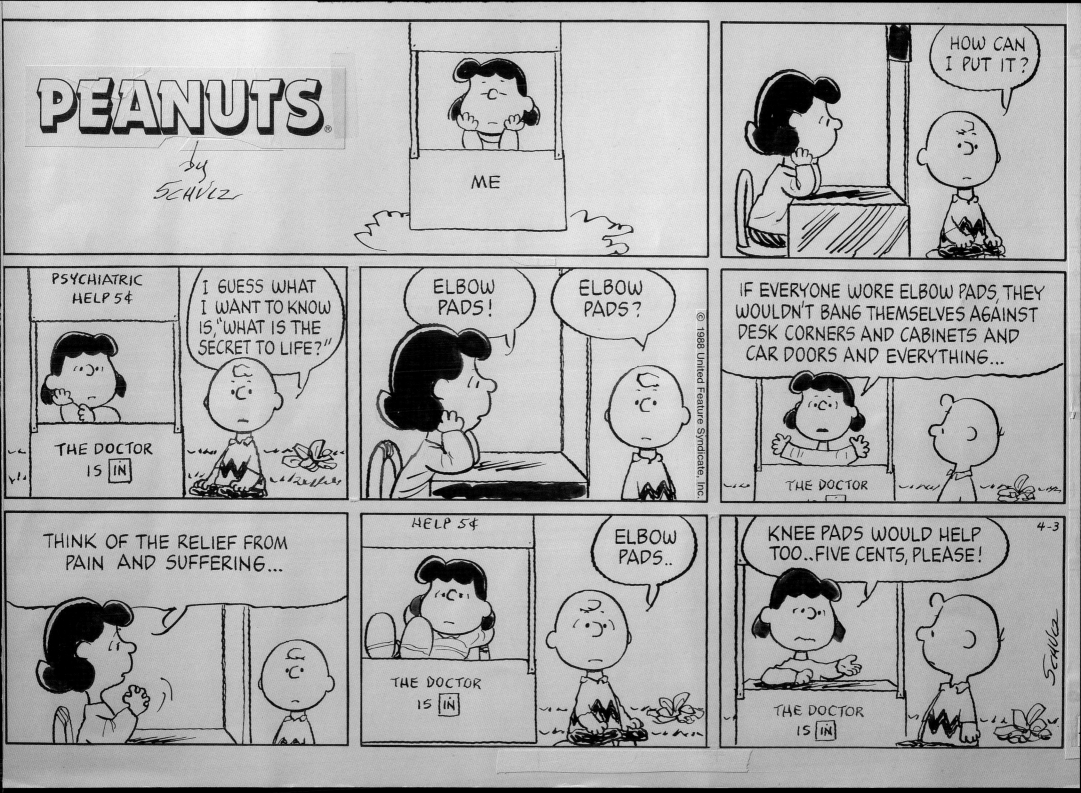

Original art for Sunday comic strip, April 3, 1988.

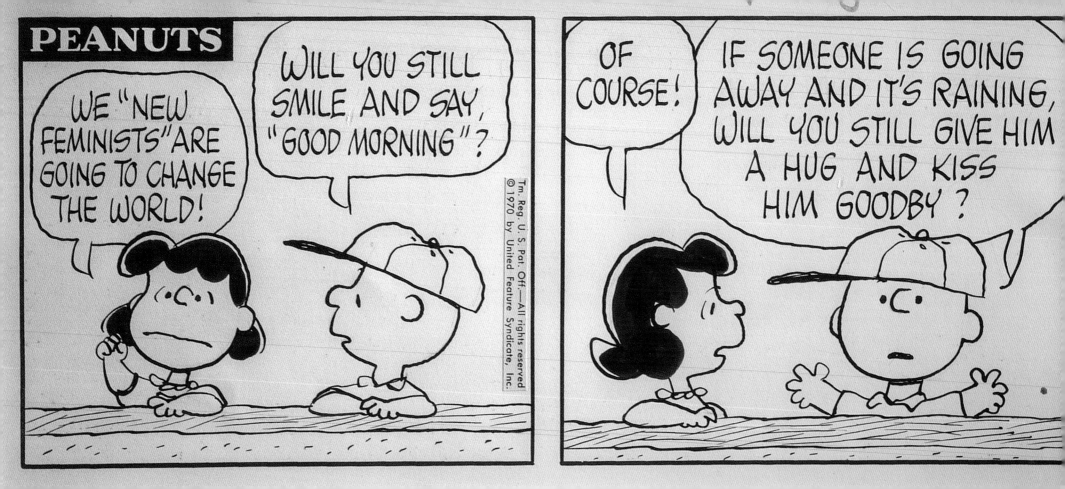

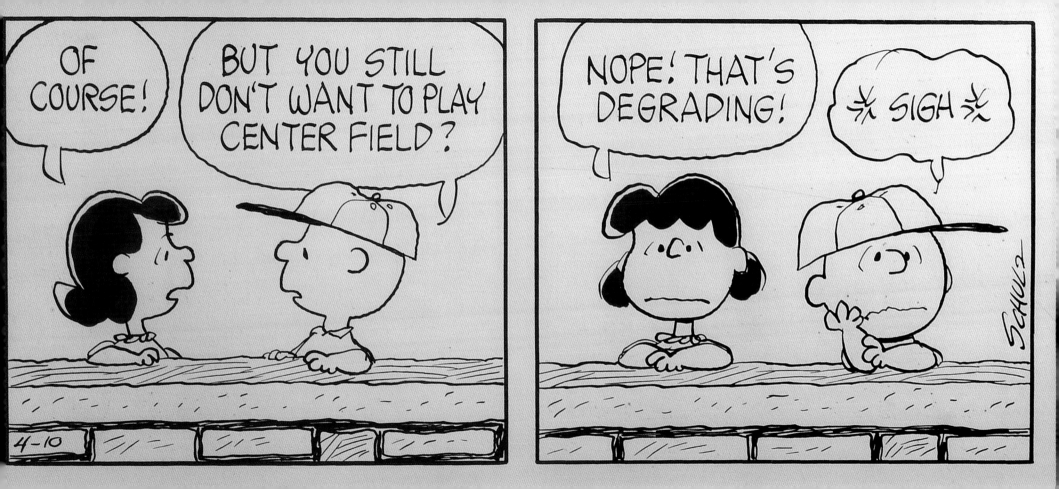

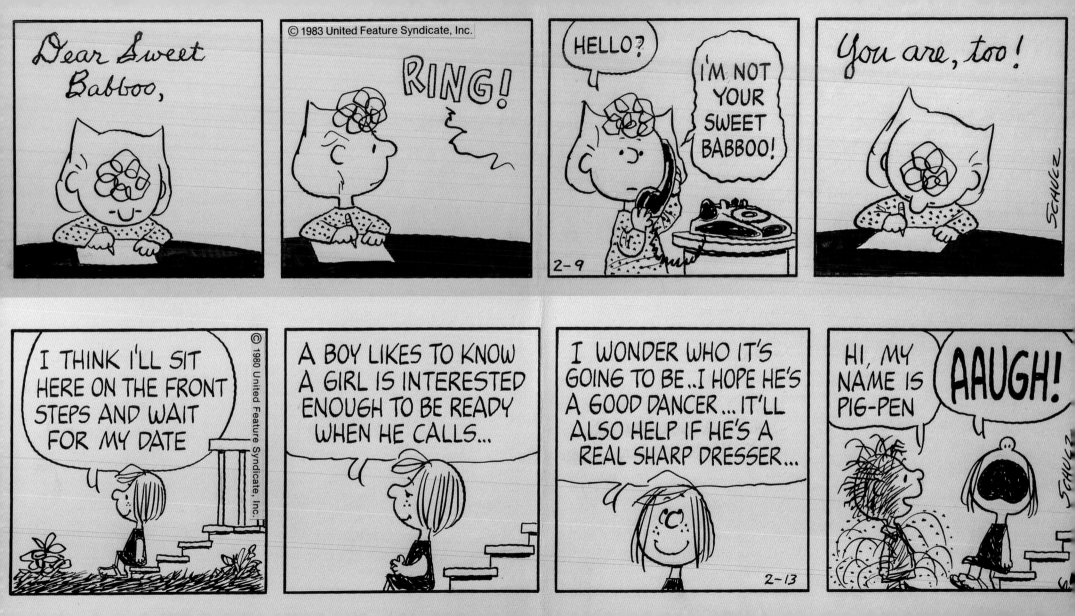

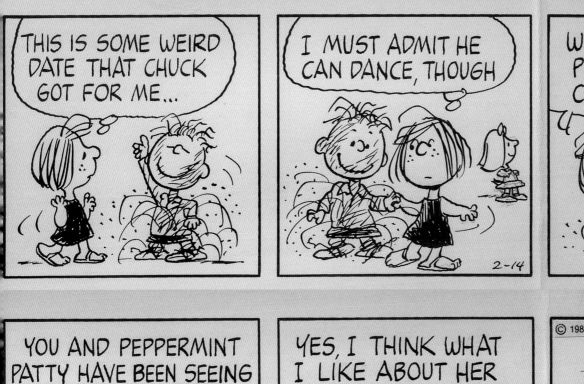
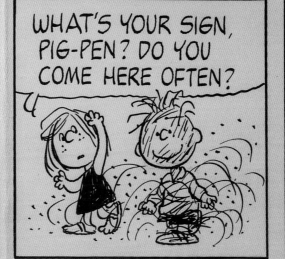
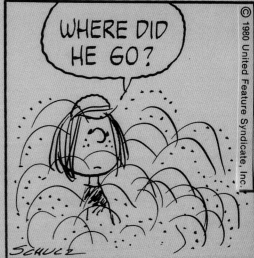
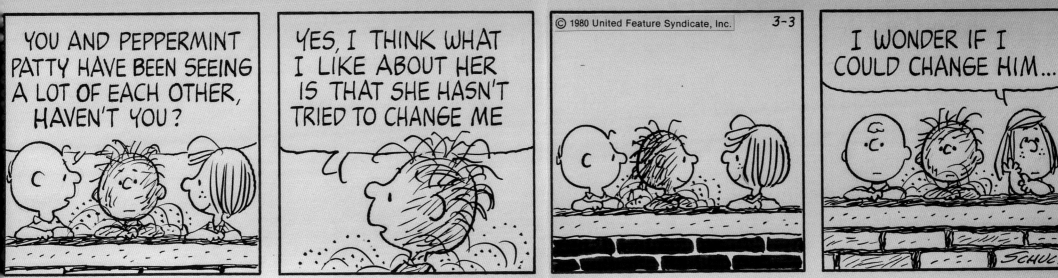

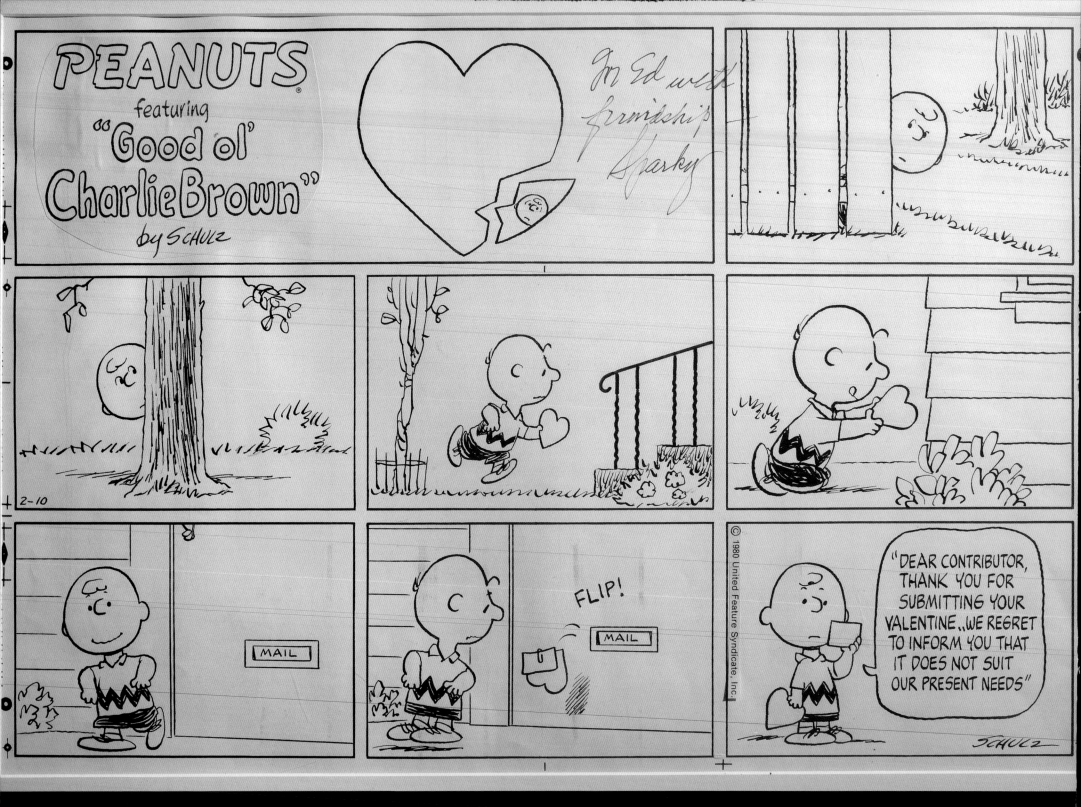

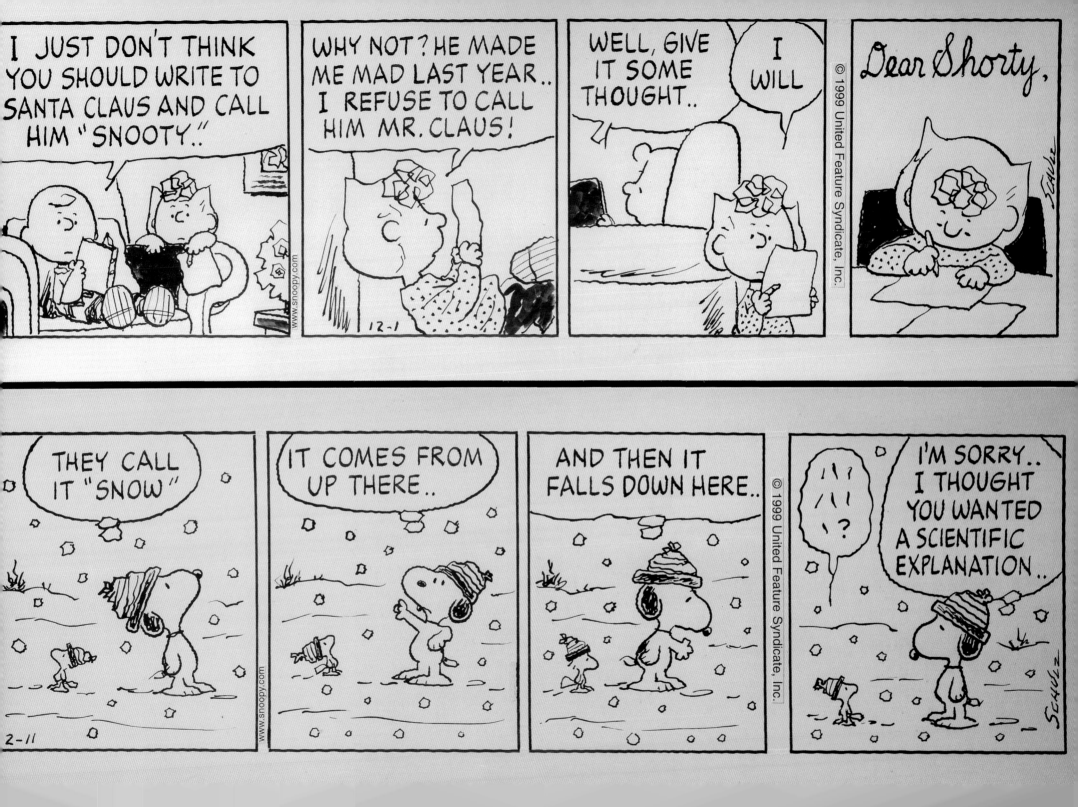

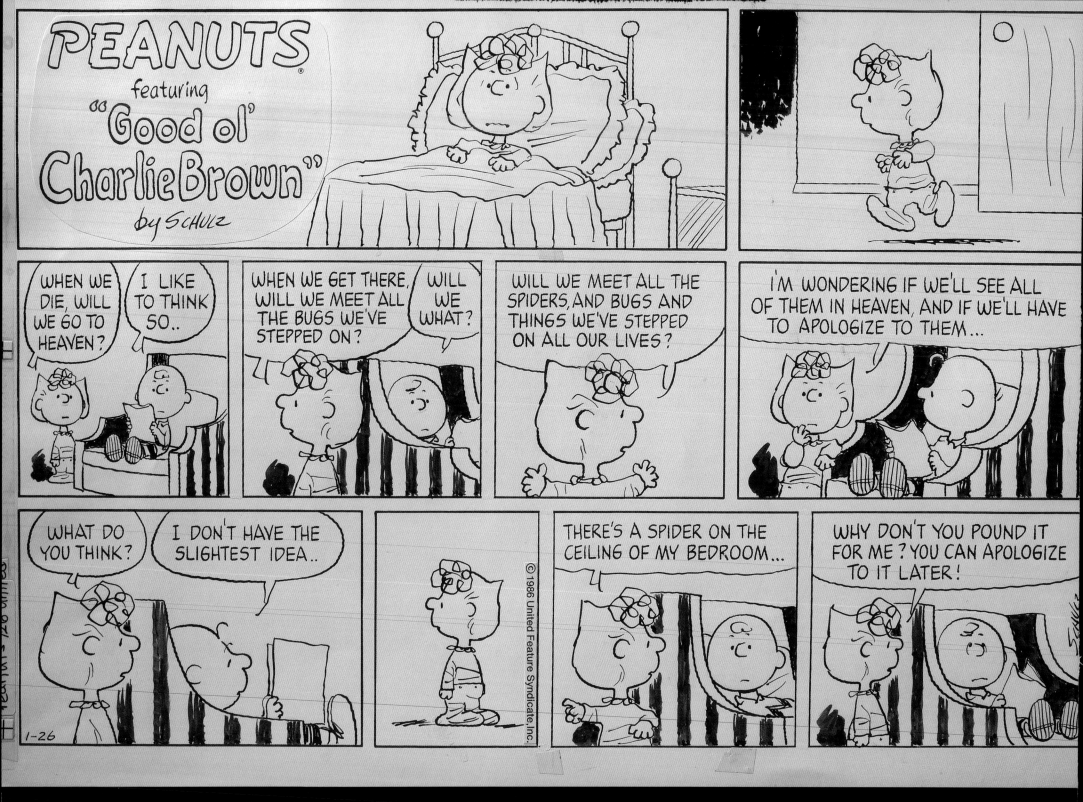

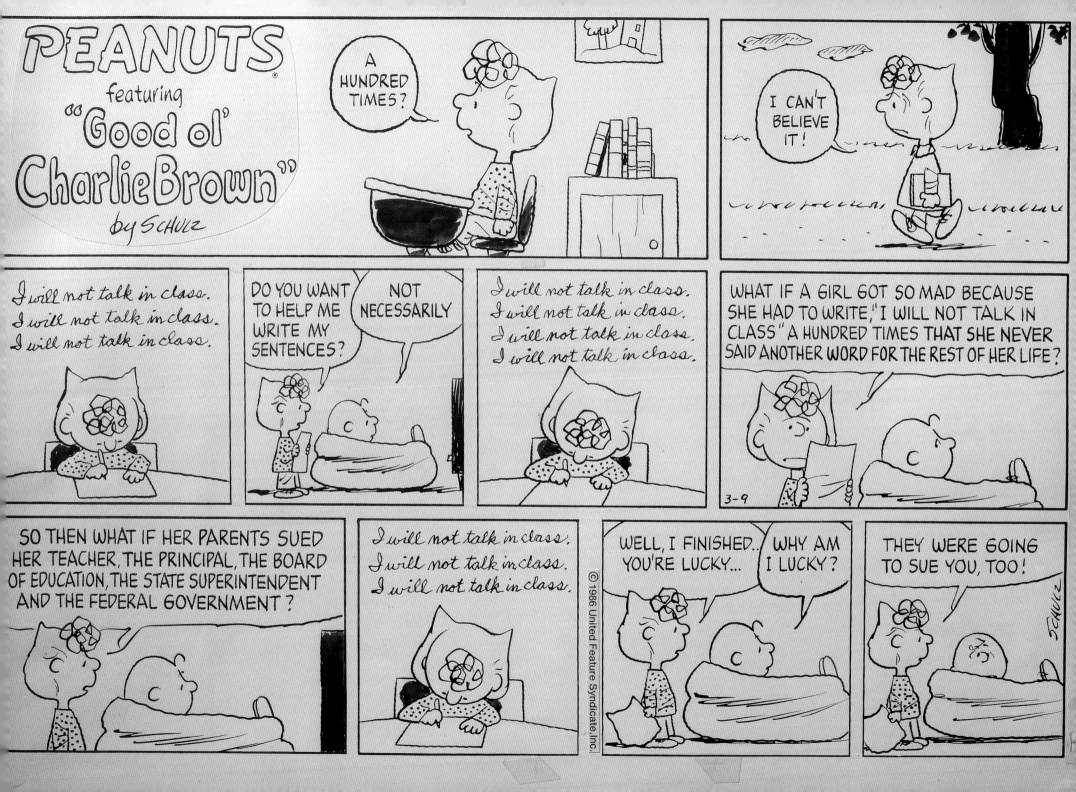

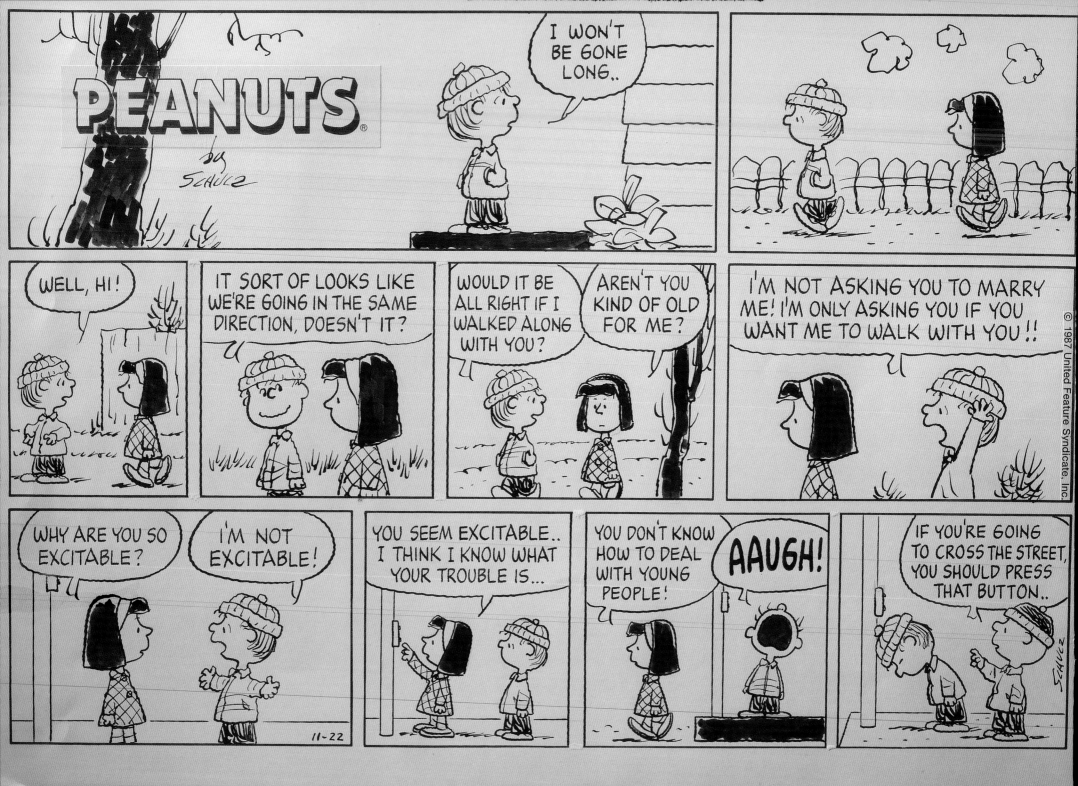

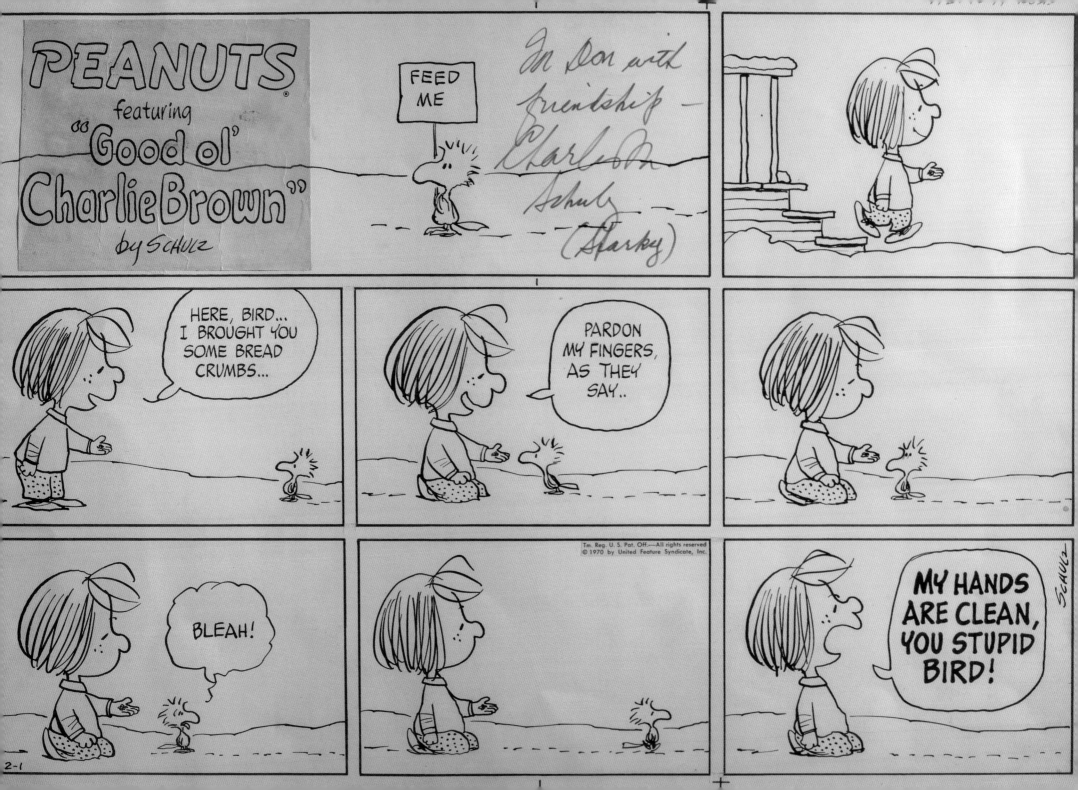

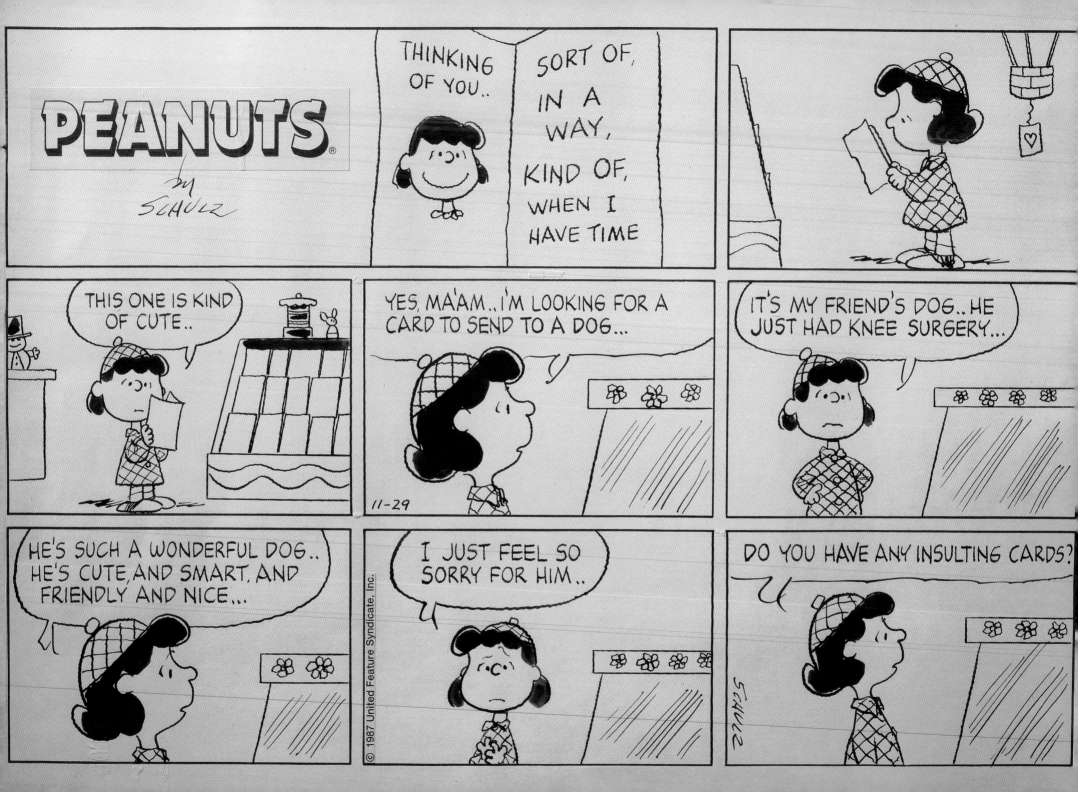

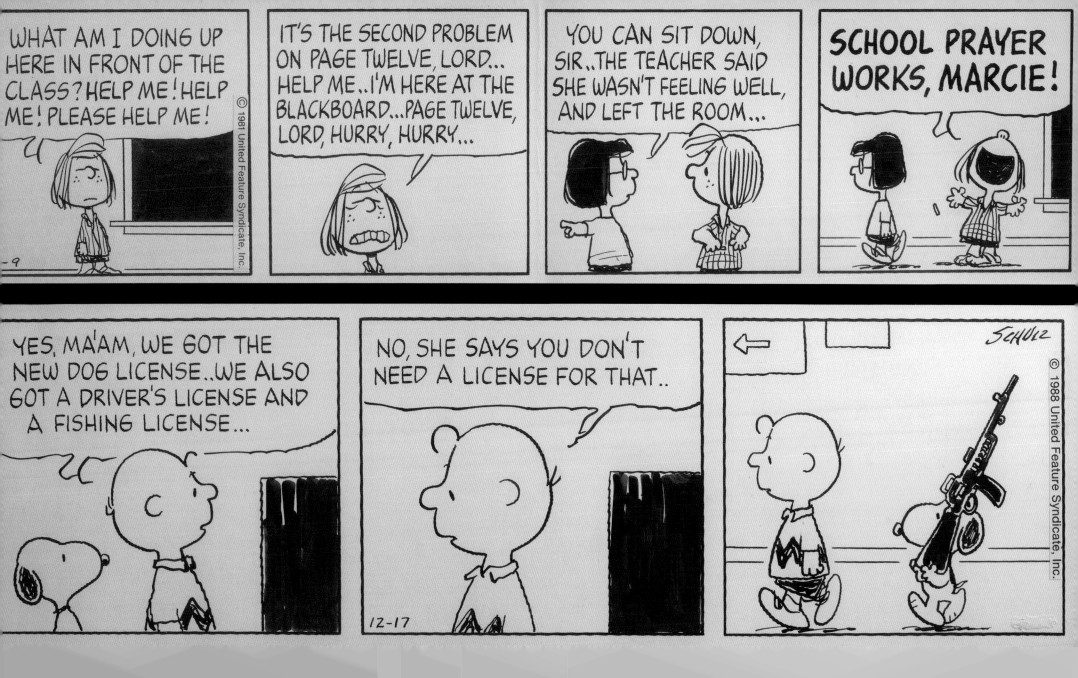

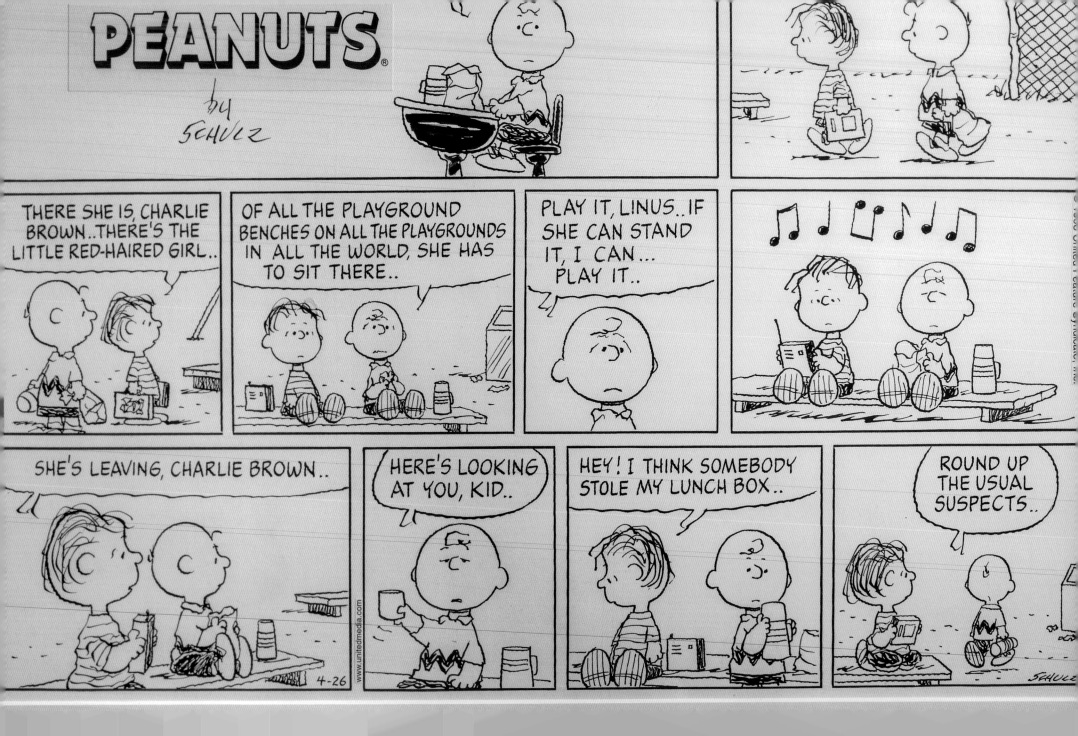

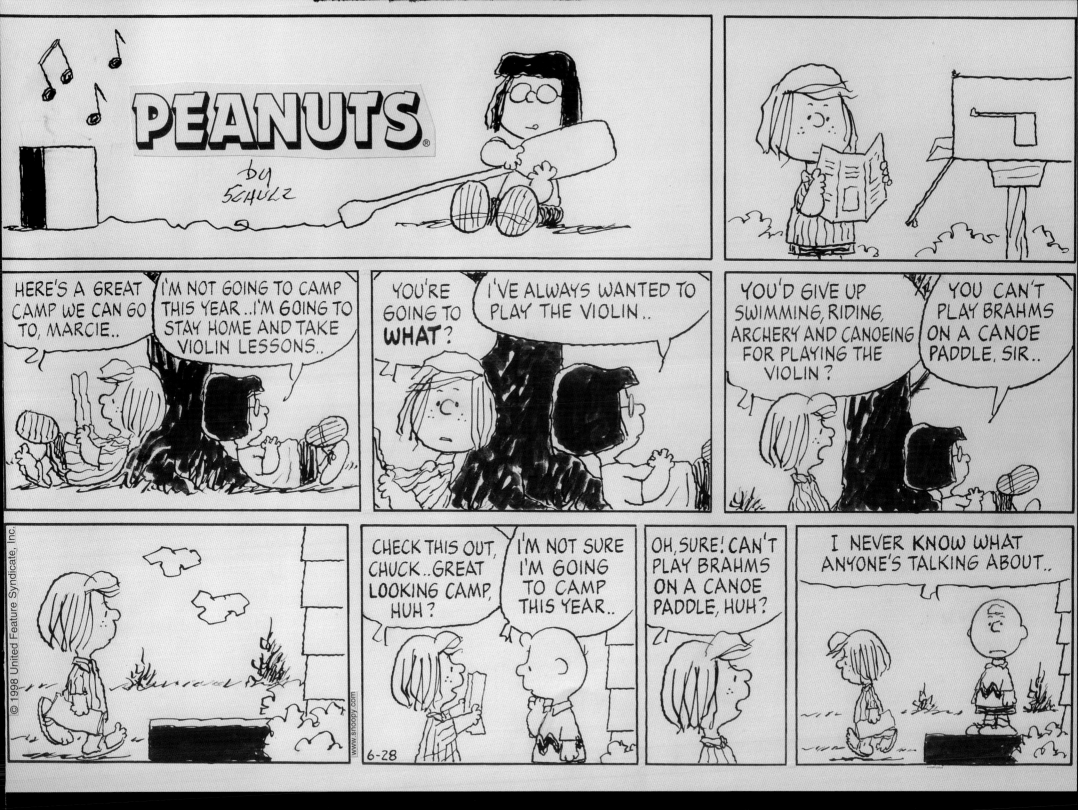

Decade after decade, Schulz's fame continued to soar as Charlie Brown, Snoopy, and the rest of *Peanuts* adorned the covers of magazines across the country.

LEFT TO RIGHT

TV Showtime cover, a supplement of *The Cleveland Press*, June 3–10, 1966.

TV Guide magazine cover, October 28–November 3, 1972.

Liberty magazine cover, Winter 1973.

TV SHOWTIME

The Cleveland Press
JUNE 3-10, 1966

You're Out, Charlie Brown!

Local Programs Oct. 28-Nov. 3 15¢

TV GUIDE

Good Grief! Another Charlie Brown Special

And the man who made it all happen↑
Page 34

THE GREAT CARTOONS OF THE CENTURY
75¢

Liberty Winter 1973 Then & Now

32 WAYS TO MAKE A MILLION DOLLARS

WIRETAPPING: IS SOMEONE LISTENING ON YOUR PHONE?

BOBBY RIGGS TELLS HIS SIDE OF THE TENNIS STORY

EMILY POST ON HOUSE PARTIES

MEMORABLE STORIES BY BEN HECHT JOHN D. MACDONALD KATHLEEN NORRIS ROBERT BENCHLEY

'PEANUTS'— HOW IT ALL BEGAN

COLLECTOR'S SERIES
(See Centerfold)

Dynamite
THIS IS YOUR LIFE, SNOOPY!

TV3593 No.35

Dynamite

Charlie Brown, Superstar!

NOVEMBER 24, 1986 $1.95

Detroit Battles Back

TIME

Sex Education

- **What Should Children Know?**
- **When Should They Know It?**

—TODAY—
in ROOM 301—
"THE BIRDS AND THE BEES"
(AND MUCH MUCH MORE!)

LEFT TO RIGHT

Dynamite no. 6 magazine cover, December 1974.

Dynamite no. 35 magazine cover, May 1977.

Time magazine cover, November 24, 1986.

OPPOSITE **Original art for Sunday comic strip, October 24, 1999.**

SIX TV2974

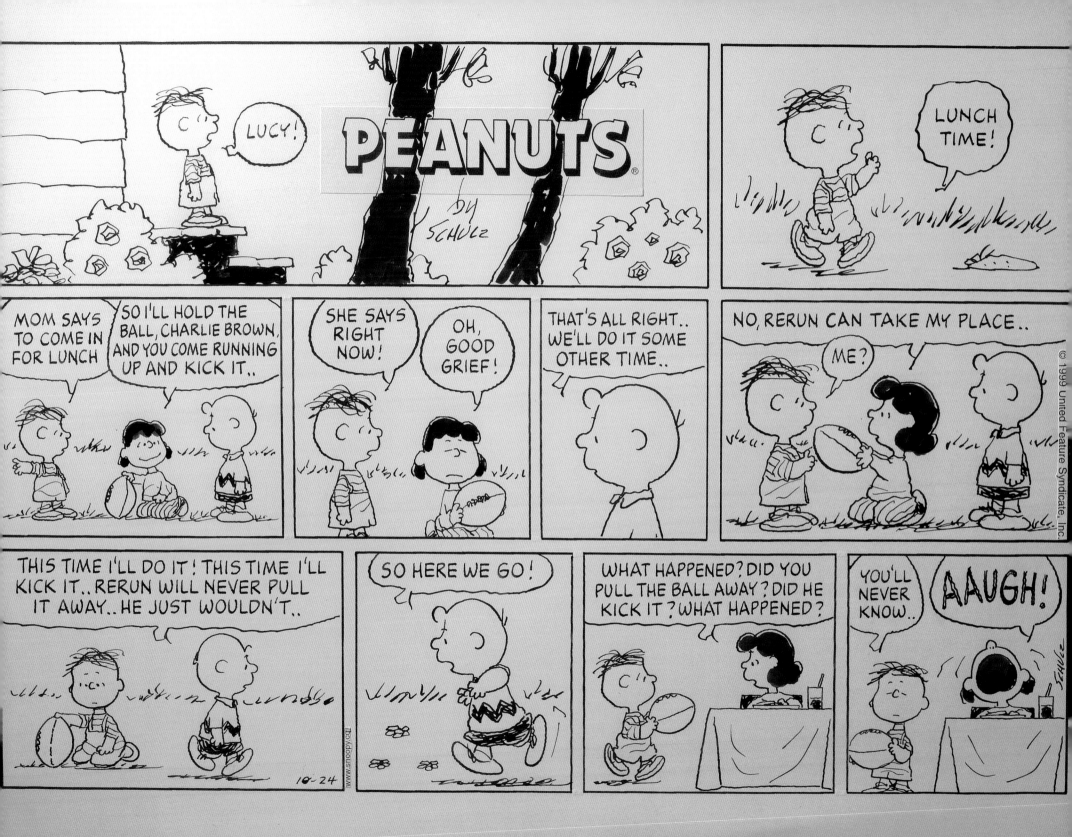

9-13-91

Schulz

OPPOSITE Unpublished original watercolor-and-pen drawing of a tree with sheep fence on the property of Egbury House, St. Mary Bourne village, Hampshire, England, September 13, 1991.

ABOVE Original ink-and-marker drawing, c. 1980s.

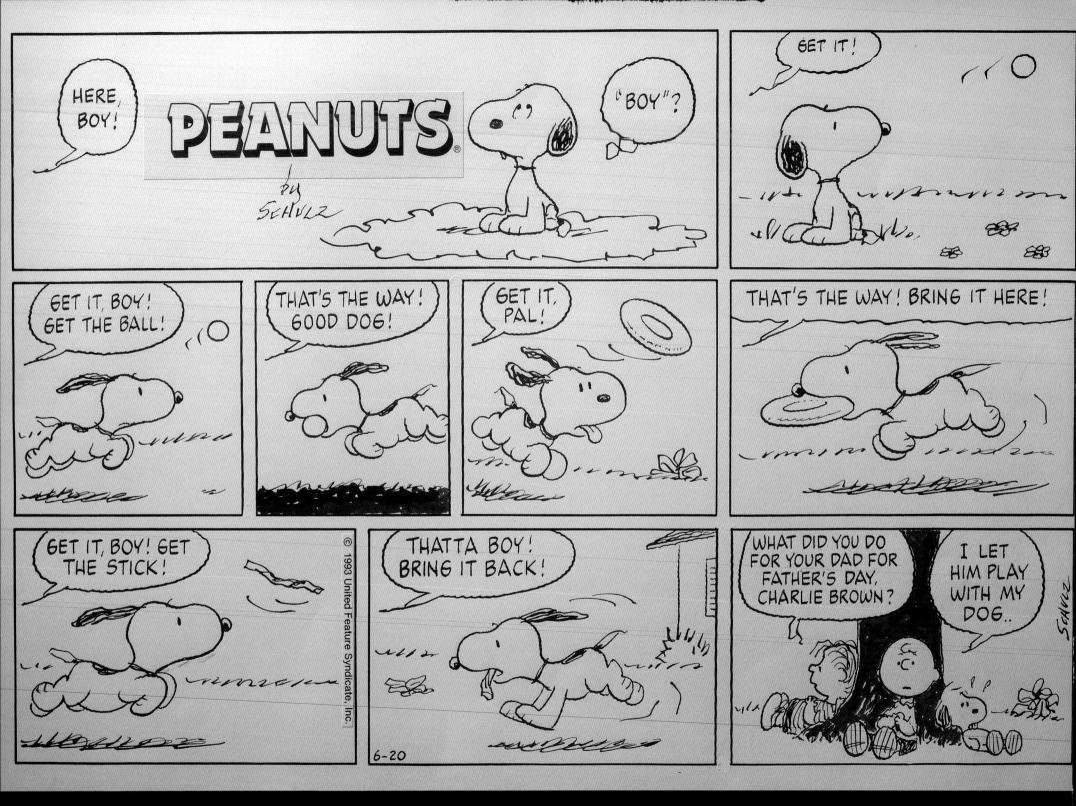

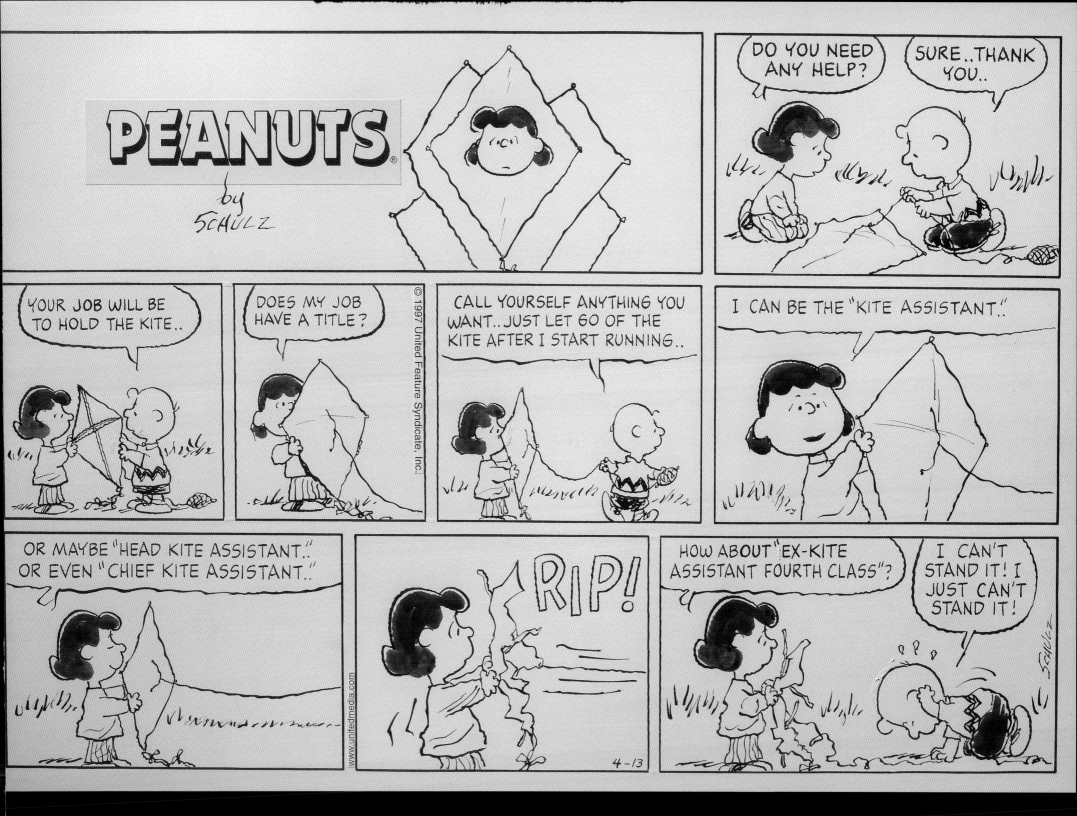

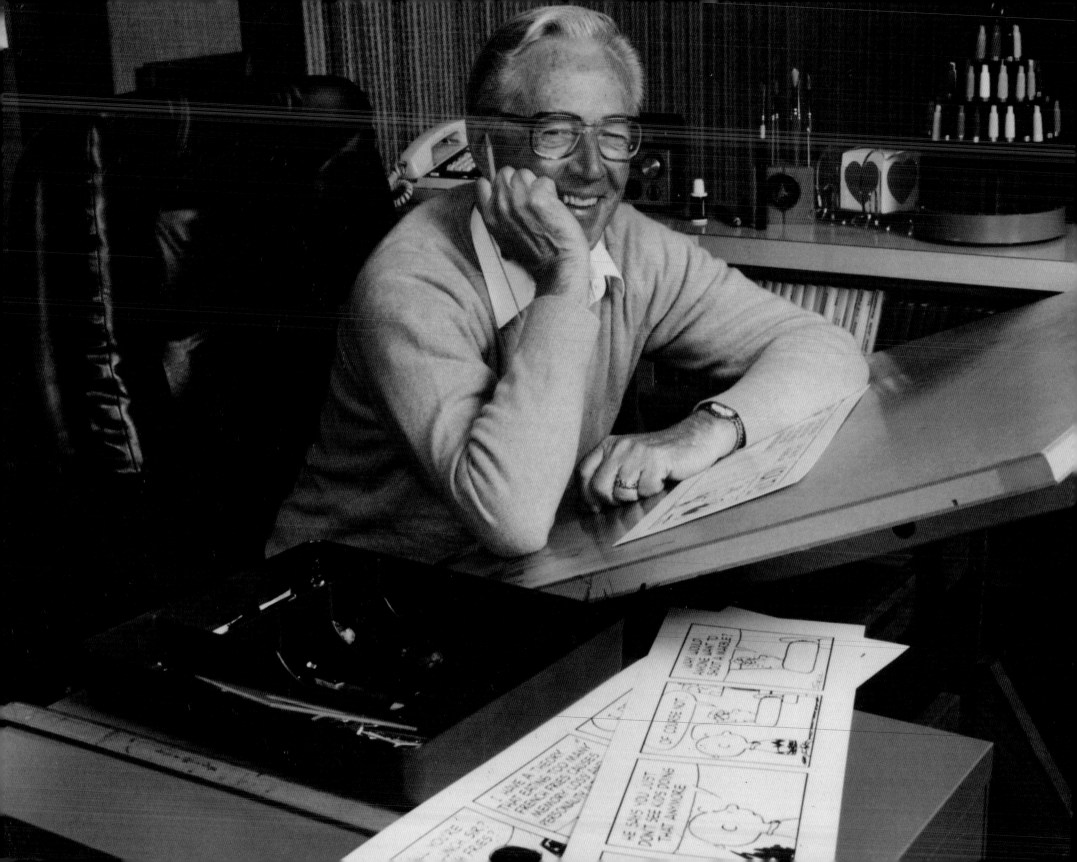

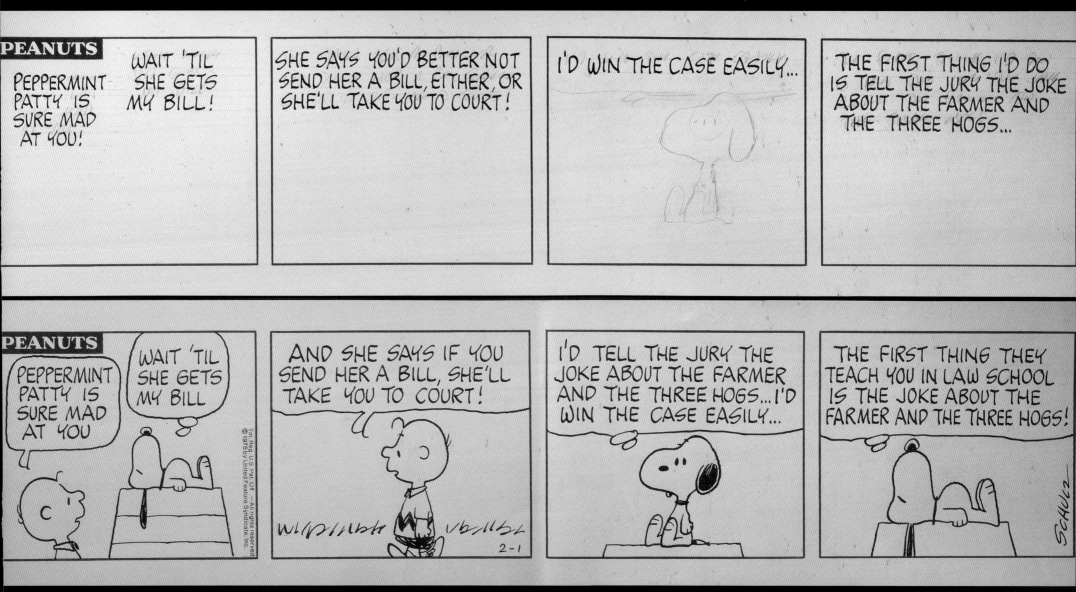

PEANUTS

PEPPERMINT PATTY IS SURE MAD AT YOU!

WAIT 'TIL SHE GETS MY BILL!

SHE SAYS YOU'D BETTER NOT SEND HER A BILL, EITHER, OR SHE'LL TAKE YOU TO COURT!

I'D WIN THE CASE EASILY...

THE FIRST THING I'D DO IS TELL THE JURY THE JOKE ABOUT THE FARMER AND THE THREE HOGS...

PEANUTS

PEPPERMINT PATTY IS SURE MAD AT YOU

WAIT 'TIL SHE GETS MY BILL

AND SHE SAYS IF YOU SEND HER A BILL, SHE'LL TAKE YOU TO COURT!

I'D TELL THE JURY THE JOKE ABOUT THE FARMER AND THE THREE HOGS...I'D WIN THE CASE EASILY...

THE FIRST THING THEY TEACH YOU IN LAW SCHOOL IS THE JOKE ABOUT THE FARMER AND THE THREE HOGS!

2-1

Throughout his career, Schulz discarded working sketches or gave them away, and it is because of this latter practice that much of the material in this book survived and is now part of the archives at the Charles M. Schulz Museum and Research Center.

Many of these last working drawings on newsprint or yellow legal paper are crumpled because Schulz balled them up and tossed them into the trash. Luckily, Edna Poehner, the Creative Associates secretary from 1995 to 2003, rescued as many of these from the dustbin of history as she could, knowing these preliminary roughs provided invaluable insight into Schulz's thought processes at this later stage of his career.

LEFT **Pencil sketch for daily comic strip, April 7, 1999.**

OPPOSITE **Original art for Sunday comic strip, May 6, 1984.**

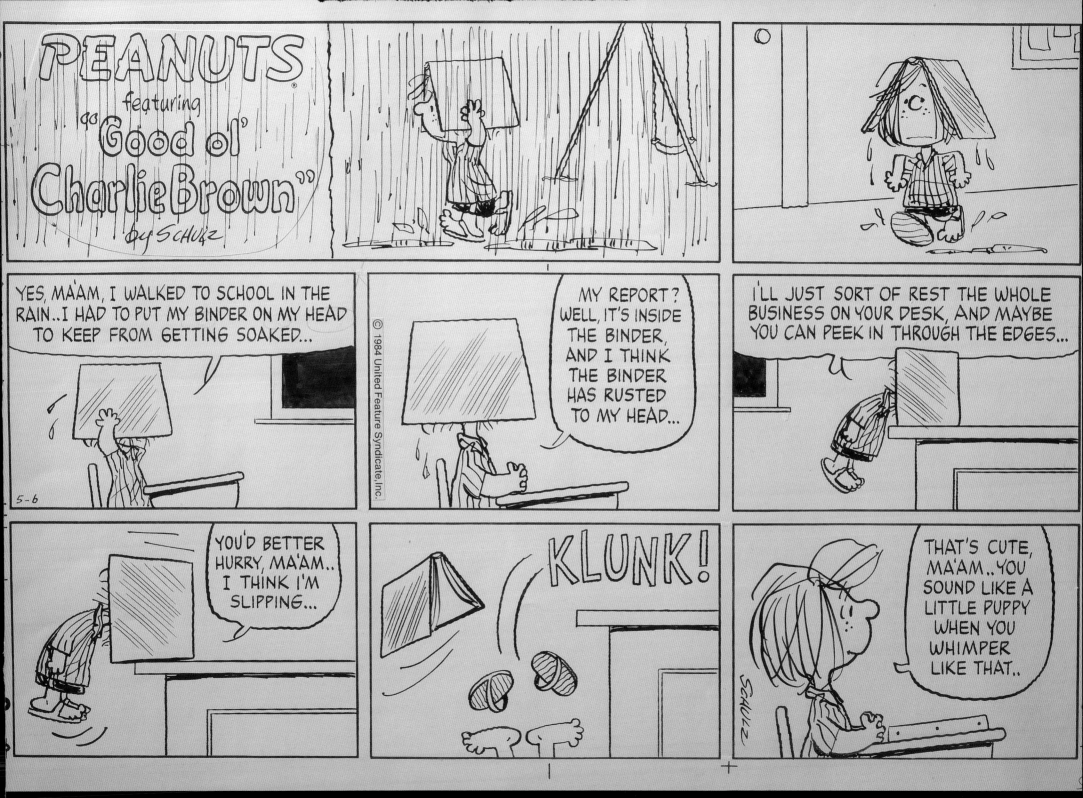

8/1994/sparky for Donovan

Original art for daily comic strip,
February 10, 1999 (opposite top),
and related pencil sketch, dated
December 17, 1998 (this page).

Original art for daily comic strip,
February 12, 1999 (opposite bottom),
and related pencil sketch, dated
December 18, 1998 (following page).

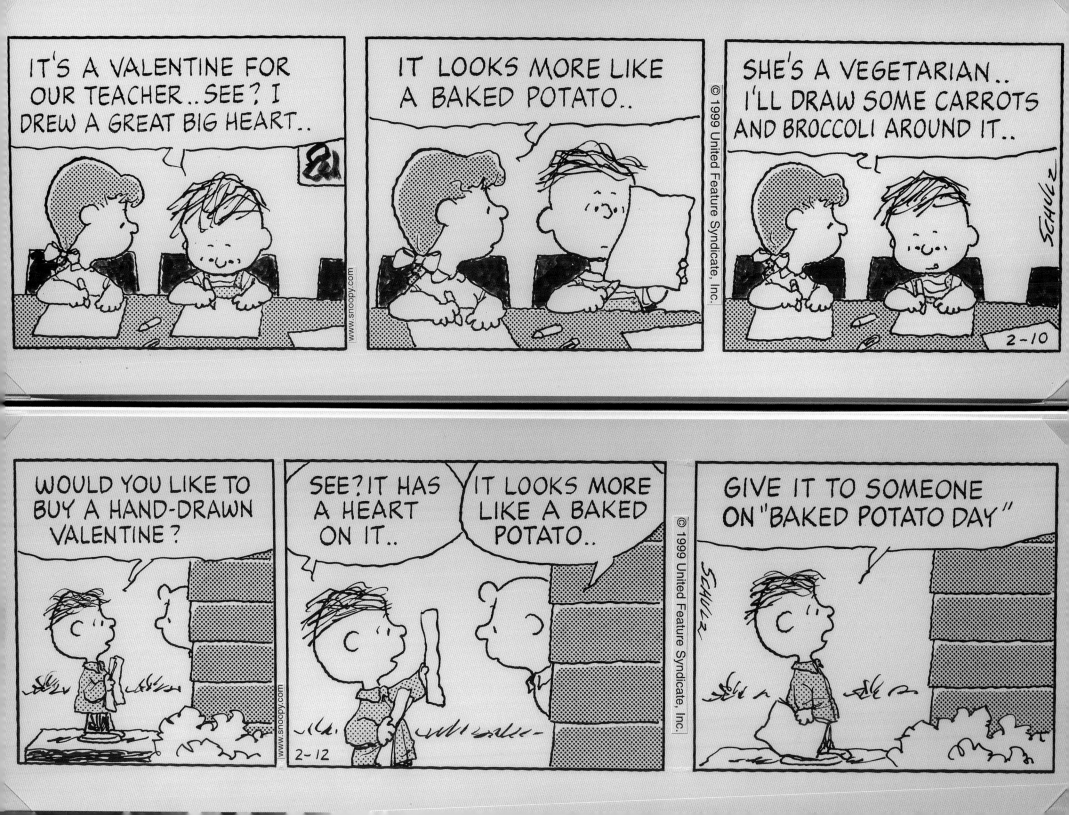

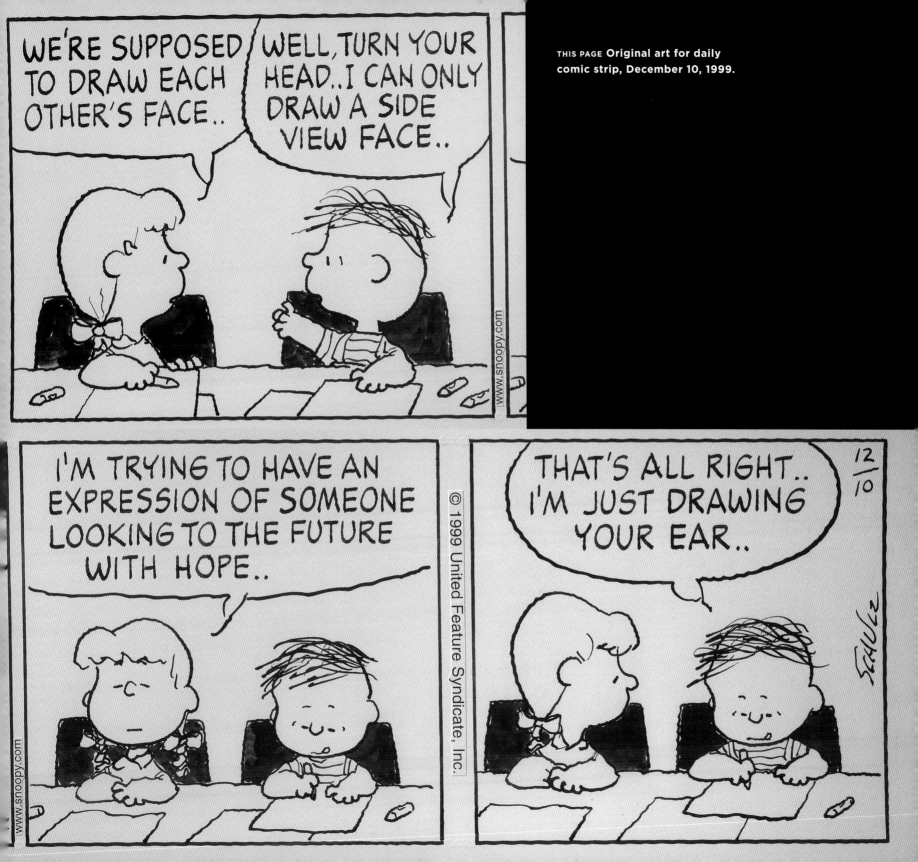

THIS PAGE Original art for daily comic strip, December 10, 1999.

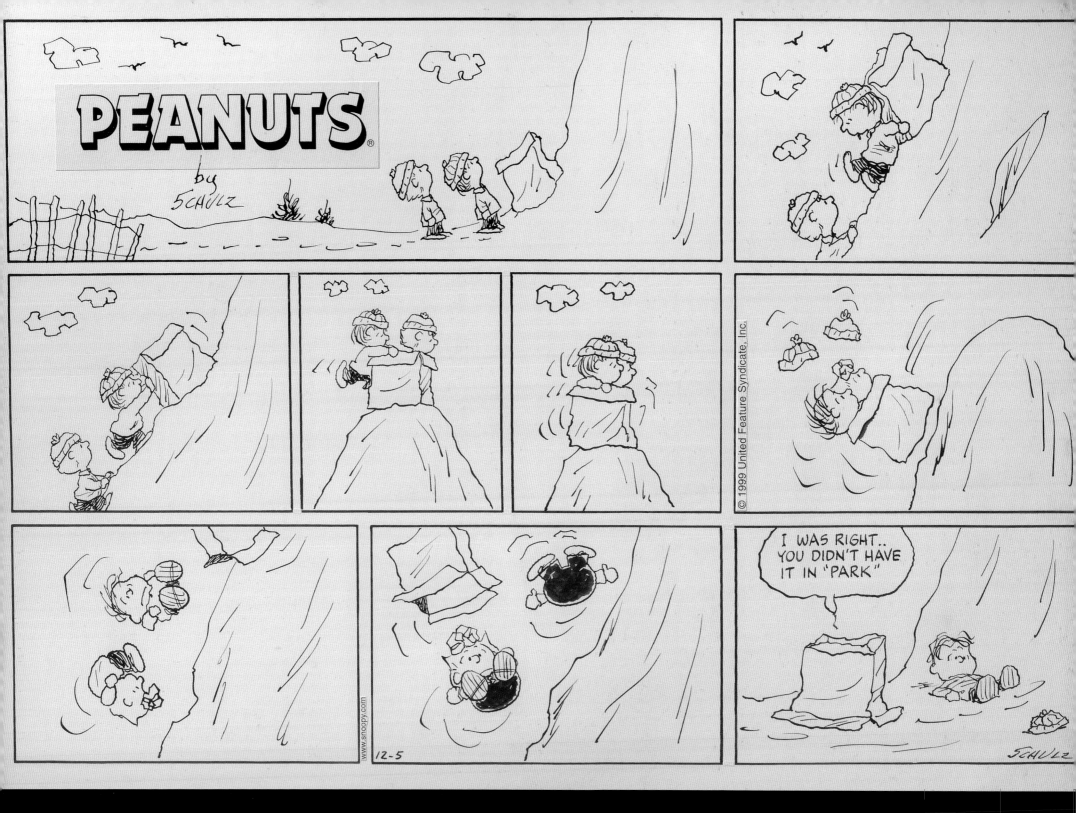

PEANUTS by SCHULZ

ME?

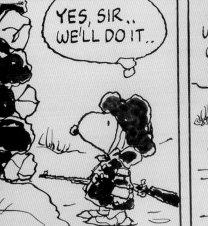

YES, SIR.. WE'LL DO IT..

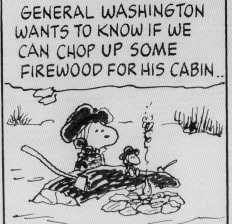

GENERAL WASHINGTON WANTS TO KNOW IF WE CAN CHOP UP SOME FIREWOOD FOR HIS CABIN..

1-16

www.snoopy.com

© 2000 United Feature Syndicate, Inc.

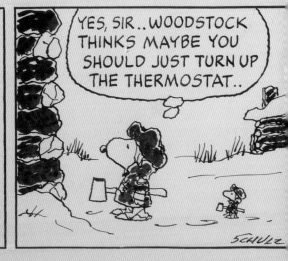

YES, SIR.. WOODSTOCK THINKS MAYBE YOU SHOULD JUST TURN UP THE THERMOSTAT..

SCHULZ

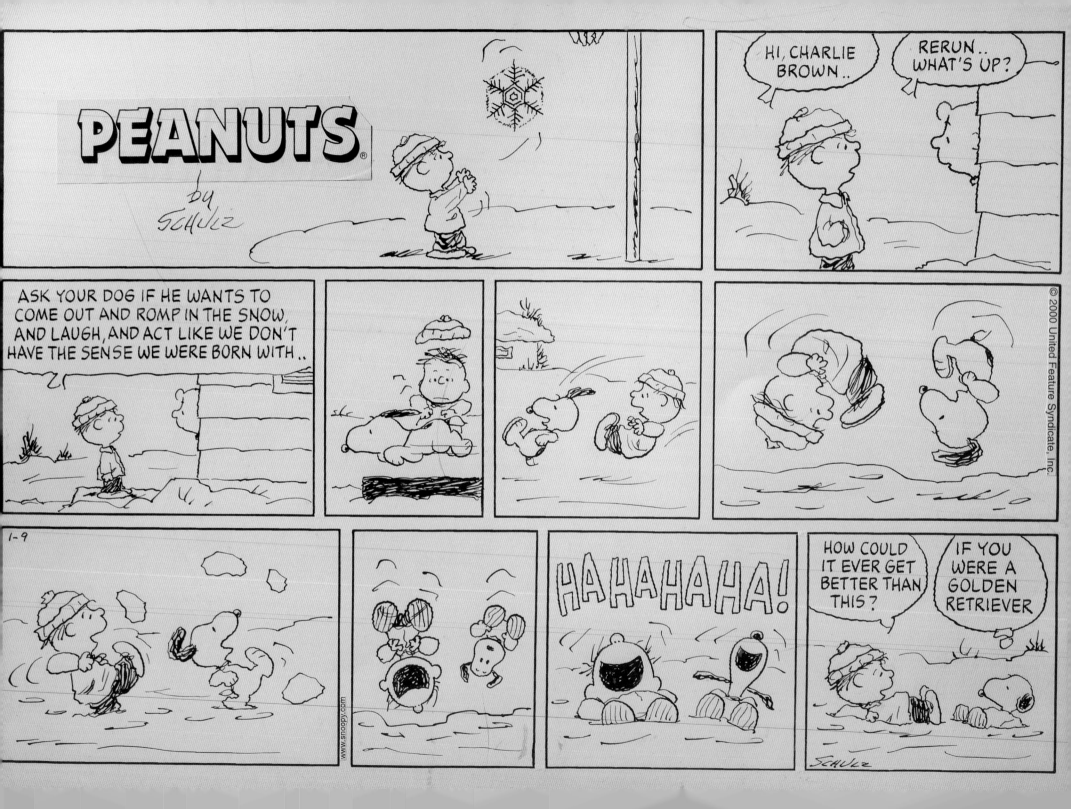

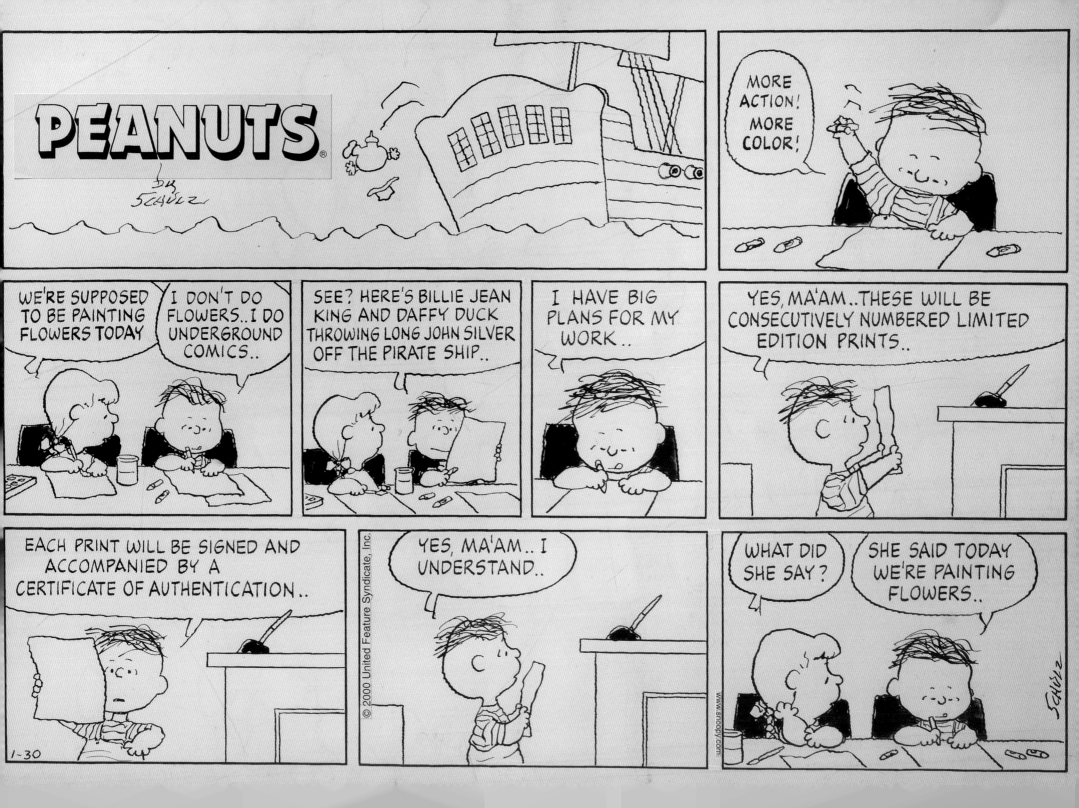

66When you're talking about people who make their living at [cartooning], I think you are simply discussing someone who just likes to draw funny pictures, and that's what I like to do. I would be doing this even if I had to do something else to make a living. I just enjoy drawing funny pictures. That doesn't mean that I'm having the time of my life every day. Sometimes it's plain hard work.99 —*CMS*

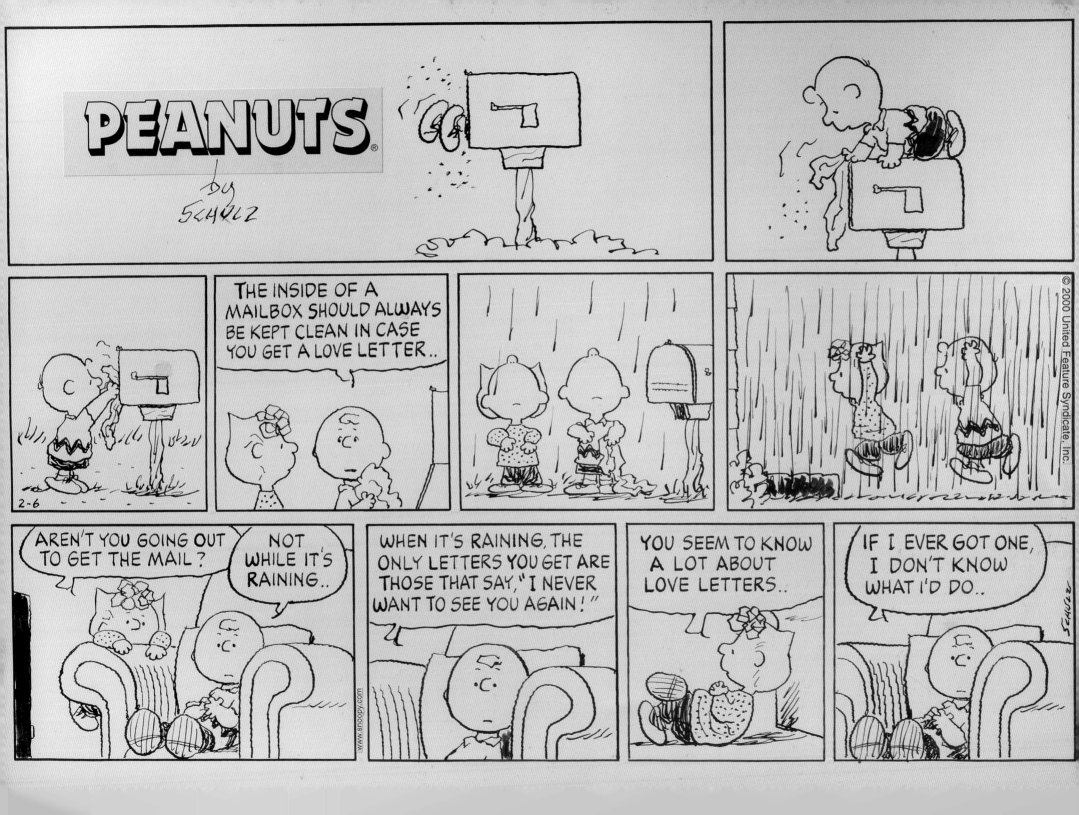

7/13/99

2004.003.011

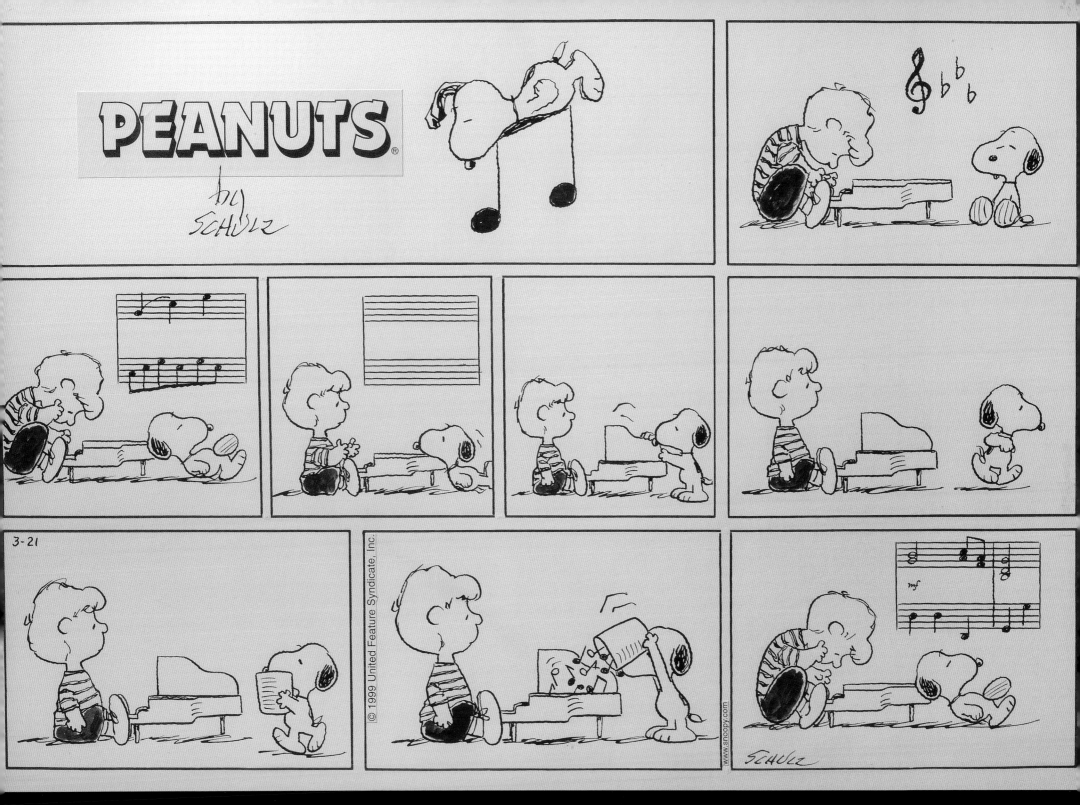

THANKS A TRILLION.

People trust MetLife so much that we now have over a trillion dollars worth of life insurance in force. That makes MetLife the largest issuer of life insurance in North America. We got there by offering excellent insurance products, quality service and by being careful and conservative in our investments.

You made us what we are today. Thanks a trillion.

GET MET. IT PAYS.®
✳ MetLife®

> **"**I cannot help that the comic strip brings in a good deal of money. I do not draw the comic strip to make money. I draw it because it is the one thing I feel I do best.**"** —*CMS*

In 1985, the *Peanuts* characters began appearing in an advertising campaign for the Metropolitan Life Insurance Company that continues to this day. It is a natural fit: One of the most important qualities an insurance company wants to instill in its customers is trust, and after thirty-five years (at the time), Charlie Brown had more than earned it. Pairing established cartoon characters with such an enormous concern as MetLife was another first for *Peanuts*, one that has yet to be replicated.

ABOVE **MetLife poster, c. 1986.**

OPPOSITE **Detail, unfinished daily comic strip, c. 1970s.**

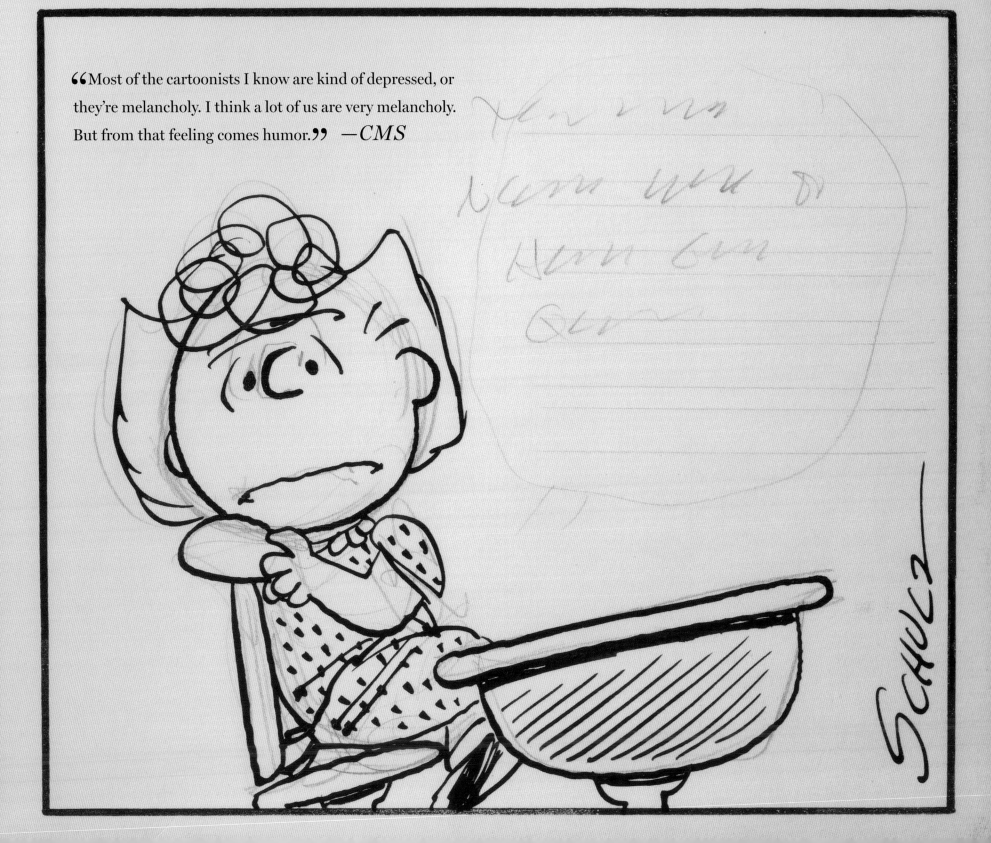

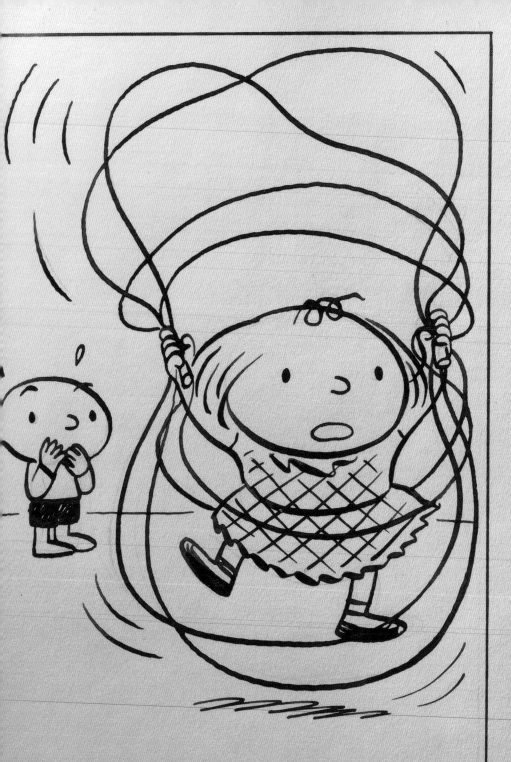

COLOPHON

The images in this book were photographed by Geoff Spear at the Charles M. Schulz Museum and Research Center in Santa Rosa, California, from July 14 through July 21, 2014, using a Canon 5D Mark II camera. A total of 387 shots were taken (some containing multiple images), using 1,859 exposures.

The text and quotes of this book are set in Miller Text and Miller Display, a transitional serif based on the Scotch Roman style, designed by Matthew Carter and released by the Font Bureau in 1997. The letterforms' readability and even color have led to its use by many newspapers worldwide.

The captions are set in Gotham Bold, a family of widely used geometric sans-serif digital typefaces designed by American type designer Tobias Frere-Jones for the Hoefler Type Foundry in 2000. Gotham's letterforms are inspired by characters used in utilitarian architectural signage that achieved popularity in the mid-twentieth century.

EVERYTHING'S NECESSARY

The contributions to American and world culture by Charles M. Schulz are happily incalculable. It's simply impossible to know how many lives he touched, smiles he brought, spirits he raised, hearts he uplifted, or artists he inspired.

Finally, I suppose, that's the beauty of it. We can't know.

But we do know this: Schulz did it using only his mind, ink, some pens, and 17,897 pieces of paper. He made all of that out of nothing.

And out of nothing, he made everything.

—CK, March 2015

"I would be satisfied if they wrote on my tombstone, 'He made people happy.'"

—*CMS*

OPPOSITE **Detail, unfinished comic strip, spring 1950.**

LEFT **Detail, unfinished sketch for daily comic strip, undated.**

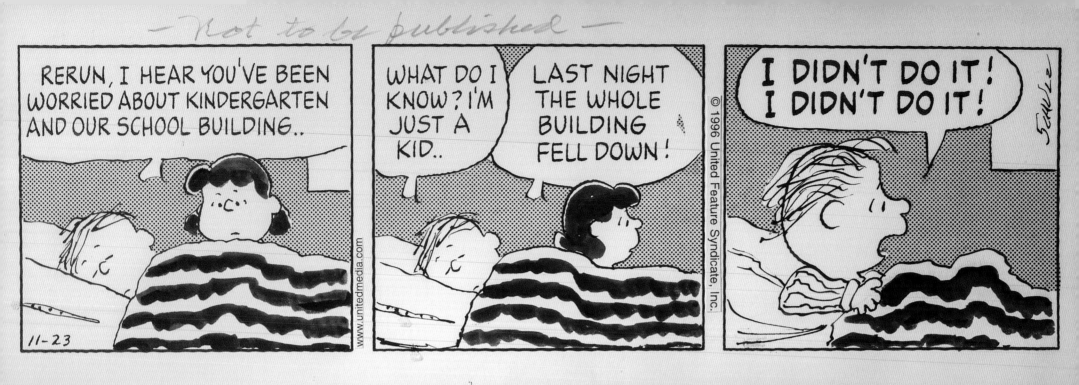

Original art for unpublished, discarded daily strips, November 23, 1996 (above), and October 31, 1998 (below).

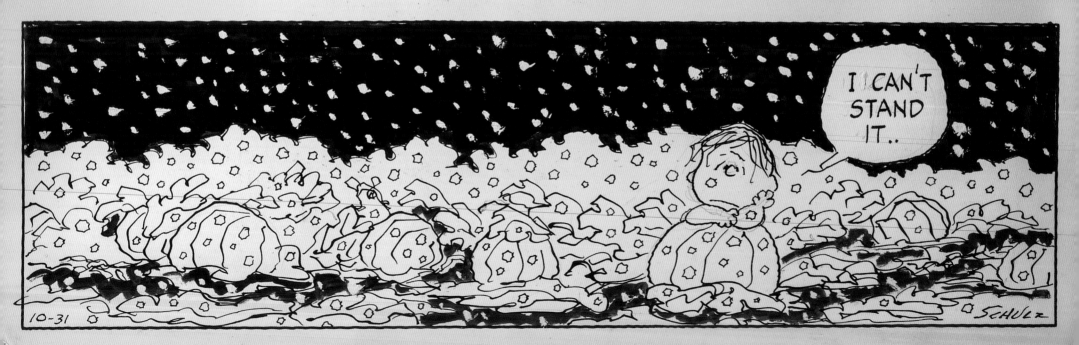

THIS IS ALMOST HOPELESS!

GRATITUDE IS A WARM "THANK YOU!"

My heartfelt love and thanks to Jeannie Schulz for her trust in me to bring this material to print. It has been an honor and a privilege to know and work with her over the last fifteen years.

Paige Braddock is the keeper of the Schulz flame at Creative Associates and a great champion of how we wanted to present this material. She is also a dear friend and a terrific artist. We could not have done this book without her. Thanks also to Alexis Fajardo at Creative Associates.

Geoff Spear once again proved himself a master of the lens in capturing these artifacts and bringing them into stunning, touchable relief.

The staff at the Charles M. Schulz Museum and Research Center made doing the art research for this book seem all so easy. Their knowledge and cooperation was truly astounding: Thanks to Karen Johnson (director), Barbara Gallagher (board of directors), Corry Kanzenberg (curator), Cesar Gallegos (archivist), Nina Fairles (collection manager), Maggie Stockel (collections registrar), Toma Day (facilities manager), Adriana Breisch (facilities assistant), Lauren Faulkner (exhibition manager), Susie Martinez (product and graphic designer), and Dinah Houghtaling (traveling exhibitions manager).

At Peanuts Worldwide LLC: Thanks to Craig Herman, for all his efforts to make this book happen, and to Leigh Anne Brodsky, Melissa Menta, Kim Towner, Chris Bracco, Jessica Dasher, and David Brioso.

And last but certainly not least, at Abrams ComicArts: Charles Kochman was more than the editor of this book, he was its beating heart and worked tirelessly to make it happen. Thanks also to Nicole Sclama (editorial assistance); Shawn Dahl, for handling all the details on the page layouts with grace, skill, and a lot of patience; Chad W. Beckerman (design assistance); Jen Graham (managing editorial); Alison Gervais (production); Paul Colarusso (marketing); and Gabby Fisher (publicity).

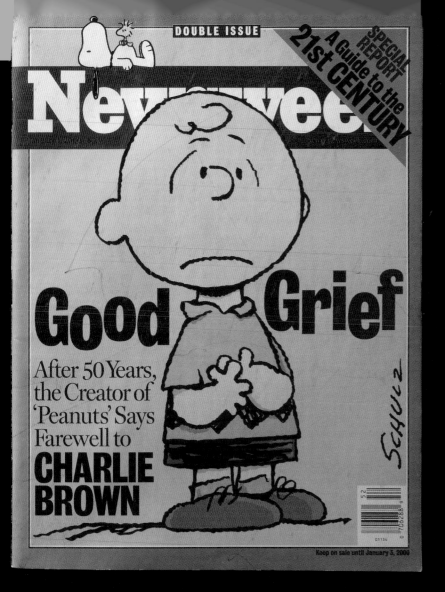

SPECIAL REPORT
A Guide to the 21st CENTURY

Newsweek

Good Grief

After 50 Years, the Creator of 'Peanuts' Says Farewell to CHARLIE BROWN

Schulz

Keep on sale until January 3, 2000

When Schulz announced on December 14, 1999, that he was retiring due to health reasons, it instantly became front-page news worldwide. The cover of *Newsweek* lamented the end of an era on the milestone date of January 1, 2000.

ABOVE *Newsweek* magazine cover, January 1, 2000.

OPPOSITE TOP AND FOLLOWING PAGE Handwritten notes and illustration from Paige Braddock, December 1999.

OPPOSITE BOTTOM The last *Peanuts* daily, Monday, January 3, 2000. Six Sunday strips would publish after this, with the last one appearing on February 13, 2000.

THE LAST STRIP
BY PAIGE BRADDOCK

The story of the last *Peanuts* comic strip is one I've mostly kept to myself. I had only been working at the studio for a few months when I noticed that Sparky didn't seem like himself. Uncharacteristically, he was struggling to finish inking a week of dailies. I offered to help him by lifting elements from previously inked strips and using those lines to finish the week for him digitally on the computer. I even offered to letter them using his font. (I rigorously measured the leading and kerning, only to have someone at United Media change the lettering after I delivered the strips. To this day I regret not putting up more of a fight about that.)

The day Sparky handed over the six dailies for me to finish was the same day he suffered a stroke at the studio. He was standing at the door of my office, with the strips in his hand, and simply said, "Something doesn't feel right."

Jean Schulz called me late one evening a few days later to tell me Sparky had made the decision to retire. After his stroke he had a hard time speaking, so he'd asked Jeannie to call and read me his idea for the last daily strip because there was some urgency to getting it completed and out to newspapers. As I listened I jotted down the message on scrap paper and sketched a little Snoopy at the end of it, basically recording a visual note to have Snoopy relay the message. That final daily ran on January 3, 2000.

I talked with Sparky a couple of weeks later about how I would compile images from previous strips to create the final Sunday comic, an expanded version of the daily, that would appear on February 13. The daily had been much easier to construct. For the Sunday comic I sat with Sparky and asked him to tell me what his favorite visuals were from the strip. Communication was difficult for him, but we took our time. He said he thought it was funny when Snoopy tried to steal Linus's blanket, he laughed at the image of Lucy getting hit on the head with a baseball, he was particularly proud of Snoopy as the Flying Ace, and he chuckled about Peppermint Patty fumbling through school. I tried to reflect these favorite moments of his as if Snoopy was remembering them as he typed Sparky's message to his fans.

In the end, because I lifted elements from previous work, it can still be said that Schulz authored every single comic strip. That was important to him. And it was important to me. I will forever feel a sense of reverence for those moments with Sparky when he was at his most vulnerable. Providence allowed me to be there to help when he needed it most. For that I am grateful.

PAIGE BRADDOCK IS THE CREATIVE DIRECTOR AT SCHULZ'S STUDIO IN SANTA ROSA, CALIFORNIA.

= DEAR FRIENDS I HAVE BEEN FORTUNATE TO DRAW C.B. AND HIS FRIENDS FOR ALMOST 50 YEARS. IT ~~HAS BEEN~~ HAS BEEN THE FULFILLMENT OF MY CHILDHOOD AMBITION.

= UNFORTUNATELY I AM NO LONGER ABLE TO MAINTAIN THE SCHEDULE DEMANDED BY A DAILY COMIC STRIP.

= MY FAMILY DOES NOT WISH PEANUTS TO BE CONTINUED BY ANYONE ELSE THEREFORE I AM ANNOUNCING MY RETIREMENT.

= I HAVE BEEN GRATEFUL OVER THE YEARS FOR THE LOYALTY OF OUR EDITORS AND THE WONDERFUL SUPPORT AND LOVE EXPRESSED TO ME BY FANS OF THE COMIC STRIP

Dear Friends,
 I have been fortunate to draw Charlie Brown and his friends for almost 50 years. It has been the fulfillment of my childhood ambition.
 Unfortunately, I am no longer able to maintain the schedule demanded by a daily comic strip, therefore I am announcing my retirement.

 I have been grateful over the years for the loyalty of our editors and the wonderful support and love expressed to me by fans of the comic strip.
 Charlie Brown, Snoopy, Linus, Lucy... how can I ever forget them.

Charles M. Schulz

1-3-00

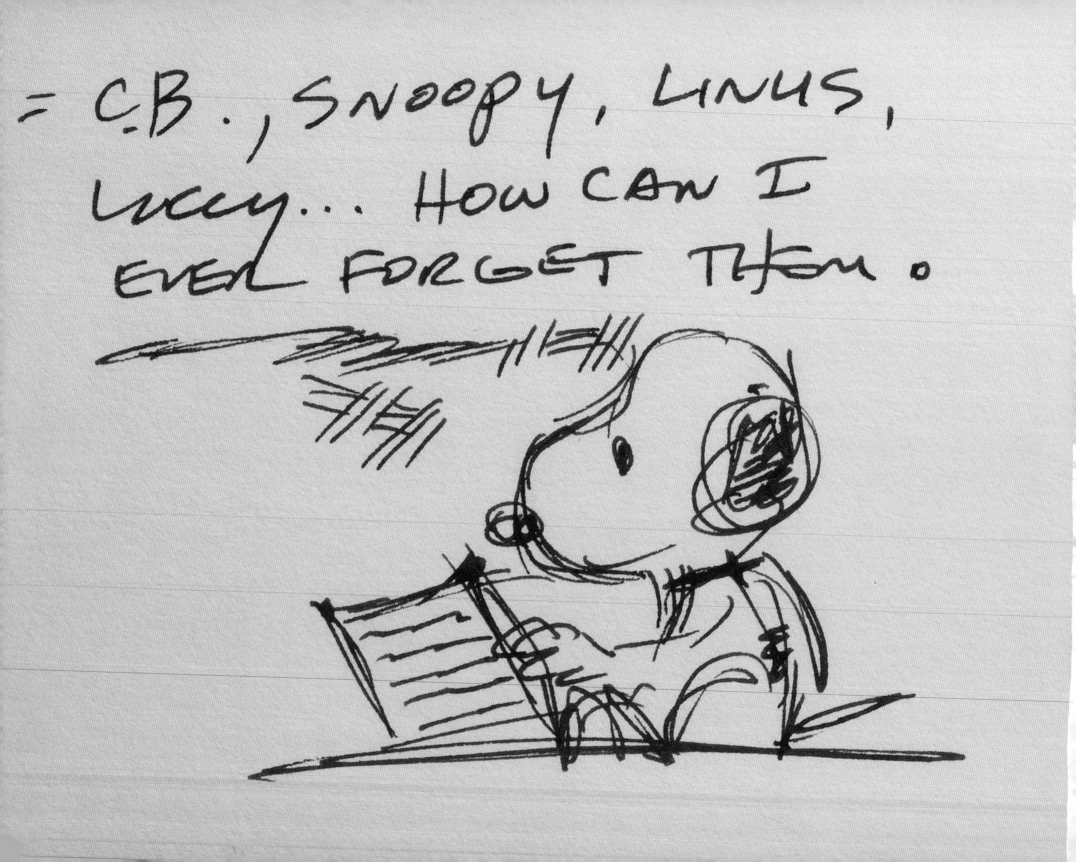

Dear Friends,

I have been fortunate to draw Charlie Brown and his friends for almost 50 years. It has been the fulfillment of my childhood ambition.

Unfortunately, I am no longer able to maintain the schedule demanded by a daily comic strip, therefore I am announcing my retirement.

I have been grateful over the years for the loyalty of our editors and the wonderful support and love expressed to me by fans of the comic strip.

Charlie Brown, Snoopy, Linus, Lucy... how can I ever forget them...

Charles M. Schulz

2-13-00

The last *Peanuts* strip, Sunday, February 13, 2000—a day after Charles M. Schulz died in his sleep at his home in Santa Rosa, California.